DATE DUE

BRODART. Cat. No. 23-221

INTERIOR
LANDSCAPES

INTERIOR
LANDSCAPES

A LIFE OF PAUL NASH

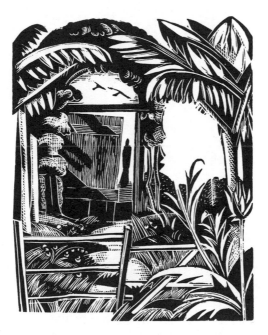

JAMES KING

Weidenfeld and Nicolson
London

For Christine, Alexander, and Vanessa,
with my love

Contents

v

CONTENTS

Plates

Illustrations in the Text

Acknowledgements

I WISH TO thank the following friends of Paul Nash who provided me with invaluable information: Edward Bawden, Barbara Bertram, Mary Doncaster, Margot Eates, Audrey Withers Kennett, the late Henry Moore, the late Clare Neilson, Richard Seddon, the late Anstice Shaw, and, especially, Ruth Clark. Ronald Blythe talked with me at length about John Nash, Frances Spalding answered my questions about Roger Fry, and Clarissa M. Lorenz corresponded with me about her life with Conrad Aiken. I have also benefited from the help and advice of Peter Fullerton, James Ravilious, and, especially, Donald C. Goellnicht.

Anyone who writes on Paul Nash is perforce concerned with the rise of modernism in English art, and I have learned a great deal from the recent studies by Isabelle Anscombe, Richard Cork, Dennis Farr, Charles Harrison, Richard Shone, Frances Spalding, Simon Watney, and William C. Wees. Clare Colvin and Sarah Fox-Pitt of the Tate Gallery Archive were gracious in helping me through their vast Paul Nash holdings. Joyce Whalley of the Victoria and Albert Museum Library kindly made various documents available to me; Susan Lambert, Deputy Keeper of Designs, Prints and Drawings at the same institution provided information and assistance regarding Nash's design work. I also wish to thank Rona Barrett, Bruce Whiteman, and Charlotte Stewart of Research Collections, McMaster University Library, for many favours.

I am also grateful to the John Nash Trustees for allowing me to read and quote from papers of which they hold copyright. My greatest indebtedness in this regard is to the Paul Nash Trustees

(Andrew Causey, Clare Colvin, Robin Langdon-Davies, and George Wingfield Digby) who gave me access to all the documents in their possession and who have given me permission to quote from them. Each of the Trustees read this book in typescript and provided me with invaluable suggestions regarding matters of fact and interpretation.

I should mention here that Nash wrote in a straightforward, vigorous and witty manner, but he often composed his letters in great haste without regard to grammatical niceties. I have occasionally inserted capitalization and punctuation in order to make my citations easier to read.

When I began research on this book in the spring of 1981, I was a John Simon Guggenheim Memorial Fellow, and I wish to thank that institution for its generosity. I received subsequent, much appreciated financial aid from the Arts Research Board of McMaster University.

I am also grateful for the expert editorial advice and guidance I have received at Weidenfeld from John Curtis, Linden Lawson, Margaret Wallis and, especially, Juliet Gardiner. No author could hope for more intelligent or sensitive assistance.

Finally, I conclude with special thanks to the late Anstice Shaw, who in her capacity both as a Paul Nash Trustee and a relative of Paul's, encouraged me to write this book. Anstice was helpful to me at every stage of the research, shared her memories of Paul with me, took me to visit his friends, and in every conceivable way was the guardian angel of this project. I very much regret that she did not live to read the book.

Introduction

PAUL NASH is justly recognized as one of the great English artists
of this century. He is in the tradition of Blake, Palmer and
Rossetti, but he expressed this inheritance in a distinctly twentieth-
century style. Throughout this book I shall argue that Nash's
development as a landscape artist is clearly paralleled by the work-
ings of his own inner landscape. This may seem a very strong claim:
how can a series of paintings, in which human figures are largely
absent, reflect the mind of the artist, his conflicts and his torments?
My answer is that Nash saw landscape as the staging ground for
important questions about the meaning of death, the distrust of
women by men, the depiction of the absent, and the place of the
artist in the modern world. As I shall show, these were central
preoccupations to which he returned continually, and I shall show
also that Nash's manipulation of landscape embodies his concerns
about these deeply personal and artistic problems, the self becoming
the subject matter of Nash's art.

Death, the fear of the feminine, the presence of the absent, and
modernism are, then, the boundaries within which this study seeks
to construct an interpretation of Paul Nash's life and art. He himself
attempted to describe the interdependency between his life and his
art in his autobiography, *Outline*, but readily admitted that this task
had caused him much anxiety: 'After an interval, the "bounding
line," as Blake called it, would again become clear and I could see
the way to continue.' He saw the 'inevitable' in his development as
an artist, but he could not 'force' that life history into being. His
existence, he knew, had been fated, but he claimed he did not 'wish

I

to exaggerate the significance of this impression, or to suggest anything mystical'. And yet he had been caught up with supernatural forces to which, he realized, he had been obedient: '... I turned to landscape not for the landscape sake but for the "things behind", the dweller in the innermost: whose light shines thro' sometimes.'

He believed also that the greatest mystery was derived from the greatest clarity. Clarity and mystery, the precise and the ineffable – these were the forces that intrigued him. And so Paul Nash throughout his career depicted the trees, land, and sky which he loved with a concise sublimity.

His career began in an excessively literary way, and literary elements are prominent throughout it. He became interested in international modernism in the 1910s; by the thirties he was its advocate not only in his oils, watercolours, book illustrations, and design work, but also in his Unit One activities, in his articles for the *Week-end Review* and the *Listener*, and in *Room and Book*. However, he did not, like his friend, Ben Nicholson, cut himself away from the traditions of English art. On the contrary, he attempted the difficult task of integrating the contemporary with traditional English landscape painting. In the face of enormous obstacles, he merged his early devotion to Blake and Rossetti with surrealism – a direction in which he was profoundly influenced by Giorgio de Chirico.

In all his attempts at modernism, however, Nash retained an interest in the mysterious and the ineffable, particularly death. Indeed, he was obsessed with death: did it bring extinction or did it release the soul into a new, higher existence? Many of his paintings ask this crucial question and, continually, he tried to find suitable answers.

Of course, death is a central concern in Romantic art and, to a large extent, Nash worked within that tradition. However, his attraction to the pictorial evocation of a world beyond human sight was intimately connected to his search for his mother, the parent whose mental illness and death had, from the time of boyhood, deprived him of certainty. The often hesitant movement in his work is due in large part to doubts as to how to capture this elusive 'reality', almost always associated with women, who are seen as both benign and evil. Ultimately, the evocation of the mysterious

and the exploration of death are an effort on Nash's part to be reunited with the missing, female emanation of himself. This may seem an excessively Blakean or Jungian view of Nash's life and art, but, as we shall see, it is one which is in accord with the artist's life.

The artist who would capture the landscape of death must deal with a terrain which has never been seen by mortal eyes. This is why Nash in many of his pictures until the last five years of his life hints at unseen presences or depicts mysterious conflicts between objects, or suggests that the inanimate may be infused with a life from which mortal man is excluded. In Nash's art, there was a continual search for the metaphysical reality which hovers at the precipice of human life, and he experimented with various methods of capturing this mysterious activity. The urge to experiment – and to become a truly modern artist – was thus abetted by Nash's unsureness of what he wanted to portray, this unsureness becoming a source of strength rather than weakness.

Thus, his art can be divided into a number of phases. He began with monochromatic, mystical landscapes; then, starting with his First World War pictures, he showed the interaction of man-made objects (shrapnel, the steps at Dymchurch, barriers, the Avebury stones, tennis balls) with various terrains. Late in the thirties, in his Second World War pictures, he made landscape fused with objects, and in the last five years of his life he turned to vividly-coloured landscapes from which all man-made objects have been removed.

Despite the varied pattern of his work, Nash, as I have suggested, was an artist who retained a strong literary bias throughout his entire career, and I have tried to show how he imbued his images with meaning. Nash would have agreed with Magritte, that 'what should be painted was more important than how to paint' and 'that painting could be made to speak about something *other than painting*'. Specifically, Nash's pictures are often depictions of psychic conflicts, the full implications of which may not have been obvious to him.

In order to write of the intimate connection between Nash's inner life and his art, I have written extensively about Nash's life, although this book is more a critical biography than a life history. Indeed, I have often used the outer facts of Nash's existence as a scaffolding to reconstruct the development of his inner, creative side. For this reason, in addition to discussing Nash's oils, watercolours, and

book illustrations, I have devoted a great deal of attention to his autobiography and to his extensive critical writings. For similar reasons, I have concentrated on his dealings with other writers and artists. In particular, I demonstrate how Nash reacted in an extremely negative way towards Roger Fry and Bloomsbury. Nash's deep-seated hostility is hard to reconcile with the known facts, but in published and unpublished writings he commented with great disdain on Bloomsbury, insisting that his career had been blighted by Roger Fry's malignant influence. Nash's strong feelings on this score may not be justified objectively, but I have felt it essential that his thoughts should be aired. As well, I have shown how Nash, in the twenties and more especially in the thirties, became a spokesman for modernism very much in the mould assumed earlier by Fry.

Any new study of Nash should mention Anthony Bertram's biography, published in 1955. Bertram was an excellent scholar, and his study has much to recommend it. However, he did have firmly-held aesthetic principles into which he tried to mould Nash, and he was sometimes denigrating when Nash did not conform to them. In addition to this, I have unearthed many new facts about Nash's personal life. For, although Bertram attempted to obtain all the available documentation on Nash, he was frequently hindered by Margaret Nash, the artist's widow, or by his concern for her feelings. As a result, it is often difficult to discern Nash the man in the life of the artist; there is, for instance, almost no discussion in Bertram of Paul Nash's marriage, which was one of intense vitality. Although Margaret was disliked and distrusted by many of her husband's friends and associates, Nash cared deeply for her, and she provided a great deal of much-needed encouragement. Nevertheless, she had her own imaginative world of automatic writing, astrology, and other such preoccupations into which she frequently retreated. In addition, she rightly expected Nash to fulfil many needs, and this he was frequently unable, or unwilling, to do. As a result, there was a great deal of quarrelling, and in the twenties the couple lived apart for long stretches of time. In any reassessment of an artistic career as autobiographical as Nash's, the positive and negative sides of his marriage must be taken into account, and I have done this. Indeed, it was only in his intimate, often poignant, letters to Margaret that Nash spoke freely: he was a sophisticated, exceptionally charming

man, who often concealed, even from close friends, his uncertainties and conflicts. By citing a number of unpublished letters to Margaret, I am able to provide a link between the man who suffered and the artist who transformed those sufferings into art.

In addition to Anthony Bertram's biography of Nash, I have found the books on Nash by Margot Eates and Andrew Causey to be extremely helpful. These contain a great deal of useful information about Nash and, in many instances, I have pursued lines of thought suggested but, because of the nature of their studies, not fully pursued by those writers. Margot Eates knew Nash in the last six years of his life, and her memoir of him is written from the perspective of one thoroughly conversant with twentieth-century English art. Andrew Causey's monograph of 1980 is now the definitive account of Nash's iconological interests and stylistic development. It is a meticulous, precise, and thoroughly-researched study.

My study differs from these three books in two crucial ways. First, this biography provides, as I have indicated, hitherto unavailable details on important aspects of Nash's life, particularly his marriage, sexuality, and health. Second, I have isolated what I consider the central themes of Nash's art and thus provide a critical analysis of his entire career, with close attention to his most important works.

Many of Nash's best canvases reveal the precarious balance between art and life. Like Yeats in *Among School Children* and *The Circus Animals' Desertion*, he was fascinated with the process of creativity, the difficulties of being an artist, the failure of the artist to find a suitable method of expression. In a manner also remarkably similar to the poet's, Nash wanted to be a modern artist whose structural, formalistic values rejected a Georgian past. However, his desire to abandon a lush pastoral landscape in pursuit of a more geometrical, yet essentially figurative, approach to painting often involved him in considerable turmoil. And yet, despite difficulties, he persisted in his efforts to unite his Romantic inclinations to the demands of new expressionistic techniques.

Often for Nash, fear of failure was therefore linked to his concern with *how* he should express his vision, but, during his long career as a painter, his vision often changed as well, his conception of the nature of death, women and the presence of the absent undergoing

major transformations from 1910 until his death in 1946. Indeed, Nash continually attempted to understand the 'things behind' and, as well, he sought a style to reflect his often tumultuous inner world, becoming in the process one of the most experimental English painters of his generation.

Isolation and the Joy of Places

1889–98

'I WAS BORN in a house called Ghuznee Lodge, Kensington. It was not an attractive house and I never loved it. But there was an odd character about it....'[1] These are the stark opening sentences of *Outline*, Paul Nash's autobiography. As in the artist's oils and watercolours, the world of *Outline* is one of settings, *not* people. It is a work which hauntingly evokes places: houses, landscapes, secluded spots. And it is this ability to summon up the personality of such locales which gives that book its peculiar charm.

Although a skilful portraitist, Nash throughout his career avoided the depiction of the human face. 'My anathema', he once said, 'is the human close-up.'[2] *Outline* displays the same propensity, his strengths as a writer being, not surprisingly, quite similar to his powers as an artist. The almost deliberate exclusion of other persons in Nash's autobiography provides a clue to understanding his unhappy boyhood.

Nash was a tense and fearful child, afraid of and yet fascinated by his disturbed mother. His earliest years were, however, fairly serene. He was born on 11 May 1889, of yeoman stock, and he always maintained that his dedication to landscape was part of his inheritance from his ploughman ancestors. 'What better life could there be – to work in the open air, to go hunting far afield over the

wild country, to get my living out of the land as much as my ancestors ever had done.'[3] He traced his ancestry back to the fifteenth century to Henrie Nash of Oving in Buckinghamshire, whose family rose from husbandmen to yeomen to gentlemen.

William Nash, Paul's great-grandfather, was the Lay Rector of the parish of Langley Marish, but, although continuing to draw tithes, he built a chapel in his farmyard where he instituted a nonconformist minister. William's oldest son, also William, inherited Langley. However, that William, who died at thirty-eight, did 'nothing except lose money in rather a grand way quite beyond the resources of the family'.[4] William's brother, Zachary, purchased Langley from his brother's widow, and he rented it to his other brother John, Nash's grandfather.

This John Nash married Susanna Dodd of Peppard in Oxfordshire in 1846. She died in 1875, but the gracious hospitality she had instituted carried on well beyond her passing. Nash remembered with fondness the 'old state' of Langley: 'Guests came and went, tea-parties gathered in the shade of the mulberry-tree, shooting luncheons were devoured in the paddock under the chestnuts, and Christmas was still a family festival.'[5]

Although the tradition of the family had been agricultural, William Harry, Nash's father, was admitted to the Inner Temple in January 1871, at the age of twenty-three, and called to the Bar two years later. He was to become revising barrister for Gloucestershire and Recorder of Abingdon. Nash as a young man saw himself and his father as 'close companions, not so much as father and son, more as brothers'.[6] However, in the first part of *Outline*, William Harry Nash is obscure, almost invisible; he is not as strong a character in the narrative as his own father. Indeed, William Harry is a forbidding person in the opening parts of his son's autobiography: 'My grandfather and I were great friends. He liked children, but he had an odd phobia about dogs. If he patted a dog he would go at once and wash his hands.... My own father was distinctly nervous of dogs, regarding them as applicable only to sport, and beyond that as a powerful nuisance and a good deal of a menace.'[7]

Nash's mother, Caroline Maude, daughter of Captain John Milbourne Jackson, a naval officer who died before Nash's birth, emerges as a beautiful, frail figure in *Outline*: 'I think she seemed

always delicate, subject to headaches and so often obviously worried.'[8] At about the age of eleven, Nash became aware of ominous rumblings, although the difficulties between husband and wife obviously preceded their son's remembrances. 'For some while my mother had not been her normal self. Without being told anything definite I realised that some trouble was haunting our home. Often mother seemed disinclined to eat. I heard arguments about this between my parents. My father seemed annoyed, my mother irritated. My mother began to look thin and strained. Evidently something was wrong.'[9] In *Outline*, Nash also referred obliquely to 'the strain of constant anxiety'[10] of his mother's illness; however, during the composition of that autobiography he had written more openly about his mother's 'illness' and then decided to suppress the passage:

> ... in the sad [] of our dark dark Beautiful but delicate mother who used to be so quick and gay, and so troubled to think on my dearest memories of her and fraught with a sense of disquiet. I see her great agate eyes change and become overwhelmed with misery and anxious distress as at the reminder of something dreaded. Perhaps already the horrid disease was at work preparing the cruel doom which was to overshadow all.[11]

Barbara, Nash's sister, stressed the centrality of her mother's illness and death on the formation of her brother's character, and Nash's strong feelings of a 'doom' which 'was to overshadow all' confirms her impression. He told Tony Bertram in 1934, 'my experience since I was a boy and saw what illness can do to cripple life is that above all health is everything'.[12]

All three Nash children had been tortured by their mother's uncertain flashes of temper. They had hazy but gloomy memories of constant tears and continual threats. As well, Caroline could be violent and once attacked Jack, her other son, with a butcher's knife.[13] Her 'disease' was certainly a mental condition, probably manic depressive in nature, which completely overtook her in about 1905. From that time, until her death in February 1910, she lived – for increasingly long periods of time – in various rest homes and mental asylums. One of the institutions in which she was confined was near Paddington station, and Nash in later years had sad memories of visits to her there and avoided that part of London.

Nash was perplexed by his mother's mental anguish, and he was the victim of that suffering. He obviously experienced keenly a sense of loss and separation well before her death, and as a small child, he turned to his father to receive the love and care normally bestowed by two parents, and this bond was crucial to his well-being. However, William Harry was not a demonstrative parent. Nash remained devoted to him, but it is doubtful whether he received much warmth or tenderness from him.

The younger Nashes, John, who was born in 1893, and Barbara, born in 1895, are also largely absent from *Outline*. They appear almost by chance near the outset of the narrative and, unexpectedly, later on, when Nash is at the Slade: 'My brother and sister were now beginning to emerge from the chrysalis stage of school careers into an equality of companionship with the elder members of the family.'[14] Nash was four when John was born, and Barbara followed two years later. Being only two years apart, John and Barbara quite naturally formed a conspiratorial relationship against their older brother, the 'old man', as they called Paul.

Outwardly, Paul was a model child, whose quiet gentlemanliness is revealed in a Christmas note to his absent parents: 'I hope you are enjoying yourselves at Langley. We have both been good boys. Jack would not go to sleep again today, but he is very sweet. I am going to hang my stocking up tomorrow night and see what Santa Claus will bring me. We are going to dress up the nursery tomorrow.'[15] Despite the obvious affection, there is a constrained formality here, which displays his reluctance to declare the fullness of his love to his parents.

If Paul's dealings with members of his immediate family lacked warmth and intimacy, he found solace with other, usually female, relatives. 'Aunt Gussie was a very small woman of great dignity. Her head was fine with strong, delicate features.... She could paralyse impertinence with a word or look, for ... her "words were honey, yet they were very swords". To me she was infinitely kind, although she could be stern.' Augusta Bethell, a daughter of the first Baron Westbury, married in 1890 Nash's uncle, Thomas. Earlier, Edward Lear had been in love with her, but it had been a thwarted liaison. Nash recalled in *Outline* that when Lear 'was sad and failing in his solitude at St Remo, he begged her to come out and choose his burial place'.[16] Thus, Aunt Gussie, once the beloved

of a well-known English painter, was an obvious person for Paul Nash, in writing his self-portrait as a young artist, to dwell upon. Her drawing room, he fondly recalled, was full of Lear's water-colours whereas Ghuznee Lodge contained the 'tender, limpid paintings'[17] of Caroline's brother, Hugh Jackson. In Aunt Gussie's drawing room, his young eyes fed upon exotic landscapes of 'the blue vales of Albania, the cedars of Lebanon, or a group of flamingos mirrored in a pool'.[18] Aunt Gussie was a person of refinement and taste, whose house was the setting for aesthetic experiences – such elegance being absent from his own home.

Aunt Molly, his father's sister (Mrs George Chapman), was cosily beneficent: 'She was shrewd and very capable and kind, but her great gift was for making other people happy, or at least less depressed or dull. She was a sort of human tonic and her energy was endless.'[19] In providing this description of his aunt, Nash is giving his recipe for an ideal mother and describing the relationship he did not experience with his own. His other aunt, Edith Sarah Nash, the custodian of the rectory, was a 'lovable person with a deep sweet voice'.[20]

Nash's memories of his earliest childhood centred, however, on his grandfather, whom he recalled as kindly but stern: 'you did not trifle with John Nash nor contradict him lightly – at least not twice, for the force of his personality was such that he compelled immediate respect'.[21] The boy observed him dealing decisively with problems, and he was impressed by the 'perfect condition'[22] of the farm. If life with his mother and father was not ideal, perfection to the young boy resided at Langley. He remembered the hens' eggs collected there. 'Ever since I can remember sensation I have been delighted by the sight and feel of birds' eggs. They represent for me a kind of beauty which to this day nothing supplants.... The fact that it is potentially alive I do not think ever interested me. I experience only an aesthetic emotion. As a child in my grandfather's study I had some such instinctive experience.'[23]

As a young child, Nash associated Aunt Gussie and his grand-father with the pleasures of art. They are also the most strongly conceived portraits in the gallery of his early life. Caroline and William Harry hover on the outskirts, and there is a curious absence of detail in the renditions of the two people who should be central to the first part of the narrative. Those honours go to others, but

the real force and vitality of the beginning parts of *Outline* are, as we have seen, in the evocations of place.

Indeed, Nash presents a rich assortment of trees, gardens and parks which appear as if by magic. Towards the end of the first chapter of his autobiography, he tellingly describes his encounter with his 'first authentic *place*':

> For me it held a compelling charm. It was conspicuously ghastly on dark days in the beam of a low sun, or it shone steely blue in its metallic mood in early spring. Sometimes it was poetically pale and enchanted and could suggest a magical presence, not, however, by its personal figuration, but by some evocative spell which conjured up fantastic images in the mind.... There are places, just as there are people and objects and works of art, whose relationship of parts creates a mystery ... this place of mine was not remarkable for any unusual features which stood out. Yet there was a peculiar spacing in the disposal of the trees, or it was their height in relation to these intervals, which suggested some inner design of very subtle purpose.

At the edge of this haunted locale stood 'an ancient beech, leaning precariously forward and, for some years now, held up by a crutch. Oddly enough, I think it escaped the regard of the whimsicals, but it is full of personality as a tree and dangerously like a witch, if that is how your mind works.'[24] That was obviously how young Paul Nash's mind worked, and throughout the narration the young child invests places with compelling mystery. However, houses, which must be directly associated with people, are described with some apprehension.

Ghuznee Lodge, for instance, was a 'grey, high house facing across the line of vision taken by the other houses in the street, bending its gaze past the church';[25] it was also a 'pariah'. The Grange, a house in Hampshire rented by his grandmother and Aunt Rhoda, was equally repulsive: 'It was rambling and shady, shut in by shrubberies and heavy trees. It had a sense of airlessness and gloom. I see it always shrinking into the obscurity of twilight. Its character depressed me to an unnatural degree.'[26] Langley Hall, imbued with his grandfather's protective kindness, is the only house in the first part of *Outline* which does not seem ominous.

The small child's sense of isolation was heightened by some of his experiences of nature, as in his discovery of evil in the midst of

apparent innocence: 'One day in the orchard I went to pick up an apple when, almost from under my hand, a snake rose up hissing, and turning, moved away between the trees seeming to bound along on its monstrous length.... So many innocent things now began to have a sinister nature.'[27] Yet, the terrors the child experienced by day were nothing compared to what he often suffered by night. 'One was undoubtedly a formal dream of a non-figurative or non-representational idiom. But it was not static. The horror consisted in being hemmed in by vast perpendiculars of changing dimensions.'[28] He also dreamt in a 'more realistic' manner of being trapped in a tunnel, 'horribly, unable to squeeze through or to back out'.[29] As an adult, when Nash used snakes in his art, he bestowed upon them an ambivalent quality. They may seem ominous, but for him, like Blake, superficial appearances can be misleading and serpents often represent the possibility of man transcending the world of appearance for the world of the spirit which lies beyond it. Nash would, as well, become intrigued with 'non-figurative' art in the 1930s, when he converted his childhood nightmares into art.

Nash's interest in flying, of release from the ordinary claims of being mortal, is revealed in another series of dreams, which 'consisted, simply, of flying or floating, usually downstairs and round about the top of the hall. Sometimes, I would find myself in other places, unknown country perhaps, easily traversed by a process of leaping and, by some act of will, keeping afloat for a good distance before sinking slowly to earth.'[30] In the 1940s, he would be fascinated with aeroplanes and create, especially in *Totes Meer*, images of great vitality depicting them. As well, birds, especially the phoenix, symbolize for Nash the questing for a world beyond the apparent one.

There was another dream – this one of searching. He would be climbing the steps to reach the nursery. Fear would begin to overtake him. He would approach a dark corner. As he turned, he would catch 'in a quick side glance into the gloom – a dog, a black dog, silent and still'.[31] The animal would not pursue him, but Nash would run away, terribly shaken. This black dog would even appear to him when he was playing with his brother and sister. 'Or, at a party I would gradually become aware, not of its presence, but of its approach.'[32] The sense of a looming presence – central to Nash's work – is introduced here in the narrative. In many of his paintings

and drawings, he evokes for the viewer the presence of a hidden person or force. He hints at something unseen. In these pictures, what is absent can be as important, often more important, than what lies directly before the eye. Ultimately, Nash's youthful fears of confinement, of being trapped would lead to speculations about the freedom lying beyond the world of appearances. He was forever capturing 'with a side glance' the world of symbols behind materialism.

Nash's childhood dreams obviously provide significant clues to his art – he later ransacked them for the vibrant images which endow many of his paintings with an unnerving other-worldliness. Despite an unavoidable amount of self-advertisement in his autobiography and despite his eagerness to link his precocious self-awareness to his mature artistry, *Outline* is undoubtedly a truthful account of the boy. In the first pages, moreover, the reader meets an anxious child, one who is trying to penetrate the veil of reality in order to reach the truth behind appearances.

Because he was denied many of the joys of family life, Nash discovered his greatest happiness 'in the wood' where 'everything seemed to be listening': 'Yet whatever happened to me ... throughout my life, I was conscious always of the influence of the place at work upon my nerves – but never in any sinister degree, rather with a force gentle but insistent, charged with sweetness beyond physical experience, the promise of a joy utterly unreal.'[33] Young Nash found consolation in this 'joy', such experiences becoming the centre of his world. He would later in his career as an artist explore their beauty and mystery. Also, by hinting at invisible realities – 'silent and still' in his various 'places' – he suggests the presence of hidden figures associated with the feminine and his mother.

Perhaps because of his experience of desolation, Paul Nash invested his emotions in places. The life he gave to them may have been in part the devotion he wished to bestow upon his troubled mother or his reticent, inhibited father. Despite his disclaimer, there is often an ill-boding aspect to those landscapes. This probably derives from a sense of alienation, the other side of love. He had craved his mother's affection, but she, due to circumstances beyond her control, had not been able to give him all that he needed. He obviously felt some resentment against her, and he often acted towards the other women in his life in ways which replicated his

Bookplate for P. G. Broad, 1910

mother's earlier behaviour. Distrust of women was an inheritance his mother had unwittingly bestowed upon him, and Nash often associated the feminine with the 'sinister'.

Nevertheless, love was a far stronger force than hatred in Nash's character, and his fascination with death also stems from a conviction that it would help him to recover the maternal tenderness of which he had been deprived. Thus, the pursuit of the mysterious was for Nash part of a continuous, largely unconscious, attempt to retrieve the love of his 'dark dark beautiful but delicate mother' and to comprehend 'the cruel doom' which overshadowed his earliest years. For him, nothing was stronger than the position of the dead among the living.

Nash's recollections of early childhood end near the Serpentine, where he feels a 'cold chill' as he experiences a 'strange impression' of the garden. He asks his nurse, Harriet, to wait for him:

'What is it?' 'Only a place.' 'No, come along, it's getting late, it will be there to-morrow.' 'No, no.' 'Nonsense, come along, you can find it another day.'[34]

Nash was constantly looking for and discovering what he had never seen before. His greatness as an artist derives from his extraordinary sense of experimentation, his constant search to capture the elusive. And the quest for hovering presences and exotic images was with him from the beginning. Out of childhood's sorrow came strength.

Further Isolation and Dedication to Art

1898 – 1906

ALTHOUGH NASH experienced deprivation as a child, he found solace in 'places'. At the age of ten, he was still entranced by the upper, aerial parts of houses and by ghosts. One day, in the presence of Harriet and two other servants, he casually looked out of the window and over his shoulder at the sky: 'A cloud mounting up, parted, and I saw a figure in white lean out looking at me, it seemed, and holding up a warning finger.'[1] This 'visitation' occurred in the midst of a bout of influenza: 'Its nature, too, at once alarming and ludicrous, was like something in a dream and seemed to express with cruel mockery my haunted state, for the symptoms of my illness became evident, not as a rash or a swelling, but as a noise. . . . It was like being pursued by a demon.'[2]

Nash was a dreamy boy, and, he claimed, not a particularly attractive one: 'I was apparently robust and had no picturesque attributes. On the contrary, my hair was so black and thick and stubborn as to be called the blacking brush, and I had rabbits' teeth and an odd-shaped head.'[3] It was in January 1898 that the boy with the thick black hair was introduced to real schooling at Colet Court, the preparatory school for St Paul's, where he was plunged into a world of bullying and cruelty.

His earlier experiences of schooling had been blissfully serene.

During a school holiday spent at Yateley with Aunt Molly, he had been conveyed to a decrepit house: 'I found it rambled because it was not a normal house, but a Dame's School. We waited in a comfortable-looking room until the door opened and a rather stout lady with a sweet, smiling face glided in. I was presented and was astonished and alarmed to find I was to be enrolled as an extra special member of the school, the only boy among an unknown number of girls.'[4] Nash soon settled in – he claimed that he did not learn very much 'except not to be afraid of girls and how to get things done for me'.[5]

At Colet Court and for the remainder of his school days, Nash was never an ideal student, although he tried hard and was thought of as earnest by his teachers: 'My liberty had been taken from me … in those years I suffered greater misery, humiliation, and fear than in all the rest of my life.'[6] For him, even the gruesome experiences of 1914–18 were less horrible. The child is defenceless against the towering cruelties of school; the adult has at least some understanding of the horrors of war – and possibly some psychological defence against them.

The person at Colet Court who made the strongest impression on Nash was 'a tall heavy boy with a fattish white face and a quiet voice'. This boy, the ringleader of the bullies, is the central figure in Nash's reminiscences of Colet Court, and it was under his tutelage that Nash realized he was not a coward, 'although … hardly physically courageous': 'one day I discovered that I lacked some nerve which should have been there to meet the emergency, but being absent betrayed me to disaster … to a certain extent I was always subject to this nervous failure, which generally took the form of acute apprehension'.[7]

Gradually, Nash learned to master his new environment. He became 'hardened to fights and minor brutalities', and, two years after, he even joined in an attack on one of the bullies who had earlier tormented him: 'I had to jump to reach his face. His pendulous, princely nose bled richly, then two great tears rolled down, mingling with the dark blood.'[8] Nash was as fascinated by his new-found pluckiness as he was ashamed of it.

There were other distractions from schoolwork. Nash became a Sherlock Holmes addict, and, in the process, one of a small group of boys who became convinced that an attempt was being made to

break into their house at Colet Court. Ultimately, this enterprise 'involved so much tapping and whispering that we ourselves became frightened'.[9] The theatre was also a source of wonder, its 'artificial beauty'[10] deeply attracting him. He wanted to have his own Punch and Judy show, and he even built a model theatre. Not surprisingly, he was also interested in directing and controlling the presentation of 'places': 'I invented, coloured and illuminated all the scenes, and was especially good at caves and rocky coasts.'[11]

At school work, Nash demonstrated 'average intelligence'[12], but this never extended itself to his bugbear, mathematics: 'Every examination showed the same result; my total suffered by the scores of marks lost in arithmetic, algebra and geometry. Actually, I was capable of quite complicated methods of computation to prove my sums. But the answers were fantastically wrong.'[13]

Nash's lack of ability at numbers was deemed tragic by his parents who had determined that he should follow a naval career. 'Certainly, I cannot blame my parents for not dedicating me to art, but in offering me to the sea I think they were a little casual. Even respect for the quaint tradition that the fool of the family goes into the Navy hardly justified this policy.'[14] This decision seems particularly callous because young Nash saw the sea as cold, cruel, and 'in a threatening mood, pounding and rattling along the shore – a fascinating but rather fearful joy'.[15] In fact, he had narrowly escaped drowning on two occasions: 'I can still hear the alarming rattle of the pebbles sucked back by the ebb and the frantic cries of paddling children and nursemaids confused with the yelling of the gulls. As the wave enveloped me Harriet groped and grabbed me just in time.'[16] Much later, Nash's fear of the ocean's destructive potential would be enshrined in his Dymchurch pictures.

Nash had been destined for the Navy because Caroline Nash's family – the Jacksons – had dedicated themselves to the sea for four generations. 'In the Painted Hall at Greenwich I had been shown my great-grandfather's ship, the *Hebrus*, gaining a fierce victory over the French frigate, *L'Etoile*.'[17] In fact, Caroline Nash appears as a major character in *Outline* only as a parent worried about her son's aptitude for mathematics and sports: 'My mother's eyes were anxious. What was I to do? Why was I such a fool?... My parents (especially my mother) were eager for me to show ... proficiency in games. There were family traditions.'[18] A 'ludicrous but poignant'

incident further betrays his mother's worries. Nash had not done well at the school's sports day, but he had managed to win the consolation race: 'My poor mother, seeing me coming, rushed to the door, her face happy with pride. "Oh you won a cup! What was it for, dear boy?" "The consolation race," I sang out. "Oh ... oh ..." All the joy went out of her face.'[19]

Eventually, Nash became, by the time he was ready to leave Colet Court, 'virtually head of the House'. The child who had been cruelly treated a few years earlier became 'exalted and tyrannical'.[20] This is merely polite exaggeration. In fact, he remained an overly sensitive boy. When his parents were away on holiday in Swanage in 1902, Nash, thirteen at the time, was left behind with his Aunt Maggie and her husband who lived at Primrose Hill. Their servant, 'Old Charlie', walked Nash to the bus which took him to Hammersmith. It was on such an occasion that the young man witnessed a grim scene:

> One morning we were hurrying along hand-in-hand down the hill, when on the broad pavement outside the public-house we found something horrible was happening. There was a man and woman and a little crowd beginning to edge up to them. The man was shouting in a violent voice, the woman was deathly pale. Suddenly, he hit her in the face; some blood splashed on to the pavement. 'You bloody cow', he shouted. I saw her begin to cry.[21]

The early pages of *Outline* contain incidents of great happiness, moments of shared tenderness with his grandfather, the thrill of finding a new 'place' – but on the whole it was a world of anguish and cruelty that Nash remembered.

At the age of eleven, as we have seen, Nash became directly aware of his mother's instability. Then, suddenly, a new scheme was announced. The family was abandoning London in favour of the country. The Nashes had decided to build a house at Iver Heath, in Buckinghamshire, a setting to which Nash responded enthusiastically: 'The road-hedge was thickly grown with holly, elm, hawthorn, and briar. The dog-roses were just opening. In the ditch, the red berries of the arums had thrust through their sheaths. There were birds everywhere. It was the real country, only fifteen miles from London.'[22] The discords of family life were modulated by this retreat to the countryside, where the tranquil beauty of the trees

soon entranced him. The immediate change in Nash's life was that he became a boarder at Colet Court, where he was enrolled until the autumn of 1903, at which time he entered the senior school, St Paul's. For the most part, this new status brought him into the 'care of ... human and kindly men'.[23]

Almost no records have survived to chart Nash's dealings with his parents at this time, although an overtly comical letter from his mother of 22 May 1903, near the end of his time at Colet Court, hints at some of his tribulations and her resulting worries. An aunt of Paul's had been visiting, she tells him, and they 'had a *long & happy* day in Town; she says she knows you will pass, she will eat her hat if you don't, so be sure you do, or I am afraid she will have bad indigestion'.[24]

He had no sooner moved 'across the way' to the 'big school' in the autumn of 1903 when it was decided that St Paul's did not have the necessary 'machinery'[25] for getting him into the Navy. In reality, Nash's fall from grace came when he was daydreaming, his imagination having come to life in response to a work of art: 'the monster representations in mosaic by Sir William Richmond of the more famous old Paulines, from Milton to Marlborough'. The reverie came to an abrupt end as a voice bellowed out, 'You're doing no good here': 'The next second a formidable stomach had overtaken the voice and was trained on me like a gun. Behind this I could see an enormous uncared-for beard leading up to a great God-like head, out of which blood-shot eyes were glaring and from which the voice was raising again in a deafening crescendo.'[26] From this intrusive giant, Dr Frederick Walker, the headmaster of St Paul's, Nash was turned over in November 1903 to 'Commander' Littlejohns of the Planes, a cramming school at Greenwich. There was no caning at this new school: 'That was too elaborate. Punishment was swift and direct. If you were slow or stupid you were cuffed till your head sang.'[27]

Nash had been set loose into a new world of schoolboy sadism. 'Fright and constant cuffing only made me more stupid. I became the butt of the class and even the other boys looked on me as a kind of moron.'[28] The central, humiliating episode in Nash's description of life at the Planes is the Commander's attack on him when he could not come up with a sum. 'With a roar of fury he began to shout questions at me, cuffing my head with heavy blows on the

ears. I remained dumb and impotent. . . . A few minutes later there was a kind of half-strangled screech followed by a resounding slap, and the Commander's voice, hoarse and nearly inarticulate with passion.'[29] Nash eventually made his way to the washroom – his ears were bleeding, and he could not stop crying. He wrote to his father describing the incident, but the hoped-for reprieve was not forthcoming: 'it was quite clear to me in his letter that I had to go on'.[30] Nash's salvation came unexpectedly when it was discovered that he was an excellent football player. The Commander now dubbed him 'Julius Caesar'. Nash had found a way of conquering the tyrant's heart.

Despite the lease on some sort of life at the Planes, Nash had to be expelled when he failed to pass the naval examination. Mr Littlejohns was distraught, as he told William Harry Nash in a letter of 8 September 1904: 'Poor Julius! I am afraid he will never make anything of Mathematics: a really good boy whose influence is always for good: a boy liked by all the staff as well as ourselves. I shall always be glad to see him and to hear of his welfare. What is he going to do now? It must be something non Mathematical.'[31]

Their hopes dashed, the Nashes now decided that their oldest son was to become an architect, allowing him to return 'ignominiously'[32] to St Paul's. From the autumn of 1904 until July 1906, Nash remained there. Dr Walker had died but 'the authority who reigned in his stead regarded me with a dubious eye'.[33] Nash was further disheartened when he was placed on the science side of the school. 'As an awkward case I was relegated to the notorious Upper Transitus, where no one pretended to work and which had a reputation to keep up as the form which could not be disciplined.'[34] In December 1904, Nash's masters characterized him as 'Weak but improving', 'Variable worker', 'Poor, does not work', and 'Moderate'; in drawing, he was 'Fair, improving'. He pulled himself up a bit the following year; in drawing, he became 'very fair . . . improving in Mechanics'.[35]

Nevertheless, Nash was plainly bored by the curriculum to which he was subjected. One day, he came upon another boy drawing at an easel. Eric Kennington, 'who lived not as other men, but like a bird, rather, on a perch, knocking off likenesses of the plaster casts and whistling tunelessly the while',[36] had already resolved to become an artist. Nash realized that his skills were hopelessly behind

Bookplate for Assheton Leaver, 1910

the other boy's. Nevertheless, his mind 'wandered away, lost in the strange thoughts and memories that arose'.[37] Nash's imagination had literally taken flight, and it would not turn back. He too would become an artist.

———————— • ————————

Rossetti, the Moon and the Woman in the Sky

1906 – 10

NASH'S INITIAL DEDICATION to his calling had an accidental air to it. He was curious about Kennington, who was not like the other boys at the school. Nash was aroused by the prospect of a career which offered not only separation and isolation but also the opportunity to investigate the exotic and aerial. However, his imagination was not focused. His halting apprenticeship is largely attributable to his attraction to the profession of 'artist'. He wanted to be like Rossetti or Blake, and he never lost his desire to capture the otherness so central to Romantic art, but he had to learn to delineate it in precise visual language. Later, his search would be for suitable stylistic vehicles with which to explore the visionary world which obsessed him. His initial steps in that direction, however, were not promising.

Crushing financial difficulties overwhelmed Nash and his father during the first four years of the son's new calling. Caroline Nash was by now an almost permanent resident of nursing homes and mental asylums, the cost of which placed an enormous strain on William Harry Nash's income. Despite this, he fully endorsed his son's decision to become an artist. Mr Nash's support is especially remarkable since he did not really understand such an undertaking. His support at this time was crucial, since Paul was beginning to

see himself as a failure, and, as he observed, 'I found, too, that in the opinion of a good many people, I was practically doomed to continue a failure'.[1] Nevertheless:

> my father remained unshaken.... Perhaps he remembered his own youth and how, of all people concerned, his father had been almost alone in supporting him in his rash resolve to read for the Bar.... So when I proposed earning my living as a black and white artist or illustrator of some kind, no objection was raised. In fact, everything was done to launch me on this precarious career.[2]

Mr Nash introduced his oldest son to some acquaintances of his – a historical novelist, a publisher, and a newspaper illustrator – who did not prove helpful. Nash, however, was touched by the support he received from his father, and the beginning of the closeness between the two was forged at this time, William Harry becoming Nash's closest friend – just at the time of Caroline's death and just as Nash's dedication to art came into being. 'Together we began to face a different world which gradually brought us the consolation of peace of mind and, in course of time, something like happiness.'[3] As the son said, 'How I should have felt had my father's support weakened.... But he never wavered.'[4]

Nash's stumbling approach towards being an artist is due in large part to the fact that at this time he forged his identity as an artist in isolation. As a young man, he was acutely aware of the difference in taste and outlook which lay between his family circle and people who, though of his father's generation, were devoted to art. This distinction was underscored for him when he later visited Will Rothenstein's Hampstead home:

> For the first time I realised I was in the presence of taste ... my attention was constantly diverted from the occupants of the room to the room itself. The austere beauty of its lines and intelligently considered spaces, its colours in a low key, set off with perfect effect the many lovely pictures and objects, which had been selected with subtle discrimination to enhance the simple forms of the furniture.[5]

In the 1930s, Nash would become one of the great exponents of 'modernism' in contemporary design and live in surroundings chosen to reflect his own highly-developed taste. As a young man, he was entranced by beauty which he did not fully understand but

which, nevertheless, intrigued him. His 'opening' as an artist began in a similar, untutored – almost primitive – way. The artistic sensibility came early, but the means to entrap it developed slowly.

On 17 December 1906, Nash enrolled in art classes at the Chelsea Polytechnic. He moved from there to the London County Council School at Bolt Court (off Fleet Street) in the autumn of 1908. Nash began at Chelsea as a part-time student but he later entered the full course, which included life classes: 'I soon found that the Chelsea Polytechnic was of no use to me. At that period its instruction was not practical enough for my needs and I began to feel I was wasting my time.'[6] A teacher at Chelsea recommended Bolt Court: 'The whole purpose of the school was avowedly practical. You were there to equip yourself for making a living. It suited me.'[7] The years at Chelsea and Bolt Court, however, did not suit Nash's art. He acquired some basic skills during those four years, but he was certainly not in touch with contemporary trends, although it is doubtful that he wanted to be.

At this time, Nash continued to be attracted to the role of artist, becoming steeped in romantic medievalism. Indeed, his earliest efforts as an artist combined such a view of art with direct, practical application. As well, his letters and drawings of this period display a remarkable knowledge of Keats, Hardy, and such lesser writers as W. J. Locke and E. F. Benson, and his prose is suffused with a lush romantic exuberance:

> But today, as I came thro the wood, under an arch of tempest and led by lightnings, I passed into a green sun splashed place. There, there I heard the singing of a rapt song of joy! there ah there I saw the flash of white wings.[8]

Such enthusiasm sometimes led to excess. From 1908–10 Nash executed at least twenty-eight bookplates in slavish devotion to Rossetti, Burne-Jones, and Beardsley's *Morte d'Arthur* illustrations. These are competent, if somewhat overblown pieces, and they show Nash trying to combine his neo-Romanticism with the practical demands of selling his art – of starting a career which would be financially lucrative. 'They were generally extremely complicated, as they set out to interpret the personal qualities of the owner.'[9] The drama of the relationship between objects – a major theme in his later work – had its hesitant beginning here, the bookplates

developing from pastiche to an attempt to capture the personality of the person for whom the plate was designed, to a sophisticated use of design in a three-tier arrangement, to designs which reflect Nash's own individual brand of romanticism with a concentration on place, atmosphere, and especially, the moon (see pages 15 and 22). The movement, although hesitant, was already towards clarity.

Nash was to look back at these four years as wasted time, when he was attempting desperately to acquire the technical skills of his craft. It was at Bolt Court, however, that he met two distinguished artists who offered him encouragement. The first was the 'last conspicuous pre-Raphaelite' Selwyn Image, who, impressed with Nash's pen drawing illustrating Rossetti's *Staff and Scrip*, invited him to tea. This was important for Nash, as 'It marked the first occasion of my entry into another world. As a family we had no social–artistic connections.'[10] The second person was William Rothenstein who, accompanied by Gordon Craig, visited an exhibition at Bolt Court. Rothenstein asked if the poem acccompanying the Rossetti illustration had inspired it. Nash said this was so. There was a pause – a very dramatic one – and then Rothenstein proceeded to give Nash's work full marks. Rothenstein's own work in the 1890s had been influenced by Whistler and various French painters, especially Degas. He had been a pupil of Legros at the Slade and in 1900 had become very receptive to Impressionism. Despite Nash's obvious artistic immaturity, Rothenstein discerned in the young man's work a capacity for strong form and abstraction – for Rothenstein, however, pure abstraction was a cardinal heresy.

Nash's imagination was now struggling rapidly to express itself. At first glance, it might seem that his devotion to Rossetti was a backward step which would only lead to acclaim by artists and collectors who were rooted in the past. By any standard, Nash's entanglement with Rossetti was overwhelming, and almost completely dominated him: 'I read every word relating to him and knew almost every poem and picture. Owing to his example I began to practise the dual expression.'[11] Nash even wanted to be, he confessed, another Rossetti. In later years, however, he would see this early infatuation as pernicious.[12]

The obvious reason Rossetti held sway over Nash was that he represented to him the ideal of the artist as free spirit. Nash had

been initially attracted to art for the liberty it seemed to offer. As well, his imagination had evolved poetically rather than pictorially. It was natural, therefore, that he wanted to model himself on a practitioner of the 'dual expression'.

However, there is a much more pervasive, if subtler, force at work in Nash's espousal of Rossetti. Nash's commitment to art was made during the last years of his mother's life when he was deeply distressed about her. At the same time, his sexuality was developing. He was a young man who desperately wanted to be in love. He saw women as attractive and voluptuous, but he also, as in the case of his mother, had experienced women as remote and aloof. He was distrustful of women while at the same time being deeply attracted to them.

Rossetti's poems depict the pangs of a sexuality which finds itself drawn to women, but which, in the process, perceives them as cold and withdrawn. Indeed, Rossetti presents sexual longing as a snare into which men are betrayed and then destroyed, the male becoming crushed because of women's paradoxical – and perverse – natures. In *The Blessed Damozel*, for example, Rossetti depicts the lady in both her spiritual and sexual aspects, a duality which intrigued Nash and which he imitated, as we shall see, in two early pictures.

From the time he was a young child, Paul Nash had undergone experiences which underlined for him Rossetti's observations. He had known tenderness and yet that tenderness had been withdrawn. He had loved his mother, but she had seemed to reject him and the other members of the family. In the first works by Nash in which his particular stamp is discernible, he attempts to come to grips with this enigma. Two drawings of 1910–11, *Our Lady of Inspiration* (page 30) and *Vision at Evening* (plate 9), clearly reveal this.

In each of these pictures, a woman's face hovers over a landscape: 'I saw a woman's face within the skies/ ... But ah, my vision faded all too soon....'[13] These faces are spiritual presences, Diana-like in their evocations of an existence under the dominion of the moon. However, the landscapes themselves are permeated with sexuality. In *Vision at Evening*, Nash depicts the Chiltern landscape so that it becomes the recumbent naked body of a woman, with her breasts as the low hills in the foreground.[14] Similarly, the enmeshed trees, shrubbery, and brambles of *Our Lady of Inspiration* are the female genitalia.

27

In *Outline* Nash provided an extensive description of the direct inspiration for these two drawings; he had been walking along the Alderbourne on the walk back to Iver Heath.

> These journeys through the night, this halt by the stream, and this voice, made up the influences which compelled me to write poetry. For now I needed an outlet for a new thing which had begun to stir in me and growing, gradually to absorb my whole mind and body, the strange torture of being in love. Henceforth, my world became inhabited by images of a face encircled with blue-black hair, with eyes wide-set and luminous, and a mouth, like an immature flower, about to unfold. But the whole countenance, as I saw it so often in my dreams, seemed remote, untouched by human warmth, lit only by some other radiance which poured out of the eyes in their steady gaze – unaware of the mundane world; certainly unaware of me.[15]

The form of these visions may have been dictated by Rossetti or a watercolour by George Ruff owned by his cousin Nell Bethell's family. The face was undoubtedly that of an early love – certainly, it disappeared when he broke with her: 'The face in the night sky, the voice by the bridge of the Alderbourne had, as I feared, been only a dream.'[16] Since those two drawings are about sexual desire, it was appropriate that the face resembled that lady's.

Significantly, those pictures also portray women separated from their bodies and who are, perforce, remote and chaste, and perhaps, cruel. Both faces seem to beckon, offering spiritual closeness, that closeness precluding the body. These pictures are also about invitation (life) and rejection (death) – the dual state of the relation between men and women according to Rossetti and his disciple, Paul Nash. For both men, the house of life is filled with the presence of death.

These two early pictures are a young man's drawings in which he portrays the travails of human love, the conflict between reason and passion, death and life. They are also concerned with his mother's final illness and death. Caroline had offered love to her son, and she had then withheld it. Her love had been real but, nevertheless, transitory. Nash obviously relived the drama of his relationship with his mother in all his future dealings with women. They were desirable (and also saw him as desirable), but they could also abandon him. In turn, Nash, as we shall see, could be extremely

28

flirtatious, replicating in his behaviour the beckoning and then withdrawing stances he perceived in women. In any event, the depiction of the tragic inevitability in the relationship between men and women in Rossetti appealed to Nash because it encapsulated his own experience.

When Caroline died on 14 February 1910 Nash, who was then twenty, told his cousin, Nell Bethell, 'she came to the end of all life. I cannot tell you how terrible death is.'[17] His cryptic words conceal the poignancy of his grief. For the remainder of his life he would, Ruth Clark, a close friend, remembered, quickly change the subject when his mother's name was mentioned. The memory had become too painful.

The faces quickly disappeared from his work; in another sense, he never abandoned them. The depiction of invisible presences in Nash's work from 1910 onwards ultimately reflects a search for the mother who disappeared from the home and died away from it. The evocation of the mysterious and the exploration of death are, therefore, an attempt on Nash's part to be reunited with her. The often hesitant movements in Nash's later work are due to doubts as to how to capture this elusive reality – almost always associated with the feminine – about which he had deeply conflicting feelings: did it offer love or, more likely, did it betoken isolation and death?

From 1910 onwards Nash became a landscape painter, perhaps because it was in nature that he saw reflected the conflicts between mothers and sons, men and women. The human figure did not provide him with the necessary vehicle for the exploration of the absent, the face in such circumstances being insufficient for an artist who wanted to probe the aerial, seemingly absent but alive world of the spirit. It was that shadow world which he sought to depict in his paintings, and the quest for it was to become his religion – and his life.

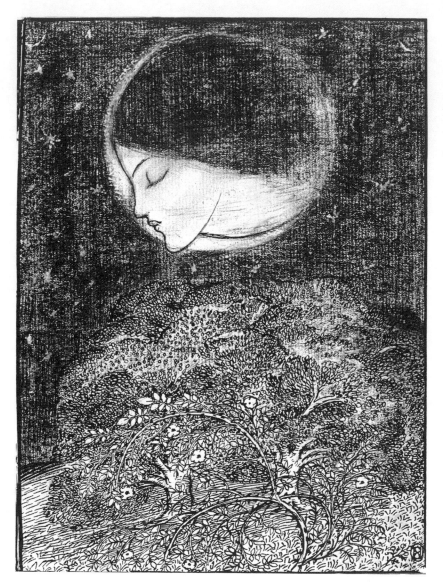

Our Lady of Inspiration, 1910

FOUR

Sybil Fountain and Gordon Bottomley

1910 – 12

'I AM FRIGHTFULLY AFRAID of striking a wrong note,'[1] Nash, speaking of his dealings with women, told his cousin Nell Bethell in 1909. Some were 'stunners',[2] whose beauty infatuated him; he wanted to adore, to be subsumed into the spiritual essence of a woman. At first his sexual urges were largely sublimated, but he was searching for an ideal woman. He wanted to fall in love – and so he did.

Eleanor Love Slingsby Bethell was the daughter of Lord Westbury's second son and therefore a niece of Aunt Gussie. Nell, who lived with her mother at Brighton, was intelligent, pretty and possessed of a charming stutter, which was as engaging as her considerable charm. In January 1909, Nash was bewitched. In his most chivalrous manner, he confessed himself entranced; at the same time, as he told Nell, he knew she would dislike 'anything mawkish or sentimental'.[3] This did not prevent him, however, from becoming ensnared: 'I think I am mad to write this postscript, mad to dare to, but I love you quite unalterably, quite unfalteringly, and so, little matters. . . . I think I feel & think as deeply as others and more deeply, than many. . . . Oh Nell Nell, have pity for I do *mean* this.'[4] Nash was afraid Nell would consider him a 'feather head' or a 'buffoon'.[5] She obviously did not regard him as such, but her common sense

told her that she was dealing with an impulsive young man. She tactfully rebuffed him, and ten days later Nash seemed almost pleased to have been rejected: 'just forget it was ever said but remember also that it was never said thoughtlessly or with anything but earnestness and truth'.[6] Nash began to see Nell as a sister, just as three years later, in the midst of a particularly painful rejection, he asked Mercia Oakley to 'stand with outstretched hands upon a hill wind-blown, sun-kissed, one with the great earth'. She was to be a 'dreamer who can dream my dreams'.[7]

Nash met Mercia because her grandmother, with whom she often stayed, lived next to the Nashes at Iver Heath. Nash was particularly attracted by her singing: 'What I love about your singing is the birdyness of it and the wildness o'it.'[8] He obviously heard a mixture of spirituality ('birdyness') and sexuality ('wildness') in Mercia's voice. He did not make a declaration to her, but he wished that it had been possible for them to fall in love with each other. 'If only I could have been that man you met & fell in love with & you the girl I was destined to meet & know for my dream & desire. Instead of your being in love with a man who don't care & I meeting a girl who don't give me a thought.'[9]

There was definitely more 'dream' than 'desire' in his overtures to Sybil Fountain, the girl, he claims, who did not give him a thought. Hers is the face in *Vision at Evening* and *Our Lady of Inspiration*. She was Nash's 'formosa dea' from 1910 to 1912, just as Nell had been in 1909. He may have met Sybil as early as 1906. Nash vaguely recalled a waggonette arriving at Iver Heath from which Mrs Fountain, Sybil and her two sisters emerged. He was overcome with bashfulness at their first meeting, and shyness seems to have marked their entire courtship, which probably began in earnest in 1909.

Years after – in the 1950s – Sybil Fountain claimed that she would have married Nash 'if he had really asked me to and persisted a little'.[10] Sybil wanted to be persuaded, and Nash was unsure of himself. However, this is far too simple an explanation of the affair. Nash's sexuality was not fully developed when he met Sybil. He obviously experienced erotic feelings towards her, but, at the same time, she was the remote goddess. He wanted to sleep with her, and yet he wanted her to be inviolate. His attitude to Nell and Mercia could become brotherly, but, for some reason, such a transition was

not possible with Sybil. He wanted to chase her and, perhaps, he wanted to be spurned.

Nash was certainly hesitant to declare his love, except in poems. 'But to the human subject of my inspiration I had never spoken, except through the poems and although she read them all, after three years she had made no sign.'[11] Sybil was obviously supposed to distinguish between symbols and the reality behind them. However, Nash's reticence met its match in Sybil's maidenly decorum.

This stand-off lasted until late 1911 or early 1912, when Nash learned that Sybil, whom he saw at increasingly long intervals, was staying with friends in London. He decided to 'force' an encounter: 'I did not know the number of the house, I felt only a strange certainty that we should meet. As I came into the street the sunshine was still warm on the pavements. When I entered the third square I saw her walking towards me. We met with the most obvious pleasurable suprise on her part; but I looked in vain for the slightest hint of any deeper emotion. Her lovely eyes expanded like butterflies sunning their wings on a cool flower, her slightly crooked mouth parted invitingly.'[12] Sybil was going off somewhere and refused Nash's invitation to tea. Angry and determined to break the 'morbid spell'[13] of his thwarted romance, he insisted on a further meeting, which consisted of 'huddled, unintelligible phrase and frighten'd eye'.[14] Nash was baffled. He stood up to go: 'As I did so I felt something slip from my shoulders and recede into the darkness behind me.'[15] Even for a young man before the Great War, which ushered in many changes in sexual morality, Nash was unusually shy. He told Mercia, 'I looked deep down into the girl's soul & read as maybe she long ago looked into mine – knew. I have been in love with an idea. That was because I was a poet & a fool.'[16] Nash had been more in love with Sybil than she with him. And this destroyed the relationship: 'I had to have some return.'[17] He would pursue, but only to a point.

A little later, in May 1912, Nash was awakened late at night by a friend, Wilkie Brooks, who wanted him to meet his lady friend, Mlle Veré Seutoni. Nash, clad in pink pyjamas, agreed to receive the couple, and he was impressed with the lady. 'Well she's a spaniard & a Gipsy.... She has done me a good deal of good in a curious way. She has dispelled some of my reserve!!' Obviously, the lady had found Nash attractive and had shown her interest. He had

become used to ladies to whom he was drawn but who either rebuffed or seemed unaware of him. In turn, Nash became flirtatious, his habitual bashfulness having been, finally, overcome. Soon after this meeting, he told Mercia that, contrary to any rumour she might have heard, he had *not* eloped with Veré, who had confessed her love for him. Nevertheless, he told Mercia, 'No one falls in love with me. It isn't done.'[18] To a large degree, this was false modesty. He was an exceptionally attractive man, his hooded eyes, aquiline nose and sensual lips gave him, however, the look of one who could be cruel in love.

Veré, according to Nash, had ten hearts but none were ever at home. He felt he had behaved 'shockingly'[19] by stealing Veré from Wilkie, even though he well realized that her conduct, as well, had been outrageous. 'Veré carries a knife you know & stabs one at odd times if she's annoyed.'[20] She even caused a scene in a park when she plucked some sprigs of lilac, Nash having to hasten her away in a taxi to avoid the fury of the keepers. As well, Wilkie was angry at Nash for his overtures to Veré. 'I never thought I should turn out a traitor. It only shows how little one knows of oneself.'[21] His sexuality having asserted itself, Nash's art was about to do the same.

Three years earlier, in 1909, Nash had designed a bookplate for W. L. Goldsworthy, one of the Iver Heathans who, he felt, were not intellectual but into 'whose nets ... strange fish would sometimes come'.[22] Mrs Goldsworthy described such a catch to Nash in the late winter of 1910. It was a book, *The Crier by Night*, by a poet from the north known to her family. Nash soon realized that it was an 'inspired' narration: 'Throughout the ghostly drama a dark mood prevailed, impregnating the scene and giving its puppet characters a superreal life. This mood, the nocturnal scene, the mysterious, horrific nature of the Crier and the extravagant poetic language seemed to accord with my own imaginative experience.'[23] So taken was Nash with the play that he 'decorated' (page 37) the volume with three drawings depicting the most emotive scenes from it. Mrs Goldsworthy was delighted by Nash's artistry, but indignant at the liberty he had taken. Nevertheless, she sent her copy of the book to the author, Gordon Bottomley.

Fifteen years separated Nash from Bottomley (he was thirty-six in 1910), who was to act as a father-confessor to the fledgling artist.

As we have seen, Nash was in isolation in 1910, and, by force of circumstances, so was Bottomley. He had been born to a middle-class family of Keighley, Yorkshire, and his father, an accountant, had been devoted to books and Swedenborgianism. He was evidently a stern man, and, as a youngster, Gordon, an only child, had turned to his mother with whom he claimed to share an intuitive accord. Although Bottomley had wanted to study medicine, he became at sixteen a junior clerk in the Craven Bank. Shortly thereafter, he suffered a serious illness, a harbinger of the violent haemorrhaging which first manifested itself two years later. In 1905, he tried to live in London, but he lasted only thirteen days. His illness drove him out of the centre of literary and artistic life and into further isolation. In that same year, he married Emily Burton, and they settled near Morecambe Bay. For the next thirty years, he lived as an invalid.

Bottomley, in his cloister-like retirement, was attracted to the work of Ricketts and Shannon; his first published works, *The Mickle Drede, Poems at White Nights, The Gate of Smargadus, The Crier by Night*, were extremely derivative closet-dramas which attempted to find in words the equivalent of the *fin de siècle* pictorialism of those two artists. Letters were an important part of Bottomley's narrow existence, and he corresponded with, among others, Yeats, Laurence Binyon, and Edward Thomas. Although he was in touch with some of the most innovative writers of his time, Bottomley's own interests were narrowly focused. He responded to symbolism, to Gordon Craig's revolutionary conceptions of stage design, but, at heart, he was a follower of Rossetti. His moment of artistic epiphany had come in the summer of 1893 when he had come upon a reproduction in a magazine of *The Blessed Damozel*. He, like the members of the Pre-Raphaelite Brotherhood, decided not to live the 'life of today': 'My business has seemed to be to look for the essentials of life, the part that does not change. In this I conceive I was guided and fostered by Rossetti, instinctively learning that art is a distillation of life and nature – not a recording or a commenting and only incidentally an interpretation.'[24] At the beginning of their curious friendship, both Nash and Bottomley were attempting to rekindle the neo-medievalism of the Pre-Raphaelite Brotherhood. They wanted to resuscitate the past and to describe the inter-penetration of the corporeal and the spiritual. They were idealists who were not interested in innovation. Bottomley was an initiate

35

in the mysticism of retreat, and Nash was the novice upon whom he bestowed his wisdom.

Bottomley's *Crier* depicts men as victims of female intransigence. The play is set in the 'interior of a cottage near a misty mere and among unseen mountains on a wild night of late Autumn'.[25] Hialti, the Northman, is not the master of his own house. Thorgerd, his wife, is a sinister, controlling figure who is angry at Blanid, the Irish Bondmaid, whom she realizes is in love with Hialti. Thorgerd herself is not in love with her husband, but she does not wish Blanid to have him. Blanid, who was a princess in a previous existence, knows that Thorgerd means to block her, and she decides to promise her soul to the Crier if, through death, he will remove Hialti from the cottage and Thorgerd's evil influence.

> *But I'll not die and leave him to her lips;*
> *Though I can never have him she shall not;*
> *For I can use this body worn to a soul*
> *To barter with that Crier of hidden things*
> *That, if he tangles him in his chill hair,*
> *Then I will follow and follow and follow and follow,*
> *Past where the imaged stars ebb past their light*
> *And turn to water under the dark world.*[26]

Blanid has mixed feelings about her intended victim but finally opens the door to the Crier and makes her bargain with him. Hialti is then tricked into going out into the night to assist some hapless woman caught in the storm and is soon drowned. Blanid decides that she cannot keep her pact with the Crier and asks for Thorgerd's assistance:

> *My body was yours; now you have saved my soul.*
> *My soul is utterly yours to serve in living,*
> *To clothe your soul and be your very heart*
> *In love and soft, unconscious giving of life.*
> *Mother, I have done evil – punish me;*
> *Because we loved him, love me and punish me.*[27]

Thorgerd refuses to speak. Blanid, forced to go to the Crier, runs out into the night. Her far-off shriek is heard, and Thorgerd, overwhelmed, falls to the floor.

Blanid at the Door, 1910

The Crier is filled with intimations of cruelty and violence, particularly in the appeals Blanid makes for Thorgerd's sadism to be unleashed on her. Nash, in the midst of his thwarted affair with Sybil, was obviously drawn to Bottomley's presentation of Hialti as

37

a victim of two women's strong, cantankerous wills. The depiction of the conflict between Blanid's life of slavery and her former, spiritual existence would also have appealed to him. Another strong theme in the play – Thorgerd as a cruel, withdrawing maternal character who could offer solace to Blanid, but who refuses to do so – would have found a strong resonance in Nash's psyche.

In Gordon Bottomley, Nash discovered not only a dedicated seeker of 'the magical way that light suddenly emanates from within something that we had previously and vainly endeavoured to illumine from without'[28] but one who also insisted on perseverance and total dedication. 'Many weaklings can be brilliant at a spurt; but it needs much concentration of nature to do even as much steady glowing as a glow-worm does.'[29] Constantly, Bottomley reminded Nash that he would have to commit himself totally if he wanted to become an artist. The acolyte had to become a priest: 'you must love art even more than you love life, and work hardest at art'.[30] As well, Bottomley could be a relentless critic, as when Nash told him that he was thinking of going to live in Paris. Bottomley considered the School of Paris not of the 'least use': 'the impostors learnt a highly organised series of tricks which enabled them to pass as up-to-date real artists with nothing to say'.[31] The pursuit of an essentially English mystical vision was Bottomley's goal, and, ruthlessly, he attempted to hold Nash to it.

The Slade and Wittenham Clumps

1910–12

B OTTOMLEY RIGHTLY STRESSED to Nash the importance of acquiring technical skills, knowing full well that his protégé was sadly lacking in this regard. To this end, Nash registered in October 1910 at the Slade, where he remained until December 1911. Nash began four days a week of drawing from the antique. Casts of classical and Renaissance busts were strewn about randomly, and most of the students sat astride wooden donkeys. When arriving in the morning, each student was required to write his name on a sheet of paper pinned to a board and was then supposed to be engrossed in copying. Bread was often used as an eraser.

The Slade in those days was dominated by Henry Tonks, physician, adherent of the Pre-Raphaelite Brotherhood and, *par excellence*, draughtsman. According to Tonks, the students had to be purified by classical sculpture before they approached life itself. The Slade motto was 'Drawing is an explanation of the form',[1] and it was Tonks' mission to teach precise depiction of structure. His taste, like Nash's at this time, was decidedly fusty. In 1913, he said of the avant-garde London group: 'The leaders ... have nearly all come from me. What an unholy brood I have raised.'[2] He certainly did not at all admire his new student's technique when Nash, self-confidently, sought an interview in order to display his drawings:

His surgical eye raked my immature designs. With hooded stare and sardonic mouth, he hung in the air above me, like a tall question mark, backwards and bent over from the neck, a question mark, moreover, of a derisive, rather than inquisitive order. In cold discouraging tones he welcomed me to the Slade. It was evident he considered that neither the Slade, nor I, was likely to derive much benefit.[3]

Sometimes, a student would manage to intimidate the 'Iron Duke'. On one occasion, he sarcastically asked a new student (who was also an amateur boxer), 'I suppose you think you can draw.' The student, with suppressed fury, collected himself and retorted, 'If I thought I could draw, I shouldn't come here, should I?'[4] Even the astringent Christopher Nevinson wilted under the Master's scornful eye: 'I was wringing wet by the time he left me.' Sometimes, in desperation, the students at the Slade would chant, 'I am the Lord thy God, thou shalt have no other Tonks but me.'[5]

By December 1910, however, Nash had changed his mind: 'I like Tonks more and more. He is so full of thought & care for the strugglers, & teaches wonderfully.'[6] By July 1911, Nash realized that Tonks' demanding technique had helped him to express his visions better:'I am at last beginning to draw a little better, thank God. I draw much more directly & fearlessly, at the advice of Tonks & have found it helps me greatly.'[7] Bottomley was a bit taken aback by this effusion, warning Nash:

After what I said in encouragment of your going to the Slade, and in anticipation of all the good you could get there, it cannot be thought that I am unsympathetic or prejudiced toward the Slade. But you go there to learn to express the visions that are in you – and such a man as Tonks can help you to widen your means of expression enormously; but you must not let him teach you what to express, for he is the slave of his eyes and will never see anything but what is there.[8]

Bottomley's criticism of Tonks is surprising in that both men were firmly opposed to the newest trends in painting, as practised on the Continent. For example, Tonks was deeply upset in October 1910 to learn that his students were contemplating a visit to Roger Fry's exhibition, 'Manet and the Post-Impressionists' at the Grafton Galleries:

Suppose they all began to draw like Matisse? Eventually, Tonks made one of his speeches and appealed, in so many words, to our sporting instincts. He could not, he pointed out, prevent our visiting the Grafton Galleries; he could only warn us and say how very much better pleased he would be if we did not risk contamination but stayed away.[9]

Nash did attend the exhibition (and its sequel in October 1912) but, he rather ardently proclaimed, he was not 'touched'.

According to Nash, the Slade itself was a 'typical English Public School seen in a nightmare.'[10] This time, the school bully was Nevinson, who limited himself to mental torture. An unassuming boy with very curly hair was greeted with 'baa-a-a' as he entered a class; a fellow who habitually wore dancing pumps was called The Duke. A hapless chap who offered cigarettes to others on every conceivable occasion became 'Have-a-smoke'. Nevinson, Edward Wadsworth, and Stanley Spencer, along with a few others, formed the Coster Gang, which roamed Kensington and Soho in black jerseys, scarlet mufflers, and black caps. 'This often entailed,' Nevinson recalled, 'visits to Tottenham Court Road police station, Bow Street, and Vine Street.'[11]

Nevinson, attempting to affix a label to Nash, asked him if he was an engineer. 'I came in for Nevinson's sarcasm because of my rather neat appearance. In those days I wore stiff collars, conventional suits, a hard hat and spats.'[12] Years later, Nevinson remembered Nash as 'very correct and formal'.[13] Nash's orthodox wardrobe was certainly in startling contrast to Stanley Spencer's unkempt appearance, Mark Gertler's Swinburne locks and blue shirt, and Nevinson's Latin Quarter tie and naive hat. Nash was not yet in the vanguard of the fashionable in clothing or art.

Despite his conventionality, Nash soon made friends with the dandyish Ivan Wilkinson Brooks, with whom, we have seen, he later quarrelled over Mademoiselle Veré. Claude Miller, who, disgusted with Cubism, had abandoned Paris, was another acquaintance. Nash, like many of his fellow students, was enchanted with Dora Carrington and her thick blonde hair, blue eyes, and disarming stutter. Nash won Carrington's regard when he lent her his braces under trying circumstances. They were riding on top of a double-decker, and she demanded them there and then for a fancy dress party. A serious-comical touch lingered on in their friendship, as

this sparkling note from Nash, in which he defended himself in the wake of a quip she had made about his face, reveals: 'All I will say here is – never fear to be "friendly" with me – I am an extraordinarily harmless affectionate animal – probably of the ant-eater tribe & as for being offended by your main conclusion upon my appearance – pouff, Carrington what nonsense!'[14] Dora Carrington later became involved in an unsatisfactory 'platonic' friendship with John Nash and ultimately spent much of the remainder of her short life in a physically unrequited affair with Lytton Strachey, but her first love was Paul Nash, as this snippet from a letter she wrote to John reveals: 'Thank Paul for his wonderful letter. I felt, do not tell him, bad pangs of jealousy, that Bunty [Margaret Nash] must have stacks of such letters, whilst I have but few!' Even after his marriage, Nash confessed to Carrington his early infatuation with her:

> ... when have I ever ceased to admire [your fair form]. From the first moment when I, a bashful student, sitting among the plaster casts of the Antique Room, stole covert glances at you, an attractive chattering flapper in a check over-all, and became inflamed with a wish to know you; down to the present time when I sit here, a considerably married man, but still retaining those tender feelings cherished for you all these years and an unabated admiration for your charms from your turned-in toes to the crown of your golden head.[15]

Ultimately, the friendship between Nash and Carrington rested on their mutual admiration for the English school of art, as manifested in the work of Blake and Rossetti:

> The copy of Blake I possess is incomplete and there are in your book many poems I have never read. My dear Carrington I thank you exceedingly. I expect you love Blake as I do. His verse is the most purely touching and inspiring that I know – It moves me in the same way that all sweet & simple actions in life & all wonderful and clear effects of Nature, move me. And at the same time what immense mystery it contains! The Tiger – isn't it startling? It would shake the mind of even the most material & prosaic city man if he would read it twice.[16]

In 1913, Carrington and Nash were resolute defenders of the English tradition. Their brief flirtation soon faded, although both later felt that they could easily have fallen in love.

Eventually, Nash's closest associate at the Slade was a short but

powerfully-built young man, 'with a physical poise which suggested he was in some way athletic'.[17] At first meeting, the face, 'three-cornered' as Nash heard a lady at a viewing describe it, seemed familiar. While Nash and the strange youth were sitting on the grass, Mark Gertler joined them and rather teasingly asked Nash's companion, 'Oh, Nicholson, how does your father paint those *marvellous* black backgrounds?'[18] The penny quickly dropped. Ben resembled his father William Nicholson, one of the best-known artists of his day, and a man celebrated for the deftness of his painterly style and personal appearance: in his *Alphabet* of 1898, 'A is for Artist' is a self-portrait, but 'D is for Dandy' can be seen leaning against the wall. Ben Nicholson and Paul Nash quickly became friends, and Nash enjoyed visiting the Nicholson house in Mecklenburgh Square with its blue ceiling and black mirrors.

Nash's new friend did not take art school seriously – he did not have to. Ben had absolutely no contact with Tonks. In fact, he had little to do with the Slade. He enjoyed spending his time 'patting imaginary dogs':[19] he would sign in in the morning, go off to lunch at Schoolbred's, and spend the afternoon playing billiards. The abstract formality of the rectangular green field and the constantly changing relationship of the balls to the angles of the table were more relevant to his art than anything he could have learned at the Slade. Unlike Nash, Ben found his artistic centre early. His first completed painting, *Still Life of a Painted Jug* of 1911 strongly hints at the formalistic, geometric directions of his later career.

Although Nash was introduced to bohemianism through the Slade, he later felt that he had not acquired many practical skills there. It was without regret that he departed in December 1911 and, eventually, in November 1912, returned to Bolt Court 'because I'm a damned ignorant brute and lack knowledge of gents and ladies shapes & anatomy'.[20] Nash's lack of technical expertise would haunt him well into the 1920s. As Tonks had told him: 'You are like a man trying to talk who has not learnt the language.'[21]

Towards the end of his time at the Slade, Nash moved in October 1911 to 19 Paulton Square, Chelsea, where he remained until the following May. On 22 November 1911, he playfully asked Bottomley, 'Do you know Chelsea? how it goes – anyhow you realise there's a river & embankment & things like that. Well Paulton Square runs down from the great noisy King's Road to the quiet

easy going old river.... I have been most lucky. I have one room on the first floor. It has two down-to-the-floor-up-to-the-ceiling sort of windows which look onto trees – God be thanked.'[22] It was a small bed-sitting room which was papered with rosebuds. Nash substituted light grey paint for the flowers and hung dark blue curtains.

Gradually, Nash became accustomed to London; 'However deeply implicated by inheritance I might be with the soil and with the sea, there would always be this third factor of the town in which I was born.'[23] One of the most immediate transformations was in his dress, Chelsea fashion becoming most important to him during the period 1911–12. Nevertheless, Nash relinquished London in May 1912 because his 'field of operation seemed likely to develop in the country'[24] and he wanted to be near his father. There were financial considerations too, and he felt uneasy about draining his father's limited resources. The more immediate reason for the retreat was the break with Sybil Fountain which happened some time around March 1912, and the ensuing fracas with Mademoiselle Veré. His courtly attitudes in jeopardy, Nash retired to collect himself in the countryside.

Nash also returned to Iver Heath because it was the 'place' which had haunted his imagination during his time in London. Almost unawares, he had acquired a great deal of technical expertise which now allowed him to capture his vision: 'An instinctive knowledge seemed to serve me as I drew, enabling my hand to convey my understanding. I could make these branches grow as I could never make the legs and the arms of the models move and live.'[25] His feelings emerged now in his landscapes. Although he was not comfortable with the human form, he was able to take what he had learned at the Slade and apply it to trees, in which he invested much drama. And it was the Bird Garden at his father's house at Iver Heath, to which he had moved with his parents in 1901 at the age of twelve, from which he drew his inspiration.

> Like the territory in Kensington Gardens which I found as a child, its magic lay within itself, implicated in its own design and its relationship to its surroundings. In addition, it seemed to respond in a dramatic way to the influence of light. There were moments when, through this agency, the place took on a startling beauty, a beauty

to my eyes wholly unreal. It was this 'unreality', or rather this reality of another aspect of the accepted world, this mystery of clarity which was at once so elusive and so positive, that I now began to pursue and which from that moment drew me into itself and absorbed my life.[26]

Nash had been pursuing this 'unreality' of the Bird Garden and its surroundings since 1911 in pictures such as *Bird Garden* (plate 10), *Night in Bird Garden, Spring at the Hawk's Wood*, and *The Wanderer* (plate 11). The 'startling beauty' existed in the sense of mystery that he found in this locale and which he had, by 1912, a bit more asssurance in rendering. As *Landscape with a Large Tree, The Field before the Wood, The Three* and *The Dark Garden* amply demonstrate, his ability had begun to come into unison with his vision. He now knew that the 'individualism' and 'character' he sought in his art was to be found in landscape drawings 'for they are very real to me and I feel I succeed better in "finding myself" thro them than in any other direction. Nature is there before me & any thoughts of how other people would express what I see there do not intrude on my mind – I go ahead my own way.'[27] His trees were his people through whom he gave hints at the 'things behind'.[28] Sometimes, Nash, nevertheless, found this pursuit discouraging: 'Oh if I could paint my visions, if I could tell my dreams – it is an useless old cry but indeed I feel how little I have attained.'[29] However, he knew instinctively that he was heading in a significant direction.

In *Outline*, Nash claimed he abandoned poetry when he broke with Sybil, when his infatuation with her had vanished. To a certain extent, this was true. More importantly, he now allowed poetical metaphor to be absorbed directly into his pictorial depictions of landscape. Nash always remained a poetical painter – one whose imagination is visual and verbal rather than purely visual – but he began to fuse the two sides together in the landscapes of 1911–12. He told Bottomley, 'I am *not* giving up inventive imaginative designs but I must take most time just at present for landscape'.[30] Bottomley was not pleased by this revelation, although he realized the inevitablity of what was happening in the young artist's development:

I was first attracted to your drawings by the glimpses they gave of the secret places of your mind; but I knew then that you would have to learn exteriorisation and observation before you could tell your secrets potently; so I am not sorrowful that you seem to be leaving

your first love for the sake of interpreting the secrets of external nature ... for I trust your essential vision.[31]

Nash, too, was beginning to trust his own pictorial talents, although gothic and literary pictures such as *The Pyramids in the Sea* (page 49), *The Cliff to the North* and *In a Garden under the Moon* belong to 1912–13. All three drawings show landscapes governed by the moon – and, therefore, by Diana and the feminine. In the first two, the terrain (pyramids and cliff) is threatened by water, presumably under the control of the moon, and by the shadow of a woman, respectively. In *The Pyramids in the Sea*, in particular, phallic, masculine order is contrasted to undulating, feminine chaos. A small but pubescent girl dances *In a Garden under the Moon*. Behind her, on the right, a man wields a dagger and a king sits under a canopy-like structure in the centre background. Nash is illustrating the conclusion to part 2 of Coleridge's *Christabel*:

> *A little child, a limber elf,*
> *Singing, dancing to itself,*
> *A fairy thing with red round cheeks,*
> *That always finds, and never seeks,*
> *Makes such a vision to the sight*
> *As fills a father's eye with light;*
> *And pleasures flow in so thick and fast*
> *Upon his heart, that he at last*
> *Must needs express his love's excess*
> *With words of unmeant bitterness.*[32]

The commingling of love and hate are here depicted in the contrast between the sprightly elfin child and the savage murder which takes place behind her back, between the parent's love which can only express itself in 'words of unmeant bitterness' and the innocence of the 'limber elf', between the innocent virginity of Christabel and the rampant sexuality of Geraldine, who is associated with the moon in Coleridge's poem. As with *The Crier*, Nash was drawn to a literary text which showed the cruelty of a strong, controlling woman.

In some of his more purely landscape pictures, Nash dealt with similar conflicts with even greater assurance. In *The Wanderer* (1911), the viewer is confronted with the barrier of high trees in the foreground through which the male figure has made his way into the forest, which is in the upper half of the picture. The man

is about to disappear, to be swallowed up by the trees. There is an air of menace here. The drama resides in the fact that the forest may be benign or *possibly* contain some malignant force. The viewer is not sure. Similarly, the Bird Garden drawings hint at at a presence hovering behind the trees. In these pictures, Nash does not rely on two separate picture areas (as in *Our Lady of Inspiration* and *In a Garden under the Moon*) to provide a dramatic inter-action – the drama is united into a single organic whole.

In September 1911, Nash visited Wallingford in Berkshire and first came upon the Wittenham Clumps (two mammiform hills two miles north-west of Wallingford in the Sinodun Range), the only place to play a comparable role to the Bird Garden and its elms in his art up to 1914. 'The country round about is marvellous – grey hollowed (*or* hallowed) hills crowned by old trees of Pan-ish places down by the river. Wonderful to think on. Full of strange enchantment. On every hand it seemed a beautiful legendary country haunted by old Gods long forgotten.'[33] This was Nash's reaction in 1911. A year later, he had determined to capture the 'secrets' of the wild woods, the immediate result, *Wood on the Hill*, being an arresting piece of picture-making. At Wittenham (plate 12), Nash was overwhelmed by the interpenetration of landscape, history, magic and form which confronted him at the Clumps. This was indeed a timeless moment:

> Wittenham Clumps was a landmark famous for miles around. An ancient British camp, it stood up with extraordinary prominence above the river at Shilllingford. There were two hills, both dome-like and each planted with a thick clump of trees whose mass had a curiously symmetrical sculptured form. At the foot of these hills grew the dense wood of Wittenham, part of the early forest where the polecat still yelled in the night hours. . . . They eclipsed the impression of all the early landscapes I knew. This, I am certain, was due almost entirely to their formal features rather than to any associative force. . . . They were the pyramids of my small world.[34]

Nash was particularly impressed by the way in which the two great mounds of Clumps, the nearer he approached them, rose higher and higher above his sight as the land fell away. His dedication to landscape painting was forcefully brought home to him at Wittenham in 1912. He now knew the prey he wanted to stalk.

The Slade had taught Nash to be patient: 'It was better to think

or to absorb first, before beginning to interpret.'[35] Also, he now allowed his landscapes to emerge in precise, visual terms. Although his landscapes of 1911–13 directly reflect sexual longing in the undulating female forms, such preoccupations are controlled by the 'definiteness' of his renditions. The exotic triangular (masculine) shapes from the P. G. Broad bookplate and *The Pyramids in the Sea* were transferred into the more domestic. but still pyramidical, rendition of the trees at Wittenham. Nash also discovered at Wittenham that the most personal artistic statements can be achieved when the artist surrenders himself to the landscape before him. The Bird Garden pictures of 1911–13 reflect the conflicts within Paul Nash; at Wittenham, deeply moved by a landscape not directly associated with his family, he discovered the perfect vehicle through which to depict not only the various forces within himself but also, at the same time, to dramatize those forces in art of more universal significance.

Assistance to Nash in his dedication to landscape came at this time from an unexpected source, Sir William Blake Richmond, the son of Blake's follower, George Richmond. The introduction came through Mrs Harry Taylor, the sister of the Hon. Audrey Handcock, who was to become William Harry Nash's second wife on 8 July 1915. Bottomley thought Richmond would encourage Nash in the direction of 'fine imaginative art which is not common nowadays'.[36] However, Richmond, almost seventy at the time he met Nash, had succumbed into comfortable portrait painting.

Nash's early memories of Sir William had been of his mosaics at St Paul's Great Hall: 'immense images that overwhelmed the walls'.[37] A few years before, Augustus John, William Orpen, and Albert Rutherston, Slade friends, had been deeply offended by these compositions: 'The place has been utterly spoilt and looks like a second-rate café – it is a mass of glittering gold.'[38] Richmond seemed at first unfriendly and crusty, but he soon warmed to Nash's charming eagerness. He was moved by Nash's work, obviously observing the rapid progress that had been made during 1912. In July, when Nash showed him some of the landscapes he had done that spring, he told him: 'My dear dear boy, you have a great feeling for Nature'[39] and he claimed that Nash saw landscape in a new way. He even offered to provide an introduction to the Carfax Gallery. In a young man's slapdash, waggish way, Nash told Nell Bethell:

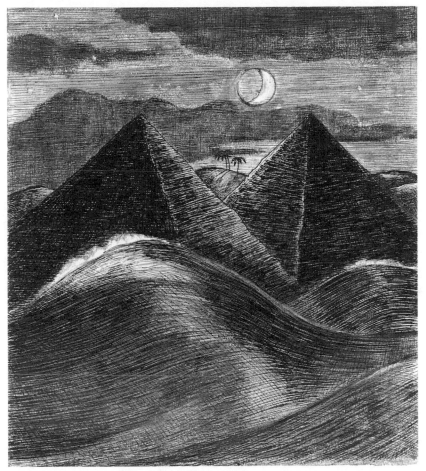

The Pyramids in the Sea, 1912

You know I believe that Billy Richmond took me up.... One day I took him some queer drawings from Nature, not sheep in the shade or cows in the cool, but trees as I saw 'em and a great vague drawing of massy forms half seen and a splash of spring sunlight down a lane. Billy is excited and thinks I shall be a great landscape painter. Bow wow![40]

Writing to Nash on 8 December 1912, William Rothenstein also showed a prescient understanding of the young artist's aspirations:

I liked your poems very much – as in your drawings you show a very particular appreciation for a certain intimate quality of nature.

49

> In your drawings however I feel a more direct inspiration – the
> material facts of nature render up to you more naturally their essen-
> tial reality than seems to me the case with your poems where you
> are haunted by poetical memories of things read.[41]

Although Nash persisted in his literary ('inventive imaginative')[42]
drawings well past 1912, he excluded them from his Carfax exhi-
bition in November 1912.

Impelled by Sir William's recommendation, this ambitious, largely
inexperienced artist took his drawings to Arthur Clifton, the sar-
donic but perceptive manager of one of London's most fashionable
galleries. If he was impressed, Clifton usually tried not to show it.
Nash, rather nervously, interrupted Clifton's viewing: 'Sir William
thinks these are something new.'[43] Rather somnolently, Clifton
agreed. Novelty having been established, Nash demanded an exhi-
bition. Clifton came to life. That was impossible, the Gallery being
booked months in advance. Desperation coming to the surface, Nash
retorted:

> 'Why can't I have an exhibition on this wall?
> 'But we never have exhibitions there.' Clifton was now fully awake.
> 'Well, why not?'[44]

Nash, who could be very determined, got his way.

The visitor to Paul Nash's first show would have been struck by
the uniformity of the twenty-one landscape drawings, Nash's inter-
est in the exotic being readily visible only in *The Pyramids in the Sea*
and *The Falling Stars*. The Bird Garden and elms constitute the
majority of the show, *Wood on the Hill* being the most memorable
of the few Wittenham pictures. These drawings, most of them dark,
and evoking moonlit woods, were well, if not warmly, received. P. G.
Konody thought them undisciplined but promising. The reviewer in
the *Daily Telegraph* thought Nash aimed at 'expression rather than
illusion', going on to observe that Nash drew 'as if he were a minor
poet intent merely upon making pretty verses. . . . We hope that this
artist's delicate talent will not be swamped either by mannerism or
by naturalism. The former seems to threaten the greater damage.'
Indeed, Nash was aware, well before his exhibition, of the strictures
which would be raised against him, and he was already working to
strengthen his 'illusion' and to avoid unnecessary 'mannerism'.

SIX

———————•———————

Margaret

1913

NASH TOOK GREAT CARE to dress fashionably for his Private View. Clifton was surprised, and most certainly not pleased, by the young artist's regalia of silk top hat, malacca cane, snuff-coloured trousers, black jacket, and white spats. All this was a trifle too ostentatiously splendid for a gallery situated on one of those 'expensive, rather secret streets running between Piccadilly and St James's'.[1] Nash's adviser on dress was the Slade's man from Mexico, 'so-called from his habit of arriving each morning in Gower Street riding an elderly bicycle and wearing some sort of equestrian leggings and a wide-brimmed hat'.[2] This master of salubriousness was Rupert Lee, whom, when first meeting him in a washroom, Nash asked to pose as the gypsy, Lavengro: '"Will you sit for me for a figure in composition I am doing?" Rupert gave Nash a searching look. "Yes, if you like, what is it about?" '[3] Like Nash, Lee lived in Chelsea, and soon invited his fellow artist to tea.

Nash was astounded by the bareness of Lee's Fulham Road flat. There was nothing 'upright in the room, except an easel, and that was the leaning kind'. Two men, smoking hookahs, were sprawled out in 'awkward luxury'[4] on the floor. Nash accepted a cup of tea and listened to the conversation which was supposed to be philosophical in nature. With some effort, Rupert managed to raise

himself from the floor to show Nash his paintings in tempera and gold leaf. These were obviously not serious undertakings. Lee confessed that his real passion was for music.

Nash realized at once that Lee was much more worldly-wise than he was, and sensed that Lee used his languourous sophistication to detach himself from others. Under this mask, nevertheless, was a kind person, and to Nash he was certainly 'frank and warm-hearted'.[5] Nash sometimes stayed the night at Fulham Road and later, when Lee moved, at 3 Old Church Street: 'I slept in a hammock made draught-proof with coats and rugs. "Toilet" was easy – a basin and a couple of tin-pails, a rather frightening lavatory downstairs and the Chelsea Public Baths.'[6]

Nash's introduction to fashionable poverty and bohemian living was through Rupert Lee, and it was at a *'very important'*[7] tea at Old Church Street in February 1913 that he met Margaret Odeh, to whom he became engaged two months later (and whom he married in December 1914). The artist who was just beginning to cultivate the contemporary in art had met the New Woman:

> She was small and extremely slender with small feet and hands, but the remarkable feature of her appearance was the head which seemed large in proportion to her slight body. This impression was partly due to a cumulus of dark hair, grape-black in colour, which mounted round her brow. The whole structure of the head was vigorous, from the capable forehead to the firm chin. The eyes were large and wide-spaced and the mouth rather full.[8]

Although he rarely chose to use it, Nash had a remarkable talent for portraiture – both in pictures and in prose. Margaret's exquisite physical beauty and Nash's response to it are brilliantly enshrined in this first 'impression'.[9]

Nash was deeply struck by Margaret that evening at Old Church Street, and he paid attention to the presence 'of some deeply affecting event that now haunted her eyes'.[10] Margaret often play-acted, and she liked to think of herself as a siren. She may have evoked 'mystery' in order to attract the attention of the dark, handsome stranger. In any event, Nash felt an instant rapport with her. He had up till then been troubled by women and their place in his life as an artist. 'What was best for him, to marry, take a mistress or live alone?' As well, he distrusted marriage: 'We would be tied up, we should

be tied down, fidelity would be impossible, boredom inevitable.'[11] However, all of his previously-held convictions were cast aside by this small, vivacious woman. Just as his naivety about art had begun to disappear, his fear of involvement with a woman waned.

Margaret, the daughter of the Reverend Naser Odeh and Mary Ann Eleanore, daughter of John Gilchrist Dickson of Dumfries, was of Arabic and Scots ancestry. She had been born in Jerusalem where her father was chaplain to the Anglican bishop. Odeh was shortly afterwards transferred to St Mary's Mission in Cairo, where Margaret spent her childhood. At the age of fifteen in 1902, she was sent to Cheltenham Ladies' College, going up to St Hilda's College, Oxford, in 1905. Margaret's parents eventually joined her at Oxford, where Mr Odeh became an independent tutor in Arabic (T. E. Lawrence was a pupil). The Odehs were living in London when Paul and Margaret met in 1912, Mr Odeh becoming chaplain to the Infirmary at Hillingdon in Middlesex soon after.

Margaret had left Oxford in 1908 with a degree in modern history. She tried teaching but found it did not suit her health, which was always precarious: 'Her second teaching post had been at Scarborough where, when the winter term came round, the intense cold of the North Sea winds had affected her throat. For a time she had been unable to use her voice and had been warned that she must give up teaching as a profession.'[12] Throughout her life, Margaret was to suffer from many minor complaints an inordinate amount of the time. Psychological stresses inevitably led to physical breakdowns, and short stays in rest homes usually followed such bouts.

In 1912 Margaret became assistant to the secretary of the Tax Resistance League (Woman's Suffrage Society) and in 1913 organizing secretary to the Committee on Social Investigation and Reform. Although she had dedicated herself to all aspects of social welfare regarding women, Margaret took a special interest in the plight of prostitutes and attempted to find them alternative employment in Cottage Homes; as she said, she hoped such a scheme would provide 'a normal home life with training in such employments as: intensive gardening, poultry-keeping, dairy-work, hand-weaving, dressmaking, cooking, and housework, etc., in order to suit the different capacities and tastes of each woman'.[13] Margaret's attempts to help these ladies even extended, she later claimed, to disguising herself

as a prostitute; so garbed, she 'had actually entered notorious brothels in search of girls unwillingly recruited to them, or had been approached by "proprietors" with offers of large sums to escort groups of young women to white slavery in South America'.[14]

Lance Sieveking, who knew Margaret from September 1914, was particularly struck by her oriental appearance. Her exoticness and her quick response to Nash's overtures must have reminded Nash of his thwarted liaison with Mlle Veré the year before, Margaret's liveliness and frankness being in stark constrast to Sybil Fountain. But, as Sieveking noted, 'far more than her considerable abilities, and capacity in practical affairs, was her gift of clairvoyance'.[15] She instilled 'into the ordinary events of every day a mysterious – an almost mystical – element'. Life with her became 'infused with a sort of transcendental quality'.[16] Margaret's physical beauty and her spirituality were an irresistible combination for Nash.

Rupert Lee, however, warned his friend: 'Bunty's a charming little humbug.'[17] Margaret could be outrageously demanding, invent stories about imaginary encounters, and tell blatant lies. She was also extremely self-reliant. Her father regarded her 'more as a son'[18] than a daughter. For Nash, there was the assurance that she would mother him, take care of him, and organize his sometimes chaotic life. He might also have sensed that she could be extremely detached, even from those for whom she cared deeply. Ultimately, it was the seemingly perfect interpenetration of the body with the spirit, of exuberant warmth and cool detachment, which made her the perfect woman for him. Nash claimed that, at long last, he was not afraid 'of waking from a dream but rather know I hold a reality'.[19] He assured Bottomley, 'she is going to look after Paul & Paul's going to be all the world he can to her. In fact she is what he has been seeking for & she says he is what she was seeking for too.'[20]

Shortly after meeting her, Nash informed Margaret that he would marry her. She straightforwardly rejoined, 'Yes, I expect you will.'[21] Impulsively, he pulled her into his arms. 'As we kissed all doubts dissolved and the questions we might have asked ourselves were answered. In the fusion with each other, a third sprang into life, we became one only to become three – each other and ourselves. It was the only sum I ever understood.'[22]

One of his last impressions that first night at Old Church Street was of Margaret's small hand in its neat kid glove 'running down

the banister rail like a little black mouse'.[23] After the ladies departed, the mouse in Rupert's flat, who had been causing a great deal of trouble, was caught. Nash pleaded for mercy on the animal's behalf and he released it on the nearest street corner. He had to do this rather hurriedly because a man, accosting him, wanted to make a meal of the creature.

Just before daybreak, Nash had a nightmare in which he was descending some dark stairs. Suddenly, he came upon a mouse which he followed into a nearby cemetery. Margaret was seated there on a chair near a tombstone. 'One hand was bare, the other hung down covered by a black kid glove.'[24] Rupert was there as well, working at his easel. Nash then sat down on the tomb and took Margaret's gloved hand into his. Instantly, it was transformed into a black mouse. Both Rupert and Margaret disappeared, and a head appeared over the wall demanding the mouse, who was frightened, as was Nash. They were trapped. That was the end of the nightmare.

Nash had been enthralled by his encounter with Margaret, and from the start he responded with exuberant stupefaction at the wonder of knowing her. But he was also afraid of being separated from her, of not being able to protect her from harm. From the start, he was desperately fearful of losing her, and this made his ardour all the more intense.

Of course, Nash's dream of separation and loss was linked directly with his obsession with his mother and death. Nash became once again the deprived, needy child. Margaret, potential lover and new mother, sits near the tomb. Nash is united with her, but when he touches her she disappears. He is left with the mouse, a pale symbol of her whom he loves but who has been taken away from him. He is frightened, cornered. There is no resurrection from the dead in this sequence.

In his early drawings, Nash had depicted the mystery which is death, shown convincingly its hovering presence in the Bird Garden, the elms, and at Wittenham. To a large extent, however, he was still a very young man desperately afraid of being deprived of love. As the dream also shows, Nash wanted to protect someone else. The would-be dandy and bohemian was courtly, intent on returning his lady to the protection of Camelot. Perhaps significantly, 'Mouse' was one of the nicknames he bestowed upon Margaret.

———————•———————

New Beginnings

1913 – 14

NASH CONTINUED to be obsessed with Margaret: 'my mind, my soul, my heart, my manhood, my strength, my weakness, worships you. Is in you. Is *you*.'[1] He had been chosen by this beautiful creature, and he wrote of their love with a frank eroticism missing from his early drawings and poetry:

> When we lie together it does not seem in this age but far far more primitive, more romantic & wonderful than anything to day. You skip back into your ancient loveliness. You seem a pure eastern beauty glowing and warm, passionate and seductive. ... You are a pinky lotus. I am a bewildered bee who comes & sips & sups and makes delightful journeys – right inside.[2]

His devotion was all-encompassing and passionate. A vision of Margaret would banish his gloom, a wave of joy would overwhelm him. 'I can't think what to call the Kiss we have when it burns us & saps us & drinks us up.'[3]

Gradually, Nash began to learn about Margaret's work, and he was shaken by her depiction of the plight of women: 'The revelation you gave has shocked me ... I mean to see if I possess *any* sort of power which I may use to fight this devil. You, I am convinced, *have* power & I think it likely you have a mission.'[4] Indeed, he drew

a particularly strong prose sketch of his beloved throwing off her usual daintiness as she went off to lead a suffragette rally:

> She was dressed completely in brown. Brown shoes and stockings, brown dress with some kind of knitted coat. On her soft black cloud of hair she wore a hard brown hat of uncompromising but by no means unbecoming form. It was clearly in the nature of a helmet and was firmly held by a brown veil passing under her chin. Her small double-jointed fingers were encased in very neat gauntlets and in her right hand she carried a brown leather dog whip. Her cheeks had a high colour behind the veil and her dark brown eyes had gone almost black with the dark glow of battle.[5]

Nash claimed that Margaret, in this costume, looked 'slightly formidable and no less attractive'.[6] This is his second portrait of her in *Outline*, and the reader is finally allowed to see her from a different vantage point. She remains feminine, but her domineering, almost masculine, side asserts itself.

A year before, Nash had apologized to Mercia for his sometimes beastly temper: 'forgive my damnable behaviour this afternoon. There is no milder description of it. I can tell you I seemed to be burning and burning.'[7] From the outlet, Paul, in a like manner, quarrelled with Margaret. On 13 June 1913, he abjectly apologized: 'Foolish me. I was not hurt the other evening – my Baby, don't think I cannot appreciate you when you are feeling cross and tired. Heavens, how poor I must be if I cannot bear little clouds that pass....'[8] Such disputes almost always centred on Nash's work. He wanted Margaret's inspiration, but, sometimes, he did not wish to be with her. Understandably, Margaret, who needed encouragement in her own career, would become resentful. Nash told her, as he had earlier told Mercia: 'I get these perverse quizzical fits & they are very mean.'[9] Four months after meeting her, he promised: 'sometimes I shall turn back & stay. It's only my work is stronger & that is for you as well as me. I therefore can't neglect it.'[10] A letter from October is a bit more explicit on this same unresolved dilemma: 'I am too involved in my work just now to be a very nice lover but forgive me Bunty. I shall become better soon. Don't think I am indifferent – it is only I am abstracted a while.'[11] Despite these travails, Margaret remained his muse: 'I feel very humble about my work & as tho I were only just beginning, which I believe is so. I

am only beginning. But how exciting! how far to go, what lots to do. And my little love to stir me & help me on.'[12] Paul and Margaret would thus pull back from the gulfs dividing them, deciding against marking out 'boundaries'. Nash was frightened of a permanent break: 'I am afraid to look it in the face lest Medusa-like it freeze me.'[13] He obviously did not wish to lose the person who was, very significantly, both a 'seductive thrilling mistress ... and a gentle Mother'.[14] However, Nash found it easier to love Margaret at a distance. He would be enthused with seeing her but would quite soon afterwards want to be by himself. He used his career, then and later, as his excuse. Nash enjoyed the company of women, but he was often wary of them.

William Harry Nash did not share his son's enthusiasm for Margaret: 'My father took the announcement of my engagement with his usual philosophic front. What went on behind I could guess, perhaps....'[15] Nash claimed that Margaret and his father soon became friends, but Mr Nash's lurking disapproval took the form of enmity towards the liaison between Rupert Lee and Rosalind Pemberton, Margaret's friend.

It may have been that Mr Nash's feelings in that instance stemmed from suppressed feelings about his son's involvement with Margaret, whom he saw as a non-traditional woman. Father and son quarrelled when Paul attempted to bring Rupert and Rosalind into 'better odour' at the time his father was outraged that the offending couple had decided to get married at a registry office: 'I think what most surprises him is my evident huge indignation at the injustice of his attitude. This amazes him, of course, for he imagines all the just indignation should be on his side.'[16] Nash's closeness to his father was further diminished when he struck out against the older man's fastidious concern for convention. In March 1914, when Paul and Margaret were planning a visit to the Bottomleys, discretion was absolutely necessary:

> Bunty and I agree that to travel in a train thro England would not only be a dull but a sinful thing. So we mean to go in a cart or buggy of some sort and creep gradually up to see you and see everything upon the way. *But* it must be a secret journey. For to publish such an idea would be to electrify the family – I mean the elder ones, fathers, Aunts & uncles.... So we mean to be very careful and quiet

and of course there is nothing in the least wrong in it really & to be prevented by convention would be absurd.[17]

Outwardly, Nash's dealings with his father may not have altered, but the son, who was beginning to explore some of the newer trends in a style of life and a method of art, removed himself more and more from Iver Heath.

Nash's drawings did not change in a marked direction immediately after meeting Margaret. Nevertheless, his relationship with her brought to the surface the fusion of sexuality and landscape which had played an important, but largely unconscious, part in his early drawings.[18] What was refashioned almost at once was Nash's conception of himself as artist. As he told Margaret, his career, as well as his life, had just begun. In the years immediately before the war, their love infused Nash with an enormous amount of energy: he strengthened his friendship with Bottomley, asked Yeats if he could illustrate his poems, assisted his younger brother at the outset of his career, caught the attention of the art world, and flirted briefly with Bloomsbury. At the same time, he was attempting to strengthen his 'illusion' and to come to grips with modernism.

Although he was confused about dates in *Outline*. Nash finally met Gordon Bottomley in December 1912 at the home of Robert Trevelyan in Holmsbury St Mary in Surrey. Nash's correspondence with Bottomley had been frequently interrupted by his friend's poor health, and so he was surprised to meet that May a vigorous-seeming, larger-than-life giant in Gordon Bottomley, whose features 'seemed molded like his own undulating hills. His slightly flattened, black crest, roofing his broad sloping brows, together with the larger sweep of his great red beard, all suggested rather the flow of polished, sculptured planes.'[19] This portrait, largely composed of metaphors from landscape, splendidly evokes a 'Northern God who in happier times might have lived in a grove and dispensed oracles'.[20] Emily, in contrast to her husband, was petite. Her quiet efficiency and swift, darting movements made her 'part bird-woman, part fairy.'[21]

Robert Trevelyan, a friend of the Woolfs, Roger Fry, and Eddie Marsh, had been an ardent Tennysonian as a Cambridge under-graduate. At twenty-seven, when Nash met him, he was a Georgian

poet, who had precariously attached himself to the fringes of Bloomsbury, although not always with grace. Virginia Woolf was disgusted with him, as she said in 1929: 'he wanders off to the Press, suffocates them with boredom ... and lays not the tiniest egg in the long run'.[22] In 1912, Bob Trevelyan had a small collection of paintings, of which he gave Nash a tour. During this promenade, Nash noticed that Bob seemed, all too obviously, to be nursing a joke. Finally, he asked Nash to identify the painters. Nash was hesitant and embarrassed – his knowledge of other people's work was not yet extensive. Finally, Bob confessed that all the paintings, which were in a wide variety of styles, were the work of one man: Roger Fry:

> He went on to point out that these pictures were not essays in the manner of John Varley Marchand, Matisse or whoever else, but authentic Roger Frys painted during the periods of the particular influence he was under at the time. 'Now, of course, it is Cézanne', added Bob. In which case, I thought, what can he find to like about *my* drawings? I felt a growing desire to meet the high priest of art.[23]

Although Nash would soon be admired by Fry and join him at the Omega Workshop, he was ultimately hostile to Bloomsbury and its chief architect. In telling this anecdote in *Outline*, Nash suggested that what he despised about Fry and his associates was the insularity and smugness which sometimes got in the way of their best efforts. Nash especially did not like Trevelyan's self-satisfied joke, which reminded him that he was a young man who still did not have an artistic centre. Two-year-old Julian Trevelyan even had the audacity, which further incensed him, to ask his mother, 'who is the man with red ears?'[24]

Nash called on Yeats, to whom Rothenstein had given him an introduction, in April 1913 to propose a series of illustrations to *The Wind among the Reeds* (1899). 'I approached him with great hardihood – bearded him in his lair & fortunately found him at home.'[25] Yeats was in a 'shadowy' room, sitting near a dying fire. Amusedly, he looked over the drawings and then asked languorously, 'Did you really see these things?' As Nash said, 'Before the master of visions seated in his own ghostly room which was growing darker every minute, it seemed necessary to be uncompromising.'[26]

Later, he speculated that he had been unable to convince Yeats of his sincerity. However, Yeats confessed himself intrigued by Nash's suggestion that he 'accompany' *The Wind among the Reeds*, but he said that there might be difficulties with his publisher. After the interview, Nash felt that the great man had merely toyed with him, not really having been at all interested in the project. Subsequently, when a letter arrived from Yeats' publisher saying that he, rather than the poet, was not favourably disposed to the venture, Nash was relieved: 'I was less downcast than I had expected.'[27]

Nash's sense of having been released from an undertaking no longer of interest might have stemmed from his realization that although his poetical impulses were still strong in 1913, he had to advance his work in purely visual terms if he were going to be a successful artist. At this time, Yeats was under the influence of the young American, Ezra Pound, and Yeats may well have seen Nash as a charming but retrogressive young man.

John (Jack) Nash comes forth slowly from the shadows in *Outline*. William Harry, Barbara, and he were with Paul on holiday in Wallingford in September 1912 when Nash first attempted to draw the Clumps he had seen the year before: 'Jack was withdrawn to the river for an afternoon's fishing.... My objective was the Clumps.'[28] There is the faintest hint of sibling rivalry in the passage that follows a few pages later: 'My thoughts wandered to the shooters over the hill and to Jack.... I hunted my quarry, I watched and waited, I had to know where and when to strike. And what was there to choose between a bird, a fish and a sketch, except that my drawing would last longest.'[29] Later in *Outline*, Nash describes Jack's sensitivity to music. He also mentions that his brother and sister were part of a closely-knit group in 1913–14 surrounding Margaret and him. Strangely, Nash does not reveal that his brother had become an artist by 1912 and that he had encouraged his sibling in this pursuit. The mature artist who wrote *Outline* was estranged from Jack, and he chose not to mention the aid he as elder brother had freely bestowed years earlier.

Jack had been educated at Langley Place, Slough and then at Wellington College. For a few months after leaving school, he worked as an unpaid journalist for the *Middlesex and Bucks Advertiser*. In June 1912, Nash sent some of Jack's drawings to Bottomley,

who was brutally frank about Jack's strengths in comparison to some of his older brother's glaring weaknesses:

> I don't know how the instinct for draughtsmanship entered your family, but it is there and it would be useless to try to chill it ... In facility and lucidity and directness of expression, and in his faculty of keeping his material untroubled, he has advantages over you; but of course it remains to be seen if he can preserve these qualities when he has as much to say as you have.[30]

The following year, in November 1913, the brothers exhibited together at the Dorien Leigh Gallery, where, by mid-November, Jack had sold seven drawings to Paul's four. Rather than being jealous of his brother's early success in the same profession, Paul was magnanimous. He told Bottomley in July 1913: 'I am glad you see such promise in Jack: for my part I think he is going to do really fine work & he is so extraordinarily productive I stand by in amaze and envy.'[31] In 1913, Paul was bathed in Margaret's love, and he was pleased by the kindness shown to her by Jack and Barbara. In turn, his nurturing tendencies were directed towards his younger brother.

The poster for the Dorien Leigh exhibition shows Paul dressed in bohemian finery, whereas Jack is clothed in a traditional suit. Margaret, Rupert, Rosalind and an unidentified woman wander in the background poised between Paul's Wittenham Clumps in the top background and Jack's golden wheat sheafs in the lower background. This joint effort displays the different directions the brothers took in their careers: Paul towards a mystical interpretation of landscape, Jack towards energetic, colourful renditions of the scenes immediately before his eyes. Although the brothers were both dedicated landscape artists, Jack's is the true countryman's portrayal of the actual world. In recognizing his younger brother's talent, Nash knew that there was little or no conflict in their ambitions as artists.

Before the war, Jack was to be associated with the Friday Club, the Camden Town Group, and the Cumberland Market Group. Although the brothers' First World War pictures show few stylistic similarities, they were linked together well into the 1920s, as Paul told Jack on 9 December 1922: 'I know most people think of us as one flesh – John painting with the right hand, Paul with the left, or at least as being in the same house, eating out of one bowl & having

our wives in common!'[32] Paul's exasperation at such a view of the brothers Nash is vividly expressed later in the same letter:

> Dear old muddle headed [Frank] Rutter [the critic] has writ a book about his pet painters & you & I share a chapter. This is an economical age among other curses. According to R your art has the elements of true greatness & I am a genius fashioned by war & altho I can paint better now I've never done anything so '*powerful*' – Orpen is a modern blend of Van Eyck & Frans Hals. Ginner the most important painter we have. Duncan Grant is not mentioned and so on and so bloody pissing, vomiting, belching, squittering on.
> We have our Fry
> To tell us why.
> – Clive Bell as well –
> But who can utter *quite* like Rutter?[33]

Later, in the thirties and forties, with some justification, Jack felt that his older brother used him as a stalking horse, Paul carefully presenting himself as the serious dedicated artist in contrast to his younger brother's more facile efforts. Paul certainly seemed the more highly-strung of the brothers. His comic gifts were not as great as Jack's, his work being much more concerned with the world of the spirit. Paul in his life and work certainly made consistent efforts to explore the underlying meaning of the world around him. He questioned his origins and allowed himself to be puzzled by the vagaries of existence. Love, hatred, separation, and death are the major threads in his work, continually re-examined in a search for understanding. He was also aware of the deeply intuitive, feminine side of his nature, and he cultivated this, even though such a task often involved intense inner turmoil and anxiety. In contrast to his older brother, Jack clearly demarcated his life from his art: there is little sense of conflict in his splendid portrayals of the English countryside. In his inner life, however, he was much more tortured than Paul. He later became involved in a number of affairs with women, even though his longings were sometimes homosexual; the greatest emotional commitment he made during the course of his life was to a fellow soldier in the trenches.[34]

In 1913, two prominent collectors bought Paul Nash's pictures. Michael Sadler, the Vice-Chancellor of Leeds University, was a strong

supporter of Augustus John who, he claimed, had simplified his art and had achieved in the process a fresh primitive vision without, like the English Post-Impressionists, going too far: 'He is a development, whereas Post-Impressionism is an open breech.'[35] Sadler's interest in Nash had begun as a result of a request from Rothenstein of 10 November 1913:

> ... I sent you a card last night for a show that the brothers Nash are having on Friday for a week. If by any chance you are in town, do contrive to go to it. They are both very young & extremely interesting & talented & nobody save myself & one or two equally helpless people take any interest in them. They are badly in need of both help & encouragement & Paul's work is quite first rate. The other brother is younger & still not quite developed.[36]

Nash's other patron was Edward Marsh who in 1913 said of an artist friend: 'I'm afraid he has come under the influence of dear Roger Fry whom I love as a man but detest as a movement.'[37] Marsh, forty-two at this time, was a man of impeccable dress and fastidious taste. He was the greatest private collector of English art in the early part of the twentieth century, and had a wide range of friends and acquaintances.

Marsh's father had been Master of Downing College, Cambridge, and he himself had been an Apostle in the 1890s with, among others, Bertrand Russell, Maurice Baring, and Bob Trevelyan. Marsh's funds for collecting were derived from an unusual source: 'murder money'; he was a descendant of the assassinated prime minister, Spencer Perceval, and was thus the recipient of payments from a trust paid to Perceval's relations. In his public career, Marsh was exceptionally successful, becoming Assistant Private Secretary to Chamberlain and, later, Secretary to Churchill.

By 1914, the year Nash met him, Marsh was the semi-official propagandist for Georgian poetry and Rupert Brooke, its most brilliant exponent. In 1913, he had begun *Georgian Poetry*, a series of anthologies intended to make the reading public more aware of the new directions in English verse. So successful was the first anthology in accomplishing this that eleven further collections followed. John Nash, probably accompanied by Mark Gertler, visited Marsh's flat on 22 January 1914. The two men quickly became friends, and John invited Eddie to Iver Heath, where he met Paul in late February.

Soon afterwards, Nash paid his first visit to Marsh on 4 March. Their meeting that day concerned 'Georgian Drawings', which was intended as a companion volume to the poetry books. Nash, together with Professor Sadler's son, became an enthusiastic collaborator with Marsh in this project, which faltered when the necessary subscription money could not be raised.

Marsh as a collector and Nash as an artist were in the midst of profound changes in 1913–14. Marsh had just become devoted to Gertler's art, his conservative taste having been modified by Gertler's exuberant, flamboyant canvases – for Marsh he was 'the greatest genius of the age'.[38] In 1914, however, the walls of Marsh's flat were still largely covered by eighteenth- and nineteenth-century English work. In addition to the paintings by Gertler, the only other really modern work in the flat was Duncan Grant's *Parrot Tulips*, which Marsh had bought at the December 1912 exhibition of the Camden Town Group. Gertler converted Marsh to Gauguin and Cézanne and told him that he could retain his admiration only for Giotto and Blake.

Marsh had a discerning eye, and he was immediately taken with *Trees in Bird Garden* (plate 13), which was exhibited at the New English Art Club in the summer of 1913, a drawing replete with the mystical overtones he liked in Georgian art coupled with precise, decorative, almost geometric angles. Roger Fry admired this drawing at the same show.

'Roger *who*?'[39] Nash had ingenuously asked Bob Trevelyan in 1912; by 1913 he was pleased to have a report of Fry's admiration of his work, Fry having attended Nash's Carfax exhibition in November 1912. Eight months later, in July 1913, Nash was flabbergasted to hear that Fry had said that his 'were the only things he liked in the New English'[40] the previous May. This is slightly surprising because Nash's natural inclination was towards Georgianism and away from Fry's penchant for Post-Impressionism. Although the Georgian movement aimed at a realistic portrayal of emotions, and tried to break away from the second-hand Romanticism which characterized much of early twentieth-century art in England, it did not overly stress structural cohesion, and this was crucial to Fry's aesthetic.

Fry and Nash finally met in November 1913 at the Dorien Leigh

show. Fry was only moderately impressed this time round:

> I've seen Paul Nash and arranged for him to come later on and try
> his hand at decorative work. We shall see how it turns out. It's a
> good test of where his real power lies. He has imagination of some
> kind if he can only find the way in which to use it. And he's very
> sympathetic and I should like to have him with us.[41]

Nash had a more sanguine response to the encounter. He told
Bottomley that Fry was 'immediately enthusiastic.... Of course,
he's the most persuasive & charming person you could ever meet.
Dangerous to work with or for but a frightfully shrewd & brilliant
brain and pleasant as a green meadow. He was obviously *very*
pleased with our work & stayed some time talking & inspecting.'[42]
Nash joined Omega in February 1914 and worked there for four
months. As he told Carrington, his first assignment involved deco-
rating a cushion:

> I was laboriously copying the interesting design ... of a man embrac-
> ing a fish – or swimming the channel in company with a fish or
> attempting to collar a fish in a game of Rugby football or trying to
> throw a fish in a game of catch-as-catch can (I don't know which).
> A most wonderful conception by Mr Duncan Grant. It is very pleasant
> at the Omega & I think I shall learn a great deal.[43]

However, Nash's principal Omega project, the restoration of the
Mantegna frescoes, *The Triumph of Caesar*, at Hampton Court, damp-
ened his initial fervour.

Although Fry was not 'dangerous to work' for in 1914, Nash
was not really comfortable with restoration technique and did not
feel Fry adequately trained him for the project. There was, however,
a diverting moment that winter when Jack accompanied Paul to
Hampton Court. Nash had just begun work when Fry entered the
room. The older man was instantly upset at seeing Jack stand idly
by: 'If your little brother would like to do a job of work today, he
can get down on the floor and repaint the feet.'[44] Jack obeyed the
Master's command and with tubes of Dr Colley's mixture started on
the toes, being thoroughly delighted to have been let loose in such
a haphazard way on a Renaissance masterpiece.

However, by 10 March 1914 Nash was disgusted, as he told
Margaret: 'The Omega can go to the Devil. I shan't be there.'[45]
Despite such peevishness, relations between the two men were good

until at least 3 September 1917, when Fry wrote a testimonial in support of Nash's application to be an Official War Artist: 'I hope very much that you will get opportunities for continuing the work of drawing the actual landscape of warfare. I think you have a very special talent for recording a certain poetical aspect of such scenes in a way that no other artist could.'[46] In turn, Nash continued to see Fry as an important theorist and as an artist who had tried to shake the conservative bedrock of English art in the early part of the century.

Nevertheless, in the 1940s, Nash characterized Fry as 'his own Goebbels – unless you count Clive Bell'. Virginia Woolf was 'mentally poisoned', and Duncan Grant 'like a fly sucked dry in a Spider's Web. There he lays covered in cob webs & no one knows he is dead.'[47] According to Margaret Nash, the ostensible break with Fry came in 1919 over praise given by Walter Sickert, to whom Fry was supposedly hostile, to *The Menin Road*.[48] Also, she added, Fry did not like Sickert or war art. Her story is improbable. Fry was not particularly antagonistic to Sickert, who had in 1917 warmly praised his flower paintings. And there is no marked evidence of an aversion on the part of Fry to 'a spirit of propaganda' in war pictures, which, in Margaret's account, also led him to dislike *The Menin Road*.

Fry may have sinned by omission by not writing about Nash's work, and he did pressure Maynard Keynes in 1925 to exclude Nash from the London Artists' Association (Nash was elected in 1927).[49] Nevinson, who had similar difficulties with Fry in 1916, said: 'A coterie becomes a tyrant, falsifying a man's standards. Consciously or unconsciously he trims.'[50] Paul Nash's art was not Bloomsbury in spirit: he was essentially an English artist employing landscape to meditate upon his own destiny. His work seemed to be moving towards a decorative manner (and thus towards Post-Impressionism and 'significant form') in 1913, but this was a tentative step.

The dispute with Fry may have been based on personal grounds: the proud countryman versus the refined aesthete. Nash was to become a cosmopolitan theorist on the nature of art, but, by inclination and background, he simply did not appreciate the remote stance of Bloomsbury. Also, he was a loner, who did not receive solace from the protection of a group. The quarrel between Nash

and Fry was one between opposites: Fry wanted English art to be yanked violently into the twentieth century of the School of Paris, and Nash, although later a staunch defender of many of the principles annunciated by Fry, wanted to push the traditions of English landscape as far as they could go.

The resentment of Fry probably had additional, psychic roots. Nash never openly defied his own father. In the years immediately after the First World War, he may have perceived Fry as a parental figure against whom to rebel. Later, in attempting to become a taste-maker very much in Fry's image, he may have been unconsciously displacing or surpassing the man he dubbed 'the Quaker Jesuit'.[51]

Despite Fry's guarded approbation in 1913–14, Nash was unsure of what direction to pursue: 'Instead of stimulating me to fresh efforts, my little show [at the Carfax] seemed to have halted me and left me uncertain.... Both subjects and aspects were equally confined. Groups of trees in an "upright" view seemed to be my sole interest.... In short I had got into my first rut.'[52] Although Nash was cultivating his poetical side in such drawings as *Apple Pickers, Two Figures in a Wood, Margaret in the Garden, The Girl gives the Harlot the Crucifix*, and *A Dawn*, he did not allow material which seemed to be excessively literary into the seven exhibitions in which he participated from May 1913 to the end of 1914 (the exceptions are *The Cliff to the North* and *Lavengro*, which were entered in the Dorien Leigh show). The public saw in those two years a great many trees and gardens – even Wittenham pictures were in short supply.

The artist's conflicts at this time are revealed in his letters to the inveterately helpful Will Rothenstein, Nash was dallying with 'psychic portraits', and, as well, he wanted to have his poems published. Such inclinations can be seen in the *Harlot* picture where the worlds of innocence and experience rather self-consciously confront each other. Nash, although he desired to be both a poet and an artist, was desperately concerned with technique. He told Rothenstein: 'I think you are right that my line is not so alive as my vision.' Rothenstein made specific suggestions, being, in marked contrast to Bottomley, sensitive to Nash's need to pursue a purely visual imagination. Nash confessed to him:

I have had difficulties lately in managing colour. I want all the colour

but all the drawing & definite outline too. Each picture has taken me much longer & I have laboured upon some for days & then sponged them out. I find no *way* to do things, it is terribly wearying to have to consider the way to do each picture but I have to – for tho' my end is clear to me & object in mind I find the means a great struggle being obliged to experiment over & over on each new work.[53]

Eventually, Nash's experiments led to a much more firm, careful control of line. The landscape and garden pictures of 1914 bear a superficial resemblance to those of 1913, but the new watercolours are cleansed of some of the annoying, unnecessary mannerisms of the year before. Structural elements are clearly built up and focused upon in *Avenue*; strong geometrical patterning is evident in *The Monkey Tree*; the delineation of the various parts of a landscape into a coherent whole can be seen in *Thirlmere* and *Orchard*. The promise Fry had seen in *Trees in Bird Garden* had come to fruition.

Thus, Nash's work in 1914 is a refinement of the advances made in 1913, advances which were, nevertheless, often meandering. He showed a limited capacity to become engaged fully in the newest trends, although he was not unaware of what was going on around him. It often took him a long time to contemplate a possible new influence. After a seemingly somnolent period, he would suddenly bounce back, having absorbed it fully. Such was the course of his apprenticeship to Vorticism and its parent, Futurism, in 1914–18.

In the printed version of *Outline*, Nash's précis for the remainder of the final but broken-off chapter was omitted. The manuscript reads in part:

Art revolution in England. Cubism breaks out. Publication of — Blast. Rebel Art Centre. Cave of the Golden Calf. The first & last night club worthy of the name.[54]

In March 1914, after a series of quarrels – essentially the result of a personality clash between Roger Fry and Wyndham Lewis – the Rebel Art Centre was founded by Lewis at 38 Great Ormond Street. Four months later, the first of two issues of *Blast* was published.

Blast and the Rebel Art Centre were devoted to Vorticism, a term coined by Ezra Pound to suggest a whirling force which would draw to itself a new synthesis of all the positive elements in contemporary art. It was stridently modernistic and, also, forbiddingly puritanical.

Vorticist works were heavily indebted to Futurism, and they displayed, as in the work of Lewis, a combination of strong geometric line, bright primary colour, and intense energy. The movement favoured 'the hard, the cold, the mechanical and the static';[55] its vocabulary was filled with words like 'violent', 'exploded', 'volcanic', and 'bomb'; art, as seen by the Vorticists, was instinctual and primitive. Vorticism was also fundamentally opposed to the decorativeness of Post-Impressionism and Cubism, and was, of course, less an importation into English art than those two, artists such as Lewis, Nevinson, Wadsworth, and Bomberg making distinctive contributions to English art under its aegis.

Madame Frida Uhl Strindberg's 'Cave of the Golden Calf' was the Vorticist stronghold in central London. The large, crowded basement at 9 Heddon Street was opened in the spring of 1912 as a cabaret devoted to 'gaiety stimulating thought, rather than crushing it'.[56] Eric Gill made the Golden Calf itself, and Jacob Epstein made two white plaster caryatids. Lewis, Gore, and Ginner painted decorations on large canvases attached to the walls. The Turkey Trot and the Bunny Hug were the dances; jazz bands, music hall girls and gypsies were there in abundance. It was, as Pound claimed, the 'only night-club poor artists could get into'.[57] Unfortunately, the club was short lived; after some turbulent, frequently hysterical, outbursts, it died on 13 February 1914, when its liquidation sale was held.

Nash's art shows no real traces of Vorticism until at least 1916 in *A Lake in a Wood* and *Richmond Park Encampment*, but he was a prescient young man waiting for the right moment. When he chose to employ Vorticism, it would be in an outlandish, forceful way. In 1913–14, he hovered at the edge of the avant-garde. He was also keenly aware early in his career that an artist's commitment to his profession often has to go beyond the fine into the applied arts. He told Bottomley in July 1913: 'New fields open to the eye of the artist. He seeks expression thro new forms – crafts – designs for tapestry, fans, & other things, where new beauty may be embodied. The artist's brain is seething with new ideas.'[58]

All in all, Nash's grasp very much exceeded his reach at the outbreak of the First World War. He was aware of new possibilities. He was completely taken with the Russian ballet in July 1913, and he was irritated that the Murry–Mansfield *Blue Review*, which had

Bombardment, from *Images of War*, 1919

published his Lavengro drawing and to which he referred to as 'old Blue Balls or Bloody Blue', was folding.[59]

Still, Nash was not quite sure how contemporary he wanted to be. He did not like the Slade draughtsmanship of Augustus John, and he had serious doubts about Epstein in whom 'technical power rather than vision predominated'.[60] The artist he admired most in 1913–14 was a strange choice: Gordon Craig, the stage designer son of Ellen Terry:

> In the first place Craig possessed imagination in a degree far beyond John or Epstein. For although the origin of his inspiration in regard to certain technical vehicles of his art could be traced to various sources, the style evolved was his own and it had a constant distinction. But all method and manner aside, what appealed to me in the work of Craig was the abundant evidence of poetic insight.[61]

For Nash, Craig was an English artist who had kept his unique 'poetic insight' but who had also employed luministic and kinetic theory to produce avant-garde stage design, which had been critically acclaimed on the Continent.

Another crucial aspect of Craig's art for Nash was that he too, despite the predominant absence of the human form in his work, had an inherent sense of drama. He cleansed his canvases of unnecessary clutter – just as Craig had simplified stage design.

Significantly, Craig is the last character in *Outline* as it comes to a seemingly abrupt halt: 'Gordon Craig at that moment ... was at the zenith of his career. . . . He was, to a certain extent, in his element in this setting, surrounded albeit on two sides only, for none of us liked to obtrude into his range of vision, a group of eager, slightly spellbound students.'[62] As his autobiography ends, Nash is one of an assemblage of unsophisticated young men surrounding Craig at the Café Royal. However, Craig became for Paul Nash the paradigm of the artist who not only retains his poetic insight, but who is also eager to explore the newest trends in visualization. And in this regard, the disciple was to surpass the master.

———————•———————

The Great War

1914 – 18

O N 4 AUGUST 1914, the day England entered the First World War, Paul and Margaret Nash were staying with Gordon Bottomley at Silverdale. In his typically thoughtful way, Bottomley kept newspapers telling of the onset of hostilities away from his young friends. Earlier, Paul and Margaret had visited with Michael Sadler at Leeds and with Charles Rutherston, the brother of William Rothenstein, at Manchester. Nash admired Sadler's collection which included four 'gorgeous Gauguins', but he was more impressed with what he saw at Rutherston's: 'Among other pictures there were two knock-out early drawings by Rossetti.'[1] Nash's eyes obviously still inclined towards the Pre-Raphaelites. Still, as he told Eddie Marsh, he knew that his own work was in transition: 'My pictures are promising for later developments but individually rather nice and gentlemanly: Still, I feel I have given a jump right away from "Nash trees"'.[2]

Emily Bottomley saw Nash and his fiancée as a 'Post-Impressionist' couple, and she attempted to instill some 'Early Victorian'[3] sense into them. Noting that her two young friends seemed unduly addicted to opulence, she warned them: 'From the opinion we formed of you and Bunty we decided you would need quite lots of money to marry happily. And, oh, wouldn't it be a pity to marry so

soon and feel the drag of making ends meet all along life's way.'[4] Emily's words were shrewd, for the Nashes were to be financially pressed for the rest of their lives. However, they were deeply in love and threw caution, and all other such Victorian notions, to the winds. Their combined incomes in 1914 (approximately £450–75 from salaries and family donations) would have allowed them to live modestly, but Paul and Margaret usually avoided any cutbacks in clothing, furniture and wine. As a couple, they cultivated 'style', and, though there was never anything makeshift or threadbare about their mode of existence, Nash's 'ideas of finance were', Ruth Clark affectionately remembered, 'as clouded as his mathematics ... he was good at counting chickens before they were hatched'.[5]

Margaret Nash characterized her husband's patriotism, at the outset of the war, as Elizabethan: 'He had a very clear and simple conception of his duty towards his country, which he passionately loved, and although he was the last human being in the world to tolerate the horror and cruelty of war, he had an immediate and firm conviction that he must fight for England.'[6] Nash's own letters from August–September 1914 are not as sentimental. He saw the 'whole business as most bloody stupid', and he confessed to Bottomley, 'I am not keen to rush off and be a soldier'.[7]

On returning to London that August, the young couple was overwhelmed by the spectacle of small boys marching down the street with drums and bugles. The toy war horrified them, but the possibilities of real war were unimaginable. Later that month, Nash attempted to enlist for home defence. As Margaret put it: 'I dumbly accepted his decision to enlist at once in the Artists' Rifles',[8] the depot of which was around the corner from her flat in Queen Alexandra Mansions, Judd Street. Nash was rejected by the recruiting sergeant because he was an inch too short for the six foot standard. On 10 September, however, he was taken into the regiment and went to live under canvas at Richmond Park. 'There may be emergencies later & I mean to get some drilling locally & learn to fire a gun but I don't see the necessity for a gentleminded creature like myself to be rushed into some stuffy brutal barracks to spend the next few months practically doing nothing but swagger about disguised as a soldier *in case* the Germans – poor misguided fellows – should land.'[9] In October, Nash encountered Rupert Brooke, whom he had met at Eddie Marsh's flat in March 1914,

and was told the Antwerp trenches were 'marvellous'. Nash's response was not so enthusiastic: 'I expect I should hate the slaughter – I know I should, but I'd like to be among it all.'[10] Paul and Margaret now decided against a long engagement, 'as it seemed possible that he would be sent out to France at any time'.[11]

The wedding took place on 17 December 1914 at St Martin-in-the-Fields, and the reception was held at the International Franchise Club in Grafton Street. Lance Sieveking, a fellow Artists' Rifle whom Nash had met while both were drilling in the garden of Russell Square, was amused by some of the wedding guests: 'a large number of ladies were present in the church who were unmistakably tarts from Piccadilly and Leicester Square. Judging from the glances and whispering, they evidently doted on Bunty, who was well known to them. They gave what I can only call a very unusual atmosphere to an otherwise conventional affair.' Sieveking was uncertain whether some of these ladies attended the reception. He drank a great deal of champagne, and, he recalled, 'certainly one of the ladies I stood and chatted with had a most encouraging look in her eye'.[12] The Nashes honeymooned in Somerset.

When they arrived back in London, Nash had to obtain an army uniform. Despite financial stringencies, Nash was finicky about acquiring the 'right' one. It had to be properly cut and made from the finest cloth. He commissioned Gamage's in Holborn, where several fittings were necessary. Sieveking attended one of these:

'They've absolutely ballsed it up', Paul exclaimed. Margaret attempted to pacify him.
'What's wrong?' asked Sieveking, puzzled since the uniform looked fine to him.
'Why, damn it all! Just look at the left shoulder!'[13]

Sieveking failed to see how the uniform fell short of perfection.

Nash spent 1915 and 1916 in England, moving, almost immediately after his honeymoon, into barracks at Roehampton: 'There are little Dutch gardens, Italian gardens, gardens surrounded by huge old brick walls.'[14] There was an unreal quietness to such an existence, and Nash told Eddie Marsh that he had reached 'the very real thing at last'.[15] Nevertheless, Nash became known for his adroitness in getting round sergeants and in extricating sleeping-out passes from them. He even claimed that he wanted to be

commissioned in the Ordnance Corps because the pay was higher and the work less suicidal.

Despite his talent for outsmarting the army bureaucracy, Nash was disturbed by the suspended animation that the war brought to daily life in England: 'the war looks gloomy enough but it is essentially a war of negatives . . . the end will be a totalling up of failures – the one who has the fewest vital ones wins'.[16] He saw Margaret quite often, but his jealousy was keen: 'Poor wee dove, I am sad that you are so bored without your mouse & I don't mind a bit you playing games to keep lively, so long as you are not carried off by some ardent Apollo & I come home to find an empty nest.'[17] He playfully referred to Margaret and their friend, Ruth Clark, as 'naughty wives getting drunk and carrying on intrigues'.[18] Sexual jealousy was something he could not always treat humorously, as when he dreamed that Margaret had kissed a friend of theirs '& a few other amorous young men'. When Margaret had done so, 'she raised him to a frenzy of desire. She was quite another woman and he awoke so miserable until his real love's image came with returning consciousness & he knew the other had been all of a dream!'[19]

It was not an easy time, and the couple tended to bicker when they did meet – although Nash was quick to make amends:

> All my foolish fancies have dispersed and my heart feels full of love for you, sweet one. These clouds of doubt and depression that come over me are just as ephemeral as any clouds, they soon clear, or even if they stay for days like these ghastly grey clouds of this dull week, there comes a day when they disperse. . . . Sometimes I have felt love dead within me.[20]

Nevertheless, he became increasingly withdrawn, and Margaret perceived this as the 'contagion of low ideals'[21] from the war. Nash knew he would get over this, but he needed 'something big to shake [him] & make [him] alive again'.[22] He had not yet seen service at the Front, but the horror of the war had invaded him, his own behaviour frequently perplexing him: 'Sweet heart, it did hurt me to see you cry – it's too awful – and I couldn't help feeling it was all through me; do, do forgive me my unmanly temper: your irritability which was natural enough grated on me and I weakly allowed my nerves to be affected and myself to get cross and angry.'

Nash repeatedly enquired about Margaret's work (she was attempting to start a hand loom industry which would both assist the war effort and give employment to destitute women). He even offered to design a brochure for the cause. And yet, their quarrels and misunderstandings continued to be frequent: 'I hope you did not think me horrid to rush away from you at Liverpool Street. I am stupid about leave-taking & hate partings in publick always; apart from that, there was such a crowd and confusion & myself feeling nerves & uncomfortable.'[23]

As well, Nash felt polluted by the new morality which the Great War brought in its wake, and this frightened him. His reaction to Gilbert Cannan's *Mendel*, a *roman à clef* dealing with Dora Carrington, Mark Gertler, and John Currie, amply shows this:

> . . . it is an obsession of self-seeking, self-satisfaction, self-interest, self-aggrandizement, self-love. Hence misery. And of course the main cause of the two tragedies in the story is the attitude of the men to women – it is the lowest conceivable. It is a hard discomforting tale, charged with beauty and quite exciting pathologically. . . . My darling let you and me be careful of our love, for the love of the body is a fearful tyranny & our most precious moments are not of the body. I think I am saved by a passionate tenderness I have always felt for you, and indeed I could not love or live with anyone who did not stir that in me.[24]

These are courageous, deeply-felt sentiments, but the war and its aftermath would destroy a great deal of Nash's idealism. In 1915–16, he knew such feelings were in danger of extinction, and he tried, desperately, to hold on to the values of an earlier, more chivalric society.[25]

The most momentous event of 1915 occurred on Christmas Day, when Nash was on guard duty at the Tower of London. Lance Sieveking and his father had invited Margaret to supper, and, in the midst of that meal, there came a shrill wailing sound followed by a series of explosions. As Sieveking recalled, the three rushed to the roof of Queen Alexandra Mansions: 'There in the beams of three searchlights we saw an enormous cigar-shaped object slowly moving across the sky. Another bomb was dropped. It was the first air raid. It wasn't frightening, only marvellously melodramatic.'[26] Margaret could not be as stoic as Sieveking. She was afraid the

Tower was about to be hit. To her, the Zeppelin 'appeared like some terrible dream from Dante's Inferno'.[27]

Six months later, in May 1916, Nash became a map-reading instructor at Romford, Essex, where he met the poet, Edward Thomas. According to Margaret, the two men quickly formed a close friendship: 'They enjoyed the exciting experience of night route marching, and during their spare hours in the day they would go for long walks in the country, stopping at the local pubs from time to time, where Edward Thomas would always ask the lady of the house if she could give them ... some apple pie.'[28] The two men shared a similar mystical conception of life, and this was obviously the foundation of their bond. Thomas commented, perceptively, on the sometimes excessively polite manner which Nash still adopted, describing him as 'most uncommonly charming but he carries it to excess with friends who occasionally deserve better'.[29]

In August, Nash began officer training at Denham (near Iver Heath), and, a month later, went to Camberley. On 19 December he was gazetted second-lieutenant and assigned to the third battalion of the Hampshire Regiment, which he immediately joined at their headquarters at Gosport. There he waited to go on one of the drafts, either to Mesopotamia or to Ypres Salient, where Edward Thomas was to die on 9 April 1917. The Adjutant at Gosport was sympathetic to the plight of the mobilized artist, allowing Nash to live in rooms in the town. Margaret, who frequently visited him on weekends, woke up one morning at Gosport to discover that her husband had measles. This seeming bad piece of luck turned to Nash's advantage when he was excluded from a newly-announced draft. 'This accident probably saved his life, as that particular draft went out and lost nearly all its Officers while trying to land in Salonika.'[30] Paul and Margaret were even allowed, during the quarantine, to return to London, where they went to the Oxford Music Hall to hear Marie Lloyd and Little Tich.

In February 1917 Nash was posted to the fifteenth battalion of the Hampshire Regiment. He reached France on 22 February and after some days at Rouen, he arrived in the Ypres Salient early in March. 'A merciful providence', according to Margaret, 'protected Paul while he was up the line in the Salient; it was a period of comparative quiet during which both sides prepared for a fresh and bloody onslaught. His experience of actual fighting was conse-

quently slight, but of course he took part in the nightly raids and the daily skirmishes.'[31]

Margaret also referred to her husband's 'quiet detachment' at the Front, an especially acute phrase which perfectly summarizes his first stay. Just before embarking, he had remarked how 'true those perverted words of Bernard Shaw's were: Britons never never never shall be any thing but slaves'.[32] Four months later, his sentiments had changed markedly: 'The cause of war was probably quite futile and mean, but the effect of it is huge. No terrors will ever frighten me into regret. What are the closing lines of Tennyson's "Maud"? – *"I have felt I am one with my native land."* This is the emotion and it is a satisfying one to rest with when every other has turned bitter and dead.'[33]

As well, Nash was moved by the strange unreality of being a warrior visiting a terrain which might be soon destroyed by his own hand: 'one feels nothing is real now, and this lovely weather is more maddening than the nightmare of the trenches. I never felt the terror of dreams so alive, even as a child, as I feel it here where there is no waking up.'[34] Beauty became more poignant in the landscape of desolation: 'I never feel dull or careless, always alive to the significance of nature, who, under these conditions, is full of surprises for me.'[35] Also, Nash found it difficult to decide which was the more absurd – war or nature.

During his first tour at the Front, Nash's prose took a monumental leap forwards in graphic vividness, his writing assuming the strident, direct language of the art of war: 'As shells fall in the bluff, huge spouts of black, brown and orange mould burst into the air amid a volume of white smoke, flinging wide incredible débris, while the crack and roar of the explosion reverberates in the valley.'[36] Nash had previously felt the manipulation of colour difficult in his drawings, but his prose now uses colour with direct authority. He now became aware of a way, still closed to himself, to capture this new landscape visually: 'It may sound rather chaotic, but were I Nevinson I would paint it so – a smile shaft piercing an oak beam, a riot of yellow mimosa spots – yawning arcs of sugarless tea in bright coloured bowls, tweed triangles of skirts, trim ankles with flat brogues.'[37] He asked Margaret to obtain a copy of Nevinson's 1916 drypoint, *Ypres after the First Bombardment*: 'It is a part of the world I'm interested in.'[38] The school bully from the Slade was

producing Vorticist-inspired art from the trenches and in the spring of 1917 this intrigued Nash:

> See the beauty of these camps by the roadside, all the tents are painted in savage patterns of green, red, orange and black. The bright red rusted corrugated iron roofs have been skilfully mottled with a huge design of black tree shapes spreading over the scarlet rust, making a pattern that would shut up Omega and yonder marquee, a strange nuance of dirty grey–green canvas and orange spots, would drive poor old Fry to take up cricket out of sheer ennui. How interesting in form these once stiff houses look, a rhythmic ruin of tumbling forms. What wonderful things are ruins, I begin to believe in the Vorticist doctrine of destruction almost.[39]

Nash's first drawings from France (shown at the Goupil Gallery in June 1917) display little evidence of 'savage patterns' but this letter from March 1917 does anticipate the explosion to be revealed at the second, much larger, group of war material (*Void of War*) at the Leicester Galleries in May 1918.

Margaret, back in London, found her work exhausting, being constantly filled with a 'growing anxiety' over her husband. She had been distressed by this snippet in his description of his 'sentimental journey' to France:

> ... the before mentioned naughty waitress came up to my bath room – a most questionable bath room by the way with a bed in it! – & knocked at my door; fortunately for me? for her? any how for my moral integrity, I was quite dressed. So like my master Sterne before me, I kissed her & shut the door. Even this was a lesson to me for she smelt of cheap scent. Romance is dead.[40]

And Margaret was frightened by Nash's description of human nature: 'you little women have a refining influence & love contains more romance than wine even if it is lust.... I think men are the lower animals. I know they can go lower.'[41] Margaret was chilled when she read such passages. She now realized how quickly the heat of passion could grow cold. However, there were many expressions of tenderness in Nash's letters, as in this reflection which came to mind at the intoxicating smell of French violets: 'the kind you little women wear in the spring so that when we are near you the scent goes to our heads & makes us want to have you much more nearer'.[42] Margaret's worries overshadowed her joy in such

outbursts, and, overcome with anxiety, she entered a rest home near Tunbridge Wells in May 1917. She later claimed that during her stay she had a flash of intuition that something horrible had happened to Paul, whereupon she immediately left for London. She arrived back to find a telegram announcing that he had had an accident in the trenches and had been invalided back to England.

Just before the attack on Hill 60, on 25 May, during which many in his company were slaughtered, Nash had jumped up on the parapet to draw the Very lights which were directed over No Man's Land. He stepped back while drawing, forgetting how near he was to the trench, tumbled, caught a rib on a projection, and fell straight back into the trench. Although he suffered a great deal of discomfort, he was not seriously injured; however, he was sent to the Swedish Hospital in London under the care of Dr Cyriac. Margaret was able to visit him the night (June 1) she arrived back in London: 'I went over to find him in pain and nervy, but quite in command of himself. He was suffering from a broken, floating rib, which Dr Cyriac discovered in the x-ray photograph, and not as the report from the Base Hospital had it, from merely a misplaced cartilege.'[43]

Nash remained in England for five months, not obtaining his release from the Swedish Hospital until 21 June, although he was allowed to work at the Judd Street flat. In July, he was sent to the Alexandra Hospital at Cosham with a nasal infection. By the end of August, he was discharged and attached to the Third (Reserve) Battalion of the Hampshires at Gosport, where he lived at 19 Clarence Square. It was from Gosport that he embarked yet again for France on 31 October. During his time away from the Front, Nash prepared for his exhibition at the Goupil, learned lithography, and became an Official War Artist.

The eighteen drawings at Goupil did not display a tremendous technical advancement in Nash's art. *Chaos Decoratif*, for example, is an elaboration of *Trees in Bird Garden*. Hints of the Vorticist-inspired works from his second tour can be discerned in *Raid, Preliminary Bombardment, The Front Line, St Eloi*, and, especially, *Wytschaete Woods*. These are, however, essentially decorative, their strength deriving from carefully controlled lines and strong spatial arrangements. John Cournos's admiring critique of these pictures in the 28 July 1917 issue of *Land and Water* certainly gave the young artist a much needed boost: 'someone has described a certain

poet's work as possessing the quality of "accurate mystery"; that is, mystery expressed with precision, for in many people's minds the idea of *mystery is not dissociated from vagueness and mistiness. I am glad that has come into my work.*'[44] Of course, Nash had achieved similar results in his work from 1914 onwards. The first war pictures show his ability to transfer earlier experiments with English landscape to a new locale.

Nash was also pleased that half the drawings at the Goupil show sold, and he was even more gratified to make the acquaintance of the poet John Drinkwater, who was to become an enthusiastic collector of his work and a collaborator in several ventures. In August, Paul and Margaret stayed with the Drinkwaters at their cottage in the Cotswolds, Drinkwater having organized an exhibition of Nash's non-war paintings at the Birmingham Repertory Theatre for the following month, which was an extremely jubilant one for Nash: 'Margaret is my never-fading joy and we spend the happiest times together.' As well, his confidence in his talent continued to increase, although he remained aware how 'secret and reserved Nature really is and what devotion and homage must be paid to her before she will yield her mysteries'.[45]

In July, the month before, Nash had met up with Nevinson, who helped him to learn lithography. At the same time, realizing that he very much wanted another chance to paint the War, Nash launched a campaign to convince John Buchan, then Director of Information, to commission him as an Official War Artist. Buchan was not positively disposed to Nash's work but, after being besieged by letters from Marsh, Rothenstein, Eric Maclagan, and Laurence Binyon (Nash also had letters on reserve from, among others, Frank Rutter, Fry, Drinkwater, Trevelyan, Sadler, Bottomley and, even, Tonks), he wrote to C. F. G. Masterman, Director of Propaganda in his department: 'I think we will have to send Paul Nash as one of our artists to the front. There is a tremendous consensus of opinion about his work.'[46] Finally, Nash was seconded to the Department of Information on 12 October.

In September–October 1917 Nash worked at Gosport on a variety of projects not directly associated with the War. He told Bottomley at the end of September: 'have just finished two designs from Blake's poem Tiriel – also two large pen drawings of landscapes with figures

1 *Portrait of Proud Paul,*
1922

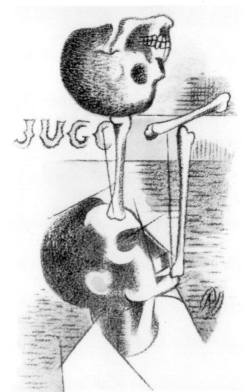

2 *And Juglers shewed
tricks with Skeletons,*
from *Urne Buriall,* 1932

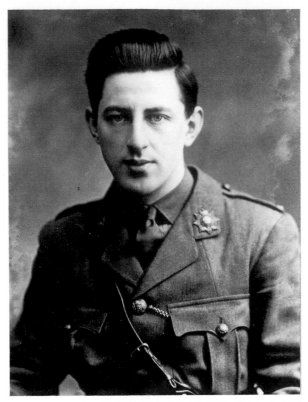

3 Paul Nash in uniform
1918

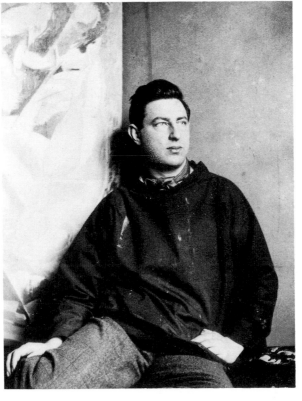

4 Paul Nash
photographed in 1920
by Lance Sieveking

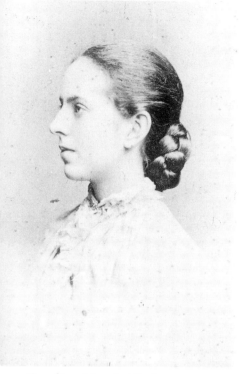

5 Caroline Maude Nash

6 William Harry Nash, drawn in 1913
by Paul Nash

7 Margaret Nash in 1912

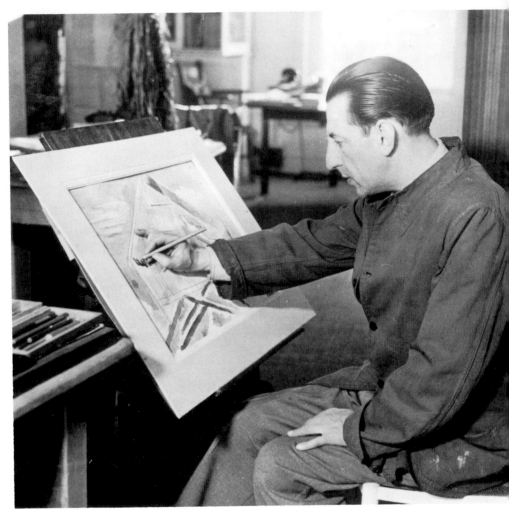

8 Paul Nash in his studio, 1940

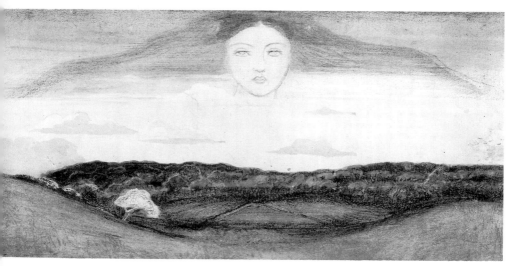

9 *Vision at Evening*, 1911

10 *Bird Garden*, 1911

11 *The Wanderer*, 1911

2 *Wittenham Clumps*, 1913

3 *Trees in Bird Garden*, 1913

14 *The Menin Road*, 1918–19

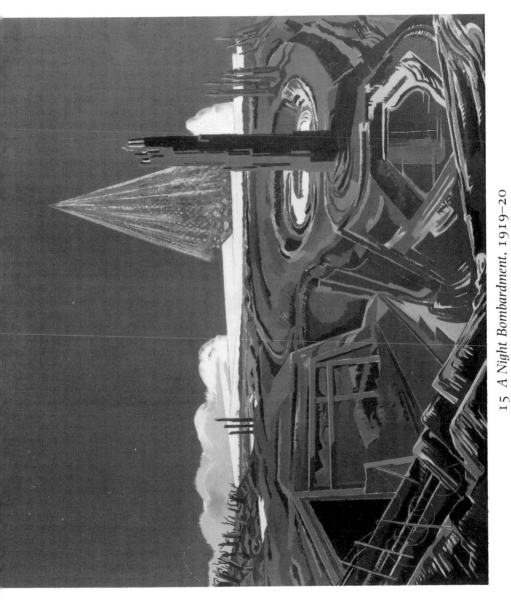

15 *A Night Bombardment*, 1919–20

16 *Danae*, 1917

17 *We are Making a New World*, 1918

18 *The Shore*, 1923

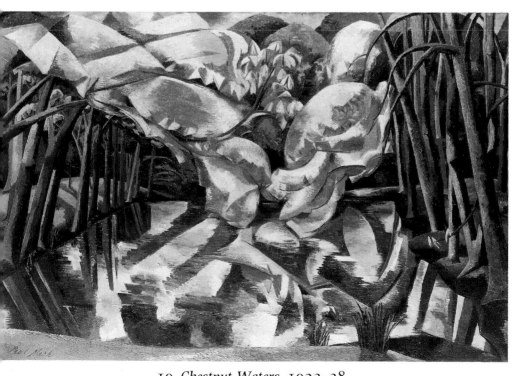

19 *Chestnut Waters*, 1923–38

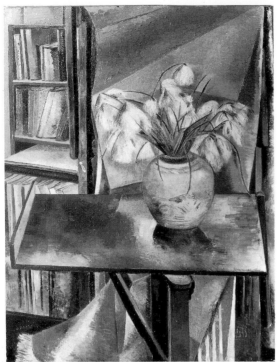

20 *Still Life*, 1927

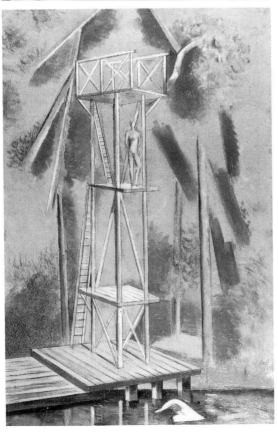

21 *Diving Stage*, 1928

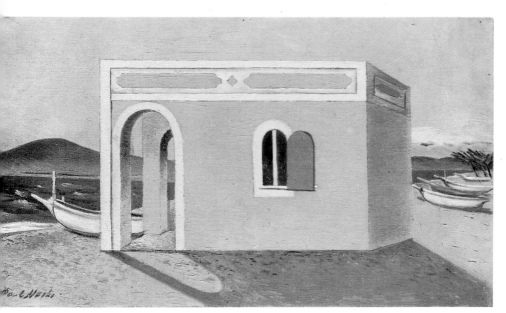

22 *Blue House on the Shore*, 1929

23 *Landscape at Iden*, 1929

24 *February, 1929*

25 *Nest of the Siren,*
1930

26 *Kinetic Feature*, 1931

27 *The Archer*, 1930

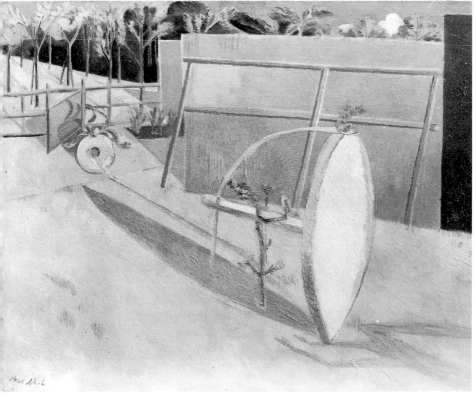

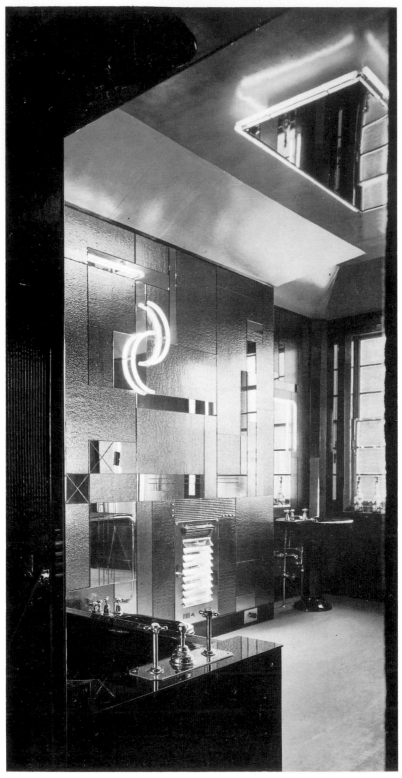

28 The bathroom commissioned by Edward James for Tilly Losch

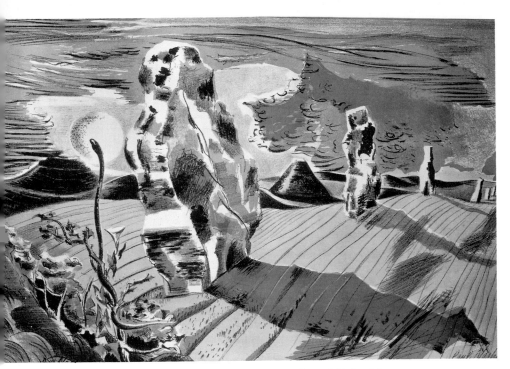

29 *Landscape of the Megaliths*, lithograph published in 1937

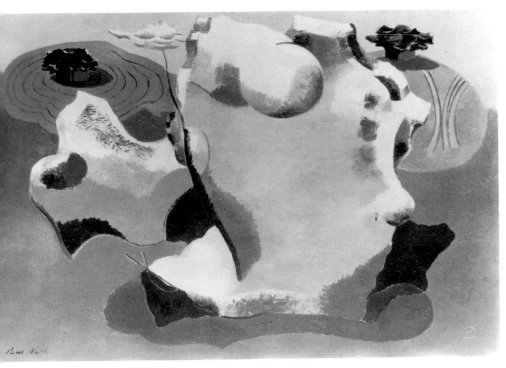

30 *Landscape of the Megaliths*, 1934

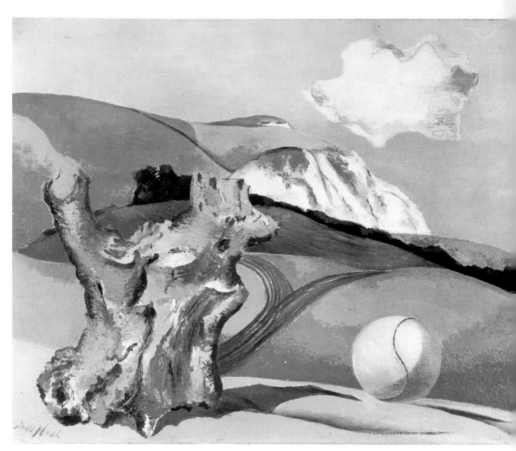

31 *Event on the Downs, 1934*

32 *Haunted Garden, c.* 1940

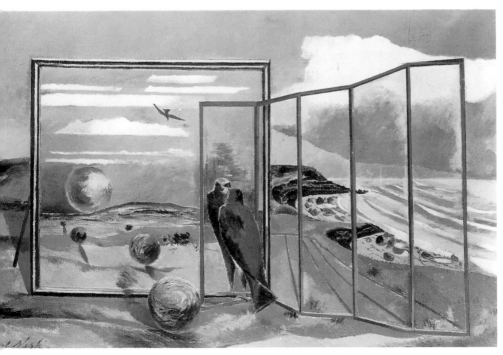

33 *Landscape from a Dream,* 1936–8

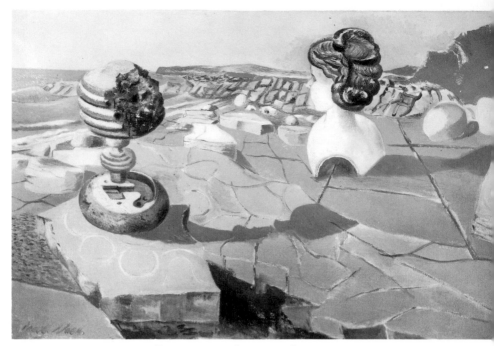

34 *Environment for Two Objects*, 1936

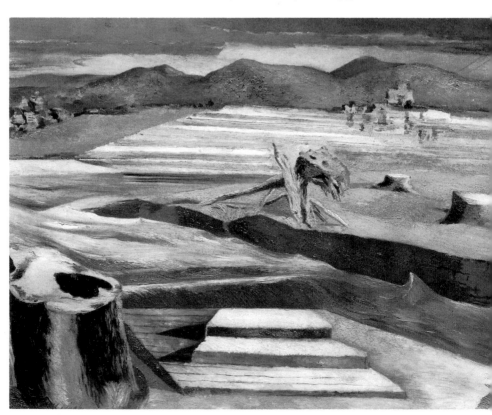

35 *Monster Shore*, 1939

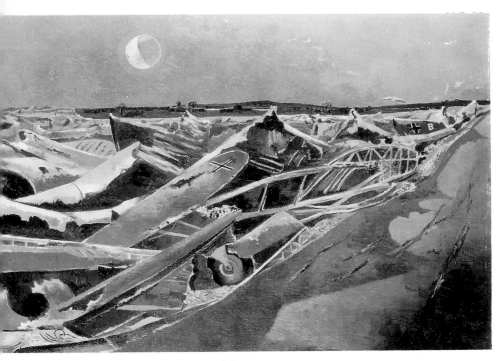

36 *Totes Meer*, 1940–1

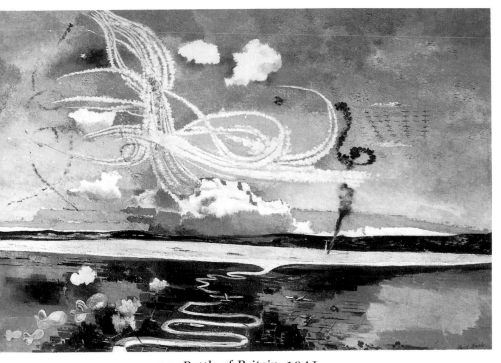

37 *Battle of Britain*, 1941

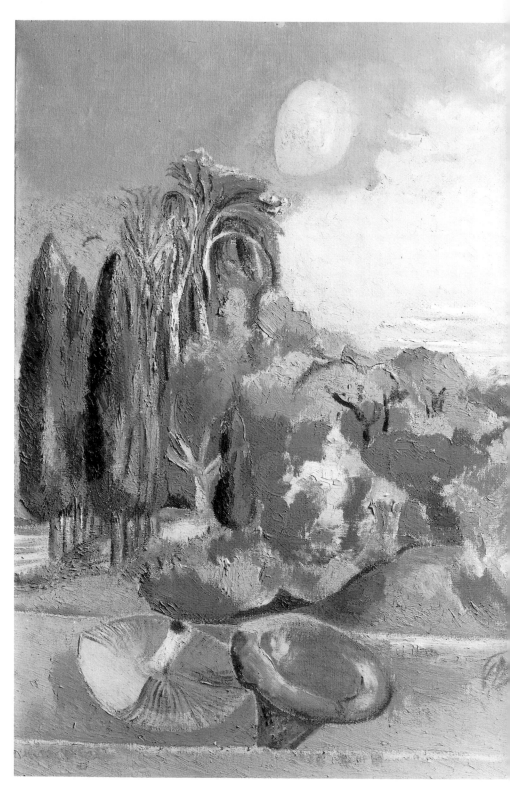

38 *November Moon*, 1942

39 *Sunflower and Sun*, 1942

40 *Landscape of the Vernal Equinox*, 1943

and three rather queer water colours in which figures of women come into the design'.[47]

One of the 'queer water colours', *Danae* (plate 16) has survived and another, *Quince*, has been destroyed, although a photograph of it remains. Both are interior scenes with women peering at men outside; ships can be seen in the background of each picture. Life is transitory the boats remind the viewer, the boats presumably taking men to battle where there is the strong possibility they will be killed.

Margaret described the interior of *Quince* as a depiction of her husband's lodgings at Clarence Square with its 'charming window in the sitting room, with its white lace curtains and exquisite Victorian wax flowers standing up under glass covers and silhouetted against the view of the port and the blue sea beyond'.[48] The title of this picture is obviously derived from the dish of fruit in the middle foreground (quince being a yellowish pear-shaped fruit used often as a preservative). The young woman, holding one of the quinces in her hand, who looks out of the window at the man in the bowler, is posed in a taut, rigid manner. She is afraid of the man – or, more properly, of her response to him. She is intrigued and yet frightened. The lady is fearful of sexuality or of betraying someone to whom she has committed herself.

Danae, the Argive princess, was locked in a tower to preserve her virginity, and the young lady in *Quince* seems to have placed herself in a self-appointed prison to accomplish the identical task. However, Nash's Danae is a very different type of woman from the girl in *Quince*. Her sexuality is burgeoning, as her posture and dress make clear. In contrast to the other woman, she fills the space given over to the interior. She longs to escape from the room and to be with the naked men she watches avidly in the middle picture area. Nash reinforces this with his depiction in the left foreground of the small dog dallying with the large phallic post. The lady in *Danae* desires to be penetrated sexually, whereas the young woman in *Quince* fears such a fate.

As he waited for the expedition to France, Nash obviously returned to some of his earliest preoccupations. He had depicted the female body in some of his early landscapes, and much of his early picture-making had been concerned with the conflict between the spiritual and the sensual. These two paintings obviously dramatized the continuance of such a division within him: should he be fearful

of his sexuality or should he embrace it wholeheartedly, perhaps promiscuously?

What is so amazing about these two pictures is that the treatment of sexuality is so direct. The Great War removed many of Nash's notions of a noble, high-minded society, and he no longer saw his own sexuality as part of a grand spiritual plan. He was never a coarse or vulgar person, but the experience of war, not surprisingly, destroyed much of his youthful idealism. He learned that human life was a cheap commodity, and he began to divide the sensual side of his nature from the spiritual. The unity of his early vision had been expunged – there was no blessed damosel and no return to Camelot.

Nash spent five weeks in France on his second tour of duty, having again narrowly escaped being sent to Mesopotamia. Most of November was devoted to drawing the immediate aftermath of Passchendaele; he then worked for the Canadian war records at Vimy for a week before returning to England on 7 December. His reaction to the events that confronted him on his second time out betray a deep weariness:

> Evil and the incarnate fiend alone can be master of this war, and no glimmer of God's hand is seen anywhere. Sunset and sunrise are blasphemous, they are mockeries to man, only the black rain out of the bruised and swollen clouds all through the bitter black of night is fit atmosphere in such a land. The rain drives on, the stinking mud becomes more evilly yellow, the shell holes fill up with green-white water, the roads and tracks are covered in inches of slime, the black dying trees ooze and sweat and the shells never cease.... It is unspeakable, godless, hopeless. I am no longer an artist interested and curious, I am a messenger who will bring back word from the men who are fighting to those who want the war to go on for ever.

Nash was afraid his message might be 'feeble' or 'inarticulate' since he hoped it would 'burn' the 'lousy souls' of the masters of war. His Tennysonian patriotism had been destroyed. When a shell dropped about ten yards away and splashed a drawing with mud, he was reminded of 'the old-fashioned Futurists'.[49]

General Headquarters at the Front tried to prevent Nash from going too far afield. Nevertheless, Nash evaded those orders. In his

notes he said, 'I begin my campaign. Difficulties of an infantry subaltern behaving like a Staff Captain. I evolve a technique. Eventually I get where I want to be.'[50] Nash's intimidation of his superiors led to some predictably perilous situations. The most dangerous occurred when his 'mad Irish chauffeur' took him on a sketching expedition along the Menin Road. He 'pilotted the car so skilfully, that he timed the constant shell bursts on the road, any of which might immediately have killed' both of them. Indeed, Nash was preoccupied with seeing more of the war than during his first tour, subjecting himself to far greater danger as an Official War Artist than he had as an infantry officer the year before.

Nash was overjoyed at obtaining a brief extension of his time at the Front. He facetiously told Masterman the consequences of losing his trusty, conniving driver: 'My excellent chauffeur is leaving, and my chef has been precipitated into the wind screen and messed up his mouth. With true spirit and the nice feeling of a faithful servant he only said, "How fortunate it wasn't you, sir!" I was much touched.'[51] Nash finally left France with 'fifty drawings of muddy places'[52] and was granted forty days of leave to work them up, although his leave was eventually extended for the remainder of the war.

He did not experience any difficulty, as he had expected, in telling his 'account' of the war, but he did face considerable trouble from the Ministry of Information, who wanted him to finance his own exhibition and to sell them his war paintings at a 40 per cent discount. As well, Nash was reminded by the Ministry that he had been taken out of the fighting line to make these pictures. Nash protested and managed to squeeze out a better price from Masterman's office. Nevertheless, he made only £10 from the Leicester Galleries exhibition. He did have his subaltern's pay, but he also had the extra expense of renting another flat in Judd Street as a studio. All of the extensive finishing work for the Leicester Galleries show was carried on in this top floor flat; he did not have a proper studio until he moved in the summer of 1918 to Chalfont St Peter.

There were fifty-two drawings and oils (his first efforts in the latter medium, into which he slipped comfortably) and seven lithographs in Nash's second war show. By any standard, it was an impressive exhibition. *Void*, *Sunrise*, *Inverness Copse*, and *A Night Bombardment*, to cite only a few examples, are terrifying renditions of the remnants

of mass devastation. The artist who a few years before had been afraid of colour now used it to render the tawdry nightmares that had confronted him. He depicted violence and its aftermath in a highly stylized, abstract manner, which owes a great deal to Vorticism and to Fry's doctrine of significant form. Man has unmade his world *We are Making a New World* (plate 17) proclaims. The ground's wave-like clumps seem pregnant, as if monstrous forms are about to be born. The rising sun, often a metaphor for hope and renewal, is here a hapless witness to desecration.

However, the great power of these Symbolist pictures comes from the fact that they are obverse representations of some of Nash's previous interests. In late 1917, he was horrified by the appearance of the French landscape which he had earlier realized had many points of congruence with the English locales which had previously obsessed him. His anger at the destruction of landscape led him to strike out with full force. Before, he had been concerned with clarity and mystery, and he brought the same forces to bear in rendering the void of war. He showed its actual destruction, but he reached beyond to examine the mysterious power of evil, which, for him, was a grim, unholy absence. This is the terrain he called up in his reworkings of the fifty muddy drawings.

Nash had escaped from hell and had survived to tell the story of his ordeal. Although he was not a satirist, his pictures are so successful in showing destruction that they look like caricatures of landscape, unreal remnants of an ungodly massacre. Nash saw before him deformed land, and this hurt him, for he had a deep, inbred love of the countryside. He narrated his tale of woe by inverting the pastoral world of his earlier career: his new-found power as an artist came to him in 1917 because he had the courage to realize that the old world he had known had been irrevocably destroyed.

A Night Bombardment (plate 15) and *The Menin Road* (plate 14) were painted after the Leicester Galleries show. Nash's pursuit of symbolical abstraction is evident in the former picture with its strong geometrical shapes, grotesque greens and magentas, and mud-filled mire out of which jut man-made tools of war and ravaged trees; in structural arrangement, this canvas is a reprise of *The Pyramids in the Sea*: the triangle in the right-hand corner of *Bombardment* corresponds to the earlier picture's pyramids, and the water-filled

Barrage, from *Images of War*, 1919

mire in the 1918–19 picture echoes the portrayal of the sea in the drawing from 1912. In *The Menin Road*, fourteen trees in various stages of destruction are the central characters in the middle ground. Nash had earlier been devoted to trees: they had been the 'people' in his early landscapes. In the raped trees of this new picture, Nash summoned up the world which had been the scene of enchantment and showed it brutalized beyond recognition. His world, and its symbols, had been redefined in the perilous new world of 1918.

The Menin Road was begun at Chalfont St Peter, where John and Christine Nash, newly married, had settled. Christine helped Paul and Margaret find a room in the home of a Belgian violinist. The Nashes lived a spartan existence there and eventually managed to make friends in the village. Then, they moved to another house. Margaret had a bad bout of influenza and could not remember any special joy on her part when the end of the war was announced. Nash felt fortunate to receive a commission for £150, a year's salary, for *The Menin Road*.

In her 'Memoir', Margaret cryptically ends her account of 1918: 'For personal reasons it became impossible for us to stay on in Chalfont St Peter after the war, and we decided to return to my flat

in London, which had been let during most of the period we were away, and find a studio in the neighbourhood.'[53] In his notes for *Outline*, Nash is more descriptive: 'We fly from Chalfont.'[54] Paul and Margaret left this place suddenly because Nash's life had been threatened by an outraged husband whose wife Nash had either propositioned or, much more likely, seduced. Margaret, who was outraged, told Paul that a friendly spirit voice had told her that this woman was his enemy and would eventually destroy him.[55] However, Nash was probably more concerned with physical violence than spiritual death when he fled to London.

When he returned to England, in late 1917, Nash's art had developed in such a way as to allow him to fuse his early pastoral vision with the forces of modernity. He saw and expressed the full horror of the Great War. In the process, however, his youthful idealism had been shattered and his innocence lost. He was now 'a war artist without a war'.[56]

—————•—————

Another Life, Another World

1919 – 21

IN JULY 1945, less than a year before Nash died, he told Bottomley
that, in the course of writing *Outline*:

> all sorts of queer things happened. I re-discovered my early life, how
> good it was & How complete in a way. When I came to look into the
> early drawings I lived again that wonderful hour. I could feel myself
> making those drawings – in some ways the best I ever did to this
> day. And because of this I suddenly saw the way to finish my 'life'....
> I feel I could make a complete thing by taking it up to 1914 – just
> up to the war. After that it was another life, another world....[1]

Outline, which he began in the mid 1930s, was thus a deliberately
unfinished autobiography. In re-reading his manuscript, Nash real-
ized that he had composed a record of the growth of his artistic
consciousness, with all its strengths and weaknesses.

After the First World War, Nash felt the need to experiment, to
lead a different kind of life. His involvement with the lady at Chalfont
St Peter began a pattern of short-lived affairs that continued well
into the thirties, when his health began to break down. As a younger
man, as we have seen, his sexuality had been carefully controlled,
almost regulated. His marriage to Margaret had fused early idealism
with sensual gratification. Nevertheless, from the outset he had

been wary of too much intimacy with her. During the war, he came to distrust the high-minded idealism to which he had been devoted. If 'Romance is dead', sex can take its place. Or so he thought. At some level, Nash's promiscuity obviously involved a search for a woman who could become everything to him, as Margaret had once been. However, since his feelings about women were unresolved, perhaps no relationship with a woman could become all-encompassing.

Margaret was deeply disturbed by her husband's behaviour, but she also realized that he had been under tremendous strain during the war. She did not approve of such conduct, but, to a large degree, she accepted it. Sometimes she would make a 'friend' of one of Paul's ladies and thus dissipate the relationship. On many other occasions she was simply patiently tolerant. Both husband and wife were part of a new breed of person thrown up in the early twenties. Willingly or unwillingly, they had to accept the fact that they lived in a society vastly different from the one into which they had been born.

Nash was at this time uncertain of the rules of art. Before the war, his work had preoccupied him, and this would be true of his subsequent existence. His energies were focused in his art, often to the exclusion of his wife and friends. His very identity was deeply intertwined in what he sketched or painted. Indeed, his work was not an escape from self but, rather, a pursuit of self. Like his ancestors, he was a hunter trying to snare prey, the prey being, in his case, his own psyche. He was relentless in his dedication, allowing it to absorb him almost completely. In the course of this pursuit, his personality changed markedly.

In a photograph of Nash in uniform taken in 1918 (plate 3), he stares intently but uneasily at the spectator, as if searching for approval. In all subsequent photographic portraits of the artist, he stares past the beholder; he is lost in thought, disdaining intimacy (plate 4). After the war, Nash appeared to be a sophisticated, sometimes austere person, often overly concerned with the advancement of his career. There is much truth in such a view of him – he became the mask he created for himself. This is evident in an exceptionally rare entity in the Nash canon: a self-portrait from 1922 called *Portrait of Proud Paul* (plate 1). Here, the precise, chiselled lines of the severely handsome profile are complemented by the sculpted hair and elegant smock. This is the public presentation of self.

However, the artist's own title for this unpublished wood engraving suggests self-mockery. Although he convincingly created the façade of pride, the man behind it was really unsure and vulnerable.

The public and the private were rigorously segregated by Nash. In conversation, as in many of his letters, he was wryly comic. Only occasionally did anger flash to the surface, as when he once told Tony Bertram about the three types of people who bought his work: collectors, enthusiasts, and 'two or three women with rich husbands who hold all the cash and loathe the sight of pictures so that their wretched wives have to buy my paintings out of the housekeeping money!'[2]

Superficially, Nash seemed little changed at the end of the war. He was discharged from the army on 13 February 1919, and remained, with Margaret, at Judd Street until July, when they went to Whiteleaf in the Chilterns, where John and Christine Nash had a small cottage. Also at Whiteleaf were Eric and Alice Daglish, whom the Nashes had met through Rupert Lee. Eric, a biologist, was an aspiring student of Nash's in woodcutting. The group at Whiteleaf was frequently joined by Barbara Nash, and there would be musical evenings consisting of arias from *The Beggar's Opera* and Elizabethan love songs. Paul had a pleasant, sweet singing voice and offered renditions of 'Blow Away the Morning Dew' and 'Deare if you change'. Frequently, he would withdraw from the group to paint or draw, and Alice Daglish recalled that the group once performed a 'rather tricky' piece which they thought they had done well by: 'At the end we looked up hopefully to our severest but kindest critic and asked him what he thought of it? "Well" he said, "I'd describe it as a pleasant din." '[3]

Whiteleaf also offered a special enticement: a view of the Wittenham Clumps. However, a significant new 'place' accidentally offered itself later that year. Through a friend, Harold Scott, the Nashes met Raymonde Collignon, the French *diseuse*, who was at this time collaborating with Ezra Pound in the revival of the music of the troubadours.[4] She invited them shortly afterwards to stay with her at Dymchurch-under-Wall, where Nash was immediately taken with the magnificent stretch of coast extending from Folkestone to Rye. Another attraction was the mysterious, almost insubstantial Romney Marsh in the distance. From this stay, a small

commission emerged, Nash being asked to design the cover for a book of Raymonde's songs. Through their new friend, the Nashes met Athene Seyler, Sybil and Russell Thorndike, Cathleen Nesbitt, and, most significantly, Grace and Lovat Fraser. The Frasers had been less than enthusiastic when they heard that the Nashes were staying at Dymchurch. They had been told that both husband and wife were difficult people. One afternoon, soon afterwards, the Frasers were walking along the sea wall lamenting the intrusion of such people into their retreat when they more or less bumped into the dangerous visitors. They immediately realized that their fears had been unfounded.

This new setting immediately unleashed Nash's imagination, giving him the much-needed opportunity to interpret a new location. His wounded, post-war spirit quickly responded to the conflict between the sea and the wall which protected the land from the water's invading force. The 'war' between land and sea also allowed him to transfer many of the technical advances made in his trench pictures into an English setting. Those earlier pictures are of French meadows and lanes irrevocably destroyed; at Dymchurch, Nash played out the same concerns: the mechanical, threatening waves advance to the wall, the man-made barrier protecting the landscape from erosion and destruction. As in *The Pyramids in the Sea*, the ocean represents destructive feminine wiles whereas the barrier is containing and masculine.

Nash had only a glimpse of the possibilities of Dymchurch in 1919; by November of that year he had rented Wyndham Tyron's studio at 9 Fitzroy Street in London, where he and Margaret also lived. Margaret's Judd Street flat was let on the theory that it was cheaper to rent a studio which could be lived in than to stay at Judd Street and rent a studio.

Fitzroy Street was Nash's base until February 1921, although he made many forays from it. In November 1919, he held a one-man show of his water-colours there, most of the thirty pictures on display being recapitulations of pre-war themes. *Wood Interior*, *The Pool*, and *The Corner* are similar in spirit to *Bird Garden* of 1911, where Nash directs the viewer to hidden, unseen forces. There were also some 'popular' works, of which *The Barley Field* is a good example, showing the artist's increasing technical skills. Nevertheless, it is only in *The Sea Wall*, *The Sands*, and *Night Tide* that the

new vision of Dymchurch emerges.

Indeed, even the first Dymchurch pictures are tentative and immature. In *The Sea Wall*, the two figures are upon a stage and look down into an orchestra pit filled with turbulent water; the viewer's perspective is from the sea itself. At the extreme right edge, a wave ascends far above the wall but falls back completely on itself. Surprisingly, the man and woman are curious, not frightened. The viewer confronts the sea directly in *Night Tide*, where the water rushes towards the foreground of the picture area. In the first Dymchurch pictures, the sea is a strong, majestic force, its destructiveness only faintly suggested.

In 1919 Nash was involved in an episode which was to dent his self-esteem. During that year (from April until November), he wrote fifteen reviews for the *New Witness*. With the exception of three pieces which appeared under his own name, he adopted the pseudonym of 'Robert Derriman' or 'R.D.'. In those articles, 'R.D.' emerges as a sophisticated critic anxious to be in the forefront of contemporary taste. He admires the School of Paris and is an advocate of 'significant form'; these advanced views appear in the evaluation of the Mansard Gallery's show at Heal's in August–September, organized by Osbert and Sacheverell Sitwell. Not as startling an exhibition as the first Post-Impressionist show, it was, rather, a show 'of quiet and subtle pictures':

> It would be difficult to say wherein lies the charm and power of these pictures, but I think an exquisite and subtle sensibility is their chief characteristic. Derain's nervous drawing, and his fine sense of form and value for tone, distinguishes him from the others. Picasso and Matisse, whose work is, perhaps, the best known, are both very considerable artists, extraordinarily free and masterly in their expression. Both are often wilful and strange in their experiments but hardly, if ever, touch where they do not create.[5]

In a review of Wyndham Tyron, 'R.D.' claims that he lacks a 'finer sense of formal significance'. This artist, nevertheless, continues to produce work 'where colour line and form contrive a most beautiful pattern'. 'R.D.' ends his commentary with a sigh of relief: 'On the whole a very interesting exhibition, and entirely free from cubist dyspepsia.'[6] In 'An English Ballet' (which appeared under his own

name), Nash suggested that a native 'spectacle' could be 'as arresting and amusing as anything shown by Dhiaghilev'.[7] He thought that Wyndham Lewis possessed the right qualities (presumably Vorticist) and then took a swipe at Bloomsbury: 'But Roger Fry now, and his friends, do you imagine them giving us an English Ballet? Perhaps – after Cézanne.'[8] In an important article 'R.D.' defended the 'National Necessity' of the artist to contribute to society (and society, in turn, to support the artist): 'we are entering an age of co-operation, and the artist must be asked to contribute to the plans of public buildings and better housing. The artist with his special feeling for form, colour and design is best qualified to add beauty to utility, and waken the public to the possibilities of their environment.'[9]

The theoretical posturing of these essays anticipates many of the practical solutions Nash would develop later in his career. In 1919, these were resolute words from an artist who in his own work was unsure of himself. He also used his sounding board at the *New Witness* to advance the cause of two artists who, he felt, were in danger of being overlooked in post-war England: John and Paul Nash. In his May 1919 review of the London Group show, 'R.D.' told his readers to pay heed to, among others, John Nash's watercolours and the large watercolour by Paul Nash. In his piece in the 1 August 1919 *New Witness*, 'R.D.' included a reproduction of John Nash's *English Woods*, and referred to Paul Nash as one of the 'professionals' exhibiting in the Eleventh London Salon of the Allied Artists. A month later, 'R.D.' devoted most of a column to a review of Lance Sieveking's *Dressing Gowns and Glue*, which contained drawings by John Nash and which was edited by Paul:

> The best of Mr Nash's drawings possess a persuasive extravagance more eloquent than any words.... Personally, I think the more discerning people should recognize ... the work of a genius. The whole book with its witty introductions, its intriguing verses and these astonishing illustrations is surely the best half-crown's worth on the market.[10]

On 17 October 1919, 'R.D.' praised Paul Nash's illustrations to two Beaumont Press books. The undoing of 'R.D.' occurred when he provided some 'Notes' on the artists in an issue of *Illustration*, the house journal of Sun Engraving Company; there, he was especially

complimentary to Paul Nash: 'His understanding of landscape, like that of his brother, is penetrating and large.'[11]

Frank Rutter, the critic and former director of the City Art Gallery in Leeds, was indignant when the names 'Robert Derriman' and Paul Nash were linked. Under the banner 'Artists as critics' in the 27 December 1919 issue of *Arts Gazette*, he expressed his disgust:

> But who is 'R.D.'? It might, on the face of it be Mr Raymond Drey, the critic of the *Westminster Gazette* but I happen to know it is not. On the other hand, I also know that Mr Nash has, most indiscreetly in my opinion, allowed himself to write under the pseudonym of 'Robert Derriman', and from information received as well as from internal evidence it would appear that the writer of the 'Notes on the artists' is one and the same with the writer of the foreword. Now if he chooses to do so I have not the slightest objection to Paul Nash writing about his brother and himself, but he really must do so as Paul Nash and not hide his identity under another name or misleading initials.... Mr Nash is a very clever and talented young man whose work I have often appreciated, but he must learn that there are some things one does not do. And this is one.[12]

According to Margaret Nash, Wyndham Lewis, a notorious troublemaker, had told Edward Wadsworth 'R.D.''s identity and Wadsworth subsequently made a scene at the Private View at the Fitzroy Street studio. She also claimed that this attack 'gave Paul such a shock to find that a perfectly innocent action [mentioning his pictures in an exhibition] could be so misinterpreted, that he determined at the time to give up all contact with art criticism'.[13] In any event, in the 17 January 1920 issue of *New Witness*, Nash made a frank admission of guilt and offered an apology.

Of course, Nash had been using Robert Derriman as a *persona* who could help launch the careers of Jack and himself. To an extent, the reviews had been pieces of self-publicity, his eye being on the main chance rather than deceit. He was a struggling artist who had seized upon an ingenious method of propaganda, and the incident reeks more of ambition than it does of chicanery. Nevertheless, Nash's conception of himself as a gentleman had been wounded, as he told Bottomley: 'If a man does something below his standard and below his friends' opinion of his standard I think he owes them at least an explanation.... It has quite seriously taught me a lesson ... in regard to myself, who I discovered to be far less reliable than

I had imagined.' Bottomley was sympathetic, feeling that Nash had made only a 'tactical mistake':[14] 'As you wrote nothing base or mean, injurious or treacherous, but only a plain statement which anybody might have signed, it doesn't matter what name you put to it – and no one will think it does when once the misrepresentation has died down.'[15]

His support over the 'R.D.' affair notwithstanding, Bottomley continued to be unsettled by Nash's pursuit of the modern. Rothenstein too had been disappointed by the Fitzroy Street show, as is obvious from Nash's comment to him on 26 December: 'Speaking of your perfected technique reminds me of what you say in your letter of the drawings . . . "if things are done away from nature, they should not have the appearance which work done directly from things seen inevitably shows."'[16] Nash went on to assure Rothenstein that almost the entire set of drawings were indeed done directly from nature, the exception to this being the two pictures, *Backwater* and *Red Night*, admired by Rothenstein and purchased by his brother, Charles Rutherston. Rothenstein's complaint had arisen from his conviction that Nash was abandoning his roots as a native English artist. Nash reported Rothenstein's reaction to Bottomley and then added his agreement about the meandering direction his work was taking: 'It is decidedly not hard, definite, in the take it or leave it sense of the word, or tightly enclosed.'[17]

Obviously, Nash was consciously moving towards 'impressionism' at the expense of the firm borders and clarity of English Romantic art. Nash ended his letter to Bottomley wistfully, and yet with a firm determination to be his own master: 'It is sad when old enthusiasts wag their beards & say dear, dear, the lad is turning out rather sadly. But I did feel on this occasion that I *knew* and Will had missed my message.'[18] Bottomley was amused by Nash's description of the Rothenstein imbroglio, but he supported Rothenstein: 'The Italian Futurists bore me: the French Post-Impressionists sometimes attract and sometimes aggravate me and always seem to me to have no concern with us (or message for us beyond one of general sincerity): I am a free-trader in politics and quite willing to let Germany sell me chemicals and France wines, but in art my Motter is "English for the English".'[19] Bottomley reminded Nash that modern art was an English impulse: 'Paul thinks he can more

quickly get to where he wants to be if he uses new traditions from France instead of old ones from Italy. And he won't; and he doesn't need to.'[20] Bottomley's advice, whether right or wrong, hit at the artistic dilemma confronting Nash in 1919: should he pursue his own vision or succumb to modernity?

If Nash's predilections turned him towards Bloomsbury in 1919, the enmity between him and Roger Fry, as we have seen, had assumed monumental proportions, which eliminated the possibility of personal contact with the group. Instead, Nash now briefly edged himself into the Sitwell circle, centred at Osbert's house in Carlyle Square. As John Pearson has suggested, 'In Mecklenburgh Square the conversation might be more penetrating, but with the Sitwells there was more variety, possibly more wit – and unquestionably the food was better.'[21] Two years earlier, Nash had defended Osbert and Sacheverell to Margaret:

> I do not agree that the Sitwells possess only surface feelings, I think they merely hide their emotions under their smart manners. Of course, I only know them slightly but should think both Osbert & Siche are poets & are sensitive & thoughtful – I dare say they would be the better for rough living & suffering, but I cannot think they deserve such down right condemnation.[22]

Despite his flirtation with Sitwell bohemianism, Nash confessed to Bottomley in December 1919 that he found 'no poet who has sprung since so good'[23] as Edward Thomas. Nash had obviously seen the Sitwells merely as a refuge from Bloomsbury.

At this time, Gordon Craig encouraged Nash to try stage design, and the earliest Dymchurch pictures show the 'stage-set' motif which was to become more and more an integral part of his oils and drawings. It was natural, therefore, that Nash, in response to Craig's prodding, agreed to design the sets and costumes for J. M. Barrie's *The Truth about the Russian Ballet*, which was a 'fantasy of mime, opera, and ballet produced by Gerald du Maurier with music by Arnold Bax, and choreography by Karsavina, who was also the first dancer'.[24] Nash's sympathies were, nevertheless, out of step with Barrie who was said to have been disconcerted by the set, which attempted to evoke 'one of the stately homes of England ... gone a little queer owing to the presence in the house of a disturbing visitor'.[25] The costumes effectively combine the hooped skirts of the

more conservative ballet companies of the time with the vivid, diagrammatic decorations used by Diaghilev.

There was a flurry of other projects in 1920. In April, Nash visited Leeds with Jack to collect material for mural paintings commissioned for the Town Hall, the scheme having been organized by Rothenstein on behalf of Sir Michael Sadler. In addition to the Nash brothers, Jacob Kramer, Albert Rutherston, Stanley Spencer, and Edward Wadsworth were involved, but the murals were never carried out. Later that year, in October, Nash began his first teaching job at an art school in Oxford run by Rutherston.

Earlier, in the summer of 1920, the Nashes were again at Dymchurch with further visits to Whiteleaf. They first visited Iden, near Rye in Sussex, when Bertram Buchanan, a retired colonel, and his wife invited them to their home, Oxenbridge Farm: 'This is an enchanting place – a more ideal farm I defy you to discover – of course we are all fearfully hot and collapsable except Bunty who dances about like a gnat.... There are calves and chicks and hens & cows and sheep and a cat & two kittens & two lovely ponds with pines and willows & poplars.'[26] The landscape at Iden would later become Paul Nash's Eden, but in 1920 it was simply a delightful inland retreat. At that time, the more turbulent encounter between sea and wall at Dymchurch still held his rapt attention.

In his most significant picture from this summer, *Coast Scene*, the human figures from *The Sea Wall* are placed at the extreme right. This canvas depicts the wall and the sea from an aerial perspective, the sea wall reaching out to the water as if it were seeking its energy in order to convert it into something human. The turbulence of the waves in contrast to the static wall is effectively portrayed, but the strongest, and most controlling, lines are given to the wall itself, which prevails over the ocean. In this picture, Nash is suggesting that the ocean, symbol of both annihilation and renewal, can be placed at the service of the human: the forces of death and destruction can be overcome. The wall displays man's controlling hand in opposition to the cruelties of nature, and the birds delight in the resultant freedom. Man may have to face death, but he does not have to accept annihilation. The Dymchurch pictures from 1923–5, such as *The Shore* (plate 18), are likewise calm and serene.

The Nashes spent the winter at Fitzroy Street, visiting Paris in February 1921. The following summer they briefly returned to

Whiteleaf, eventually renting 2 Rose Cottages at Dymchurch. Although they had now established some regularity to their rambling existence, they were, nevertheless, extremely restless.

As a young man, Nash had been intrigued by George Borrow's lush evocations of vagabond gypsy life. In the twenties, he became a bohemian who wandered from place to place. For him, a modern artist was obviously destined to rootless meandering. In reality, there was a forced quality to this travelling, almost as if to stay in one spot would prove fatal. The excitement of being on the road invigorated Nash, staying in one place diminished his energies.

When the Nashes had a semi-permanent home, tensions would quickly bubble to the surface. For, despite their somewhat languid exteriors, both husband and wife were highly strung. Margaret tried to divine the future from cards, tea leaves, and the ouija board. Sedentary occupations eventually would bore her, and she would look for adventure in her ordinary dealings with people she met. Since life was rather humdrum and little happened, she often embroidered her day's activities with excessively flamboyant accounts of what supposedly *did* happen. These flights of fancy were viewed, even by her friends, as compulsive lying. Nash would tolerantly put up with her stories for long stretches of time. Then, he would suddenly snap, and bitter quarrels would follow.

At this time Nash was unsure of what direction his work should take. There were exciting uses of symbolism in some of the 1919–20 pictures, but the visual expression had retrenched, having become resolutely old-fashioned as if Picasso and Matisse did not exist. The vigour and bite of the war pictures had seemingly deserted him.

In one of his cryptic lists, 'Old World Revisited', for the continuation of *Outline*, Nash referred to 'The Tragedy of Lovat'.[27] Margaret Nash in her 'Memoir' provided an extended description of Lovat Fraser's death on 18 June 1921:

> Lovat had hardly been at Dymchurch more than three weeks when he became dangerously ill, and it was obvious to us that he was in immediate danger and needed expert medical advice such as the local doctor could not offer him. His poor wife brought down a London specialist, and his London doctor, and Lovat was removed to a Nursing Home near Folkestone, where an immediate major

operation had to be performed. This resulted in his death within twenty-four hours.[28]

Although they had been friends for only a short time, Lovat's death was deeply felt by Nash. Superficially, they were quite different artists. Lovat's was an 'eager, instant, happy, laughing' imagination. He was over six feet tall and wore his hair long. Once, Enid Bagnold, exasperated at not being able to see his eyes, quipped: 'Lovat, do get some hair pins and be reasonable.'[29] Lovat's reputation, which was substantial at the time of his early demise, had been established in the theatre. Like Nash, he had designed a ballet (*Nursery Rhymes*) for Madame Karsavina, although his greatest success was *The Beggar's Opera*, which opened in June 1920. Despite his joviality, 'one was aware at times of a profound seriousness in the being that looked out of his eyes, which forbade prediction'. Lovat's laughing yet serious sensibility had obviously appealed to Nash: they were both men in whom the forces of whimsy and sadness moved freely.

Both Lovat and Nash were the sons of lawyers. After Charterhouse, Lovat had been dedicated to the law until his father saw the pointlessness of such a profession for a son enamoured of art. Lovat's experiences in the war did not alter his art: the intensity of the colourful, strident child-like designs of 1911–13 was retained in his post-war work. His had been an inherently theatrical imagination, and Gordon Craig conferred his *imprimatur* on him: 'he was one of those who loved the stage so much that he was giving up all else for it, only his death prevented him from giving still more and more to it.'[30] Regardless of their differences, Nash could not have failed to have been impressed by his friend's dedication to a particular course in art. In 1920, Lovat was single-mindedly pursuing his way in the world. He was not.

Lovat's death affected Nash profoundly because, just as his friend had recovered psychologically from the war and was well on his way to becoming an established artist, death intervened. Nash was confronted with the uneasy reflection that even if he found the 'correct' path for himself, he might be stymied in following it. Also, their virtually identical family background and age unbalanced him, the death of this promising young artist becoming, for him, a haunting reminder of his own death.

Nash accompanied Lovat's widow, Grace, to Buntingford, where Lovat's parents lived, in order to break the news of their son's death to them. Margaret later claimed that her husband 'conceived the design for ... *Chestnut Waters*',[31] one of his most lush canvases, during that visit. For Nash, his best art often came, as we have seen, directly out of the experience of death.

When Nash returned to London, Reginald Wilenski, the critic, lent him his Chelsea studio. However, Nash could not concentrate. The year 1921 became, as Margaret recalled, a 'fatal year'; Nash was unable 'to work in any kind of peace or with any clear vision'.[32] In September, the Nashes were visiting the Odehs at Hillingdon, and while there, Nash decided to visit his ailing father at Iver Heath. This is Margaret Nash's description of what happened:

> While on that visit he had a severe mental shock, as his father, who had been suffering from an attack of influenza, had a sudden attack during the afternoon, and Paul came into the room and saw him, as he thought, lying dead on the floor. The effect of this was to make him so ill himself that when he came back to me at Hillingdon, he suddenly became unconscious and remained in that state over a week.[33]

Nash's sketch of this event is, as usual, more summary: 'My father's illness. I go to Iver Heath and receive a shock. I get up in the night and fall down. Black out.'[34]

It is possible that a deep depression in the autumn of 1921 led him to assume that his sleeping father was dead. He had feared the worst and imagined that it had occurred. The world as he knew it was obviously coming apart. Shaken by Lovat's death, and in a time of profound personal doubt, his father's apparent death made him unable to bear more reality.

The Nashes claimed that Paul, in the face of the events at Iver Heath, had become unconscious for a week or more. According to Nash, Margaret took charge of the situation and defied five doctors. 'I am taken to London. Gordon Holmes. A week passes. I wake up again.'[35] Margaret's explanation is more detailed:

> My father summoned three ordinary practitioners and two specialists in the neighbourhood, and I felt, when I came to confer with these five doctors, that none of them realised the nature of Paul's illness.

I had found out from his sister what had happened during the afternoon at his home at Iver Heath, and so I took the matter into my own hands and decided that he ought to be taken to London and placed in the care of a Nerve Specialist. Various theories were held by the five doctors during the conference, one being that he was suffering from infantile paralysis, but I felt quite convinced that the whole history of the illness had its origin in this final shock following on the dreadful strain he had been through over the war and then over Lovat's death. We eventually found ourselves at the Queen Square Hospital for Nervous Diseases, and I was able to place the case in the capable hands of Mr Gordon Holmes. It did not take him very long to arrive at a simple explanation of the nature of Paul's illness, and he gave me instructions to sit by Paul day and night until he recovered consciousness, in order to reassure him, since he would find himself occupying a public ward, with screens round him, obviously a terrifying experience. In Mr Holmes' opinion the whole thing had come about as a result of a continuous series of frightening images presented to a highly imaginative mind, starting from the period of his work as a War Artist, and ending in the emotional shock of his father's illness.[36]

Margaret's story seems convincing: she provides a great deal of evidence to support her contention that Nash did not recover consciousness for a week and that Holmes had diagnosed the cause of the illness as the result of 'frightening images'.[37] However, Gordon Holmes's records, preserved at Queen Square, do not support her.

Upon returning from Iver Heath on Sunday, 24 August 1921, Nash felt feverish. He continued to feel listless and depressed for the next few days. On the evening of the twenty-ninth, he became restless, did not understand what was being said to him, and his face took on a 'set' appearance. During the night, he had severe convulsions which lasted ten minutes. It was under these circumstances that Margaret had her husband admitted to Queen Square on 31 August under Holmes's care. Nash was comatose arrival, but he regained consciousness later that night. On the following day, he was awake for long periods: 'By night patient answered a few questions in a loud slow voice. Complained of slight headache. Recognized his relatives.' Holmes eventually determined Nash was suffering from some form of meningitis (the admitting diagnosis was encephalitis). When he was discharged on 19 September, Holmes pronounced Nash 'cured'.[38]

The accounts provided by the Nashes are hopelessly at odds with the hospital records. Margaret's 'Memoir' was written after her husband's death, and the notes in *Outline* are from the late thirties, when Nash's asthmatic condition had worsened considerably. Although Margaret admitted that William Harry Nash's apparent death, Lovat's demise, and 'frightening images' contributed to her husband's breakdown, she later insisted that gassing in the war (of which there is no real evidence in Nash's case) was the key to an understanding of the events of 1921 and, indeed, of Nash's later debilitating bronchial asthma.

It may have been that there was a real fear on the part of husband and wife to admit that Nash's physical disabilities might have been psychologically induced, from causes post-1918. Instead, the Great War was blamed for Nash's various illnesses, and the discontents and tensions of the 1920s and 1930s were almost never taken into account. Nash's vulnerability to meningitis in 1921 may or may not have been furthered by artistic and personal dilemmas. However, his reluctance to tell the truth about this episode must have stemmed from an unwillingness to admit even to himself that he might have succumbed to pressures similar to those that had overcome his mother years earlier. In this regard, he must have feared, he was very much her son.

Despite all the setbacks he experienced, Nash made tremendous strides in his career in 1920–22. The Dymchurch pictures, as we have seen, transferred many of the strengths of the war pictures into an English setting. However, frequently in Nash's work, important advances are anticipated in book designs before being incorporated into oils and watercolours. This is particularly true of *Places* (1923), where the eight wood engravings of six locales (Buntingford, Iden, Wittersham, Iver Heath, Hampden, Whiteleaf) embrace both the landscapes of youthful innocence and of post-war experience. In *Meeting Place*, the female figure (the soul) must choose between the pond (salvation) and earthly delights (the male figure). The soul looks back at nature with some trepidation in the next illustration, but in *Garden Pond*, she arises and moves in the direction of the water. In *Dark Lake* (page 104) the lady has walked into the water, signifying her willing acceptance of annihilation. The grim, menacing 'grey teeth of an old fence look ghostly against dark waters'.[39]

Dark Lake, Iver Heath, from *Places*, 1923

Tailpiece. Iden, from *Places*

Yet, the soul accepts that the death of the self is a necessary condition for spiritual rebirth.

The last four illustrations present the same dilemma in a more overtly optimistic fashion. *Winter* is a depiction of the death of nature; the boughs of the trees are like 'steel' and a 'pallid gleam falls across metal spears'.[40] In *Path into the Woods*, the female figure contemplates her destiny – she must choose which path to take – and in *Winter Wood* she has made her decision. The final illustration (page 104) shows her at the moment of freedom (signified by the presence of the birds). A barrier separates the soul from the spectator, but it is not a menacing obstruction as in *Dark Lake*: the implication is that the spectator must make the same journey in order to experience liberation.

Nash tells the same story twice in *Places*: the truth of the self can only be found in an exploration of the worlds of death (engravings 1–4) and in the complementary search for the meaning beyond and above nature (engravings 5–8). *Places* confirms Nash's search for metaphysical art, and these wood engravings are competent but seem stylistically regressive when juxtaposed to some of the line blocks in Nash's first two books. *Moonrise* from *Loyalties* (1918) evokes Kandinsky's Murneau landscapes and both Kandinskian and Vorticist influences are pronounced in the 1919 *Images of War* (pages 71 and 87).

Places is a deliberate attempt to examine the past, a book in which Nash hearkens back to the world as it was before the Great War. The landscapes in the book indicate that Nash's idealism, though damaged, had not been completely eroded. As such, *Places* is a reaffirmation of an earlier commitment. In the 1920s, Paul Nash's task would be to find a technically accomplished way to accommodate his landscapes – his representations of a visionary world – to the demands of contemporary art.

Searching

1922 – 29

NASH'S DYMCHURCH OILS and watercolours were more self-
consciously theatrical than his earlier pictures, and there was
therefore a certain appropriateness in his decision, when he was
told by Gordon Holmes to 'avoid'[1] work, to build theatre models. He
designed sets for two plays by Bottomley, and he also began writing
to Gordon Craig, who did not feel, however, that Nash was spiri-
tually akin, the way Lovat Fraser was, to that world.[2] Most of Nash's
book illustrations over the next five years (*Mr Bosphorus and the
Muses, A Midsommer Night's Dreame* (page 129), *King Lear, Wagner's
Ring*) were taken from dramatic material and even his illustrations
to *Genesis* (page 129) look like stage backdrops, even though,
characteristically for Nash, no actors, human or divine, are present.

Bottomley and Nash continued to argue about the place of an
English artist in the contemporary world: did such a person retain
his vision or did he attempt to embrace a more universal conception
of art? Bottomley knew that Nash fundamentally disagreed with
him about how to keep his Englishness intact, and in July 1922 he
spoke of Stanley Spencer with approval:

> ... what an active little volcano he is, an amazing little fellow, and
> a painter after my heart. He has an amusing thing of the Last

Judgment, with people pushing up the grass to get out of their graves. I feel he is not always secure yet in the realization of his textures, and not always able to keep his conceptions ripening long enough before he fixes them; but if he goes on he should be one of our greatest English painters.[3]

Nash was hurt by the heavy-handed taunt in Bottomley's letter, and he implied that his disdain for Spencer was more informed than Bottomley's simple-minded admiration: 'I am afraid I am a little unsympathetic about S Spencer. I used to admire him inordinately & believed him to be the real thing with all the right inheritance of the fine qualities of the mighty & something perfectly his own which caught one by a strange enchantment.' His now more educated sensibility penetrated further than his old master's, he was telling Bottomley, who retorted with a detailed evaluation of some Spencer paintings, which began: 'P-p-p-p-p-p-p-paul, we don't agree about Spencer (Stanley)! The little volcano is capable of amazing things, and in my opinion is getting better.'[4] Bottomley might have been implying that Nash was getting worse. Nash, now more angry than hurt, rejoined sarcastically: 'As to S. Spencer we don't *quite* agree but I have a great respect for the "little volcano" & used to pin my faith to him but it would have been better for him and us if he hadn't been born behind his time – what a stunning Pre Raphaelite he'd have made. I can just picture him in the Rossetti circle!'[5]

This letter clearly shows that Nash now disdained Rossetti; however, he was not willing to commit himself to Cubism in which Bottomley wrongly suspected he had an undue interest. Earlier, Bottomley had told Nash that it would be 'an appropriate end for a real Cubist to be ... transformed into a two-dimensional being; indeed, it would serve any Frenchman right just now, for their national mind has only two dimensions – length and thickness without breadth'.[6]

As early as 1919, Bottomley had wanted to introduce Nash to his collector friend, Percy Withers, a medical doctor who because of illness had retired early from practice. By 1920, Withers' life was centred on the lectures he gave on English literature for the Oxford Extra-Mural Delegacy. Like Bottomley, he was a fervent Georgian, and many distinguished Georgian artists and writers, including F. L.

Griggs and A. E. Housman, visited him and his family at Souldern Court near Banbury.

Nash did not actually meet Withers until May 1922. He described his first stay at Souldern as 'jolly'[7], but he often found Withers pompous and pernickety. Nevertheless, Withers could be kindly and generous, and both Nash and Bottomley recognized this, even though they facetiously referred to him as the 'Mutual' (Our Mutual Friend). Withers was one of the first of Nash's patrons, subsequently commissioning a number of pictures.

Earlier, Eddie Marsh introduced Nash in 1921 to T. E. Lawrence, who was much taken with *Coast Scene*, which he saw at the Rowley Gallery. The painting kept 'recalling itself' to him 'in regurgitated waves'.[8] He told Nash, 'I want it: very much.' However, Lawrence was short of funds, and he asked if he might pay the total cost (£150) of the picture over a period of two months. Nash readily agreed to this, and Lawrence was delighted: 'I'm very glad you agree to sell the Ocean in bits.'[9]

Lawrence hung the picture in his room at the Colonial Office, hoping that *Coast Scene* would disgust or profoundly alter the sensibilities of his soulless office mates. A year later, in August 1922, he told Nash: 'If you are full of work and money don't bother to read further – but if you are not, I'm going to suggest much of the first and little of the second, to be gained in a quite dishonourable way: – drawing from photographs.'[10] Lawrence was referring to the illustrations for the subscribers' edition of *Seven Pillars of Wisdom*, which Jonathan Cape published in 1926. Despite his reservations about working from photographs of landscapes he had never seen, Nash made eight illustrations for Lawrence, only five of which were actually used in the book. In September 1922 he told Bottomley: 'I think it's going to be great fun – what a place! Petra the city of the Dead! O what a dream!'[11]

In his letter broaching the topic, Lawrence had touched a crucial matter: 'I only venture to write because I know that once you were not well off.' Nash was indeed never 'well off'. He lived as a gentleman, but his financial situation was often deeply troubled. Such difficulties were briefly surmounted at Christmas 1922 when Paul, Margaret, and their friend, Claude Miller, visited Paris, where they stayed at the Hôtel Voltaire, near the Pont Royal. Margaret claimed that they spent 'no time on this visit looking at modern

pictures, but studied the treasures of the Louvre'.[12] At this time, however, Nash was still resolutely under the sway of English landscape, and in May 1923 he provided Withers with an evocative description of the beauties of Dymchurch: 'The Marsh and this stange coast. The forms with their black magenta and orange colourings. The ancient Marsh churches. The lovely wooded canal under the hills and the hills themselves overlooking a land so fair and fantastic.'[13]

After arriving back from France, the Nashes moved from Rose Cottages to the very small Pantile Cottage, near the Church on the road from Hythe to Lydd. In *The Edge of the Marsh* (1925), Nash depicted this setting: 'The wall of the cottage that faced the road was blank, but from a side window of the bedroom one had a fascinating view of the rolling Marsh.'[14] However, by this time Nash was getting tired of the social whirl of transplanted Londoners who gravitated to his Kentish retreat: 'Poor Dym is swamped not with water but with people. O what people, I almost wish the sea would come over the Wall & drown the whole bloody lot.'[15] Nash did occasionally get away to Souldern Court, but Gordon Bottomley became 'grumpy' when he learned that Paul in 1923 had visited there without telling him: 'When I had worked so long and ingeniously and enthusiastically and devotedly and in spite of rebuffs to get you ensconced safely and profitably in the mansion of Our Mutual Friend, I did think you might have told me when I had pulled it off instead of leaving me to learn it casually from an outsider.'[16]

Being 'ensconced safely' with Percy Withers was no easy matter, however. In 1930, Nash regaled Bottomley with this anecdote:

Percy was being particularly irritating & I became sharply argumentative. Apparently I frightened P for he started back exclaiming, 'Don't get so warm! wh wh wh why yoooooooo'r eye positively flashed! Then!' Poor old Percy – you know, I like him. He has an awful fascination for me. But I can't keep up with him. I can't go there more than one quarter the times he seems to want me. But does he? Isn't all that extravagant protestation a habit?[17]

Nash was initially elated when Withers commissioned him to make four watercolours of his house and the nearby village. 'I have never been given a commission by a private individual before.'[18] Not

unexpectedly, this particular patron objected vehemently to liberties Nash took with the chosen subjects, and Nash responded stiffly on 25 July 1923: 'I cannot offer to help you over the church difficulty. So I saw it, so it must remain – at least until I can see it again when I promise you I will seriously reconsider its appearance. There was at the moment of vision a pale glow distinctly warm amid those trees, that was what interested me.... My emphasis ... was ... instinctive.'[19]

Nash's clinging to an 'instinctive' view was probably abated by the visit of Ben and Winifred Nicholson to Dymchurch in the spring or summer of 1923. Nicholson's atmospheric, geometric reaction to the sea at Dymchurch obviously reminded Nash that each artist must cling to his own perceptions, idiosyncratic as these may seem to others. Nicholson's art was considerably more influenced by continental sources than Nash's in 1923, and it is a measure not only of Nash's loyalty to his Slade friend but also of his increasing capacity to respond to contemporary trends that he wrote enthusiastically to both Eddie Marsh and John Drinkwater to recommend the Nicholsons' joint show at Paterson's Gallery in Bond Street in May 1923: 'I really think their works enchanting and simply full of promises & already some achievements of peculiar beauty. In colour alone the paintings are something fresh and original.'[20] Nash himself was beginning to become more concerned with painterly, somewhat Cézannesque, skills in the use of brush strokes, colour values, and simple, organic form.

Those skills were soon evident. Indeed, Nash's canvases in his Leicester Galleries show in May 1924 (planned since 1921) display a consistent realized achievement in technical virtuosity. *Towards Stone* may not be remarkable in its subject matter, but the handling of composition, particularly in the form of exchanges between middle landscape and the sky, is masterful. Nash also experimented in these pictures with depictions of living or active forms (waves, flowers, the human face) in contrast to more rigid forms (the shore, vases, rooms, trees). In these pictures, as Anthony Bertram claimed, Nash

> renounced all traces of romanticism and became the most classical, by which I mean architectural, of our painters. Now he puts himself outside Nature and considers her objectively. He perceives something

of her cosmic order, and in every picture of his maturer style he attempts to express that order in little, to make his pictures, therefore, not the expression of a mood of Nature, nor of a particular aspect, but of the whole, structural rhythm.... His mannerisms have fallen away ... his vision itself has become simplified and individualized; it automatically disregards the inessential.... He is ... testing the possibilities of abstract painting.[21]

These acute observations are borne out by the beautifully balanced contrast between the steps themselves and the upright blocks in *Dymchurch Steps*: the blocks are geometrical, but they are also presences participating in the action of the picture. *The Lake* (1923), the first version of *Chestnut Waters* (plate 19), the single most important painting in the show, may have been indebted to Edward Wadsworth's *Pool with Trees and Punt* (1913) or Duncan Grant's *Venus and Adonis* of c. 1919, but Nash's picture successfully balances the recumbent female nude (for which Ruth Clark posed – characteristically, Nash removed the human figure from the final version) against the pond, and the precisely articulated tree branches against the chestnut-laden boughs.

Although Nash's 1924 exhibition was a commercial success and amply showed the technical advances he had made, the pictures as a whole display a timidity in the handling of subject matter. In contrast, the illustrations to *Genesis* (1924) are consistently avant-garde. In *Division of the Light from the Darkness*, Nash builds up the heavy, dark forms against the intrusive appearance of light in an abstract manner. He is not concerned with anecdotal narration; he simply demarcates the vertical forms from horizontal ones and is content to show the opposition of the forces in line and colour.

Nash's previous work on theatre sets is evident in the *Genesis* illustrations, design work beginning to occupy more and more of his time. He became interested in textile designs through Lovat Fraser's influence and exhibited three such patterns in the Friday Club exhibition held in Heal's Mansard Gallery in 1921, but none of these was taken up by a firm. His designs were evidently not 'futuristic' enough. In 1925, however, Mrs Eric Kennington, who owned 'Footprints', a textile shop where fabrics were printed by being walked over the blocks, used 'Cherry Orchard'; from 1925 to 1929 she employed four of his designs. These patterns were marketed by 'Modern Textiles' in Beauchamp Place, which was opened

in 1926 by Elspeth Anne Little. Nash would in the future design fabric patterns (Cresta Silks), china and earthenware (Foley – some for Clarice Cliff's 'Bizarre' wares), glass (Stuart Crystal), posters (London Transport, Imperial Airways) and rugs (Edinburgh Weavers).

His most successful commercial association was with Shell-Mex, for whom he designed three lorry posters. Jack Beddington, who had served as a management trainee for that firm in Shanghai, became Advertising Manager in London in 1932. Constitutionally opposed to dullness, he sought wit and flair by merging con-temporary art with advertising. Although advertisements had been carried on the sides of lorries since 1920, he brought more dash to the series because he was inspired in his choice of artists. Thus, he linked Shell's name to the pleasures of modern design. Obviously, this venture was educational, provided much-needed publicity for both well-known and obscure artists, and was an effective way of striking out against the proliferation of country hoardings. As the art historian Kenneth Clark said, Shell was 'all that a patron should be ... they [made] it possible for an artist's work to be enjoyed by a very large number of people'. Nash was among the better-known painters invited to launch Beddington's imaginative, later legend-ary, scheme; the first Graham Sutherland to capture wide attention was a poster for Beddington. In the *Listener* of 20 January 1932, Nash applauded the directions in which Shell and Beddington had moved modern advertising:

> whereas most firms continue to bore us with catchwords and funny pictures, Shell appears to be more intelligent. Not only does it com-mission a comprehensive series of posters by the best-known modern artists, but the entire publication of its booklets ... is put into the hands of experts in typography and design. Mr Beddington, who so ably controls and directs these operations, would explain that all this is done for the better advertisement of Shell, but we have only to observe the thoroughness and distinction of his productions to realise that – consciously or unconsciously – he is discharging an aesthetic responsibility to the public.[22]

However, Nash had mixed feelings about such projects. On the one hand, they were bread-and-butter jobs which helped to finance his frequently non-lucrative career as an artist, and as such, these

ventures were a nuisance. On the other hand, he developed, particularly in the thirties, a decided commitment to the ideal of the artist as the harbinger of modernity, as the person who gives a taste for the contemporary. In this capacity, he came to see design work as a way of promulgating this dedication. If the public began to purchase objects of superior modern design for their homes, an audience for the best contemporary art would be fostered. For Nash, this was the crucial link between the applied and fine arts.

In the autumn of 1924, Nash began work on a new book project, an illustrated *Pilgrim's Progress*. With the consent of the prospective publisher, Stanley Morison, Nash requested a preface from Bernard Shaw, who did not look favourably on such a collaboration: 'This is one of the things that cannot be done. My prefaces are practically books. They take months to write and see through the press, and contain at least 30,000 words. I have to keep them up to this standard, as they command a large circulation. I can no more issue a little preface than the Rolls Royce people can issue a perambulator.'[23] Nash replied by telling Shaw that he had not realized the vast chasm separating a preface and an introduction, which was what he presumably wanted. He told Shaw: 'Mr Stanley Morison has authorized me to say he wants your preface at all costs, nothing can be too formidable, it can be twice as long as the Pilgrim's Progress if you like.'[24] Nash then went on to say: 'I may as well add that my own motives in asking you to write are almost entirely idealistic – apart from the fact that should you accept, I shall get a cheque down on account instead of waiting for royalties.'[25] Such pluck incensed Shaw:

> I must put it to you bluntly. Mr Morison or any other publisher will publish a book by me if you can procure it for him, and will give you, by way of commission, a little cheque in advance, and a few pages at the end of the volume for any stuff, graphic or literary, that you may want to see in print (quality no object) with your name on the title page thrown in under the shadow of mine.... The only dignified course for you is to tell Mr Morison that what you are proposing is a book by yourself and not by anyone else, and that if he wishes to publish an essay on Bunyan by me, illustrated by you, he can approach me directly.[26]

Shaw then announced that he would only consider such a venture if there was a 'sufficient fee': 'As it would have to run to at least four figures I do not see how he could make it pay; but this is his affair. Now do you understand – bless your innocence!'[27] Nash, by now irritated, replied by thanking Bernard Shaw for his 'charming letter': 'I am afraid that you have taken my last letter rather more seriously than I intended and my frivolous reference to the cheque on account has sent you in the wrong direction.'[28] Nash then described the plans for the book in detail, asserting that the project was his venture and that Shaw's collaboration was 'an inspiration after the book had been undertaken by the publishers'.[29] He even reassured Shaw about the soundness of the project and of the obscure artist who had approached him:

> I have concluded perhaps erroneously from reading the first part of your letter that you had never heard of my name until the other day and that you are unfamiliar with my work. So I am taking the liberty of sending you the book [Genesis] to look at as I think it contains my best engravings on wood and some of my best designs. It was published in a very limited edition and quickly sold out so it is probable you may not have seen it.[30]

Nash's cockiness did not sit well with Shaw:

> Frightful nonsense! The seeds and the waters, and perhaps a ray or two of the light, are quite good jokes, but the rest! — —
>
> I hope you don't really deceive yourself, or imagine that you can bluff me into believing that such tom-foolery is better than Michael Angelo's version on the Sistine ceiling. I am much too old a bird to be taken in.
>
> Robert Louis Stevenson, an amateur, did this sort of wood cutting much better.
>
> Get out.[31]

Now thoroughly provoked, Nash sent Shaw a wire: 'Thanks for book. Now I know. Stevenson unfortunate example. Didn't engrave.'[32] Years later, in the thirties, Nash had a dream which he asked Conrad Aiken, the American poet, to interpret:

'I was walking up a steep hill to G. B. Shaw's house and saw several hideous old women, all naked, one with her derriere marked off in squares like a preliminary sketch. Only Shaw's pretty secretary was clothed. Now what do you make of that, Dr Freud?' 'Too complicated and abridged as you tell it', Conrad said stiffly. 'But I'll hazard a guess. The climb to Shaw's house might symbolize intellectual inferiority, the nude and unattractive old women suggest suppressed sensuality, while the fully clothed secretary could be the unattainable object of desire. Well, you asked for it', [he said as Paul winced]. 'I happen to agree with Freud that dreams are the most important clues to the unconscious.'[33]

The quarrel with Shaw had obviously left its mark on Nash, who quickly abandoned the Bunyan scheme. When the Nashes were desperately short of money in 1928, Margaret suggested that they sell the Shaw letters, but her husband rejected such a scheme: 'perhaps a good idea but hadn't we better wait till the old dear dies?'[34]

On 1 September 1924, Nash was appointed an assistant in the School of Design of the Royal College of Art, where he remained until July 1925. The decision to hire Nash was taken by Rothenstein, the college's newly-appointed head, who, with considerable difficulty, persuaded his Board to employ artists on a part-time basis. Rothenstein, a great admirer of Nash for many years, was in the process of transforming the RCA from an institution which produced only designers and teachers of art into a fully-fledged art school. The acquisition of people like Nash was an important part of Rothenstein's reform.

Robert Anning Bell, the professor of design just before Nash arrived, had been a forbidding character, very much in the mould of Tonks, although his successor, E. W. Tristram, was more accessible: 'He was a medievalist, devoted to the task of discovering, recording & restoring early church murals.'[35] Edward Bawden has recalled that Nash appeared at

the right moment, &, what is more, he came into the Design School, the habitat of the lowest of the low. The Royal College of Art in the early twenties was smaller than the smallest Provincial School today; it was divided into four schools, Painting, Sculpture, Engraving, Design & accordingly the first three ranked as Fine Art & the last as

Applied Art. This distinction, absurd though it is, is still maintained today by dealers for commercial reasons, but then it was as real as being a child of acknowledged parentage or being an orphan, the offspring of a gentleman & a whore. As a designer I felt it keenly.[36]

Into this dispirited encampment Rothenstein introduced a mysterious stranger, who silently examined the work of each student and then left before being introduced. However, the new teacher's identity was soon guessed.

Nash's best students were undoubtedly Eric Ravilious and Edward Bawden. Bawden had vivid recollections of Nash as a teacher. He

talked to each of us individually in the manner of two artists exchanging their personal experiences. There was no artificial barrier, no talking down as between God and man, teacher & the one who was being taught. Nash brought into the dingy mustiness of the room a draught of fresh air. He spoke of Samuel Palmer, of Lovat Fraser, the Curwen Press, the processes of graphic reproduction & so forth; he looked at work most carefully seeking to discover our thoughts, what we were trying to do & never, never did he impose his own point of view ... he possessed natural dignity & did not belittle any student by using easy sarcasm. To myself he showed friendliness: we exchanged work, for wallpaper designs he gave me wood engravings & allowed me to choose them.[37]

Characteristically, Nash dismissed his work at the RCA: 'I have a huge studio and an official desk with a tin box for letters and lots of buff envelopes and a tray with 14 pens. I tell you I'm the Hell of a nut.'[38] Despite bouts of slapdash self-depreciation, Nash extended the vision of his students, encouraging them to read Homer, Dante, Borrow and Yeats. He was also generous to Bawden and Ravilious, suggesting to the latter that he extend his flair for wood-engraving, and introducing him to likely publishers of illustrated books.

Another young person with whom Nash was much involved at this time was Audrey Withers. At their first meeting in 1922, Percy Withers had mentioned the keen interest in art he shared with his nineteen-year-old daughter, who was then away at boarding school, and whom Paul did not meet until the following year. Audrey, soon to go up to Oxford to St Hilda's (and later editor of *Vogue*), became

infatuated with Nash soon after she was introduced to him. Margaret noticed this disturbing trend and warned her husband about the dangers involved in turning a young lady's head. Although he did write her a number of provocative letters, he decided not to pursue Audrey:

I'm not really avuncular or paternal, but you are rather like a very young animal all over the place, kicking up your heels and scampering round in circles, it's charming to watch you and very tempting to run after you but I feel it's my place to sit on a wall and say woa! steady! – from time to time at least, especially when your dear Mother's expression rises to my mind! but I'll join in the chase on occasions – in the future, when they're the *right* occasions.[39]

Despite her husband's pledge to leave Audrey alone, Margaret, when she accompanied him to Souldern Court, found it difficult to contain her jealousy.

Once, in an attempt to find employment for Margaret which would allow them to augment subtly the Nashes' slender income, the Withers asked her to make a dress for Audrey. Margaret agreed and an expensive pink fabric was ordered from Liberty's. When the parcel arrived, Margaret announced that the 'wrong' side of the print was the more attractive and insisted on making the dress with that side showing. Dismayed, but out of politeness, Audrey dutifully allowed Margaret to measure her and, later, tried the dress on in the presence of her parents and the Nashes. However, she threw the dress away, with her parents' permission, immediately afterwards.

Despite her fascination with Paul, Audrey was often irritated with his perfunctory treatment of her parents. In particular, she suspected that Nash disliked her father and only accepted invitations to Souldern because of the free meals and congenial landscape. He would simply appear for lunch and dinner and then vanish soon afterwards. If the maid was tardy in serving a meal, Nash would often pick up a sketch book and draw until the food was placed on the table.

A small incident confirmed what she had previously thought might be ungenerous fantasies. Percy liked to read aloud to his company, but he liked his guests to coax him to perform. Audrey, sensitive to her father's feelings in this matter, went out into the garden one evening to ask Paul to make this request of Percy. When

she approached Paul and told him what she wanted, he immediately said he would do what she wished, but the wincing tone in his voice and the sneer on his face betrayed the contempt he felt for her father. Her eyes were filled with tears as she returned to the drawing room.[40]

A strange incident occurred during the winter of 1924. In December that year Paul and Margaret went to Paris, again staying at the Hôtel Voltaire, and then travelled to Cros de Cagnes, three miles from Nice. Lance Sieveking had recommended the Pension de la Plage, where the Nashes stayed for almost three months. At the Gare de Lyons, as they were about to leave for the Riviera, the Nashes encountered Ford Madox Ford, in the company of an attractive blonde, at the brasserie. (The Nashes had met Ford in 1922 or 1923 when he stayed with them at Dymchurch when Paul was illustrating *Mr Bosphorus and the Muses*.) Later that evening, just as Paul and Margaret were about to enter their carriage, Ford, as Margaret recalled, 'rushed along the platform and threw a bunch of keys at Paul, explaining that the little blonde lady, to whom he had introduced us, had to go into the train much higher up and had left the keys of her suitcase with him by mistake.' He asked Nash to take the keys and told him that he would write to the lady and put her in touch with the Nashes.

In fact, the lady was staying at Cros de Cagnes, the only room she could find, she claimed – somewhat dubiously – being in a bordello. A great deal of consternation was expressed at the Pension de la Plage a few days later when the lady arrived to retrieve her keys. The proprietress was aghast that Nash had the keys of such a woman in his keeping and assumed she was his mistress. She was flummoxed when Margaret calmly announced that she must have the woman's address in order to invite her to dinner. The proprietor, obviously more worldly-wise than his wife, sighed: 'Ah, les Anglais, what diplomats they are.'[41]

Nash called the blonde lady 'The Ghost', as she never 'seemed to have any real existence, and indeed had a very pathetic and eventful history'.[42] Margaret, who does not give the lady's name, provides an extremely romantic pedigree for her: she was an English woman, a would-be novelist married to a deserter from the French Foreign Legion, whom Ford had taken up in order to further her career as

a writer. In fact, the lady was Jean Rhys, the novelist, whom Ford, at the insistence of his more permanent mistress, Stella Bowen, discarded at this time, Stella having found Jean a job as a ghost-writer. The thirty-five-year-old Rhys may have embroidered her own life history for the benefit of the Nashes. She was from Dominica, which she had left in 1907; in 1919, she had married Jean Lenglet, who had been extradited to Holland in 1923. It is very possible that Margaret, as was her wont, embellished the story that was told to her. In any event, Jean Rhys was frightened by her surroundings at Cros de Cagnes, and the Nashes paid her fare back to England: 'she then disappeared from our lives in the same ghost-like way in which she had appeared'.[43] Nash's account to Tony Bertram is extremely brief but much more vital: 'I bumped into that old rascal Ford in Paris, but only on the eve of our departure. He was extricating himself – God knows which – by, with, or from some woman, some more or less new one, and looked a little distracted. I think she'd been making him a scene. He looked more like Silenus in tweeds than ever and was lamentably short of wind.'[44]

As Nash told his brother, his sense of colour was enlivened by his sojourn on the Riviera: 'Lovely grey blues, pinks, grey greens, infinite gradations of tones of yellows, creams & whites especially in the buildings.'[45] In a letter to Audrey Withers, he was passionately lyrical: 'Oranges burn among the dark hills, mimosa gleams at intervals incredibly yellow. Olives, those cool blessed trees harmonise all these strange notes.'[46] The Nashes went on to Italy in March. They visited Genoa, Pisa, and Florence, but Nash was especially taken with Siena and the masters of the Primitive School. However, he and Margaret did not enjoy their stay in a country which was caught up in Mussolini's climb to power, Margaret discovered the owner of their hotel in Florence going through Paul's belongings, and, subsequently, the Nashes witnessed a noisy disturbance at the railway station at Ventimiglia, where one of the guards flourished a pistol in Margaret's face. The couple were happy to be returning to France, and, shortly afterwards, England.

The Nashes' homecoming that spring was shattered by the news that Margaret's mother had to undergo an operation for cancer. Margaret, who was pregnant, miscarried. By the autumn, when she was well enough to leave her parents' home at Hillingdon,

the Nashes rented Iden Cottage from their friend, Colonel Bertram Buchanan.

By the end of November, Paul found Iden a desolate place. He complained to Margaret, who was in London:

> It is really terribly cold down here, and I am afraid for you to come down. Indeed, unless we can contrive something I hardly think I shall be able to work here – but we must. It's too ridiculous, Bertie is obviously the world's worst fool. He's built a room here with window space which needs a fireplace four times the size. It is a summerhouse, that's all.[47]

He also suffered the misalliances of his unfaithful cat who, after nights of carousing, arrived home 'heading for the kitchen like a torpedo'.

> After a short feed and a perfunctory wash she slipped out again.... She tottered back about 9. Ed [Burra] was here. He called her the whore of Iden. She now uses the house like a hotel, looks like a damp hearth rug and has been indifferent to all human society, whilst making her unfortunate master the laughing stock of the village.[48]

Discomforts and interruptions aside, Nash worked for thirteen hours a day, and became an enthusiastic gardener as well.

Six months later, anger and disappointment had given way to enchantment, as he exuberantly proclaimed:

> The garden is simply a riot of colour ... about nine tenths of the flowers have come out red, but there is a deal of pink and the canters [Canterbury Bells] bulk up with a good deal of mauve and some white.... It was so delicious arriving in the moonlit garden, smelling of flowers and hay. It's too incredibly lovely down here now and by the time you come it will be even more perfect, for all the canters will be ringing their bells and the honeysuckle will have burst into bloom.[49]

Later, he inveigled his brother into making him 'a very pretty gentleman's rock garden' and when he needed 'herbacious stuff and *Pinks*', he asked Percy Withers for 'throwouts'.[50]

By the mid-twenties, the Nash marriage had become one in which separation played an essential part. Paul and Margaret quarrelled incessantly if they were thrown together. However, they wrote

letters full of passion and commitment. They spoke their closest feelings when apart, their intimacy sustaining itself only at a distance. In 1913–14, their times away from each other had been short and infrequent; in the twenties, they simply could not live together for long stretches.

In 1927 Paul tried to put a good face on their difficulties:

> I'm sad my dove felt I misunderstood her – it is only as you say we come together from different worlds almost but that is nothing, my sweet – we soon get adjusted and there must always be matters we see differently about. You are ... very serious minded ... you know, take you all around, & [I] a bit of a happy go lucky really – You are cautious, I am careless – I'm afraid it's bound to weary you but remember I am a slippery sort of fish & my very changeability is my protection.[51]

Nash's most unabashed expression of the conflicts between himself and his wife was also written at about the same time.

> I am distressed to know you can't be happy in the cottage without me, but I think that is only because you are really not so well just now. As I see you get miserable if I am not about, I will do my best to avoid going away on visits tho' I confess I feel the need of change from time to time. I hope while you are in town you will take definite steps to find out what lies at the root of this nervous trouble, but you need not fear that your dove will let you down. He feels too acutely the tragedy of such suffering not to do as much as possible to relieve it. I fear I am not a very helpful companion and have fallen into habits of irritability lately. Forgive me, dearest. I get desperate & exasperated. But never reproach yourself when I am away because I have not the kind of mind which is given to brooding or a good memory of unpleasant things of any sort.... I could always forgive an injury simply because I should not be able to remember it very clearly. It's not a virtue, but I don't think I have room for lumps of resentment for any length of time. What venom I possess is like the snake's, the result of automatic reaction but I hope it comes from Wit rather than bile. Anyway I beg of you not to torture yourself with reproaches. I may get angry & snap but I cherish only loving thoughts of my dove. I know I get bored but I'm bored with what you're bored with most of the time – illness. My fear is only that your courage will give out – that sometimes really frightens me.... Don't be morbid, darling. There is no accident in the divine mind – as our

friends say. We have lovely times to look forward to but I expect we have to fight for them – we're both fighters.[52]

The gulf between Paul and Margaret began to be bridged only after 1936, when, because of his failing health, Paul needed his wife's constant attention.

In addition to marital worries, Nash was deeply worried from 1926 to 1928 about the direction his work was taking. He felt that he had a 'unique position as an artist'[53] in England, but he knew Bloomsbury and Roger Fry were opposed to him: 'although the attitude of Fry's lot must change, it remains to be seen whether their malice will evaporate tactfully or simply intensify'.[54] (Nash is referring to Fry's attempt to have him excluded from the London Artists' Association.) Nevertheless, if Nash sometimes felt he had to overcome antagonism from various critics, he was unrelenting in the demands he made upon himself. In April 1928, he told Margaret:

> I do not feel we shall be at Iden much longer. I sense a change. It is too cramped. If we were by ourselves I should suggest living in Paris for a time but I fear that is out of the question. I am very puzzled what to do. I want to expand yet do not see my way. It is the same with my work. I feel it must make a definite move but in what direction? My work is always going into the same mould – the moulds turn out different colours & substances ... but they are all more often the same shape. This is a result of unenterprise, of a subconscious playing for safety. I would be released from that. Alas I feel caught at present. It is no time to experiment over much just now and if my show succeeds I shall be drawn to produce to take advantage of the propitious moment. Well, well it's no good being too introspective.[55]

However, Nash could not help himself. Despite the pain introspection brought in its wake, he seized upon it as the instrument of change. His breakthroughs always came after intense inner turmoil.

The show to which Nash referred was his November 1928 exhibition at the Leicester Galleries. *Dahlias*, *St Pancras Lilies*, and *Still Life* (plate 20) at the London Artists' Association the year before had amply demonstrated his continuing mastery of technique and his ability to work well with cubist-inspired shapes within the still-life tradition. However, *Cactus*, and *Autumn Crocus* at the Leicester Galleries are much more ambitious attempts at introducing abstract

formulations into a traditional still life. Edward Wadsworth admired the latter painting (as well as *Mantel-piece* and *Tower*) which, in its contrast between a fragile plant and the hard geometrical structures surrounding it, looks forward to the *Urne Buriall* illustrations. *Riviera Landscape* in particular, although markedly indebted to Wadsworth's Mediterranean landscapes, is a sharply angular, extremely colourful attempt to respond to continental art.

Nevertheless, the most exciting entry in the 1928 exhibition was *Diving Stage* (plate 21) At first glance, this does not appear to be an accomplished picture, but in that canvas Nash attempted to unite the European influences which were impinging upon him with the icons which haunted his imagination. The platform itself is rendered in an improbable geometry haphazardly conjoining platform upon platform; the figure, poised on the penultimate stage, is not realistically rendered: he is allegorically, not photographically, real; the picture's background is only broadly suggested; the most careful attention to traditional narrative detail is given to the swimmer in the water, this person presumably having jumped from the highest stage. This picture is an uneasy attempt to use some contemporary means to articulate the artist's overwhelming interest in mortality. Does the water bring renewal or does death come from water? Is the water associated, as in *The Pyramids in the Sea* and the Dymchurch pictures, with the feminine and the sinister, or does it betoken renewal? Is man adrift on the sea of life, or does spiritual rebirth come only through physical death? *Diving Stage* reflects the dilemma in which Nash was caught in 1928.

Most of the paintings in the 1928 exhibition are facile, being of what Nash himself called, as we have seen, the 'propitious moment'.[56] Nevertheless, however much Nash may have had an eye to the main chance, he could not be an out-and-out opportunist. He had the technical power, he knew, to take advantage of the enormous popularity his new work could bring. Despite overwhelming temptations, he pushed out into the unknown depths into which *Diving Stage* was leading him. In deciding to 'reach out'[57], he realized full well the risks he was taking. He chose to be adventurous. As he said to Margaret, in praise of contemporary French art, they had 'real mental daring. "Tactic audacity" says Cocteau is knowing "how to go too far." How different!'[58]

Gordon Bottomley and Nash continued to bicker about modern

art. In mid-February 1927, Nash told his friend: 'I know a gulf has gaped between us so far as aesthetic sympathies are concerned and your occasional references to modern work make me uneasy when it comes to considering my own in reference to your tastes.'[59] Bottomley snapped back: 'It is true where you see a revolution in vision I only see a change of recipe.' Bottomley went on to castigate Monet, Cézanne, Signac, and Matisse: 'you seem to believe that progress in art is possible, just as progress in Science is possible, whereas I believe that art has always been complete since it first began to be expressive and that local variations of method such as anatomy, or perspective, or volumetry, or geometry, never change or vary the things an artist can say'.[60] Nash may have argued the 'modern' side in his letters to Bottomley, but he was caught between ancient and modern within his own being.

Nash's artistic, and personal, direction was certainly very unsure as he put the final touches to the 1928 show. In a conciliatory gesture, he told Margaret, who wanted to settle in London:

> I do indeed wish you had some other interest in life but not only for my own sake. I fear London life would not be likely to solve the problem, rather it might make things worse. I find London very difficult to work in but if you feel very strongly that you could stand it & benefit by it I daresay I should accustom myself in time.... I don't like you to feel I need relief from you & that I am unsatisfied. I feel it is quite unnecessary. I have only tried to stand up to something I feel is a danger – the concentration of one being upon another. I want you to be happy in spite of me. I dread getting into a habit of mind towards you which is the smallest bit resentful or unsympathetic. I want perfect equality. We both need to develop our independence – I of you as much as you of me.[61]

For Nash independence was a synonym for isolation. From the beginning, he had feared 'the concentration of one being upon another'. He did not wish to settle in London because he and Margaret would be forced together there. The approaching deaths of his own father and of Margaret's parents were also troubling him.

Mrs Odeh died at the beginning of 1928, and Margaret then had to look after her now quite feeble father. As well, Margaret experienced a crushing sense of guilt about the bitterness with which her mother had faced death, feeling, at the same time, that

Paul had implied that she had been neglectful of her. To this charge, Nash replied as clearly as he could:

> I think her bitterness was directed against circumstances of life which were against her so much.... We all blame indiscriminately – you as much as any – we let fly as they say. Had I allowed myself to intercept all the arrows my dove has loosed off, I should have perished like Sebastian, but I just make myself either impervious like a shield or hollow so they never really hurt me! It was always pathetic to me how you wished Mother to share in everything you enjoyed & I know the thought of how she missed so much is almost unbearable.

> I felt death was kind because it took her in good time. True before she had suffered but still while she was herself in almost every way. She had a certain impatience of mind which was the result of living always with a child – I think that was both beautiful and tragic for her. In one way she wished your Father to be always the same – in another she was frightfully bored. Is anything complete or perfect?[62]

In the same letter, Nash went on to reflect in a more general way on the meaning of death:

> No one of us uses enough imagination about others. All of us are concerned with our own vision of what is. We cannot simply see that what *is* to us is *not* to one we love. I cannot realise what after-life can mean. The mind reels at the thought of absolute perfection. It does not lie within human conception. Somehow to be born again seems to me the ideal but how, in what form?[63]

Since he could not yet 'realise what after-life can mean', he pushed himself further and further in his quest for understanding. Nevertheless, it would take him a long time to find the right 'form'.

At the same time that Nash was ruminating on Mrs Odeh's death and on eternal life, he was aware that his father was in poor health. He was thus especially gratified by his father's letter of 18 November 1928 in response to receiving a copy of the catalogue of the Leicester Galleries show: 'More striking perhaps than the number sold is the prices obtained. One wonders how those who fixed them were so daring, but they were right in their Estimate of what high prices people will now give for your pictures.'[64] William Harry Nash was plainly puzzled by his son's paintings, and his bewilderment is discernible in this letter. Nash was an affectionate son, but he

realized full well how different a path in life he had taken from his father, who had no natural taste or judgement in artistic matters.

Despite this, there was a strong bond between father and son which had reached its height, as we have seen, when Nash's mother died. Not unexpectedly, he was desolate when his father died on 27 February 1929. Margaret told Tony Bertram that 'nothing in their whole married life so profoundly affected her husband as his father's death'.[65] To another friend he wrote: 'It was a tragic business losing my Dad. As you know I loved him very much. . . . A part of my life goes with him for in so many ways he and I were linked.'[66] In a similar vein, he told Gordon Bottomley: 'He died full of years – having passed 80 – and to the end was vigorous and clear in his mind. One is grateful for that but the loss is there – it leaves a void. Apart from personal loss I feel acutely the pathos of my father's death. – Do you think I shall see the Spring?, he said.'[67]

Nash's art had changed remarkably at the time of his mother's demise. The great carnage of the First World War had also prompted a remarkable stylistic transformation. A similar process took place in 1929. Nash had been unsure of his direction well into 1928, and his work in 1927–8 only hints at the more mature pictures which he made during 1929 and early 1930. Where there had been confusion, clarity emerged. The great canvases of 1929, particularly *Blue House* (plate 22), the two versions of *Northern Adventure*, and *Landscape at Iden* (plate 23) show a surprising adaptation of Giorgio de Chirico's metaphysical–surreal landscapes: the apparently random placement of disparate objects, the dream world ambience, the concern with painterliness, the precision of detail, the concern with the relationship or dramatic tension between incongruous objects – are all common to both artists.

The Italian artist's work had a substantial showing at Tooth's in 1928, where Henry Moore was 'completely bowled over'[68] by them (however, reproductions of de Chirico had been available in the various French periodicals available from Zwemmer's bookshop since the late 1920s). Nash's 'borrowing' from this celebrated artist is not surprising in the light of his earlier assimilation of Futurist and Vorticist techniques in his First World War painting and lithographs. As we have seen, Nash often took a great deal of time to ponder the work of other artists before introducing their insights into his own work. In the 1920s, he had obviously felt the pressure

to become modern, but he was not really able to embrace cubism and its deviations as readily as, say, Ben Nicholson.

Nash had been isolated at Dymchurch and later at Iden, but he knew he had to make some change in his art. He wanted financial security, and there was, as we have seen, the temptation to pursue the successful still-life painting which had made the 1928 Leicester Galleries show a success. He was also very much an ambitious man who wanted to be a great artist. However, such worldly considerations gave way when, in 1929, he began to use precisely painted objects to capture the landscape of death. In these pictures, undertaken while he was mourning his father, his direction as an artist suddenly came into sharp focus.

When Richard de la Mare of Faber and Faber wrote to Nash on 8 May 1929, just two months after his father's death, asking him to illustrate *Dark Weeping* (page 145) by AE, the Irish mystical poet George Russell, for the Ariel series, Nash was unenthusiastic. He had experienced difficulties on an earlier book in this series with 'a monstrosity entirely opposed to my design'. He also told de la Mare that he would require a higher fee:

I am primarily a painter. Painting is really a whole time job: my paintings are: a) twice as difficult, b) take twice as long to paint, c) (incidentally not because of a & b) sell at twice the price as two years ago.

On the other hand making designs such as you want may easily take as much thought and time as a small painting requires. Why does one make designs such as you require – for the fun of the things really.... Then why a fee at all you might say.... Well, you see, it's like this – but I have already bored you.[69]

Despite such peevishness, Nash must have been particularly moved by these lines from the poem

> *The soul must rise and go unto its Father*
> *For a myriad instant breathing eternity.*
> *And then returning by the way it came*
> *It wakes here to renew its cyclic labours.*[70]

AE's symbolist poem is about the soul when asleep, but Nash clearly responded to it as a commentary on the soul's release from life and subsequent entry into immortality. On the cover design, the shadow

of the ladder indicates the ascent and descent of the soul; on the title page, the movement of the illustration is from the starry sky to the recumbent mortal figure to the convolvulus, a process suggesting man is a creature deriving his existence from infinitude, who resides in the mundane shell of this world until he is reborn into the higher sphere represented by the flower.

However, this search for immortality is an arduous one, as *Landscape at Iden*, where de Chirico's influence is more pronounced than in the illustrations to *Dark Weeping*, shows. Man may hunger for the infinite, but the world into which he is born is one of profound sorrow and continual strife. In that picture, there are three picture areas: in the immediate foreground are objects – the stake, the basket containing logs, the wooden screens flanking either side, the large pyramidical group of logs at the centre; in the middle ground, there are the dead trees which are precisely distanced from each other and placed within a carefully drawn rectangle and fence; in the background are hills, forest, and sky which are much more lush in colour than the ground and trees in the middle area. The contrast in the two latter picture areas is between nature under the control of man and nature under its own aegis. Although rebirth will obviously take place in the middle picture area, the vitality of nature is lacking: nature left to herself is a capable provider; and yet, man must harness nature in order to survive. The discord implicit in the middle and rear picture areas is the backdrop for the drama unfolding in the foreground, which is also the scene of conflict.

The basket of logs and the tall, carefully constructed screen represent the female which is containing and ordered; the left hand foreground is given over to a single upright split log and a smaller, much more roughly-hewn screen behind which a serpent is entwined on the fence – this is the dominion of the masculine. The picture is concerned with opposites, but the triangular wood pile suggests a common source from which the stake and the contents of the basket tub have been derived. Nevertheless, this canvas depicts estrangement between the realms of the male and the female. The death of his father obviously recalled to Nash his mother's death and the separation from her both he and his father had experienced. The objects in this painting are also overwhelmingly alone, devoid of human presence. This is the landscape of personal isolation.

Other 1929 canvases attempt to discuss reality in highly symbolic,

Quince's House, from *A Midsommer Night's Dreame,* 1924

The Division of the Light from the Darkness, from *Genesis,* 1924

precise ways. In *Northern Adventure*, the scaffolding blocks the viewer from seeing into the railway station. The screens from *Landscape* are rearranged in *Month of March*, but a large picture frame prevents the viewer from seeing properly. The barriers which intrude into the viewer's vision in these paintings, a motif used in *Places*, may be the artist's way of dramatizing his realization that he cannot completely encapsulate or explain the vision he is working towards. Or, more likely, Nash might be dramatizing the difficulties inherent in attempting to reach the end of a spiritual quest. The tranquil *Blue House* is the domain of death. Lush organic forms (particularly the red-topped mushroom) and fallen leaves are consigned to decay in *Swan Song*. However, the huge blade which cuts into the stump in *February* (plate 24) makes the most dramatic, almost crude, statement concerning the power of death to intrude itself into life.

In another image, almost as discordant as *February*, *Nest of the Siren* (plate 25), Nash portrays the malevolent intrusion of the female. The siren blocks the viewer's ability to see the evergreen plant which is being trained up; there is also an implied contrast between the architecture of the green portico (art) and the plant (nature). This picture anticipates the chilling *Salome* (1931), where Nash, in his juxtaposition of the smooth ovoid (decapitated head) next to the Baptist's curly tresses, depicts the results of a conspiracy between two women, the wilful daughter, Salome, and her controlling mother, Herodias. This theme is reiterated in *Environment for Two Objects* and *Changing Scene*, both from the mid-thirties. The fear of the feminine disappears only in the paintings done in the last four years of Nash's life. Before that, as in his earliest canvases, women are objects of desire and inspiration who can be cruel and withdrawn.

A common theme in these pictures is an obsession with the presence of death in life and sometimes, more particularly, with the extinction of vitality in the relationships between men and women.[71] In all of these paintings, the drama is between objects – the human presence has been more noticeably removed than in other Paul Nash paintings from the 1920s. The death of William Harry Nash forced his son to think in clear artistic terms about his sense of estrangement from Margaret and from his mother. It also provided him with the impetus to explore the existence into which his father had been released.

The Jugler

1930 – 32

NASH WAS MORE RECEPTIVE than he had been before to 'modern' pictures when he and Margaret, accompanied by Ruth Clark and the painter Ed Burra, journeyed to France in February 1930. Paul used some of the £3,000 left him by his father to pay for this much-needed trip. Ruth was recuperating from an operation, and Burra, who had spent the previous summer in Toulon in the company of Jean Cocteau and 'his strange menagerie of friends'[1] was one of a coterie of artists, writers, and actors at Iden into which the Nashes drifted. Among the others were Martin Shaw, the songwriter and piano accompanist of Isadora Duncan, Edie Craig, Ellen Terry's daughter, and Edward Wadsworth, Nash's classmate from the Slade, who drove down to Iden in his white Rolls Royce.

Burra was a diffident, self-conscious young man (he was twenty-five at this time) who had quietly rebelled against his wealthy parents. He talked in an assumed Cockney drawl, was interested in red-light districts and low-life, and was seemingly devoid of ambition. When his parents entertained, Ed 'ate smoked haddock in the kitchen with the fifteen or so servants, guests [being] told that dear Ed was buried in his art'.[2] Extremely frail from childhood, Burra was for most of his life a semi-invalid who in his offhand way cultivated an aura of Firbankian decadence.

When he first met Nash in 1925, Burra had been in 'great trepidation' but soon saw the older man as a 'new playmate in the neighbourhood' who demonstrated the 'greatest charm'. A year later, he told of a surprise visit he paid to the 'great artist' who was at work in his garden 'at one with the nature he so tenderly portrays. He was robed in a seaman's jersey and kerchief bought at the village shoppie.'[3] In turn, Nash felt that Ed was essentially a descendant of Hogarth, rightly seeing a kinship between Hogarth's Progress pieces and Burra canvases such as *John Deth* and *Beelzebub*.

Burra, whose carefree disregard for convenience warred against the inclinations of his three travelling companions, gave a vivid description of the train trip from London to Paris in 1930: 'Paul never slept a wink & moaned from time to time. The floor was so hot you could hardly put your feet on it. Twit [Ruth Clark] & Margaret tied-up their heads in handkerchiefs & put on bedroom slippers. I fell in a torpor.' In addition, Ed's bohemianism was fundamentally opposed to the seven suitcases, two hat boxes and knapsack which accompanied his friends and which seemed, he quipped, like '50 rucksacks, a kettle & 90 suitcases'.[4]

Despite such petty differences, Nash's friendship with Burra probably confirmed him in his search for a representational style which could be both English and contemporary. In addition, according to Margaret, the 1930 trip to the Continent brought her husband into contact with Ernst, Arp, Gleizes, Masson, Zadkine, and Picasso; 'Paul . . . became really interested in an aspect of Surrealist painting, namely, the release of the dream.'[5] As we have seen, Nash had been cultivating de Chirico's metaphysical style for at least a year before this trip, but he first avowed the experimental works of the School of Paris at this time, becoming a conscious proponent of modernism (the various forms of cubism, abstraction, and particularly, surrealism) after this visit. In a letter to a friend, Burra recorded, with characteristic preciousness, his impression, probably one shared with Nash, of Léonce Rosenberg's gallery: 'Such a show my dear of Metzinger, Chirico, Gino Severini, Herbin, Ozenfant and others (Max Ernst) all very abstract. I've never seen such a beautiful show for years.' Burra was particularly taken with 'a lovely Surréaliste peintre called [Jean] Viollier all red plush birds' nests in trees with the Venus de Milo's head and shoulders coming through the top'.[6] Although *Nest of the Siren* had been painted the year before, Nash

undoubtedly perceived a kinship between his work and the Viollier.

After Paris, the party moved south, visiting Toulon, Cassis, and Mantigues; they also spent a week on the island of Tamaris (in Toulon harbour) in a boarding-house kept by an ex-nurse, who, as Margaret recalled 'maintained a small holding attached to the house, and we were somewhat alarmed at the intimate relationship between the guests' rooms and the livestock on the farm. Lovely small piglets walked in at your bedroom door which opened on to the garden, and hens and chickens had a passion for my face cream and Paul's shaving soap.'[7] The Nashes became irate when a goat consumed some of Paul's oil paints. Despite this setback, he made many sketches of the boats in Toulon harbour: 'I drew valiantly from my window every day, baffled and desperate in my ignorance, tangled up in unsuitable rigging, bewildered yet fascinated by the strange architecture of things.' He also enjoyed sitting out in the sun slowly enlarging his 'liver with too much coffee' and going out into the port. As well, he delighted in evening excursions to cinemas and sailors' bars. Ruth and Margaret had their doubts about such outings, Ruth especially regretting the time 'wasted in cafés in this glorious country'.[8] They decided, after Paul came down with bronchitis, to leave Toulon for Nice.

On the way to the railway station at Toulon, the group ran into Horace de Vere Cole, a notorious practical joker they knew in London, at a restaurant. (In February 1910, Cole had been the instigator of the 'Dreadnought Hoax' in which he, Duncan Grant, Anthony Buxton, Guy Ridley, Adrian Stephen and his sister, Virginia (later Virginia Woolf), hoodwinked officials of the Royal Navy into believing that their party comprised the Emperor of Abyssinia and his court, who wanted to inspect the most secret man o'war then afloat; they were allowed to do so, and the incident would have gone undetected, but Cole informed the *Express* and the *Daily Mirror* of his group's success in gaining admission to *Dreadnought*.)[9] At the end of the meal, as Margaret recalled, Cole suggested that Nash try a liqueur called Marc:

> Large port glasses were filled up with this drink, but I no sooner put my lips to the spirit than I realized that its white colour and aroma bore a close resemblance to Arrac, a potent spirit made in Palestine and used by the Arabs to counteract attacks of malaria. I had tasted this in my youth when I was given it for malaria in a very minute

quantity, and realized that it was a very dangerous and potent drink.[10]

Paul downed a glass, and Margaret, well aware that her husband could not tolerate strong spirits, hurried him off to the railway station, where he became violently ill.

At Nice, Ed, characteristically, preferred a 'drab hotel' to the 'genteel' hotel 'conceived for the comfort and catering of South Kensington abroad' in which the four stayed their first night. Unfortunately, Paul suffered another attack of bronchitis. When they arrived back in England, he was diagnosed as having Trench Mouth, 'obviously contracted in one of the dirty cafés of Toulon or Nice – more probably of Toulon'.[11] In a letter to Percy Withers, Nash left a characteristically witty account of the journey: '*Jamais plus, jamais, plus* ... will I go abroad in a circus. Of course, *everyone* wanted something different, we ricochetted round the Côte d'Azur like a demented game of billiards.'[12] Years later, Margaret would pinpoint the 1930 trip to France as the starting point of the bronchial asthma which eventually killed her husband.

Nash dubbed 1930 the year he lost three homes: the cottage at Iden, the family home at Iver Heath, and the Odeh residence at Hillingdon. The move in December 1930 to New House, Rye, was made to accommodate Mr Odeh, who had developed angina and could no longer live by himself.

New House was a 'strange looking place': 'a very tall house of three floors, with the front windows facing on to the upper main street in Rye which leads to the Church, and the garden at the back of it going down the cliff in a series of steps, with a magnificent view from the back windows over the Romney Marsh towards the flashing lights of Cape Gris Nez on the French Coast'.[13] Rye locals asserted that the terrace of houses to which New House belonged had been brothels in the early 1800s. The legend also claimed that the bodies of sailors who did not pay for the services they had received had been casually thrown out into the street. Clarissa Aiken, exasperated with the archiac inconveniences of Jeake's House (built in 1689) described the Nash residence as a 'modern house perched on a cliff above the Salts and ... furnished in exquisite taste, the walls hung with Paul's watercolours'.[14]

Conrad Aiken lived in England from 1921 to 1927, returned to Harvard, and settled in Rye in 1930 with his second wife, Clarissa, whom he subsequently called Lorelei II. According to Margaret, Aiken immediately recognized a kindred spirit in Nash; in a sentimental aside, she said 'they mutually helped one another in their aesthetic expression, and Paul found in him one of the most sympathetic minds he had hitherto encountered. Conrad revived Paul's natural love of poetry and helped to bring out in Paul's work a surer form of poetic expression.'[15] In his evocation of Rye in his autobiographical novel, Ushant, Aiken dubbed Nash one of the 'noble or beautiful or delightful spirits' which had blessed his existence. He had 'not only the feline grace and Persian eye ... but also the unsleeping and amusedly affectionate and immortal watchfulness of a mind half man's, half satyr's, the love of beauty that was oddly both animal and mineral'.[16] Ushant was published in 1952, six years after Nash's death, and Aiken could then immortalize the mystical side of their friendship. In 1930, Nash was a 'philanderer and rogue to beware of',[17] his roving eye being the cause of some tension.

Aiken became convinced, unfairly, quite soon after he met Clarissa, that she was promiscuous, becoming inordinately preoccupied with what he felt was sluttish conduct. Nash's flirtatious behaviour made him suspicious, although Clarissa herself was not attracted to Nash: 'I found Paul innocuous enough – a blue-eyed, black-haired aesthete wearing a fancy cravat and quizzical smile. Margaret, an Irish-Arabic mystic, seemed the stronger of the two.'[18] Despite his wife's heated denials, Aiken was constantly afraid that Clarissa and Paul were on the verge of an affair. Clarissa recalled an incident which later led to a bitter fight with her husband:

> With the skill of long practice, Paul asked if he might sit on the arm of my chair and show me his book.... When I said no, he looked dashed. What was I afraid of – B.O. or S.A.? I felt churlish at that and relented, though anticipating a rumpus. Conrad was torturing an eyebrow. Margaret laughed later on, when I asked her to muzzle Paul. 'I can't deprive him of free speech, Clarissa.'

Aiken's anxiety was certainly not alleviated when he witnessed, shortly afterwards, Nash's overtures at a party to Ruth, a sophisticated brunette from New Bedford, Massachusetts, who was a

paying guest at Jeake's House: 'Ruth became restive, wedged between [another visitor] and Paul, the latter alternately caressing her thigh and nibbling her elbow. Later that evening, she giggled, admitting, "I'm glad that I can prove the bites on my arm came from Squidge's fleas and not from Paul's teeth." '[19]

If Clarissa saw Nash's advances as a nuisance, she was captivated by Margaret's warmth and vitality – she became Clarissa's 'straightener'[20], the American woman being impressed by Margaret's ability to take 'a firm stand with Paul'. However, Clarissa's speculations about Nash's 'womanizing' are confirmed by Barbara Bertram's recollection that he propositioned her quite soon after they met, suggesting that they go off somewhere for the weekend. Barbara, newly married, was shocked by this rakish overture. However, when she told Tony what had occurred, he coolly replied that Nash was a habitual philanderer and that Margaret, although she voiced her objections, was a remarkably tolerant spouse.[21]

Other acquaintances at Rye were the Yogi, Yeats Brown, who unfortunately preferred silence to conversation, the garden designer Colonel Gray, and Una, Lady Trowbridge and Radclyffe Hall. Una's mother, Mrs Harry Taylor, had been one of Nash's first patrons, having introduced him to Sir William Richmond, and Nash had known Una and her sister, Viola, as children.[22] Margaret and Clarissa did not like Radclyffe Hall, who they thought was overly obsessed with the possibility that Una's ovaries might have to be removed.

At about the same time he settled into New House, Nash began writing for *The Week-end Review*. He worked for that journal intermittently until June 1933; as well, he alternated with Herbert Read as art critic for the *Listener* from April 1931 until the end of 1932. In these reviews, an aggressively modern Paul Nash can be discerned, an artist who is convinced that 'even the most drastically non-representational work of art, if produced by an artist who, consciously or unconsciously, apprehends the formal character of natural structures, may be "true to nature" in this larger sense of the symbolisation of natural form'.[23] Nash was impatient with those who insisted that if 'an artist creates abstractions he is ... abandoning painting "as understood" '.[24] With approval, he quoted from Fry's 1912 second Post-Impressionist catalogue: 'These artists

do not seek to imitate form, but to create form, not to imitate life but to find an equivalent for life ... in fact they aim not at illusion but at reality.'[25] (Nash's own later use of the word 'equivalent' to describe his own work obviously comes from Fry.)

Nash, who, together with Reginald Wilenski and Herbert Read, had taken on the mantle of modernism, now became an ardent advocate of a variety of approaches in art:

> Any close study of modern art will reveal at least one fact, that the range of pictorial expression has enormously increased, but what is particularly evident is that the material employed in picture-making now derives from three distinct sources – the material world, the sub-conscious or dream world, and the world of abstraction or non-representational form.[26]

Nash saw William Blake, who had influenced his earlier work, as an English painter who had employed the sub-conscious world:

> Perhaps the strangest contribution to the history of the pictorial subject in England, and one whose character is, in a sense, extremely modern, was made by William Blake. Blake is said to have hated Nature, and his work certainly shows a contempt for natural appearances. Like the surrealists of to-day he sought material for his pictures in other worlds. Within the realm of the mind he conceived certain very precise and solid images, bright with colour and of a rather persistent curvilinear design. The finest of these do indeed burn with unreal life and seem the product of unique vision.[27]

If Nash defended Blake because he saw his 'surrealistic', 'colourful', 'curvilinear' work as manifestations of the English tradition he himself was pursuing, he made similar claims for Christopher Wood:

> The thirty-two paintings on view at the Lefevre Galleries in King Street, St James's, represent the work of the last two months of Kit Wood's life. As the art of an English artist they are chiefly remarkable as evidence of an almost unique ability to 'read, mark, learn, and inwardly digest' the modern French idiom. They possess none of those hesitancies and embarrassments so often noticed in transcription; at the same time, one is relieved of the tiresome obligation to acknowledge them as 'essentially English'.[28]

Nash himself was not comfortable with all forms of modernism, but he did explicitly state the concerns, as he saw them, of a con-

temporary artist, who had to create pictures which appealed not only to the

> sense of sight but [also] to the whole experience stored in our being. This expression is divided into two stages, conscious or unconscious ... Either he is touching obliquely upon your hidden impressions, your consciousness of beauty in the abstract, your sense of harmony in colour and form, your appreciation of balance and direction, and so on, or you may regard him as offering a discovery of his own which is a new adventure for your understanding.[29]

In describing his reaction to El Greco's *Laocoon*, Nash hailed that picture as 'the outcome of an effort not simply to describe an imagined scene, but to create, by means of formal symbols, a compelling drama of abstract beauty'.[30] He went on to say that

> The natural curiosity in subject is overcome by a startled interest in *object*. In fact, the immediate appeal of such pictures is that of, virtually, abstract values in form and colour alone. Such an appeal is decidedly unsettling to normal untrained or mistrained powers of appreciation; the simple conception, that every picture tells a story, is suddenly supplanted by the altogether difficult idea that every picture plays a symphony. Now this is just the point of difference between what I believe most people like in art and what I like. They like the picture to tell a story; I like it to play a tune.[31]

The 'symphonic' arrangement of pictorial elements had been discovered by Nash in 1929, and de Chirico, as we have seen, had been the most instrumental artist in helping Nash to see 'objects'. In April 1931, he talked of the Italian painter as the inventor of 'a new pictorial terrain, or rather he at once discovered and created a new "world"'.

> He has, in his best moments, an extraordinary power to make things *happen* in a picture. His compositions do not flow like those of Matisse or build themselves like Picasso's. They happen with all the startling event of a vision or a dream. These happenings are by no means fortuitous, the structure of their content is definitely architectural. The elements of scale, perspective and illumination, used with cunning science, always play an important part. It is this architectural quality in Chirico's work which, combined with his poetic vision and personal sense of colour, give him prominence among his

contemporaries and, were it more insisted upon, should make his influence a healthier one than it has proved to be.[32]

Nash's praise of de Chirico is ultimately a description of his own art from 1929, this essay of 1931 being a rationalization of directions he himself had taken two years earlier.

As his critical writings indicate, Nash tended to take in pictorial and stylistic influences intuitively and then rationalize – to himself and others – the process he had undergone. He was distrustful of allowing the unconscious free rein in picture-making, but he usually responded to other artists in a purely visual way, without allowing intellectual factors to dominate his essential concern to find a painterly solution.

In his magazine articles, Nash emerges as a defender of the best in contemporary art. In *Room and Book* which was written in 1931 and published the following year, he attacks the 'taste of the antique':

> With what sort of curtains and rugs does the city man's wife brighten up the drawing-room? Old English chintzes and Persian carpets. What is it that his mother-in-law is irritably working on her tambour? A tea-cosy of Jacobean design, And so it goes on. An endless dance of ancient masks like a fearful fancy-dress ball composed of nothing but travesties of the Jacobeans and poor Queen Anne. It is time we woke up and took an interest in our times. Just as the modern Italian has revolted against the idea that his country is nothing but a museum, so we should be ashamed to be regarded by the Americans as a charming old-world village. They do not respect our modernity because we have no pride in it ourselves.[33]

Nash propounds the 'imaginative use of modern materials and modern methods' to create a harmonious world where, 'even for a short space of time, we may enjoy the forgotten luxury of contemplation'.[34] In the course of his treatment of modern furniture, Nash castigated Roger Fry and Omega, making the point that 'Morris and his workers were both artists and craftsmen; Mr Fry and his workmen were just artists and painters':

> It is fortunate that the artists so actively employed with their brushes included such painters as Duncan Grant, Vanessa Bell and Mr Fry himself, and there is no doubt that the more fortunate type of Omega room will someday astonish and please visitors to the Victoria and

Albert Museum, but the whole expression must be regarded as a temporary phase which was not altogether happy in its after-effects.[35]

At the same time that he was composing a theoretical study which deals in large part with modern book design, Nash was illustrating Thomas Browne's *Urne Buriall* and *The Garden of Cyrus*;

Desmond Flower of Cassell and Co. approached Nash in 1930 concerning illustrations to Browne, a writer with whom Nash was already familiar. Since his paintings, particularly oils, were not selling well, Flower's proposal that Nash obtain £200 on account, plus a 15 per cent royalty on the edition of 215 copies, was especially welcome. Nash was supposed to make fifty finished drawings (only thirty-two were made) from which stencils would be created. Oliver Simon of the Curwen Press was in charge of production, and John Carter, who was an acquaintance of Nash's, prepared the text. This project took up most of 1931. Nash first made preliminary drawings in pencil and crayon, from which he prepared final chalk drawings. From these, monotype collotypes were printed; Nash would then water-colour the monotypes, return them to Curwen, where coloured collotypes were issued and sent to him for approval. Nash was exceptionally fussy about colour reproduction – his only serious complaint, though, was that one illustration, *The Vegetable Creation*, was much too 'hot'.[36]

Urne Buriall and *The Garden of Cyrus* have always been published together, and Carter was merely following an established custom in coupling the two essays. *Urne Buriall* is a learned treatise dealing with the sepulchral urns found at Walsingham in Norfolk, but Browne also describes the burial rites of various religious sects. *The Garden of Cyrus* deals with the frequent recurrence of the quincunx – or lozenge pattern – in nature and proclaims this as evidence of the underlying order governing existence.

The time Nash devoted to Browne was the longest given to any design or book project during his entire career. Indeed, he perceived that illustrating these two works by the seventeenth-century polymath was an opportunity to take stock of his progress as an artist. Up to 1931, Nash was trying to find a way to reconcile English subject matter, particularly of a mystical nature, with contemporary art. In tackling Browne, he found an ideal way to do this: Browne had been interested in the geometry underlying the natural order,

and Nash's defence of modern (and his own) art had placed great reliance on 'architectual quality', 'beauty in the abstract', and 'harmony in colour and form ... balance and direction'. In addition to his declared interest in form and structure in *The Garden of Cyrus*, Browne was fascinated by the possibility of immortality and by 'the whole experience stored in our being ... conscious or unconscious'.[37] Thus, Nash was attracted to Browne because he realized not only that *Urne Buriall* spoke to some of his deeper interests (death, the life beyond death, the English landscape), but he also knew that Browne was obsessed with the symbolism inherent in visible structural patterns such as the quincunx.

From the outset, then, Nash intuitively understood that he would not be doing Browne a disservice by translating the language of the seventeenth-century writer into contemporary art. Like himself, Browne was an artist interested in exploring the meaning and structure of existence. Both men were experimenters, who knew that everything 'began in order, so shall they end, and so shall they begin again; according to the ordainer of order and mystical Mathematicks of the City of Heaven'.[38] In treating Thomas Browne, Nash was thus able to pursue his two principal interests at the outset of the thirties: 'mystical Mathematicks'.

Nash literally depicts Browne's antiquarian interests in approximately half (eight) of his illustrations to *Urne Buriall* (*Frontispiece, Water hath proved the smartest grave, Tokens, The opaline shone on the finger of the dead, Buried Urne, Funeral Pyre, The Opened Tomb, Pyramids in the Desert*) by showing the urns, their contents, and man's vainglorious attempts to preserve corpses against the ravages of time. The other seven are concerned with the survival of the soul after death, and in emphasizing this, Nash departs from the spirit of Browne's essay. For example, Browne dismissed the Phoenix myth, but Nash's bird rises triumphantly against a vivid pink sky. *And Juglers shewed tricks with Skeletons* (plate 2) is openly autobiographical, for this figure is Paul Nash himself, who juggles the text in order to give it resonances not intended by Browne. The skull above the figure's head is a *memento mori* – a portent of what his head will become after death.

The Soul Visiting the Mansions of the Dead (page 145), the most geometrical of the illustrations to *Urne Buriall* itself, underscores Browne's assertion: 'But the secret and symbolicall hint was the

harmonical nature of the soul; which delivered from the body, went again to join the primitive harmony of heaven from whence it first descended.'[39] *Ghosts* (page 160) continues the spiritual auto-biography implicit in *Jugler* by recalling the final wood engraving to *Places*, where the figure had reached the end of the path; there the spectator was prevented from following by a fence in the foreground. Now the viewer sees the landscape that the figure has chosen to explore and from which he was previously debarred. As in *Places*, the descent of the figure represents a willingness to enter into the self. The kingdom which this man reaches is the most surrealistic of the settings in *Urne Buriall*: it is a sea-bed populated by jellyfish and other ocean creatures; a female head leads him to the tree in the foreground of the picture. This visage is reminiscent of those depicted in *Vision at Evening* and *Our Lady of Inspiration*, and Nash's earlier insistence on connecting women and landscape is re-introduced here. This lady is a Beatrice who guides her Dante to the oak, which is clearly the symbol of spiritual renewal in *Generations passe*. As in Nash's earliest work, the mystery of human destiny is linked to the feminine and death. Significantly, the female presence here is serenely benign, but the full implications of this were not to be resolved for a long time.

Sorrow (page 175) elucidates Browne's insistence on the division in the time between darkness and light: '. . . and oblivion shares with memory a great part even of our living beings; we slightly remember our felicities, and the smartest stroaks of affliction leave but short smart upon us. Sense endureth no extremities, and sorrows destroy us or themselves.'[40] Nash's picture, however, goes against the force of Browne's words. The sun, emblem of life and energy, is joined in a quincunx shape to both a torn branch and a broken pillar: in death there is life – and the renewal of life, Man may experience sorrow, but ultimately he will be reunited with the beneficent force which gave him being. As with *Ghosts*, the significance of this illustration would elude Nash for some years to come. The tailpiece to *Urne Buriall* is an abstract diamond quincunx: the assertions of immortality in the first treatise will be proven geometrically in the second.

The opening design to *The Garden of Cyrus* is a diagram of a quincunx and the next, *Vegetable Creation*, is a description of the third day of creation done in a somewhat more realistic way than

in the earlier *Vegetatian* from *Genesis*. Many of the remaining illustrations to *The Garden* are adumbrations of the quincunx in the various facets ('Artificially, Naturally, Mystically') of Browne's text. In *The Quincunx Naturally Considered*, a serpent ascends the plinth holding the pineapple, and in *Convolvulus and Mandrake*, both plants observe the motions of the sun. As for Blake, the serpent for Nash is often a symbol of goodness and spiritual rebirth; however, it also signifies the discrepancy between God's providential creativity and man's often mistaken notions of guilt: the snake is God's creature but man, from his reading of Genesis, has made all serpents evil. For Nash, however, the entire creation contains God's redeeming love implanted in the mystical geometry of the quincunx.

The endpiece to *The Garden of Cyrus* and to the entire volume depicts Browne's assertion that the 'Quincunx of Heaven runs low, and tis time to close the five parts of Knowledge; We are unwilling to spin out our awaking thoughts into phantasmes of sleep.'[41] In this design, the starlit sky and sea on one side are contrasted to the sleeping head on the other. In both portions of the illustration, the quincunx is present – there are five bright stars in the night and the countenance of the sleeper is criss-crossed with the quincuncial pattern of a higher life. As in *Dark Weeping*, sleep is a metaphor for the entry into the full beauty of death, and a poem by Nash written during 1911–12 clearly anticipated this:

> And when he woke he thought, if this could be
> No waking dream but sweet reality
> Surely this might be that far golden land
> Where my lady haply waits for me
> And as he mused two maidens passed him by
> Of whom he asked – What is this country called?
> And they made answer – This is Paradise.[42]

Urne Buriall gave Nash the opportunity to reflect on some of his earliest, still predominant interests and to find a contemporary stylistic vocabulary with which to utter them.

The watercolours and oils from 1930–1 do not display the firmness of intention manifested in the Browne illustrations. Pictures such as *Lares, Kinetic Feature* (plate 26), *Opening*, and *Rotary Objects* are not convincing. Nash was trying in much too deliberate and

opportunistic a manner to imitate abstract/cubistic approaches with which he was not comfortable.

In *Harbour and Room*, one of the most successful paintings from this period, the ship, sea and harbour invade a sitting room. Nash received his inspiration for this picture from the reflection of a ship in an enormous mirror hung in a French hotel room. From this fleeting experience, he evoked a momentary, eerie impression as the water gently penetrates the room. Whereas the sea had previously been associated by Nash with feminine, destructive powers, its presence here suggests the sleeping world of the unconscious, as in the *Dark Weeping* illustrations. In time, the siren gave way to the muse.

Wood on the Downs displays an extremely precise but ultimately rich and satisfying geometry; the subject is Ivinghoe, Bucks, 'an enchanted place in the hills girdled by wild beech woods, dense and lonely places where you might meet anything from a polecat to a dryad. All the knolls and downs go rolling about against the sky with planes of pale coloured fields stretching out below.'[43] Nash told Margaret that the pigeons had so settled in the branches that the woods 'looked like monstrous orchards bursting into bloom'.[44] In his painting, Nash emphasizes the undulating, colourful lines of the landscape, while still managing to convey some sinister touches.

Although he did not complete them until sometime later, Nash had begun work on his various Archer canvases in 1929–30 (plate 27). In these pictures, a masculine figure 'more mischievous than menacing' is a 'shadow-shooter' who can

> only score bulls and groups, or wound and kill with a *cast shadow*. And he is generally after some rapidly revolving thing like the object in the picture. But his real 'headache' as you might say, is a counter-menacing *shadow* in the form of a woman with long flying hair! She is always on his track. Nothing but her shadow is ever visible but that is quite enough for the Archer and, sometimes, too much – as in the picture Archer Overthrown.[45]

Nash's language here is obscure, perhaps unintentionally so. He himself is the 'shadow-shooter' who can create art only out of the recognition of death and the world beyond death. Although he is alive and must deal with 'revolving objects', his real love is the shadow world. His enemy is the female 'counter-menacing *shadow*'. (Nash had depicted and then attempted to erase her from *Night*

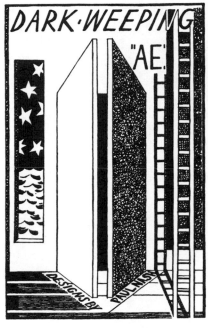

Cover of *Dark Weeping*, 1929 Title page of *Dark Weeping*

The Soul Visiting the Mansions of the Dead, from *Urne Buriall*, 1932

Landscape from 1912–14; she survives, however, in *The Cliff to the North*.) As in his earliest pictures, this figure is a woman who is not only threatening but also comforting. She is, after all, the fount of inspiration. In 1930–1, Nash still saw the elusive women of his earliest work as the sources of both death and creativity. But he had not yet discovered their full meaning.

America,
Unit One and Avebury

1931—3

NINETEEN THIRTY-ONE was the year of 'Minnie the Moocher', 'Mood Indigo', and 'When the Moon Comes Over the Mountain', and later that year Paul and Margaret made their only visit to the United States. John Palmer of the Carnegie Exhibition had invited Nash in December 1929 to be the British Representative on the International Jury, at which time he declined because it would present 'difficulties over the production of my work'.[1] When Palmer approached him again, early in 1931, he decided to accept: 'I had expected the blow to fall sooner or later but I will confess I had hoped it might be later!'[2] After Margaret decided to accompany her husband, Paul suggested to Palmer that they travel second-class as a couple in exchange for the first-class fare offered to him alone. The compromise finally reached was that the Nashes travelled out first-class but returned third-class. From the outset, Nash had misgivings, as he told Margaret:

> I wish to God I had never accepted but again it was largely in the hopes the trip might do you some good. And the silly superstition always lurks in our minds that money can be made out of that bloody country.... I have been reading this book *Al Capone*. I find nothing amusing about it. Something is lacking in me I suppose. The picture of these dirty cold blooded murders and cowardly impotent government

sickens me. What kind of men are these? The war was dreadful enough but it was fought bravely and in a sort of mistaken idealism but to take life for beer – my God. I think I shall vomit from New York to Pittsburgh and back beside all across the Atlantic.[3]

Nash's trepidations about the United States gave way to acute dismay when he saw a 'mischievous press release written apparently by some not very well-informed lady with an inadequate command of language. . . . She has treated me to about the nastiest paragraph I have read in the course of many years!' The offending notice in the *Pittsburgh Sun-Telegram* read:

Paul Nash, the English member, made his first appearance in Pittsburgh as an artist with the British War Exhibition. Since then, his peace-time paintings have been logical performances but anti-climax to that dread picture 'The Menin Road'. Nash was more indelibly affected by the war than any other painter.

Now at 42, his paintings suggest that active life has passed. His beach scenes & still life command the respect of the intelligent given to contemplation. They are, however, utterly divorced from life.[4]

The last sentence, perhaps confirming some of his own worst fears about the directions in which his art was going, must have particularly rattled him.

The Nashes set sail on the *Mauretania* on 12 September. Their luxurious cabin was three decks under water-line, and Margaret found this a frightening experience, 'especially when strange fish stared in on us through our permanently latched port-hole window'.[5] To celebrate their trip, Margaret gave her husband a camera, the only one he ever owned: an American-made No. 1A pocket Kodak series 2. The first of his 1,300 surviving photographs were taken on the *Mauretania*, these pictures beautifully capturing the linear modernism of the ship's architecture juxtaposed against the endless expanse of sea and sky.

The French and Italian jurors, as well as the Nashes, were accompanied by Mr and Mrs Homer St Gaudens. Life on board ship proved uneventful except for Signor Oppo, whose fervent admiration of Mussolini and dedication to fascism Margaret found repugnant. She frequently, in her role as his interpreter, 'had to suppress his remarks in order not to hurt the susceptibilities of American officials'.[6]

A heat-wave, accompanied by flashes of lightning and torrential rain, greeted the Nashes upon their arrival in New York. Paul was immediately captivated by the mathematical exactitude of the city's streets, the 'burnt-out volcano'[7] appearance of Central Park, and the omni-present Gladstone bags containing whisky, gin, and other kinds of illegal alcohol. Paul and Margaret were unhappy to be deprived of good wine, but they quickly became addicted to iced coffee heaped with whipped cream.

Margaret found the city lacking in vitality, but she admired the Italian and Chinese ghettos. In particular, she disliked the top of the Empire State Building: 'I must confess that it was a height and a scene calculated to induce suicide if for no other reason than in despair at man's destruction of the beauties of nature and the consciousness of his plight in achieving that destruction.'[8] Her husband's reaction was very different, as his remarks in *The Herald-Tribune* make clear. The skyscrapers'

> very preciseness, their extremely subtle colour harmony, the variety of straight lines, broken by jets of steam and by penthouses and parks – to me they mean that through this space, balance, stress and contrast New York is in search of harmony. It is trying to find beauty in solidity.... This aspect of New York indicates the passing of sentimentalism. It indicates that New York is attempting to face nature and its future alone.... Nonetheless the link with the human desire – with superstitions – is so strong that you have not yet developed the courage to completely let go. How else am I to explain those skyscrapers which begin with such marvellous logical simplicity yet which are spoiled by atrocious gothic ornamentation at the top?[9]

Nash obviously admired New York's fusion of 'solidity' with 'harmony'; he was also responding, although with some reservations, to the city's commitment to modernism.

Shortly before leaving for the United States, Nash had published in *The Week-end Review* an essay on 'American Humorous Draughtsmen' (an article on the English practitioners had appeared earlier on 18 July). He began by regretting the lamentable ignorance of American art in England, but he then proceeded to mention that there was a 'side of American art which not only commands intelligent interest, but has the advantage of being, in some of its aspects,

familiar to us all': American humour. 'A people that can make being murdered *sound* funny, however dull it may feel, must possess a sort of magic.'[10]

Nash then examined film and, in particular, Walt Disney: 'Disney's genius lies in his extravagant impossibilities; he has done more to release our inhibited consciousness than the solemn assurance of many psycho-analysts. It used to be thought unreasonable to want the moon; now, Mickey Mouse can just make an incredibly long arm and reach it down.'[11] After praising Disney, Nash extolled Krazy Kat, the Katzenjammer Kids, and the artists of *The New Yorker*, particularly Peter Arno, John Held Jr, Soglow, and James Thurber. 'The last two are both draughtsmen of the single line, using it as a child might, carefully – with protruding tongue – which is Soglow's method except, I suppose, for the tongue; or (apparently) vaguely scribbling, which Thurber affects, and Matisse. Both methods are beautifully successful.'[12] In contrast to *Punch's* stuffiness, *The New Yorker* offered the outrageous and the deeply serious – in particular, Nash admired Thurber's *The Owl in the Attic* not only for its treatment of the simpler themes of love and understanding 'but also the rarer and tenderer unsupportabilities'.[13] Ultimately, it was the sense of mystery, so vital in his own art, for which Nash liked Thurber. Nash's art was frequently solemn, but comic drawings were always an integral part of his letters. He clearly recognized the thin line separating farce from tragedy.

In his article extolling Thurber and cohorts at *The New Yorker*, Nash had begun by stating that in 'England we know very little about modern American painters'.[14] Having been struck by the affinities between himself and Thurber, Soglow, and Arno, Nash replied, when asked which American artists should be placed at his table at a luncheon held in his honour at the Century Club, that he wanted the artists from *The New Yorker*. Thurber was dumbfounded:

> I was living in Connecticut at the time, and some official in charge of the luncheon phoned me long distance, beseeching me not to fail to show up at the lunch. Even now [1951] I do not know much about art, American or otherwise, and then I knew very little, except the names of a few famous painters. At least twenty were on hand when I arrived at the Century Club, and I recognized the names of Jonas Lie, Burchfield, and four or five others. Paul was a little late, and when he did get there, we all lined up to greet him, like the front

file of a platoon. He wandered slowly down the line, shaking hands, smiling, and obviously ignorant of most of the names that were mentioned. When he came to me, he embarrassed the hell out of me, stopping to talk, while the other men shifted uneasily and there was a lot of nervous coughing. He insisted that I sit on his right, and I began to get extremely restless and afraid.

Thurber's fears were justified. Nash extolled Milt Gross to a formidable man with dark eyes and a huge spade beard and asked him how he could get in touch with Gross. 'The gentleman, probably the director of a gallery or editor of a recondite art magazine, replied gruffly, "I am sure I wouldn't have the faintest idea." Paul stared at him. "He is one of your great artists", he said, and I kicked him under the table.' Later, Thurber said to Nash, 'You didn't seem to realize that you were in the midst of the forefront of American art, and that none of those men ever heard of me or Milt Gross.' Nash rejoined, 'From what I know of their work, they are bringing up the rear of French Modernism.'

Thurber subsequently introduced Nash to Harold Ross, the editor of *The New Yorker*. Nash suppressed a smile when Ross, in his usual acerbic fashion, barked at him: 'Nash, there are only two phony arts, music and painting.' When he arrived for a cocktail party at Thurber's apartment, the living room was filled with steam, Thurber having turned the hot water on full for a bath. 'Paul, of course, loved this incident, and especially the fact that, when the fog had cleared, there was Otto Soglow sitting on a chair. Soglow is scarcely more than five feet tall, and was one of the men Nash admired for his "Little King" drawings.' The conversation turned to the inability of comic artists to deal with death, and Nash said 'that the common drawing of a man falling from a building and speaking to someone on the way down did not represent death, since the man was forever poised in the air, and it was Paul who said of [Thurber's] drawing "Touché!" that the man whose head had been cut off was not actually dead, because he could obviously put it back on again'.[15]

After a week in Manhattan, the three jurors were scheduled to leave by train for Pittsburgh. Just as the party arrived at Grand Central, detonations deafened them. Signor Oppo jumped behind Margaret, 'muttering in [her] ear that these were the wicked Italian Socialists endeavouring to blow up the station because he represented the great fascist regime of Italy'. He was nonplussed when

Margaret told him that the noise had been caused by a troop of Boy Scouts, who had thrown to the ground squibs which exploded when stepped on. Eventually, the jurors, accompanied by the now ubiquitous Gladstone bag, boarded the train. Nash did not enjoy his stay in Pittsburgh, despite Mrs St Gauden's efforts as hostess, Margaret having remained behind in New York. He found the acrimony which soon broke out between the European and American judges particularly unpleasant.

Nash visited Washington, DC before returning to New York, where he and Margaret stayed another full week before sailing back to England. At the Biltmore, as she subsequently told everyone, Margaret was mistaken for Mrs Andrew Carnegie. Their ship, the *Samaira*, sailed on 9 October, and third-class was obviously not as comfortable as first-class. Nevertheless, Margaret maintained, with a fine touch of reverse snobbery, that their companions on the return journey were 'professional men and women, with a sprinkling of writers and artists' who were far more interesting than the 'cynical millionaires' of the voyage out. Their first impression of London on their return was that the buildings 'had shrunk and looked like cottages after the towering monsters of New York'. 'But the air was balmy and the light was delicate and diffused; the grass looked so beautifully green in the parks, and the trees and flowers welcomed us in Kensington Gardens.'[16]

'The great difficulty facing any fair-minded critic of American contemporary art is the same sort of embarrassment which America herself presents to the startled European on his first encounter – that of quantity.' So Nash wrote in his assessment of American art in November 1931: 'From the impressions received during a short visit I am inclined to make a definitive division between those painters who have survived the French influence, or can at least support it without loss of self-respect, and those who cannot. Of those untouched by it, so far as I was able to discover, there are none.'[17] Despite his assertion that American art was too derivative, Nash found much to admire in artists such as Lyonel Feininger, Charles Delmuth, and Peter Blume, whose architectonic *Parade*, one of two pictures reproduced to accompany Nash's article, was quite similar to his own Atlantic photographs and water-colours.

<p style="text-align:center">*　　*　　*</p>

Since the market in oils and watercolours in 1932 continued to be dismal, Nash gratefully accepted a commission from Edward James, the renowned collector of surrealistic art, to design a bathroom for his wife, the dancer, Tilly Losch. Two years earlier, Nash had won second prize in a competition sponsored by *Architectural Review* to plan a London apartment for Lord Benbow, an imaginary Clydeside shipbuilder. The contestants were supposed to cater for the client's sympathy with the modern 'without producing an atmosphere too redolent of the stable and country'. They were asked to strive for 'an effect which is gracefully sporting'.[18] Nash made many droll suggestions: a carpet marked out as a tennis court, a door frame painted like a goal-post, and tube lights made to resemble bails and wickets. But he was quite serious about glass: 'no other material contains so many elements of magic. A careful study of its application must stimulate the least imaginative mind and excite it to adventure.'[19]

When Edward James, who was constantly giving his unfaithful wife 'endless presents'[20] to keep her attention, approached him, Nash focused his design on glass: James's love of surrealism was obviously an additional inducement towards such experimentation. Almost every conceivable surface in the bathroom was faced with this material. The walls were fitted with rectangular sheets of deep purple, pink, black – plain and patterned. The door, the screen around the shower and windows were made of a semi-opaque variety, the bath being encased in a black marmorate. The sanitary fittings were made of black glazed earthenware; the floor was covered in pink rubber; the shower, the exercise ladder, the towel rail and the cosmetic table were constructed from chromium-plated tubing. The only curves Nash allowed in the room were in the tube lighting and practice arabesques. Despite its almost remorseless contemporariness (plate 28), Nash's metaphysical concerns are evident in the exercise ladder which is similar to the one on the cover of *Dark Weeping*.

The declining health and senility of Naser Odeh made life back at Rye harrowing. While staying with John and Christine Nash in March 1932, Nash enjoyed the company of his year-old nephew William (who was to die in a motoring accident in November 1935): the little boy was 'the nicest chap you can imagine. So happy and fearfully strong.... But, O what a tie & a responsibility.' As he also

told Margaret, he looked forward to better times, when they would finally be free:

> Anyway we will have a lovely little holiday whatever happens. I too look forward to a nice gay care-free time & we will escape to the woods & find a secret place and enjoy each other. Isn't it lovely that we can still do that with just as much joy as ever. My dove is desirable to me. I'm sure it is very great nonsense about her having no sex charm. I think she has so much that she has to hide it – otherwise ther'd be a riot.[21]

Two months later, in May, Nash was in London, working on Tilly Losch's bathroom, and he was skirting the turbulent life at Rye: 'I should like to hurry down to comfort my mouse at once: I feel like a rat who has scuttled out of the plague ship – a bothered rat who has forsaken a poor little ... defiant Mrs rat.'[22]

In addition to his domestic trials, Nash continued to be depressed by poor sales of his pictures, his Oxford retrospective in October 1931 and exhibition of illustrations and stage designs at the Batsford Gallery having netted a dismal total of eleven guineas.[23] In early 1932, he was understandably gloomy: 'No servants and no money and all that sort of thing, but we are picking up a bit now and hoping for better days.'[24]

Naser Odeh died in August; Clarissa Aiken, who was there during his final moments, was taken aback by the obstinate cantankerousness with which he confronted his end:

> I had been spelling Margaret, keeping vigil at [her father's] bedside, until 3 a.m. the day before he died. He was terrified, struggling for breath, the mottled hand clutching my wrist, the face under that nimbus of white hair ashen and shrunken, the eyes sunk in their sockets. Margaret, hollow-eyed, had a dreadful time with him. He had grumbled at paying the vicar fifteen shillings for the last rites. Ten was all he used to get. It took the doctor's shot of morphine to bring the final oblivion.[25]

As Margaret said, her father's death brought hope as well as sorrow: 'We now found ourselves for the first time in many years with a small private income, since I was my father's only child and I inherited everything that belonged to him. It looked as if we were to have some rest after the long strain.'[26] But the rest was not to be.

Paul and Margaret visited Anthony and Barbara Bertram at York

in November; at the end of that stay, Nash caught a severe chill, suffering, by the time they reached London, 'from an abnormally severe attack of influenza'.[27] Nash seemed to shake this off by New Year's Eve, being well enough that night to dine with Margaret, the Bertrams, and the Bullets at the Gourmet and then to go on to a late supper with Charles Laughton and Elsa Lanchester at the Café Royal. The festivities ended at the Laughtons' flat, but Nash's flu was back in full force the next day. As soon as he and Margaret returned to Rye, Nash recovered quickly.

In February, however, Nash became suddenly ill with severe asthma, following an expedition to visit Gerald Reitlinger at Thornsdale. This attack being more intense than the previous ones, Margaret became apprehensive when the local doctor, 'not one of the reassuring type', brutally told her that Paul had to leave Rye – and England – immediately. As in 1921, Margaret decided to press for a further, more learned opinion, remembering that their friend, Hilda Felce, had been treated successfully for a similar condition by a London specialist, Dr Cameron, who owned a private clinic at Tunbridge Wells. Nash 'jumped' at the chance to go there, although Margaret insisted that he stay in rooms near the clinic: 'I did not allow him to go into the clinic as a patient, as I strongly believe that life in the proximity of people ill with all kinds of strange diseases, is a bad atmosphere for a sensitive, imaginative mind.'[28] The Nashes did not wish to admit that Paul's 'sensitive, imaginative mind' might have been in part the cause of the asthma which would haunt him for the next thirteen years.

On 12 June 1933, *The Times* published a letter by Nash announcing the formation of Unit One, a group which would stand 'for the expression of a truly contemporary spirit, for that thing which is recognized as peculiarly *of today* in painting, sculpture and architecture'. Nash's art had been moving towards 'peculiarly' contemporary expression for some years, but the events leading up to Unit One go back to April 1931 when Nash published an article on Jacob Epstein's marble, *Genesis*, in *The Week-end Review* in April 1931. Epstein's monumental female figure with her negroid facial features and powerful hands had caused a controversy when exhibited at the Leicester Galleries. Nash had attempted to defend Epstein as a 'modern' artist:

... artists like Epstein *are* rare. A critic remarked at the time of the exhibition that Epstein was the only artist among us to-day who still has the power to shock. That is probably true, but what is more to the point is that Epstein is the only artist among us who *wants* to shock. ... Epstein has never allowed himself to be bound by public or professional opinion. He is a creator of extraordinary power, emotional, imaginative, wilful. It is not my province now to attempt a critical estimate of his work even had I the judgment. He serves here simply as the perfect example of the artist seen as a public figure.[29]

Although Nash had always disliked Epstein's work, his comments in this instance were meant to be entirely commendatory, but Epstein, an overly opinionated, excessively sensitive genius, was offended – as his letter to the *Review* made clear:

I suppose I ought to be extremely flattered at the length of Mr Nash's 'post-mortem' on 'Genesis' and myself, but apart from the many amusing quips and divagations I am struck by the ready accusation, for it amounts to that in my mind, that I am out 'to shock'. At one point Mr Nash uses the expression '*wants* to shock' and further on this is varied as follows: 'to shock, to challenge, even to hurt the minds of men'. I might assent with as much authority that Mr Nash paints anaemic pictures in order not to shock or hurt people's feelings. Mr Nash by his accusation of my intention to shock allies himself with that large body of journalists and critics who declare that I work with my tongue in my cheek.[30]

Nash had not challenged the seriousness of Epstein's art; he had been attempting to discuss the isolation into which the artist is placed by society, assenting, albeit indirectly, to the power of art to shock. He was irritated by Epstein's petulance: 'I believed Mr Epstein honestly imagined I had tried to injure him, and very naturally he hit out. As to *where* one hits on such occasions – above or below the belt – is, after all, a matter of code.'[31] Epstein had also taken exception to this remark: 'For [Epstein], pure sculpture would seem to be not enough. A *great idea* is necessary, not only an idea of form, but a philosophical idea.' Nash was making, obviously approvingly, a point about his own attempt to unite pure painting with 'philosophical idea'[32] but Epstein accused him of simply following Roger Fry and Bloomsbury: Nash's 'saying that my concern is not only with "pure form", whatever that may be, proves that Mr Nash is

not above borrowing an idea from that school of aesthetes and critics commonly supposed to reside in the neighbourhood of Gordon Square: the "through the teeth school" '.[33] Thoroughly provoked, Nash rejoined:

> I can stand being hacked on the shins for a misunderstanding, but I do object to being hit over the head with a misquotation. Mr Epstein said that I was not above borrowing from the residents in the neighbourhood of Gordon Square the expression 'pure form' – 'whatever that may be'. Well, I am. The word I used in conjunction with 'pure' was 'sculpture', and I persist in thinking Mr Epstein knows what that may be.[34]

As Nash told Henry Moore, with whom he shared a common-sense approach to modernism, he was deeply upset by the Epstein incident: 'I imagined he had no use for the art for art's sake business & really preferred to reach the "people" but he seems to have thought I was getting him. Obviously if one writes criticism one must never speak one's own mind but find out what artists like to be said of them & say that as prettily as possible.'[35] Later in 1931, Nash exhibited in a show at Tooth's entitled 'Recent Developments in British Painting', where he entered *Kinetic Feature*, his most resolutely abstract painting. Despite the fractious episode with Epstein, he asserted in March 1932: 'When the day comes for a more practical, sympathetic alliance between architect, painter, sculptor & decorator, we may see the acceleration of a modern movement.'[36]

Indeed, Nash had become convinced, despite the inherent difficulties, that, in the light of increasing public hostility and the declining market, artists had to join together rather than fight independent, perhaps mutually destructive, battles. Nash continued during 1932 to write on the artist and contemporary art, industry, the English press, the community, the house, modern textiles; he also published *Room and Book* and employed various facets of decorative and industrial art in the Tilly Losch bathroom. It was not, therefore, particularly surprising that he cryptically announced in September 1932 that 'A marriage has been arranged – and will shortly take place.'[37] By late 1932, more arrangements had been made, as his letter to Henry Moore of 17 January 1933 makes clear: 'I have been anxious to get four of us round a table for a preliminary talk.

Yourself, Wadsworth, Wells Coates the architect & myself. I wished to limit the company to these as, between us, I feel we represent the most stable & least biased members of the rather difficult collection of people who are likely to constitute a group.'[38] Nash suggested that they call themselves 'Contemporary Group', mentioned that Zwemmer's, Tooth, and Lefevre were sympathetic to the idea, and named the artists who were to form the group, in addition to the four founders: John Armstrong, Edward Burra, John Bigge and Ben Nicholson. Nash also proposed Ted Kauffer 'as representing textile & other kinds of design but I do not know the others' opinion on this.'[39] Barbara Hepworth, now living with Ben Nicholson, was among those Nash felt should be considered for membership: 'I feel the talent of Barbara but am unable to judge sufficiently of sculpture to say she holds a place.... I heard from Ben & I shall write to him more guardedly until Barbara is decided upon!... Ben is a good fellow but I do not regard his judgment as entirely sound – & I believe you agree on this.'[40]

It was undoubtedly Nicholson's growing antipathy to representational art that led Nash to suggest his judgement was not 'entirely sound'. In any event, Nicholson may have influenced to a small degree the final selection of Unit One members: Moore, Hepworth, Nash, Nicholson, Armstrong, Bigge, Burra, Hodgkins, Wadsworth, Wells Coates, Colin Lucas. Frances Hodgkins soon resigned and was replaced by Tristram Hillier. In April 1933, the Mayor Gallery reopened after a closure of several years, and the work of Wadsworth, Nicholson, Armstrong, Hillier, Bigge and Moore was shown alongside pieces by Braque, Léger, Dali, Miró, and Ernst.

The stage was thus set for the letter to *The Times* in which Nash's assertion concerning the Englishness of the association was strongly emphasized:

> There is nothing naive about Unit One. It is composed, mainly, of artists of established reputations who are not very concerned as to how other English artists paint or make sculpture or build. But they have this in common with the Pre-Raphaelites; in the sense that those artists were a brotherhood, these are a unit: a solid combination standing by each other and defending their beliefs.[41]

He also claimed that Unit One would be preoccupied with 'Design . . . considered as a structural pursuit; imagination explored

apart from literature or metaphysics.'[42] In a subsequent article in the *Listener*, Nash defended Unit One as a heroic adventure whose goal was the contemporary:

> But the pursuit is not vaguely directed. It seems today to have two definite objects for the mind and hand of the artist. First, the pursuit of form; the expression of the structural purpose in search of beauty in formal interaction and relations apart from representation. This is typified by abstract art. Second, the pursuit of the soul, the attempt to trace the 'psyche' in its devious flight, a psychological research on the part of the artist parallel to the experiments of the great analysts. This is represented by the movement known as Surréalisme.[43]

Nash admired the first pursuit, but, as he became increasingly aware, his art was of the second persuasion. Despite differences, it seemed in July 1933 that Unit One could be held together.

In July, the same month as the article appeared in the *Listener*, the Nashes sold their house at Rye. They felt that New House was now too large for them, but they also wished to escape the prison Rye had become during Naser Odeh's last illness. They wanted to be free and after some tense negotiations with the purchaser – 'a middle-aged lady of uncertain mind and changing fancies'[44] – they agreed in mid-June to vacate the house by 1 August. The summer of 1933 was especially hot and humid, and Nash wilted in the harsh sunny weather. Margaret, saddled with a multitude of chores, was relieved when Ruth Clark 'arranged to have a special holiday from her work and take [Paul] away to stay at Marlborough while I packed up the house in the remaining three or four weeks at my disposal'.[45] On their way to Marlborough, Paul and Ruth decided to take a day trip to Avebury.

During the bus trip, Nash had an asthma attack, and was for most of the time bent over in great discomfort. He showed no obvious interest in the scenery and could not talk. Just as the bus pulled into Avebury, however, he perked up. He was taken with the huge stones and stared intently at them. Suddenly, he became animated and began to speak of the overpowering presence of the sculptured forms. He had discovered a new 'place'. As Ruth Clark recalled, misery gave way to ebullience:

> Paul was excited and fascinated. We spent long hours on the great

Ghosts, from *Urne Buriall*, 1932

grass banks entranced by the sight of the stones below in the large green enclosure – great 'personalities' erect, or lying prone or built into the structure of houses by indifferent generations of dwellers in Avebury. His response was to the drama of the Stones themselves in this quiet setting; his sensitiveness to magic and the sinister beauty of monsters was stirred, and he long contemplated the great mass of their forms, their aloofness, their majesty, the shadows they cast on the grass, the loveliness of their harsh surfaces and the tenderness of their colouring.[46]

His fatigue had vanished, and, as he told Margaret, 'If anything will preserve my interest in landscape from a painter's point of view, it will be this country.'[47]

———————•———————

Ancient Forces

1933 – 4

'YES, I'VE SEEN STONEHENGE – It's very impressive. I've read somewhere that certain primitive peoples coming across a large block of stone in their wanderings would worship it as a god – which is easy to understand, for there's a sense of immense power about a large rough slaked lump of rock or stone ...'[1] This was Henry Moore's response in September 1933 to Nash's news of Avebury. Nash's willingness to share his excitement of the stones with Moore indicates not only the closeness which the two men had arrived at through Unit One activities but also the profound influence that sculptural form now exerted upon Nash, whose reaction to Avebury was not simply to the historic association of the stones with a serpent temple but also to that place as an assemblage of sculptures. Indeed, in the various interpretations he gave to Avebury he tried to find painterly ways to deal with those objects:

> Last summer, I walked in a field near Avebury where two rough monoliths stood up sixteen feet high, miraculously patterned with black and orange lichen, remnants of the avenue of stones that leads to the Great Circle. A mile away, a green pyramid casts its gigantic shadow. In the hedge, at hand, the white trumpet of a convolvulus turns from its spiral stem, following the sun. In my art I would solve such an equation.[2]

For the next few years, Nash attempted to discover an appropriate two-dimensional solution to the problems inherent in rendering the stones.

Nash's description of Avebury finds its closest pictorial equivalent in the watercolour, *Landscape of the Megaliths* (plate 29), on which the Contemporary Lithographs print is based. In that picture, the row of megaliths, beginning in the right middle foreground, advance towards the left foreground, where a large stone decorated with lichen confronts the convolvulus in which a snake is intertwined. The drama of the picture centres on the encounter between the stones which have been artfully placed by man to make a snake-temple and the serpent who has artfully intertwined himself on the flower. The common meeting ground of the two forces – the man-made and the natural – is the sun, which is situated where the avenue runs into the mouth of the circle and where the snake's head arises.

This picture has the aura of a mystical experience, derived as it is in part from the passage in *Urne Buriall,* where Browne says: 'But the great *Convolvulus* or white-flower'd *Bindweed* observes both motions of the Sunne, while the flower twists Aequinoctially from the left hand to the right, according to the daily revolution; the stalk twineth ecliptically from the right hand to the left, according to the annual conversion.'[3] Indeed, everything in this painting converges on the sun: the large megalith, the snake, the convolvulus, Oldbury hill, which, with Silbury, counterpoints the megaliths. All these movements are towards the life-giving force, which symbolizes immortality.

The circle of megaliths was for Nash an affirmation of man's desire to make a structure which mirrors the providential care of a God who orders days and night. As in his illustrations to *Genesis,* Nash sees God as an artist who separates order from chaos. As well, the almost human striding of the large stones represents man's wish to discover the secret of existence. If, as Nash read in William Stukeley, Avebury was a serpent temple (in which 'the whole figure represented a snake transmitted through a circle'),[4] it was fitting that a snake be intertwined in the convolvulus.

In this watercolour, the quest of the stones (with their human qualities), the serpent and the flower merge into the life-giving sun. This is the unity of the entire creation: the serpent and the

convolvulus will die and the makers of the Temple are long dead, but the presence of the sun, which rises and sets each day, testifies to a providential order. There may be a touch of the sinister in employing a snake, but Nash uses that animal to insist that what is mortal will find its final transcendence after death – just as he suggests that the stones arranged by the dead can speak to us of the permanence of spiritual illumination (in *Nest of the Phoenix* from 1938, Nash paralleled the ascent of the phoenix to the serpent's release from its earthly nest).

Despite its apocalyptic nature, *Landscape of the Megaliths*, one of the last Avebury pictures painted in about 1937), is, structurally, a confrontation between a living form (intertwined nature in snake and flower) and a sculptural form (the large megalith). However, many of Nash's earlier Avebury pictures from 1933 to 1935 display a more overt interest in three-dimensional form and in discovering a pictorial 'equivalent' for them. In the 1934 oil, also called *Landscape of the Megaliths* (plate 30), a large stone in the central foreground seems to be attempting to penetrate beyond its two-dimensional limitations. Here, the Oldbury and Silbury hills are almost incidental details in the right and left backgrounds. The conflict in this painting is found in the interaction between the stone's obvious three-dimensional form and its restriction to two dimensions on canvas. In *Equivalents for the Megaliths*, the hard, geometric shapes are uneasily juxtaposed against the undulating fields in the background. Similarly, *Event on the Downs* (plate 31) asks the spectator to link the stump and the tennis ball, this canvas being reminiscent of the encounter between stump and knife in *February*. Other encounters are depicted in *Landscape of Bleached Objects, Encounter in the Afternoon, Objects in Relation, Composition,* and *Circle of the Monoliths*.

These experimental oils from 1933 to 1935 owe a great deal to Barbara Hepworth, about whom Nash had earlier expressed doubts to Henry Moore in January 1933. Nash had come to admire Hepworth's attempts to link realism and abstraction, and he realized her conflicts in this regard mirrored his own. Her experiments thus inspired him. The upright flint in *Encounter in the Afternoon* (1936) can be compared to Hepworth's *Reclining Figure* (1933), and Hepworth's *Two Forms with Sphere* (1934) has a similar juxtaposition of elements as found in *Equivalents* (1935). Hepworth's revolutionary

pink alabaster *Pierced Forms* (1931) thrusts itself at the spectator in much the same way as Nash's *Druid Landscape* (1934), which also uses a pierced hole.[5]

Photography was also still crucial to Nash at this time, and many of the Avebury-inspired pictures have photographs as dress rehearsals. But Barbara Hepworth was perhaps the predominant influence on Nash at this time. She felt, as she told him, that artists had to band together if they were 'to have any influence in this post-war world. I wish artists and writers could present some sort of unity of ideas. The general tendency at the moment is for everybody to dislike everybody else.' Her words were ominously prophetic. She also claimed that far too many people confused the fine arts with decoration and fashion with social consciousness: 'or feel that contemporary painting is alright on a rug & that it's beneath a sculptor to design a knife'. She also thought it was time for a manifesto – 'or are we to wait for society to find us a place?'[6] At this time, moreover, her aesthetics merged more and more with those of Ben Nicholson, who in 1934 made this claim for abstract art:

> ... not only the laws of nature, but space and time, and the material universe itself, are constructions of the human mind ... to an altogether unexpected extent the universe we live in is the creation of our minds. The nature of it is outside scientific investigation. If we are to know anything about that nature it must be through something like religious experience.[7]

Nash's observations to Anthony Bertram of April 1934 are quite similar:

> I am beginning to find through symbolism and in the power of association – not the rather freakish unlikely association of objects, so much as the *right* association as I feel it to be.... We are accustomed to seek forms that inter-relate, colours which are significant by juxtaposition. I desire to penetrate further – or if you like to swing my net wider to include a relationship of spiritual personality – only I suppose I must find another word for spiritual, or be misunderstood.[8]

Nevertheless, by 1936, Nash came to the realization that neither abstract nor cubistic form really lent itself to his work, and he was never fully comfortable with the designation 'surrealist'. However, his Unit One experience led him to experiment with sculptural form

('formal interaction and relations apart from representation')[9] in order to catch what interested him most: 'the "psyche" in its devious flight'.[10] Many of his pictures from 1933 to 1936 are unsuccessful because sculptural forms cannot be conveniently reduced to painterly terms, but the symbolical drama implicit between objects was an interest of Nash's from the outset of his career, as in the lady's face and the landscape in *Vision at Evening*. As well, in the 1930s, he was interested in what Ben Nicholson called an 'understanding and realisation of infinity – an idea which is complete, with no beginning and no end and therefore giving to all things for all time'.[11] Nash and Nicholson disagreed about how one pursued 'infinity', but their art had a similar metaphysical bias.

Despite Nash's unwillingness to be pinned down on this score, surrealism, of all the continental art movements, offered him the most acceptable entry to an alliance between his particular vision and the demands of modernism. In 1942, he told his friend, Herbert Read: 'I did not find Surrealism, Surrealism found me.'[12] Surrealism in a broadly defined way was, according to him, 'a native of Britain': 'It began to live in the world created by the poetry of Coleridge and of Wordsworth, a world that had inherited the songs and visions of William Blake ...'[13] Early in the 1930s, Nash was attempting to employ surrealistic techniques, as employed in *both* English Romantic art and twentieth-century continental art, to explore '*things not seen*', but he was also intrigued by how 'formal interaction' might lead him to the expression of 'religious experience' in truly contemporary art.

This path, as pursued by Moore, Nicholson, and Hepworth, was, of course, a valid one, but it was not one Nash could tread. His art was essentially narrative, and he never worked well in pictorial representations in which the foreground portion of the picture plane is dominant, as in the oil *Landscape of the Megaliths*. This observation can be strengthened by comparing the oil to the watercolour of the same name. The former is an obvious attempt to follow in the footsteps of Hepworth and Nicholson; it is resolutely modern in a manner with which Nash was uncomfortable. To a limited extent, he was trying, as he had done earlier with *Kinetic Feature*, to be fashionable. The later watercolour is a more traditional narrative painting, although it has strong elements of surrealism in it. On the whole, however, it is a private picture in which Nash's response to

Avebury is perfectly enshrined. Surrealism became a useful ally to Nash because it allowed him, as it had done in 1929, to preserve his artistic identity, and at the same time it gave him the chance to explore the contemporary.

Later, when the International Surrealist Exhibition opened in London in June 1936, Read characterized it aptly as a great catalyst,

> electrifying the dry intellectual atmosphere, stirring our sluggish minds to wonder, enchantment and derision.... The press, unable to appreciate the significance of a movement of such unfamiliar features, prepared an armoury of mockery, sneers and insults. The duller desiccated weeklies, no less impelled to anticipate the event, commissioned their polyglot gossips, their blasé globe-trotters, their old boy-scouts, to adopt their usual pose of I know all, don't be taken in, there's nothing new under the sun – a pose which merely reflected the general lack of intellectual curiosity in this country.[14]

Nash shared Read's disgust with the public attitude towards the exhibition, as this excerpt from a letter from Vanessa Bell to her son, Julian, regarding Duncan Grant's visit to the show, makes clear:

> Duncan went to the Private View and found a 10/- note lying on the floor which he tried to place on a statue so as to add to the meaning of it. Unfortunately some one, perhaps the owner perhaps not, came up and pocketed it. Then as he was going out Paul Nash came up and gave him a herring which he asked him to put outside, as he said some Philistine had attached it to a picture.[15]

Like Nash, Read was convinced that surrealism offered the modern artist an opportunity to retreat back to Romantic principles of art in which expressionist values are paramount; for both these men, surrealism was 'coeval with the evolving consciousness of mankind'.[16]

> It is in this sense, then, that surrealism is a reaffirmation of the romantic principle; and though poets and painters in all ages have clung to a belief in the inspirational and even the obsessional nature of their gifts, repudiating in deeds if not in words the rigid bonds of classical theory, it is only now, with the aid of modern dialectics and modern psychology, in the name of Marx and Freud, that they have found themselves in a position to put their beliefs and practices on a

scientific basis, thereby initiating a continuous and deliberate creative activity whose only laws are the laws of its own dynamics.[17]

In this important passage, Read suggests the crucial aspect of surrealism for Nash: it was a way of approaching landscape which would allow him to unlock the inner meaning of the world of appearances. The self can remake the world according to its own needs – this is the liberation that surrealism offered the modern artist:

> The surrealist is not a sentimental humanitarian.... Art, we conclude, is more than description or "reportage"; it is a dialectical activity, an act of renewal. It renews vision, it renews language; but most essentially it renews life itself by enlarging the sensibility, by making men more conscious of the terror and the beauty, the *wonder* of the possible forms of being.[18]

'Renewal' had been inherent in Nash's adaptation of surrealistic methodology as early as 1929; in *Landscape from a Dream*, he would apply those theories with increasing mastery.

The ostensible purpose of the visit to Marlborough in July 1933 had been to visit Savernake Forest, which Nash had first painted in the twenties. Nash also stopped at Salisbury to see Robert Byron, the art critic, whose *Birth of Western Painting* he had praised in a review in February 1931 at the expense of Fry, Bell, and Read: 'it has been left for a much younger writer, however, to lift the art of aesthetic analysis above the level of subtle criticism or ingenious argument to the plane of creative thought'.[19]

In his review of Byron's book, Nash also added a comment which was really by way of self-justification: 'To perceive through the images and monuments of man some glimmering of an ordered plan, some movement of a rhythm animating the universe, this must be the impulse of the modern writer upon Art who is not content to remain a critic.'[20] Nash's essay for the Golden Cockerel volume, *Sermons by Artists*, is perhaps his most important reflection on the 'ordered plan ... animating the universe'. There he refused to answer the obvious question: 'in Whom or in What, do I believe?', citing instead three biblical passages which fascinated him:

> Lift up your heads, O ye gates ...
> Why leap ye, ye high hills?

Wherefore, seeing we also are compassed about with so great a cloud of witnesses ...[21]

What united these verses in Nash's mind were the strong visual images in each, conjoined with the suggestion of upward (aerial) movement; they also have an obvious surrealistic quality: gates lift up their heads, hills leap, and the witnesses become clouds.

No doubt my mind's retention of [the first two] images could be explained very efficiently. They have certain characteristics in common. In both a power of movement is ascribed to inanimate things; no human or even angelic agency is called upon. The gates are exhorted to lift up their heads, the hills are asked why *they* leap. Such understanding strongly appealed to me ... Instead of referring to the prophets as an *army* of witnesses [in the third passage], which would have left them on the ground, he floats them in the air, thus appealing to an ancient conception of the spirits of the dead, that they roam the skies, watching over us.[22]

Nash then compares the faith of the prophets with the faith artists need to survive in England 'where apathy is built against him like a wall'.[23] Nash also describes the plight of the artist who dares to experiment and rebel against traditional form: 'If we need faith to live, we need more to work according to our beliefs. It is not enough to have faith which is *the substance of things hoped for*; it must stand for the *evidence of things not seen*.'[24] Nash may be talking of an art which is concerned with visual qualities which are not traditional and thus not easily perceived; however, he is also telling of his interest, from his beginnings as an artist, in the presence of the absent.

Nash visited Dorset in 1932 when Hilda Felce invited him to her home, 'Whitecliffe', in the Purbeck Isle. This little Tudor manor house, which overlooked Swanage Bay, with the Ballard Down rising behind it, was to become the Nashes' home from October 1934 until February 1935. During this excursion into Dorset, Nash used his 'new eye', his camera, to record the scenery of 'the magnificent coast which stretches from Swanage right round to Lyme Regis, with its haunted headlands and its Kimmeridge clay rocks and its uncanny petrified forest at Lulworth, ending with the superb Chesil Bank leading to Portland'.[25] Nash was elated by all that he

saw during this holiday, and sent Margaret this description of his visit to Salisbury Cathedral in Wiltshire: 'really a lovely thing and really English. It stands up surrounded by an immense expanse of ancient lawn smooth & green. We just lolled about for a whole hour looking at this lovely grey white & brown miracle with its incredible spire darting into the summer blue. I felt very happy & proud.'[26] Nash was exhilarated by Ruth Clark's companionship, although she 'looked far too pretty & well turned for the companion of an invalid.'[27]

However, the 'invalid's' health had improved markedly by November 1933, and Margaret, acting upon the advice of her husband's doctor, decided to prolong their good fortune by wintering at Malaga. The Nashes first travelled to France, arriving in the midst of an international financial crisis – the Stavisky affair. Nevertheless, as Margaret said, it was 'very exciting to feel that we had become wanderers with enough money behind us to prevent us worrying about ways and means, and the whole of the world open before us for adventure and travel'.[28] She also remembered that talk of Hitler's rise to power preoccupied everyone, including their friends, the Prassinos, with whom they stayed.

Nash found Paris 'a grey depressed town where there is no gleam of sun and all the women are in black. Not that a blond in black doesn't look pretty good but they all have a determined predestined-widow appearance which is depressing and probably unnecessary.'[29] Despite his still rather poor health, Nash enjoyed a Mae West movie, was thrilled by the exhibition of prehistoric African art at the Ethnological Museum ('sculptures, cave drawings, every sort of made thing – so lovely and so complete; one just feels – what else is there for me to do!'), and he took cold comfort from the fact that Miró, Picasso, and Léger were not selling well: 'Only the painty impressionistic like Segonzac are making anything.'[30] However, Nash soon began to cough and wheeze, and Margaret decided to head south, settling first at Avignon at the Hôtel Crillon.

Unfortunately, the damp, cold weather had followed them, and they were interned inside the hotel: 'The streets were glacial. Frenchmen skidded about in all directions.'[31] On an excursion to Orange, Nash developed 'very alarming new symptoms and it was obvious that he was on the verge of a bronchial, if not a pneumonia attack'.[32] After three weeks, Nash felt better, and he and Margaret

were about to continue on their journey to Spain when Nash had another attack. Taking charge again, Margaret led her ailing husband to Nice. After spending Christmas at an appalling hotel which, according to Nash, catered to zombies, they finally took refuge at the Hôtel des Princes. Once they had settled there, the Nashes were put in touch with Dr Hort, an Englishman, who diagnosed Nash's condition as a polypus and recommended a strict regimen to cleanse the nose. Nash told Ed Burra, who was an ardent collector of trivia: 'Did you know I had at least a dozen polipi more or less the size of small haricots in my unfortunate nose, no? Nor did I, but they've removed eleven to date. It's quite a well known affair in France – ah, les Polypes, le vegetation – mais oui. In dear old England I might have died of them!'[33] Margaret had asked Hort to give her a 'look over': 'Believe me or not she has been ordered treatments and it transpires she is far dirtier inside than I am and I'm supposed to be pretty foul.'[34] Hort subsequently sent Nash to a French physician, Monsieur Papin, who 'proved an even more attractive personality, with a passionate interest in art, and a very dexterous surgeon, who combined discretion with skill, and quickly removed the offending polypus'.[35] Nash seemed to make a speedy recovery.

Meanwhile, the Hôtel des Princes proved to be an ideal place to stay. The proprietress was congenial, and the Nashes' room, overlooking the sparkling blue waters of the Baie des Anges, was large, with tall double windows opening on to a balcony. There was a tower attached to the hotel and the back wall of the hotel looked onto another, higher wall from the top of which hung down masses of flowers, the colours of which when they blossomed in the 'riviera spring were astonishing; their beautiful shape and brilliant reds, oranges, interspersed with pale yellows, exquisite whites, and the magenta of the bougainvillaea, looked like some fantastic oriental embroidery of either Persian or Moorish origin'.[36] The Nashes' room also overlooked the large letters of the façade spelling the name of the hotel, and Nash's R and S (from two of the letters in 'Princes') paintings – in which the letters are juxtaposed incongruously against the Baie des Anges – derived from this view. These light-hearted pictures continue the placing of sculptural elements against landscape as in the Avebury pictures. In addition, there are approximately twelve surviving watercolours and forty photographs of

European and North African land- and seascapes made during this trip. Much of Nash's energy was again given over to his Kodak, which he found particularly useful for its ability to encapsulate fleeting, sometimes incongrous moments.

He felt an English winter would have knocked him out, but even a French one turned out to be an obstacle: 'I often wonder why the Hell I'm here – a tiresome invalid, profitable to no one but the bloody French. Of all the laughable fiascos!'[37] Margaret's health too remained poor, and Nash now felt Nice had a 'barbaric touch' to it. He read Virginia Woolf's *The Waves* and Katherine Mansfield's *Journal*, liking the latter particularly: 'She has a pretty wit and just the sort of fine observation of things and people which I find so amusing.'[38] He wanted to get into the 'spirit of a Roman holiday' but the Nice Carnival, as he described it to Ruth Clark, had a morbid air:

> all the big cars [came] down the Quai Etats Unis in front of the hotel. . . . They were unlit except by the rays of the street lamps they passed which cast queer lights and monstrous shadows on the immense grotesque figures as they went nodding along against the dark sea . . . these piled up groups of nonsense only half discernible, awful bloated forms in crude colours swaying and doddering about as high as the palm trees with the black waves breaking on a ghostly shore beyond, had a nightmare dignity which I found fascinating.[39]

A moribund surrealism had certainly taken over his journey in search of health. He looked, he felt, like 'three quarters of a pound, cold boiled death'.[40]

Henri Matisse had a studio near the Hôtel des Princes, where Paul and Margaret dropped in on him. When Nash's asthma was mentioned, Matisse pressed him to obtain a rowing machine similar to the one he himself used. The French artist then placed the gadget in front of Nash and then 'excitedly showed him how the fixed oars were worked; in order to apparently expand your chest and improve your breathing'. However, it soon became apparent to Margaret that this was not the cure they were looking for: 'As M. Matisse was descended from men who had always had to do with the sea and with boats, he himself possessed the robust physique which enabled him to practise this artificial rowing with great profit to his general health. It was obvious that Paul would suffer considerably if he tried

this strange exercise, and so poor Monsieur Matisse was dis-
appointed to find that his demonstration was to no purpose.' As a
consolation prize, Matisse took the Nashes to his favourite
restaurant, 'Victor'.[41]

From Nice, the Nashes made excursions to visit Matthew Smith
at Cagnes and Augustus John at Eze, where the most celebrated
English artist of his generation 'dispensed liberal hospitality to all
and sundry, while his beautiful wife watched the scene sitting
framed in the window, as if she were posing for one of her husband's
famous paintings of her'.[42] Back at Nice, Paul and Margaret were
surprised to hear that an American lady, who was staying at Monte
Carlo, had come to visit him. Instead of the pretty Riviera landscapes
she obviously hoped to find, Nash showed her the megalith pictures
on which he was working. The lady was dismayed: 'Well, Mr Nash,
I am deeply obliged to you for your courtesy in showing me your
paintings, but why do you paint?' Nash was so taken aback by this
that he lamely answered, 'I am afraid I cannot explain why I
paint.'[43] The lady quickly departed.

Paul and Margaret pressed on to Spain by way of Gibraltar, where
he again became ill. When he had recovered sufficiently, he took
more photographs. Next, they went to Algeciras and Málaga Picas-
so's birthplace. Morocco was their next stop, and they considered
wintering in Marrakesh. Instead, however, they embarked for
England from Gibraltar. The crossing was a rough one, and Nash
was again unwell: 'Paul was so appallingly ill, that the Dutch doctor
who attended him was obliged to give him a shot of morphia
in order to stop the terrifying condition of asthma produced by
seasickness.'[44] On arrival back in London in June 1934, it was
obvious that the purpose of the trip – to find some relief from Nash's
bronchial condition – had not been fulfilled. Nash was in despair.
Margaret – ever resourceful – learned of a German inhalant which
brought quick relief from the attacks. For the rest of his life, Nash's
'puffer' or, as he sometimes dubbed it, 'cobra', was never far from
his side.

In November 1933, at the outset of his trip, Nash had written to Ed
Burra who was in the United States, asking him to fill out a bio-
graphical questionnaire concerned with Unit One for Herbert Read,
who was preparing the catalogue to accompany the exhibition at

the Mayor Gallery: 'the great thing is to treat the Questionnaire merely as something which may start off a line of thought about which you feel inclined to write. Take a good look at it but don't let it get *to* you; once it seems like driving you crazy take it and wipe your arse with it.'[45] Nash also told Ed that Clarissa Aiken had been to see them while Conrad was in America and that she had told them she was ensconced in a London boarding house surrounded by male students. Ed did not bother to complete the questionnaire, but he conveyed the gossip about Clarissa to Aiken. Nash was full of righteous indignation when he wrote to Burra on 9 February 1934:

> Well all I can say is that from that day until your letter arrived the other day I heard nothing from you but I did hear *of* you. And how. About a month ago I had a troubled letter from Clarissa asking if I had told Conrad that she was on the town in a boarding house surrounded by earnest students or some balls like that. Believe me or not or believe her or not, old Connie sent a *Cable*: I challenge your virtue stop hear you are on town stop living in boarding house stop surrounded by earnest students stop. Take next boat Boston Conrad.[46]

A month later, Burra, an inveterate joker, gleefully told Nash: 'Othello and Desdemona Aiken are right this *minute* on the high seas ... and arrive I believe Saturday in dear old Rye & hope the kitchen is cleaned up or Desde will stuff her own hair down her throat & fall suffocated.'[47] Meanwhile, Burra had still not completed his questionnaire, Douglas Cooper and Herbert Read having written a statement on his behalf.

Nash wrote his own contribution to the Unit One catalogue during his stay at Nice: 'If I were asked to describe this spirit [Englishness in painting] I would say it is of the land; *genius loci* is indeed almost its conception. If its expression could be designated I would say it is almost entirely lyrical.'[48] By 'lyrical' he meant that each English artist responded, like himself, in a deeply personal way to place. During the winter of 1934, Nash had not abandoned either 'structural purpose' or 'formal interaction', but he thought he had discovered at Avebury a *genius loci* which would allow him to unlock those forces in his art.

In fact, the notoriety gained by Unit One at the Mayor Gallery

Sorrow, from *Urne Buriall*, 1932

(and at the smaller travelling show derived from it) did not help these artists to stay together. The reviewer in the *New English Weekly* sarcastically pronounced that the new era in British art envisioned by the group could not begin until 'the social structure is changed and it would be foolish to imagine that it can be changed by painting a couple of circles'.[49] Political pressures obviously acted against Unit One, but, as well, Nicholson and Hepworth were moving more and more into the confines of the rigorous abstractions demanded by the Seven and Five Society.

In late 1934, a vote was held to determine which members of Unit One were to survive – a unanimously favourable response being required to retain membership. By this time, the Unit was divided into two factions: abstraction (Nicholson, Hepworth, Wadsworth, Bigge) versus surrealism (Armstrong, Burra, Hillier). Only the two middle-men of the group, Moore and Nash, survived the 'crazy' ballot, which effectively brought Unit One to an end. In January 1935, writing to supply Aiken with information for his London letter for *The New Yorker*, Nash told him:

> you can safely say there is a definite movement towards the practice of & experiment in abstract art – among the younger artists, which is more evident since the formation of Unit One which, with its change of composition, should become more than ever the central force and inspiration at the back of contemporary art in England – or some such balls![50]

These were valiant words concerning Unit One, but its influence was, as Nash suggested, an important one for the future of British art.

Meanwhile, the Nashes arrived back in England in June 1934 without a real home. After the luxuriousness of their hotel room at Nice, 176 Queen Alexandra Mansions was small and cramped, and the dust and petrol fumes in London quickly began to irritate Nash's chest. The one bright spot at this time was a contract from his dealer, Dudley Tooth, guaranteeing him £300 a year for sixteen canvases, three-quarters of which were to be still-lifes and land-scapes.

Throughout the twenties and thirties, Nash remained resolute in the face of poor picture sales. He and money, he sadly reflected, had no affinity: 'It will neither come to me freely nor can I keep it. If

only I had heaps of the damned stuff I'd soon show my contempt for it!'[51] Despite frequent financial setbacks, he often appeared unruffled, even jaunty. He could take up the Charleston with determined enthusiasm and laugh at the ludicrous sight he presented to the astonished pedestrians who, peering through the window, could see him 'Jigging & swooping about like some demented raven'.[52] He could pass on gossip about Noël Coward: 'the homos are simply legion and guardsmen and troopers much in demand. Also . . . Noël's house in Ebury Street has been put out of bounds at Eton!'[53] He could tease Margaret: 'If you ever get unbearable, darling, I shall send you off for an affair with a Belgian poet.'[54] Nevertheless, the veneer of carefree disregard frequently peeled off, and he felt overwhelmed with despair as he saw himself going deeper and deeper into artistic waters in which he might drown: 'I do wish one day I might know how to paint. Each time it seems just as difficult.'

He hated the search for an audience which would appreciate his work: 'I really ought to have a competence and be free to forget this damned responsibility I have to all these agents and exhibitions. One is after all rather like a performing dog always being goaded onto his hind legs.'[55] In one of his more depressed moods he dubbed life 'a bitter and resentful force as jealous as the cold sea and as mean as poor old Fry!'[56] Sometimes his natural buoyancy allowed him to ride out his difficulties; at other times the black waves of depression got the better of him.

————————•————————

Landscape from a Dream

1934–6

IN JUNE 1934, Colonel Dick Rendel, whom the Nashes had met through Bertie Buchanan, invited Paul and Margaret to stay with him, his wife, and young son at his home in Owley on Romney Marsh. The Nashes were desperate to leave London, and the prospect of spending time at a favourite place appealed to them very much. While the Nashes were at Owley, the annual festival in memory of Ellen Terry took place at nearby Small Hythe, and Mary Eversley, who assisted at the Memorial Festival, helped them find a more permanent lodging at 'Cullens', a cottage at Potter's Heath. Unfortunately, the cottage proved to be cramped and filled with bats: 'Paul spent night after night chasing bats out of our bedroom while [Margaret] cowered under the bedclothes in abject fear.'[1] But the bats, no sooner put out of a window, returned; 'apparently they enjoyed the chase.'

Unfortunately, Nash's asthma returned, probably because of the cottage's proximity to the river. But, despite this, 'Cullens' was the scene of an important discovery, as Margaret remembered 'We were walking along the river bank one hot [August] afternoon and there lay *Marsh Personage*, his most thrilling *objet trouvé*: it consisted of a strange decayed trunk and a curved wooden bark which lay nearby, and it gave him a fascinating assembled object ...'[2] As Nash said,

it was a ready-made work of art: 'Yesterday I found a superb piece of wood sculpture (salvaged from a stream) like a very fine Henry Moore. It is now dominating the sitting room waiting for a bright sun to be photographed.' Of this new direction, Nash later wrote: 'Henceforth Nature became endowed for me with a new life. The landscape, too, seemed now possessed of a different animation. To contemplate the personal beauty of stone and leaf, bark and shell, and to exalt them to be principles of imaginary happenings, became a new interest.'[3]

At this time, Nash saw himself as a desolate found object: 'I enclose some pretty grim photographs. Do I really look like that? But I don't mind. Not so much. . . . You can see my uneven eyes. . . . Also one side of my mouth seems to have got depressed more than the other.'[4] A 'famous local quack' whom he consulted told him that he did have a 'panacea' with which he could 'plug' him, but he also claimed that Nash's kind of asthma was 'all a matter of senile decay'.[5] Also, Nash lamented, his 'eyelids shut up like a roll top desk, they feel like locking'.[6] In these sombre reflections, the artist captured the ravages of the illness which now constantly plagued him. His handsome face had become haggard, its lines drawn taut.

During this stay at Romney Marsh, the Nashes met Charles and Clare Neilson, who became friends and, as well, collectors of Paul's art. From the outset, Margaret had serious doubts about Clare when she sensed that there was a strong attraction between her and Paul. Margaret, who usually kept meticulous records of acquaintances, does not mention the first meeting with the Neilsons in her 'Memoir' – she does refer, however, to Nash's later 'delightful visits to the Neilson home in 1943, where "with Mrs Neilson's help" he saw the Forest of Dean, the Wye Valley, and the Severn Bore'. At the end of August 1934, the Nashes were back in London, where a specialist in asthmatic complaints provided Nash with a new type of 'boa' – the Riddell Inhalant. For a time, this new device warded off attacks. Still, as he told Ruth Clark, he remained fretful: 'No one buys my work any more apparently. . . . My painting is finished and looks pretty queer. I should like to get away and work quietly for several years – shall I ever?'[7]

In October 1934, Paul and Margaret were on the move again, this time back to Whitecliffe Farm, Dorset, which was lent to them

by Hilda Felce. Margaret loved the house, and was especially glad of the presence of the two maids Mrs Felce left behind. The Lancaster Herald, Archibald Russell, lived nearby, and Nash formed a friendship with him based on a mutual enthusiasm for Blake.

As often happened when they were forced together, Paul and Margaret quarrelled incessantly at Whitecliffe. Often Paul would ignore Margaret's histrionic outbursts or her never-ending embellished accounts of people she supposedly encountered in the high street while shopping. Sometimes, they would engage in a steady stream of well-turned repartee, punctuated with excessive 'darlings' and 'dearests'. Margaret would become particularly incensed at her husband's appreciative comments on the slim elegance of other women's legs. Or she would be insulted by his lament that English ladies purposely made themselves unattractive in order to escape his wolfish attentions: 'Do you suppose that's what really *nice* Englishwomen do [on trains]? Travel dowdy to avoid attention or *attentions* then pop into the lavatory in time to look O.K. on arrival?'[8] When visiting them, Ruth Clark usually found herself simultaneously engaged in two different conversations, Paul and Margaret vying with each other for her undivided attention. As well, Nash remained restless. He never seemed to be interested in the projects he had in hand but looked forward to a multiplicity of ventures. The 'next' series of paintings seemed to hold his undivided attention.

In the autumn of 1934, Nash mentioned to Ruth Clark the glass designs he was making for Stuart Crystal: 'the cottage is stiff with vases and tumblers. I am finding it interesting to do but rather tricky.'[9] He was undertaking this commission to overcome poor picture sales. At the same time, his reputation as a photographer was rising, as he also informed Ruth Clark:

There are some lovely new photographs to show you. I am making a last desperate shot to win one of the Listener prizes but there's a catch about competitions and I find the principal judge is a large yellow Scotch female. I'm afraid I stand a poor chance. However my reputation as a photographer is growing alarmingly. I am pretty certain it will eclipse mine as a painter unless I take a firm line. If the truth were known, photography has enormously widened my picture vision so that when I begin on a period of painting I believe I shall feel the benefit, as they say.[10]

Six months later, Nash told Conrad Aiken that he was, indeed, pleased by the 'period' upon which he had just embarked:

> I wish you could see the new pictures – they are beginning to come on now: as soon as I have a few representative photographs I will send them. For some weeks I worked contrarily & seemed getting nowhere but just lately I feel somehow released, my doubts are melting away. In April I have to assemble a show of watercolours at the Redfern Gallery, so quite soon now I shall have to concentrate in that direction.[11]

The fifty or so smallish watercolours, mostly of Swanage and the Dorset coast, hint only intermittently at a new 'direction'. Some of these, such as *Abstraction* and *Wood Fetish* display the artist's new-found interest in sculptural form as seen in the Unit One exhibition the previous year; canvases such as *Sea Wall* are strongly geometrical reworkings of previous themes and preoccupations. Most of the pictures seemed to have been produced in haste, and were little more than charming, offhand travelogue glimpses of France, Spain, and North Africa.

Indeed, Nash's new phase is not reflected in the Redfern exhibition because, as he himself said, photography had now become a major preoccupation. Many of his finest photos are simple pieces of landscape. Others are fine pieces of juxtaposition (the intricate iron railing in contrast to the sea in *Parade*; the heavily marked rocks in *Chesil Bank* placed dramatically in front of the ocean; the crushed seaweed and resilient stones in another photograph; the fence and the water in *Fence by a River Bank*). The strongest photographs, however, are of the found objects: *Marsh Personage*; the staged presentations of objects: *Dracula* and *'Lon-gom-pa'*; and in the landscapes which hint at hidden presences: *Demolition Landscape* and *Haunted Garden* (plate 32). In his photographs during 1934–5, Nash explored in another medium the subject matter which had dominated much of his previous work. His camera allowed him to see in a new direction, or, more significantly, to view his old work in a new way.

The Redfern exhibition was a financial success, and the Nashes were not unduly worried when they had to move in February 1935 (upon Hilda Felce's return from the Riviera) to Number 2 The Parade, on Swanage Front.

* * *

Shortly before leaving Whitecliffe, Nash had been given a new commission, by Jack Beddington, to undertake the *Dorset Shell Guide.* The invitation to work on the Shell guide came initially from John Betjeman, the editor of the series. The writers commissioned to produce books for this venture, which was an attempt to make motorists aware of sites and landmarks readily at hand by car, were given a free hand in assembling information on the buildings, flora, fauna, history and customs of their counties, each book containing a gazetteer of places and haunts which the compiler found of interest. This series was launched in 1934. Two years later, Beddington was using a new slogan for his lorry bill posters: 'To visit Britain's landmarks, you can be sure of Shell.'

Nash decided in his book to highlight only those features of the county 'which seem peculiar to itself'.[12] He ignored many obvious places in Dorset and the resulting book is a personal assemblage of places and things. His main interest was obviously in natural settings, but there are photographs of the head of an adder and of Tess of the D'Urbevilles' grave. There is a particularly haunting charm to Nash's photographs of the wreck at Chesil Beach and the grass steps at Milton Abbas. However, Nash's prose entries in the gazetteer are sometimes perfunctory, as in his description of Swanage: 'Perhaps the most beautiful natural site on the South Coast, ruined by two generations of "development" prosecuted without discrimination or scruple. Tragedy relieved by odd examples of unconscious humour.'[13]

Nash's introduction to his book (*The Face of Dorset*) is one of his most important statements on art because here he directly links the human face to landscape, and, in so doing, justifies his preference for landscape over the seemingly more personal use of human figures in the work of other artists:

When we speak of the face of the earth, the face of the waters, quoting that ancient imaginative expression, we probably refer to an extent or expanse of space rather than the suggestion of a featured mask. But in describing some comparatively small localised area of land and sea, it is perhaps possible to think of it in a more literal sense as, in fact, something like a countenance. At least, I have sought to conceive such an actual symbol in this description of the county of Dorset. As I see it, there appears a gigantic face composed of massive and unusual features; at once harsh and tender, alarming

yet kind, seeming susceptible to moods but, in secret, overcast by a noble melancholy – or, simply, the burden of its extraordinary inheritance. Indeed, the past is always evident in that face.

At the end of the preface, Nash reminds his reader that the object of the guide 'must be to stimulate curiosity rather than to satisfy it. You have wheels, you have eyes, what I have seen you can find – and infinitely more besides.'[14]

As his capsule description makes clear, Nash had misgivings about Swanage, although he and Margaret considered building a house there. In the midst of the search which ended with their finding 2 The Parade, he said to Ruth Clark: 'And all the time Swanage was getting us down. Every day it seemed more unbearably vulgar. The people who live there, my God, the people who come there on the buses and steamers – beyond belief.'[15] However, the Nashes were able to escape from Swanage in a friend's motorcar, touring places which were themselves candidates for the Shell guide.

Nash's relatively tranquil life in Dorset was saddened when he heard of T.E. Lawrence's death in May. Four months later, on a visit to the Withers at Souldern, crestfallen he told Margaret that he had reached the unenviable distinction of being 'regarded as the greater invalid of two [himself and Percy]. . . . I am implored not to tire myself in any way. Thus I escape all walks & as P has to do all the walking & rest twice a day in solitude, I have hours to myself on the lawn in a deck chair listening vaguely to the old mill stream & watching Nature.'[16]

The prosaic existence back at Swanage was disrupted, however, when Nash, on a brief visit to London at Christmas and New Year 1936, suffered the most serious attack of asthma that he had ever experienced. All the hospitals were closed, but Margaret finally found both a chemist who had an oxygen tent and a doctor who gave Paul an injection of morphia. This doctor claimed that the weather of the Isle of Purbeck was disastrous for an asthmatic and so, yet again, the Nashes were forced to move.

When he was preparing to leave Swanage, Nash wrote, as a parting shot, *Swanage or Seaside Surrealism*, which appeared in the April 1936 issue of *Architectural Review*. In this lively piece, he showed a flair for crisp, dry satire when he made a sardonic compilation of all the 'odd examples of unconscious humour' which had

surrounded him there. Nash began by admitting that he had only gradually discovered that 'Swanage was definitely, as the saying is, surrealist.'

> To make myself intelligible, I must refer you to certain explanations of that much-worried word. Perhaps the most popular is that of the poet André Breton, who has attempted to convey an idea of surrealism by suggesting that a statue in a street or some place where it would be normally found is just a statue, as it were, in its right mind; but a statue in a ditch or in the middle of a ploughed field is then an object *in a state of surrealism*.[17]

Nash then went on to say that any work of art not concerned 'with the mere reproduction of the bald external appearance of logical reality, may be termed surrealist in the widest sense of the word ... the latter state may be said to exist to an interesting degree in the character of the Victorian watering-place under review'.[18] Swanage, according to Nash, had led many interesting lives. In the fossil age, it was a haunt of turtles and crocodiles; much later, it became a 'vigorous fishing village'; then a '*nice* watering-place'.[19]

The person who could appreciate the full ugliness of modern Swanage would be a 'shipwrecked stranger struggling towards the shore through angry waves on a dark night'. This man 'wanders down the deserted esplanade until a stone column surmounted by a pyramid of cannon-balls set askew looms in his path. Reading the inscription that this monument was raised to commemorate King Alfred's victory over the Danes, he becomes convinced his reason has left him or that he is merely a part of a dream.'[20] The stranger becomes even more confused when he sees a Wren façade grafted on to a Victorian–Gothic structure. 'Entering the grounds of an imposing hotel, he is not surprised to find two vast Corinthian pillars standing up in the drive without any relation to the building. A memory of Chirico starts up, and he looks uneasily down at the shore, expecting to see it invaded by stampeding horses.' Other strange sights greet this visitor to a place which has 'a strange fascination like all things which combine beauty, ugliness, and the power to disquiet'.

At Swanage, Nash also began work on *Outline*.[21] This was not so much an ordinary autobiography as an attempt to grasp those elements in his being which had led to his becoming an artist. The

question of *why* he had become an artist seems to have haunted him at this time. If *Outline* was an attempt to explain himself by words, then a less cerebral attempt is to be found in *Landscape from a Dream*, the great oil-painting that he worked on during 1936–8.

In *Landscape from a Dream* (plate 33), there are three realities: a depiction (confined mainly to the right background) of the Swanage coast; a lattice structure in the right foreground framing the coast in the background; a large, framed painting which dominates the left-hand side of the picture area. At first glance, the painting within a painting seems to mirror the external world of Swanage; however, the sky in the painting is red and there are seven cloud formations; the sky in the other picture area is blue with one large full cloud.

All three realities coalesce in the hawk whose back is to the viewer in the Swanage setting, whose claws grasp the lattice, and who is depicted in the painting. The bird, who looks at an image – not a reflection – of himself, is probably the same bird who soars off into the distance in the painting within a painting. The sphere (taken from rolling grass in a Humphrey Bogart film) also has a Swanage form, but the bright red sphere in the stand-up painting depicts its transformation into another reality. The hawk and the nearby sphere are thus shown to be metamorphosed in the framed setting.

Landscape is a meditation on the process of art. The painter is attracted to landscape which he sees as a possible reflection or sounding board of important conceptions; however, in order to make it into art, he must demarcate his chosen terrain and impose order upon it (the lattice symbolizes this part of creative activity); after the painter has marked nature off, he creates a work which reflects but which is apart from nature, the resulting painting having an existence of its own.

The hawk lives in all three realities: he is within nature, he gains the attention of the artist as a subject, and he becomes in the framed painting a symbol of the possibilities of the imagination. The picture also suggests that the artist has not only the power to depict the beauty of the natural world but also to see the significance behind superficial appearances. However, he must use his power to impose order upon that beauty to effect the transformation from the realm of nature into the order of art. The artist also sees beyond ordinary

mortal significations in his art to the truth often shut away. Thus, he knows the mortal world, but he is also aware that there is a spiritual world beyond in which the sphere and the hawk participate. As well as being about the nature of art, this painting is concerned, then, with immortality and the unknown world into which death releases the spirit. It was surely not a coincidence that Nash ordered the Egyptian hawk figurine – the model for the animal in this picture – to be placed on his own tomb.

As his health worsened in 1935–7, Nash reflected back upon his Iden pictures of 1929. *Environment for Two Objects* (plate 34) and *Changing Scene* are reworkings of *Nest of the Siren*; *Nostalgic Landscape* (finished 1938) owes a great deal to *Blue House on the Shore*; the tree stump in *Empty Room* hearkens back to *February*; as well, the complex levels of reality in *Landscape* are a sophisticated restatement of the tripartite structure of landscape, barren orchard and stake-basket in *Landscape at Iden*. He drew inspiration too from the pictures he had painted at the time his father died. It seems that for Nash, death was not only a hidden, forbidding reality, but it was also a potential entry into the spirit world, and as such its mystery – and hidden face – once again inspired him.

Monsters

1936 – 9

DESPITE HIS FONDNESS for the South Coast, Nash had always seen himself as a Londoner, fascinated with its 'thousand facets and incalculable moods' and 'beauty of grey, white, and blue and ... marvellous soot-black on Portland stone'. After the various peregrinations, which had become his life from 1934 to 1936, he decided to settle in London. According to Margaret, Hampstead was chosen upon a doctor's recommendation, but the real reason for the move to Eldon Grove in the autumn of 1936 was probably because there was a nucleus of artists centred on Haverstock Hill:

> A row of studios, the Mall, housed Nicholson and Barbara Hepworth, Moore, Herbert Read, and John Cecil Stephenson. ... Walter Gropius had already arrived in England (in 1934), and had taken one of the flats in Lawn Road recently built by Wells Coates; Marcel Breuer arrived towards the end of 1934, Lazlo Moholy-Nagy and Naum Gabo came in 1935, to be followed in 1938 by Piet Mondrian, who settled at near-by Parkhill Road. Other artists, writers, and collectors connected with the modern movement who lived in this area at the time were H. S. Ede, Margaret Gardiner, Geoffrey Grigson, Adrian Stokes, and John Summerson (who in 1938 married Barbara Hepworth's sister, Elizabeth).[1]

Given Nash's commitment to contemporary English art, his new home was in an ideal location.

Despite pleasant surroundings and neighbours, and the oppor-
tunity to have a large, sun-filled studio, Nash had many trepidations
above the move, as he told Archie Russell: 'Although the furniture
is in, the house is not yet habitable, the distracted painters and
carpenters are still working doggedly on, and the blasted electricians
pull up the floors under our very feet. When all is done I think it
will be a swell house and lovely to live in. Meantime I can work in
my studio and we can take our tea on the lawn!'[2] Nash's health did
not worsen during the first few months in London, but Margaret
described one of the new treatments as being itself surrealistic: it
'consisted of being shut up in a room all night with a frightening
machine which poured out a kind of inhalation of vapourized tar'.
This regimen accomplished nothing and wore Margaret out since
she 'had to constantly visit him during the night to make sure that
he had not passed out with asphyxiation, as the room had to be
hermetically sealed so that he could inhale the vapour to its full
strength'.[3] This nerve-racking, useless 'cure' was discontinued after
six weeks.

Drawbacks aside, life at Eldon Grove, 'ugly without but spacious
within' Nash called it, was serenely pastoral, and the Nashes com-
missioned an Italian workman to make a grotto for the garden,
which largely consisted of oyster shells cemented on to rough sand-
stone. Still, Nash remained apprehensive: 'We have bought this
lovely house but I don't think two can afford it at all. Sooner or
later we shall have to divide it all. We were just about knocked out
financially by the expenses of my illness.' For Nash, his life had
become an endless series of worries about physical and financial
health. Sickness continually invaded him, rendering him wary and
depressed. At such times, he thought of suicide. Nevertheless, he
tried to brush morbid fancies aside and attempted to lose himself in
his work. The Nashes were also 'quite beggared' and would 'have
been sunk', but an aunt of Paul's died and left him 'a small packet
of dough'.[4]

There were further visits to Dorset in 1937, and Nash resumed
teaching at the Royal College of Art for two periods a week as an
assistant in the School of Design from January 1938 until the
evacuation of the school in November 1940. This bout of teach-
ing was the longest Nash ever undertook, and the £120 yearly
fee he received was a substantial portion of his average annual

income of approximately £750. However, Edward Bawden did not think Nash's second tour of duty at the Royal College of Art. went well:

> On Nash's second appearance at the Royal College of Art he did not go round to students personally, they came to him one by one where he sat in a dark basement room with the window barred & the walls lined with Office of Works bookcases filled with official ledgers. By then I was a member of the teaching staff & did not see much of Paul. His manner was pompous & any conversation was likely to be broken by an asthmatic struggle for breath.[5]

By this time, Nash had become even more bitter about his illness, and he and Margaret were desperate to find a cure.

Dr Haskins, Nash's GP in Hampstead, suggested a nursing home run by Seventh Day Adventists, who used a vegetarian regimen based on the principle that asthmatic conditions were due to dietary deficiencies. With some trepidation, Margaret left Paul there. However, when she had returned to the clinic two days later, he was 'utterly exhausted, with a continuous asthma attack'. In defiance of the clinic's regulations, Margaret obtained coffee and tea for him. She did wonder, however, if the doctor at the clinic might have been correct in his assertion that her husband's

> main digestive trouble was really of a psychological rather than of constitutional origin. He explained to me that the digestive tract was working too quickly, so that it was impossible for any quantity of food which passed through it to be immediately digested, and this state of things was due to some highly tensioned mental condition. This of course reacted on the bronchial tubes causing them to be strained and therefore causing the asthmatic attacks.[6]

According to Nash, the place was a 'looney bin', from which he threatened to escape by pretending to be 'pregnant and get into the [nearby] maternity home'.[7]

The diagnosis offered by the Seventh Day Adventists, in its insistence on a psychological rather than a physiological cause, was soon discarded by Paul and Margaret in favour of an allergy to dust. However, there can be little doubt that Nash's susceptibility to asthma may have been furthered by nervous anxiety. Lord Horder, who saw Nash for a consultation on 25 July 1945, provided this diagnosis: 'He was suffering from a gross form of chronic bronchial

catarrh with asthma and a failing heart. I had no reason to attribute these troubles to gassing.'[8] However, the Nashes continually looked for a panacea – for them, the only acceptable explanation of Paul's atrocious health was lodged in the past.

Meanwhile, Nash took the opportunity at Christmas in 1937 to revivify his friendship with Gordon Bottomley, their correspondence having lapsed since 1932. As Bottomley's letter of 17 January 1938 indicates, he had been following Paul's career during the past six years:

> And, so, we always remember to be *au fait* with you; and, as I was saying, the essential thing is not that we sometimes find ourselves not travelling the same way as you, but that we can always count on your periodically doing something that speaks to our old hearts as of old – and that tells us that Paul I (eldest member of your Dynasty) still survives and possesses the creative energy that can always delight us.

Bottomley's letter also makes clear that Nash had hinted to his old friend that he was returning to some of the interests which had fascinated him as a young man. More importantly, he also told Bottomley that he was sure his life was drawing to an early close: 'You tell me to take heart because you are now on the short way home (to the kingdom in which we first met); so I feel really entitled to remind you I once wrote to you that the best place for an artist to work is in his own parish, but that it is not enough for him until he has gone right round the world and entered it from the other side! Was I truly a prophet?' However, Bottomley's rigorous, smug sensibility had remained entrenched: 'we grow older; and love the same things and people and painters and poets.'[9]

There were few excursions away from London during the years immediately before the Second World War, although a visit to Tintern Abbey in June 1938 moved him: 'I'm not surprised Wordsworth let himself go. It's superb. One of the few really dignified marriages between the works of Nature & man.'[10] A year earlier in September 1937, when visiting Swanage, he saw a Gary Cooper film: 'It was a nice open spaces, red indian stuff with my nice Jean Arthur looking pretty good in breeches.'[11] Despite his troubles, Nash could still rally.

Nash's Redfern exhibition of 1937, and the one the following year

at the Leicester Galleries, demonstrate how much the type of canvas achieved in *Landscape from a Dream* had been consolidated, although the latter show, at which that painting was first exhibited, is a stronger, more concentrated display.

The artist's photography had been concerned for a number of years with found objects, but it was at the Redfern exhibition that photographic experiments found their way directly into paintings such as *Wood of the Nightmares' Tales*. In this picture, the mare's tails are solitary grotesque growths which have killed off everything else. Indeed, they have become the forest. This painting also shows how a hostile outside force can intrude itself into an environment and bring ruination. In this watercolour, Nash's own preoccupation with how his body had been overrun by a debilitating bronchial condition is graphically shown. Indeed, this had become his constant nightmare.

One picture common to both exhibitions was *Three Rooms* which uses a tripartite structural pattern reminiscent of *Landscape at Iden* and *Landscape from a Dream*, although *Three Rooms* is a unique instance in Nash's work of three separate images in a single picture. In the bottom image, the sea penetrates the room; however, the dominant force in this picture is the rising sun. As in the Dymchurch pictures, the sea can invade and bring destruction to any human life; the presence of the sun here, nevertheless, suggests that such forces can be conquered. The depiction of the forest overtaking and obliterating the room in the middle area is similar to the devastation of the woods in a painting such as *Nightmares' Tales*. However, there is a realm of existence beyond the forest depicted in the interpenetration of room and sky; the emphasis on the aerial in the top image points to a realm 'behind' – the forces of undoing can be conquered. It is also possible to read this picture in a Blakean manner: the bottom picture depicts the realm of innocence (which is often threatened in the *Songs of Innocence*); this gives way to the world of experience and apparent death; but the travails of human experience, if properly confronted, lead to higher innocence, where innocence and experience are fused together in a harmonious way.

In *Empty Room* Nash shows how the force of death can invade the quiet domesticity of a room. However, this picture is extremely ambiguous because the room depicted was in the Swanage home of a lepidopterist friend (Archie Russell) who captured moths by

leaving windows open at night. The room is vandalized by nature because it, in the manner of a siren, has attempted to ensnare living creatures. Nash may be suggesting that death comes to those who allow a hostile, invading force to take over their lives. In any event, the presence in *Empty Room* of the tree stump from *February* makes it clear that this picture is about death, but this conscious self-borrowing probably indicates that this canvas is concerned with his own impending death – not his father's.

Despite the richness of the Redfern exhibition, that at the Leicester Galleries was a much better display of Nash's talent. In *Encounter of Two Objects, Nocturnal Landscape* and *Circle of the Monoliths,* the pictorial experimentations of the earlier Avebury pictures are given a sharper edge. The sculptural forms here are more intrusive and foreign than in *Objects in Relation* or *Event on the Downs.* These pictures have a sinister bite to them, a quality lacking in the Avebury pictures from 1932–4. As well, the chaste beauty of *Blue House on the Shore* from 1929 has been replaced in *Nostalgic Landscape* (finished in 1938, although started as early as 1923) by harsher, more con-voluted lines.

The sometimes frightening ambience of the Leicester Galleries exhibition is clearly demonstrated in *Changing Scene* and *Environment for Two Objects,* the two oils in which the porcelain doll's head is used. In *Changing Scene,* the head looks away from the spectator towards Whitecliff and the tiny figure climbing the slope of the Ballard Cliffs (in *The Wanderer* from 1911, the person entering the woods penetrates a potentially hostile environment which, as we have seen, is also associated with the feminine); the siren-like aspect of the head is perhaps reinforced by the dead flowers next to her: does she bring life or death to the wanderer she looks out upon? Rather than being a caring, mothering figure, she is more likely a virago who uses her power to despoil. In *Environment,* the head and the charred door handle (called by Nash 'the black flower') are placed near each other looking out over Kimmeridge Bay. The suggestion here is that the lady has destroyed the handle (perhaps from rooms similar to those in *Three Rooms* and *Empty Room*), and that she also controls the sea. In all these pictures, as in *Nest of the Siren* and *Salome,* evil forces are clearly female.

Although these images are ominous. Nash asserts in *Nest of the Phoenix* that the conquest of death does not necessarily elude man –

in this case, Paul Nash. Here, both the snake and the bird boldly rise up, the snake from its earthly nest to union with the blood-red sun and the phoenix from the rock. This intensely coloured picture, a positive embracing of the world beyond death, hints at the pictorial preoccupations of Nash's four last years.

In June 1938, Nash visited Madams, the Neilsons' new home in Gloucestershire. He was entranced by the long prospects from the terrace, and the topiary below it was for him a haunted garden where hidden presences lingered. From there, he wrote a poignant letter to Margaret, who had stayed behind in London:

> My poor little Mouse. I am so desolated. I could have wept when I heard you couldn't get away. I was so much looking forward to my chap being here and sharing all the good things. My God, what can it be that haunts us so relentlessly, how can we break the spell?
>
> Charles is going to help me sell the house. He strongly advises it in the circumstances. I have told him my plan for cutting adrift and he thinks it a good one. But of course all depends on our health. There are limits. I just feel that we can't be much worse than we are and we might both get better with a change of scene and climate. ... I feel very selfish staying on here, but I am trying to get something out of it besides the rest. I must store up material for new pictures if there is a chance of these foreign shows. I am going into the whole business of agents & so on when I get back. Life, I believe has to be entirely re-constructed if we are to enjoy any happiness. ... I do so want my darling to get a new grip on life. All this evil dream will pass and we shall have a lovely Indian summer together and forget the worries of the past.
>
> This is an enchanting place. A perfect situation. The little house perched up overlooking the hills & valleys. You approach it down a winding drive through a hazel wood, but it opens up into a clearing with a sweet garden & orchard with the rather mountainous looking Malverns massed, on the horizon.[12]

It was, perhaps, wishful thinking that the Nashes could reconstruct their lives – Paul was too ill for that. In this letter, though, one can hear a poignant echo of the new intimacy which was now part of the Nash marriage. Margaret was Paul's 'chap' because as her husband's infirmity plundered him more and more, she acted in an increasingly selfless way. She became his nurse, his agent, his

confidante. His wish for an 'Indian summer' with Margaret and his sense of desolation at her absence are not polite rhetoric, as they would have been earlier.

At Madams, as his letter to Margaret makes clear, Nash thought he had found an unobtrusive but magical setting, but all this changed when he came upon the field on Carswalls Farm near Newent, Gloucestershire, near Madams:

> Have you ever known a place which seemed to have no beginning and no end? Such was Monster Field. ... We called it Monster Field for an obvious reason. Upon the surface of its green acres which flowed curiously like a wide river over the uplands, there jutted up, as if wading across the tide, two stark objects. They were the remains of two trees, elms, I think, felled by lightning during a furious storm some years ago. So violent had been their overthrow that, utterly, the roots of one had been torn out of the ground. ... Both trees were by now bleached to a ghastly pallor wherever the bark had broken and fallen away. At a distance, in sunlight, they looked literally dead-white, but, at close range, their surfaces disclosed many inequalities of tone and subtle variety of ashen tints. Also, in many places the bark still clung, a rich, dark plum-coloured brown. Here and there the smooth bole, gouged by the inveterate beetle, let out a trickle of yellow dust which mingled with the red earth of the field.[13]

The 'monsters' obviously reminded Nash of the found objects he had been photographing and painting since the mid-thirties. Also, he sensed immediately that he had discovered a new 'place'. However, the overwhelming sensation was of the trees as corpses lying in the fields, the seeming presence of death moving him profoundly. In describing the trees, he compared one to the horse in Blake's *Pity*, the other to Picasso's *Guernica*: 'It was certainly bovine and yet scarcely male. Surely, this must be the cow of Guernica's bull. It seemed as mystical and as dire.'[14] Nash's choice of Blake and Picasso as references is significant, since his career as a mature artist had been to merge the traditions of English Art with European modernism. What was most important about this event for Nash was that the bodies had an existence beyond the mortal. He made this important point about the experience:

> What were they like? What did they most resemble in life? ... In Life? Let me be clear upon that point. We are not studying two fallen trees

that look like animals, but two monster objects outside the plan of natural phenomena. What reference they have to life should not be considered in relation to their past – therein they are dead – they now excite our interest on another plane, they have 'passed on' as people say. These now inanimate objects are alive in quite another way; but, instead of being invisible by the complicated machinery of spiritualism, they are so much with us that I was able to photograph them in full sunlight.[15]

In both *Monster Field* and *Monster Shore* (plate 35), the 'monsters' intrude into the front foreground in a sculptural way reminiscent of some of the Avebury pictures. As Nash makes clear, they have been removed from finite existence into some sort of 'plane' – they have 'passed on'. It would seem that here, he directly confronts the horror of death, suggesting that he can conquer it by passing through to 'another plane'.

—————————•—————————

Machines of Death

1939–44

THE OUTBREAK of the Second World War galvanized the Nashes into yet another move. They abandoned London in favour of Oxford. The move was inspired by Margaret, who had a 'sudden hunch' that the Hampstead house would soon be bombed: 'We went up from here and nearly killed ourselves packing. We managed to get a local carrier before the exodus started.... Now the house is almost bare. We watched our lovely home break up and vanish under our eyes. We were left sitting about on odd bits of furniture, just crying.... But you know it is rather exhilarating beginning again.'[1] Nash wistfully told Archie Russell: 'Farewell Surrealist and Pre Raphaelite ghosts alike, and many charming happy days and a few dark and disenchanting ones. It was a sad reverse when I had to abandon my studio – the first and only room I have had for work only.'[2] In July 1940, Nash was even less sanguine: 'We have had the most awful time. I get very wretched often and pray for death. What can come out of such madness? I could not have dreamed of such horrid depths of the human mind.'[3] Christmas of 1940, when both husband and wife were ill, was particularly dire. 'We were left quite alone: no service to be had. Outside in the cold larder, our goose sat solid and uncooked.'[4] Depression frequently threatened to engulf him, but he was perhaps saved by the fact that the war led him in new artistic directions.

The Nashes stayed at the Randolph Hotel in September 1939. They soon found the quest for more permanent accommodation tedious: 'After some futile searches we have got some delightful rooms a few doors from here in Beaumont Street. Two poor young things a few months married – just as Margaret and I were at the beginning of the last war, only we weren't actually married – have fallen into our care.... I do not look very far ahead. I think we can only live now like certain creatures who in the scheme of Nature have a limited span.'[5] By the beginning of October, they had moved to 62 Holywell Street. Ten months later, in July 1940, they managed to get a ground-floor flat at 106 Banbury Road, where Paul's studio led to 'a huge garden, all lawn and borders *between red brick walls*. Lovely to develop if one can think of any future.'[6] Since nothing else had been available in Oxford, Paul considered himself lucky: 'I have a fine room to work in and in London the Air Ministry has given me a big studio in Woburn Place. So I am well off if everything doesn't go to blazes.'[7]

When he first arrived in Oxford, Nash founded the Arts Bureau for War Service, which was designed to make proper use of artists in war activities by matching them to the appropriate ministry or service:

> In the present emergency the talent of artists of all kinds, architects, sculptors, painters, writers, and musicians, should be regarded as potential material for war service. If this is not recognized fully and artists are not used in their own right as artists, a great hardship will fall on hundreds of men suddenly deprived of a livelihood and there will be a waste of power which might be used in a number of effective ways.[8]

Nash was obviously recalling his own struggles as a young artist during the Great War, and he was attempting to act as an intermediary who could prevent others from experiencing the bureaucratic hostility that he himself had once endured. He told Robert Byron in September 1939:

> I have been given a rather special opportunity to do something towards convincing the official mind that artists have qualifications for what I believe is called 'essential service' – apart from 'camouflage'.... You realize of course that unless architects, painters, poets, writers & so on are intelligently used, they will be wanted in ARP &

observation posts & die a lingering death from penury or rheumatism.[9]

Ultimately, the somewhat sedentary role of running the Bureau was unacceptable to Nash, who wanted to 'explain' the war, as he told Sieveking: 'I expect I shall find a way, if only the damned asthma would let up a bit.... I want to paint and what's more I wanna paint reccuds.'[10] By January 1940 the Bureau had begun to disperse its files to other organizations, and by March it had ceased to exist.

In March 1940, Nash was appointed an Official War Artist by the War Artists' Advisory Committee and was seconded to the Air Ministry until December. After his transfer to the Ministry of Information in January 1941, he made only a small number of war subjects. However, his work for both ministries was infused with a passionate hatred of Nazism and a strong conviction that art had its special part to play in defeating that enemy:

> I am acutely conscious of the position I hold and what I believe to be its responsibility. I want to use what art I have. ... I think picture leaflets should have been used if they were not, and a number of other devices directly appealing to the eye *quickly*, striking and leaving an impression before any power can prevent the impact. Photography is useful, of course, but it is too general, too much taken for granted. ... So, I feel the artist must come in.[11]

As Nash's patriotism found its fullest expression, it was accompanied with an overwhelming sense of *ennui*, perhaps compounded by his feeling that his own life was soon to end:

> I suppose we shall all end by dosing ourselves. I well understand the despair which is growing. I do not believe it comes so much because of a sense of terror or defeat as from the inability to believe that this mighty effort of blood and pain and heroism is vain. No new, better world will come of it, can you believe – I cannot. On every hand we have the shopkeepers making their profits ... and the Civil Servants and the politicians whipping up the exhausted people, draining them dry, shouting or simply announcing into their deafened ears, 'You can make it.'[12]

He did not sense any real sense of urgency on the part of the ordinary Englishman: 'I believe we shall have to *sweat* to win & my God, you don't see too much of that yet.'[13]

Although Nash was to produce many effective war paintings, particularly in 1939 and 1940, he was constantly preoccupied in making a living and keeping some hold over his financial affairs. He told Kenneth Clark in November 1940:

> I have never before had such a stimulating adventure as an artist and, of course, its possibilities of development are infinite. No, all I want is enough money to keep me and my modest home.... At the moment I am embarrassed by debts which had to be incurred. I have to live in a particular way which is not luxurious but rather soft. I have to buy an expensive drug all the time.[14]

What Nash really wanted to do was to use his art 'in the character of a weapon. I have always believed in the power of pictorial art as a means of propaganda.'[15] As he became more and more aware of his own impending death, he wanted to strike out to defend the life of his nation. Indeed, a great deal of the strength of Nash's art from the Second World War emerges from the artist's sense of a double death – his own and his country's. He had been invaded by an asthmatic condition which he knew was so depleting his body that he would die at a comparatively young age; now he saw Hitler's Nazism as a gigantic plague about to embrace his nation. He was bitterly disappointed in August 1944 when the German generals failed in their attempt to assassinate Hitler: 'With that cruel, castrated mountebank dumb and dead the whole bloody circus would run gloriously amok and gouge out Goebbels' little stoney eyes and rip up Goering's stomach.'[16]

Consuming rage is evident in the paintings done for the Air Ministry, and in those images the artist returned to the subject matter of one of his earliest fantasies: the kingdom of the air. In the winter of 1940, he began 'visiting the nearby aerodromes such as Abingdon and Harwell, and interviewing some of the prominent bomber pilots who were able to give him vivid descriptions of the air fighting in which they had been engaged'.[17] In his previous war pictures, Nash has shown a landscape ravaged by the mechanical instruments of war. In 1939–41, he portrayed the intrusion of the mechanical into landscape. The monsters, which had intrigued him from 1934–9, become animated in these pictures. They inhabit the air and then come crashing down to despoil it. Before, for Nash, the

mysterious denizens of air had been ambivalent. Now, the figures are evil, and they do not merely pillage the earth – they fuse their malignant presences into it, as in *Totes Meer* (plate 36), which shows crashed aeroplanes which have been transformed into a huge deadly wave. Significantly, as Nash pointed out to Kenneth Clark, this landscape is under the dominion of the moon: 'one could swear [the planes] begin to move and twist and turn as they did in the air'.[18] In the First World War canvases landscape was desecrated by men; in the Second World War pictures, landscape itself has been infiltrated by omnipresent evil.

The paintings *Down in the Channel, The Death of the Dragon,* and *Dead March, Dymchurch* – all from 1940 – anticipate *Totes Meer*. In the 1920s, the conflict in the Dymchurch pictures had been between sea and wall; in this Dymchurch picture, the sea and wall have been plundered by the fallen corpse of the plane. In *Rose of Death* from 1939, the parachutes descending from the sky herald invasion and destruction.

The power in Nash's Second World War pictures stems from the experiments with monsters that he made in the years immediately preceding the war. It was a natural step to move from the photography of 'monster' forms to the incorporation of similar icons in the way of aeroplanes. The irony for Nash, as we have seen, is that the sky, the source of mystery, has become the repository of pure evil. As he approached death, however, he would once again see it as the domain of the ineffable mystery which controls life.

From 1940 until his death, Nash wrote about his own art. He worked intermittently on *Outline* during these years, and it seems likely that this spurred him on to try to interpret his new work. Just as he was coming to grips with his earliest artistic impulses, he tried to discover the meaning of recent paintings. In this way, he was placing his beginnings as an artist next to final results. As we have seen, Nash was a perceptive critic of others; but only to a limited extent was he able to apply these penetrating abilities to his own canvases. His own work was largely derived from his unconscious, thus the full implications of finished work sometimes escaped him. Nevertheless, he made brave attempts to understand his own creativity.

Nash described his war art with considerable aplomb in three

essays: 'The Personality of Planes', 'Bombers' Lair' and *Aerial Flowers*. In the first, he wrote of his Second World War art:

> I first became interested in the war pictorially when I realised the machines were the real protagonists. Although vast human forces were involved – even at the beginning their operations were directed mechanically, and they assumed increasingly a mechanical appearance. Pictorially, they seemed to me unimportant compared with the personality of the machines they employed as weapons, for, so powerful were these agents of war that, once set in motion, they very soon dominated the immense stage, even though this was divided into three distinct elements, the earth, the water and the air. Everywhere one looked, alarming and beautiful monsters appeared, the tank, the airplane, the submarine, the torpedo and the mine, all had individual beauty in terms of colour, form and line, but beyond, or was it *behind*, that actual appearance, these things possessed each a personality, difficult to determine and yet undeniable. It was not wholly a matter of mechanistic character. These seemed some *other* animation – 'a life of their own' is the nearest plain expression I can think of – which often gave them the suggestion of human or animal features.[19]

As usual, Nash was interested in the mystery residing *behind* the world of appearances, and it was natural that the 'monster' form which would intrigue him the most would be aerial in nature:

> The first species on the list happened to be the Vickers Wellington.... This baleful creature filled me with awe. Its chief characteristic is a look of purpose, of unswerving concentration upon its goal. Its big mammalian head and straight pointed wings, its proud fin and strong level flight, like that of an avenging angel, all make up a personality of great strength.... To watch the dark silhouette of a Wellington riding the evening clouds is to see almost the exact image of the great killer whale hunting in unknown seas.[20]

In 'Bombers' Lair', Nash continued on the same tack, developing his interest in a nest of wild planes:

> Ideally, of course, airplanes should nest in the clouds. Even now some new kind of aerial base jutting up above the treetops may be taking place in a designer's mind. But, as things are to-day, the nearest form to a nest the airplane can be said to inhabit is its hangar.... I prefer to substitute the idea of lair, a place associated

with large, wild savage beasts and to them just as much home as the nest to the wild bird.[21]

In *Aerial Flowers* (written in 1944), essentially a coda to *Outline*, Nash returned to the preoccupations of 'The Personality of Planes' and 'Bombers' Lair', but that miniature autobiography examines the question of flight from earliest childhood memories to his last phase, the sunflower paintings.

> Like many other children, I had my flying dreams. I imagine mine may have been quite a usual type. One consisted simply of flying or floating, usually downstairs and round about the top of the hall.... The flying wish never became an obsession with me, but the domain of the sky, with its normal or imaginary inhabitants, was a pre-occupation of my early drawings, and night was my favourite time for their portrayal. I lived the dramas of the nocturnal skies – falling stars, moonrise, storms and summer lightning.... But my love of the monstrous and the magical led me beyond the confines of natural appearances into unreal worlds or states of the known world that were unknown. Here the night sky might be filled by immense figures, partly articulated by the design of the stars, or the afterglow of sunset disturbed by the burgeoning of huge dolorous heads. It was then I invented my first aerial creature.

Then, Nash claimed, other landscapes (No Man's Land, Romney Marsh) intervened. 'Even so, it is worth mentioning that at the end of ten years I had reached the point of making tentative experiments in abstract design, so called, that is to say, without recourse to equivalents composed of "recognisable" forms.' Despite his lack of success in this direction, his revaluation of colour relationships and 'poise' were, he asserted, his 'first attempts to fly': 'Once the traditional picture plan was abandoned in favour of design in space the true equivalent was virtually established. Imaginatively, in a pictorial sense, I was airborne.' As Nash saw it, his fascination with the soul visiting the Mansions of the Dead in the *Urne Buriall* illustrations was the next logical step in his progression: 'This idea stirred my imagination deeply. I could see the emblem of the soul – a little winged creature, perhaps not unlike the ghost moth – perched upon the airy habitations of the sky.... It did not occur to me for a moment that the Mansions of the Dead could be situated anywhere but in the sky.' After this project, Nash 'made no more paintings of

the sky of this kind'. Nevertheless, he exercised his 'prerogative to depict things in the sky if it suited my purpose'. As we have seen, the Second World War provided that opportunity:

> ... suddenly the sky was upon us all like a huge hawk hovering, threatening. Everyone was searching the sky expecting some terror to fall; I among them scanned the low clouds or tried to penetrate the depth of the blue. I was hunting the sky for what I most dreaded in my own imagining.... I was quickly involved in the Battle of Britain. What fascinated me particularly were the incongruous disasters befalling the Luftwaffe aircraft day by day; crashing into the cornfield or tearing upon the seashore, burning themselves away in the summer coverts, disturbing the pheasants and so on.

Nash desperately wanted to ride in an aeroplane, but this was denied him, and so: 'What the body is denied the mind must achieve.' Thus began the 'new aerial adventures', which inaugurated his last artistic phase:

> It was at this point I encountered my first aerial flowers. I say 'encountered' because they were hardly thought about in the sense of being planned, yet I regard them as a direct result of my imagining in my almost subconscious search for flight expression. They are, I suppose, equivalents of some sort. I do not find them easy to draw, even when they are clearly seen.... These small misadventures do not matter at all. The great thing is to exercise constantly in the imagining of aerial images, probing tentatively always, not unlike those incredibly brave engineers who go ahead of the infantry in search of mines – feeling for death every foot. But it is death I have been writing about all this time and I make no apology for mentioning it only at the end, because anything written here is only the preliminary of my theme.... Death, about which we are all thinking, death, I believe, is the only solution to this problem of how to be able to fly. Personally, I feel that if death can give us that, death will be good.[22]

In this remarkable passage, Nash intimates that his entire career has been a search for the pictorial 'equivalents' of death, a pursuit of the quintessential paradox that in the midst of life we are in death. He now saw more and more how integral his art had been to the inner workings of his psyche, and that the ability to depict death was something for which he had been searching in all his

picture-making. Nash's realization of this ushered in the heightened colouring of the last canvases in which he allied surrealism, the monsters, and modernism to the force of death.

Domestic difficulties continued to overwhelm the Nashes. After a protracted search for a new housekeeper, they were forced to settle for someone who was a 'poor, dumb, exasperating termite' who drove Margaret 'crackers, nuts, nerts and bugs'. Other than that, she was a 'nice old noodle'.[23] Margaret's health was also bad, and they both felt 'steadily more opaque and stinking'.[24] When the Nashes stayed with the Withers in 1941, Percy, 'in a fine state of emotional hyperbole', picked on Margaret mercilessly (she had not visited Souldern since 1923). When Paul accidentally rang a bell when going to bed, Percy burst out: 'He must be *Half Witted*.'[25] Nash could certainly be forgetful, as when he invited Olive Cook, who had supervised the reproduction of some of his work at the National Gallery, to lunch at Gatti's. They enjoyed a 'gorgeous repast' after which 'Paul confessed that he had no money with him. He had left his purse "on the piano".' So Miss Cook was left to foot the bill.[26]

Although he dubbed himself an 'impecunious asthmatical grass-hopper',[27] Nash often pushed aside the mask of devil-may-care sophistication. In a letter of June 1942 to Clare Neilson, he simply could not contain his anxiety: 'Life just gets mingier and mangier – we dwindle, the lights dim, the shadows creep nearer. The only thing to do is to keep one's eye steady on the target.'[28] Doctors came and went, and none could provide the miracle cure.

Anstice Shaw, Nell Bethell's daughter, knew Nash well in these years, and she was touched by his comradely behaviour to her and her friends when they visited him at Oxford. To her, Paul seemed almost excessively carefree – that was the only way she had of discerning that he might be masking depression. She also remembered his courtly flirtatiousness. Often, he would pick ribald passages from Thurber or Milt Gross to read to the assembled company. Earlier, in 1937, when Nash was staying at the Seventh Day Adventists' clinic in Hertfordshire, he wrote Margaret a Gross-inspired paragraph: 'Dollinck Dove, Iss diss place glifful mit sweetness und loight, dunt esk. Is it beyoind biluff wot de dreams is made from, no kidding. Does one get a kick outa de vegetarium cooking mit Kellog

shavings mit de bare faced carrot mit de potato in de straight jacket mit de boigns mitt roll a la Viennese. Yes baby, a kick from de pents.'[29]

During the last years of Nash's life, he also formed friendships with three other young people: Hartley Ramsden, Margot Eates, and Richard Seddon. He wrote to Miss Ramsden after reading her article on surrealism, in which she emphasized the *'transcription of a mood'* and 'emotional content'[30] with which landscape painting can be infused. He felt that her essay clarified many of his own conceptions of the relationship between landscape and surrealism. To Margot Eates, who would eventually write a critical study of his work, Nash sent in April 1946 one of his finest letters. Having moved to the upstairs flat on Banbury Road 'about the level of the smaller tree tops and the flight of the blackbirds and thrushes who rush madly backwards and forwards across the garden', he witnessed this event:

a tragedy occurred there. Suddenly a hawk was in the garden and seemed to pursue my blackie into his rather buffering corner of mixed heavy greenery and bounce back again with a beautiful twist and swerve like a very fast wing three quarter. Blackie let out a yelp and turned to pursue if you please, the crafty fellow. Both disappeared out of my sight and I was too hemmed in by small talk to get quickly to the window.

But looking out from my new bedroom soon after daybreak I saw on the grass what might be a hedgepig or a muddled mole dozing on the drive. But moles never doze above ground and it was too small for a hedgehog. Later, walking in the garden I found the poor Blackbird dead, as if struck down, a few breast feathers seeming torn out, one claw on guard, the other outstretched like a game boxer knocked cold. I believe he was outraged with just indignation against the marauder and in a passion of bravery dashed in to do a battle with that hawk and it struck him down. Or was it just a cat's job. No, blackie would never be copped that way or be left as he was. His buxom brown wife is always flying up here and then from the shrubbery where the nest is to look round, calling plaintively. We have been rather miserable ourselves and nothing much can be done about that.[31]

Nash tells his story with simple pathos. The incident appealed to him because like 'blackie', he was attempting to battle the spectre of the hawk.

Richard Seddon, an aspiring artist, had been Nash's pupil at the RCA just before the war. Seddon, fascinated by aesthetics and psychology, enjoyed the many hours he spent discussing these topics with Nash. His most acute recollection of Nash goes back to the day Seddon asked him to criticize a watercolour of a skating pond. To his surprise, Nash was obviously incensed. At first, Seddon could not understand the source of his irritation. Finally, Nash burst out: 'You've wrecked it! The best pictures do not have people in them!'[32]

In 1941, Lance Sieveking, whose friendship with Nash stretched back to the First World War, had become intrigued by Dorset through his friend's Shell guide. He asked Nash and Margaret to take him on a motoring tour of the county. The party set off:

> Margaret sat in the back seat and Paul in the front with me. We rolled along across Edgon Heath talking and gazing about us. We climbed about on the hills of Maiden Castle. We passed along the valley to Chalbury, and on to Cerne Abbas.... And on another day to Portland Bill, and Chesil Bank and Abbotsbury, and Swanage, astonishingly barricaded against the invader. And on, and on, back and forth, across that beautiful county, in sunny days and warm clear nights, stopping ever and again for Paul to draw, to make notes, to take photographs.... And all the while we talked, going to and fro in memory over the past thirty years and laughing and enjoying again many of the things we had done together.[33]

Despite his earlier half-serious, half-comical depiction of Swanage, Nash cherished the place – the setting of one of his greatest paintings – and he was exhilarated at the prospect of visiting it: 'There is no place I have a stronger nostalgia for than Swanage or nearby, and to reunite ... would surely be a lovely thing.'[34]

Earlier, in 1938, as we have seen, Nash and Bottomley's friendship had had been revived. In their now frequent letters, Nash incessantly plied Bottomley with questions about Rossetti, often wondering aloud about his influence and that of the Pre-Raphaelites upon his own art. Bottomley was pleased by these speculations, assuming incorrectly that Nash had at long last finally renounced pernicious modernism. However, such reflections indicate not a return to his 'parish' but rather a fascination with that 'wonderful hour' when he had first come into being as an artist:

Curiously enough, I have only lately had a *review* of DGR [Dante Gabriel Rossetti] and fallen in love with him all over again. But altho as a man I enjoy all of him right up to the end & am never tired of hunting for bits of him to piece together, as an artist, I now draw a strict line. I stand bare headed before the early water colours & nearly all the work The Siddal seemed to inspire. . . . What a strange manifestation was PreRaphaelitism! *Nothing* like what it was supposed to be. The other day I had a quite new idea about it and someday I should like to write it down and illustrate it with pictures & poems. The *Germ* is the thing don't you think? If only it could have born fruit from its true stock. . . . There indeed the mystical element evaporated, or was changed into such a different form that the vision was lost for ever. . . . The Pre Raphaelites. Yes that's it; *originally* an awakening of British art. You take my breath away a little with your list of all the things that hang together but I agree in the main.[35]

Although these remarks betray a nostalgic interest, Nash's assertion – 'I now draw a strict line' – reveals that he can venerate Rossetti without wishing to be him.

Despite his rekindled admiration for Rossetti, Nash had moved far away from Pre-Raphaelite style and conception. His final paintings are lyrical, but their stylistic expression is resolutely modern. Indeed, their heightened use of flat units of colour to convey meaning is much more reminiscent of Matisse than of Blake or Rossetti.

The Slain God

1944 – 6

NASH'S LAST YEARS were often spent in reclusive melancholy, the artist knowing full well that he did not have long to live, his heart having suffered extensive damage from the ever-present asthma. 'I suppose I expend about 60% of my energy in coughing and spitting.'[1] Nash was able, however, to conceal his private sadness with a whimsical, offhand public manner. During his time at Oxford, he made friendships with Roy Harrod, David Cecil and Gilbert Murray, taking meals at high table at Christ Church, where he imagined himself 'a posthumous after-thought of Lewis Carroll's.'[2] He and Margaret were also frequent visitors to Hilda Harrison's home at Boar's Hill, from which the Wittenham Clumps were visible. Although Nash's health had deteriorated to such an extent that he found walking difficult, he would often look at landscapes through binoculars and then compose his paintings. Many of the pictures from the 1940s have an unusually close, large foreground in comparison to the landscape in the middle and far distances because these were the views Nash obtained through his field-glasses.

There were frequent stays during this time at the Acland Nursing Home – Margaret's health having declined to such an extent that she could not care for her husband. At such times, Nash would

become discouraged not only by his wretched health but also by his inability to get on with his work. According to gossip which came Barbara Bertram's way, Nash had now become impotent – a rumour hotly denied by Margaret Nash.[3] He certainly suffered from insomnia at night, and during the day he would often drop off into a slumber in the middle of a sentence, then jerk awake with an apologetic smile. Despite all this, he could still reflect on the beauty of one of the night sisters at the Acland: 'a slim tall Irish creature with finely modelled face & strange eyes who flutters the temperature charts or I do not know men!'[4] At other times, he was intimidated by quite a different nurse, one 'with the face and mentality of a Brazil nut' who was 'driven by some queer horse or mule power at a fearful fretful fatuous rate'.[5] His sardonic sense of humour still surfaced from time to time, and he proudly laid claim to '3 quite important diseases'.[6]

It was during these years that he began to review his entire *oeuvre* and saw more and more the essential unity of his career. Conrad Aiken was touched by exactly this when he visited him at the Acland in the spring of 1946:

> We went to Oxford in the spring and had tea with him, a nurse in attendance – pathetically frail, an intense light burning brighter than ever through the thinnest of clay, his eyes more beautiful than ever, too – an extraordinary radiance and joy. He showed us, ominously, a collection of photographs of all his life's work, chronologically arranged; and what a life's work – even I had really no conception of its tremendous range, both in subject and style, yet inevitably evolving from one stage to another and all of a piece – the whole history of a tremendous *love*. I'm sure he knew he was beyond life – in fact he spoke of it.[7]

As his health and ability to work declined, Nash spent a great deal of time reflecting on his past. In the thirties, he had scrutinized his life in the process of writing *Outline*, and in the forties he reviewed his art, intimately connected as it was with his inner life. As his death approached, it was perhaps appropriate that Nash came back to the single most important setting in his early work: Wittenham Clumps. However, his return was through Sir James Frazer's *Golden Bough* – a book which had an enormous influence on various writers and artists of the thirties and forties. Nash was particularly fascinated by Frazer's descriptions of Balder and the mistletoe. Myth

had not been a predominant concern of his until this time. Now it obsessed him.

In a letter to Clare Neilson of 8 July 1943, Nash wrote: 'A great picture, the death of Balder, is growing in my mind in terms of mistletoe and oaks, rather than gods I think.'[8] Nine months later, he told her:

> I am excited by the news about the mistletoe. We must get down seriously to this business of Balder when I am with you – also Druids – for God's sake, call up all Druids on the book network. I am sure there exists a fascinating bibliography – strange and awful fellows, Druids, with strange and awful practices.[9]

Nash also asked Ruth Clark to hunt for books on such matters – and on sunflowers. He also speculated about the possibility of the soul temporarily absenting itself from the body (a theme which he had previously explored when he illustrated *Dark Weeping*). All of these concerns centred on the myth of Balder. Nash did not of course depict Balder. It would have been uncharacteristic of him at this time to allow a human or divine figure into a painting. The final equinox, solstice and sunflower pictures – some of which use Wittenham as the backdrop – are of a landscape overseen by Balder. Indeed, Nash now, to a large extent, identified himself with the slain god.

The tale of Balder is one of the most poignant in *The Golden Bough*:

> In the older or poetic *Edda* the tragic tale of Balder is hinted at rather than told at length. Among the visions which the Norse Sibyl sees and describes in the weird prophecy known as the *Voluspa* is one of the fatal mistletoe. 'I behold', says she, 'Fate looming for Balder, Woden's son, the bloody victim. There stands the Mistletoe, slender and delicate, blooming high above the ground. Out of this shoot, so slender to look on, there shall grow a harmful fateful shaft. Hod shall shoot it, but Frigga in Fen-hall shall weep over the woe of Wal-hall.' Yet looking far into the future the Sibyl sees a brighter vision of a new heaven and a new earth, where the fields unsown shall yield their increase and all sorrows shall be healed; then Balder will come back to dwell in Odin's mansions of bliss, in a hall brighter than the sun, shingled with gold, where the righteous shall live in joy for ever more.[10]

Frazer stressed, significantly, that the mistletoe took on a golden colour after its death, this being one of the principal reasons that it was called the golden bough:

Perhaps the name may be derived from the rich golden yellow which a bough of mistletoe assumes when it has been cut and kept for some months; the bright tint is not confined to the leaves, but spreads to the stalks as well, so that the whole branch appears to be indeed a Golden Bough.... The yellow colour of the withered bough may partly explain why the mistletoe has been sometimes supposed to possess the property of disclosing treasures in the earth.[11]

This last observation is a crucial one: although the mistletoe might be the instrument of Balder's death, it also contained within itself the spark of his immortality, its golden colour after its own death testifying to the fact that the divinity of the sun was present in it and that it would be resurrected once again. This paradox was particularly crucial to Nash: his art had been an exploration of the world of death, and perhaps it was natural that it would lead him to the experience of death. As well, his investigation of the world behind ordinary human understanding had convinced him that the world beyond was one which contained a great deal of goodness: 'death, I believe, is the only solution to this problem of how to be able to fly. Personally, I feel that if death can give us that, death will be good.'[12] Nash understood Frazer's paradox because he had come to realize that his own death would release him into the world of 'aerial images'.

Nash's meditations on *The Golden Bough* in Notebook 3 (at the Tate Gallery Archives) support this interpretation:

But the mistletoe considered in the Golden Bough does not die with the oak because the bough of the dead mistletoe increases in colour (gold) and in the case of the yellow buried mistletoe the 'dead' plant is more golden than the living and since it is seen hanging in the bare branches of the oak in the dark winter woods must be as golden as the evergreen mistletoe lit up by the winter sunshine. It would seem then that the mistletoe does not depend upon the life of the oak for its own life.

The causes of the golden appearance are the character of the stem which *'takes' the light* in a particular way & by reason of the stem. Being covered, often by a *golden* lichen. The leaves also light up with a curious *gold transparency*. Furthermore both plants broken off from the oak or other tree, *as they dry* tend to *become more golden* so that the gold of the bough seems to be a quality *impossible to destroy in spite of death*. Because the bough is *an agent for light* & like *gold itself*

will radiate light by *refraction*. So long as there is *light* the golden bough will live. The common denominator is *light*.[13]

Fragmentary as these reflections are, they reveal that Nash during the last phase of his career indeed discovered in Frazer a myth which helped to explain to him the full ambivalence of life, especially the kinship between life and death. As well, Balder's doom comes from within himself. As we have seen, Nash had earlier suggested that malignant outside, usually female, forces attacked men. In identifying himself with Balder, Nash at the end of his life no longer perceived himself as the victim of feminine wiles. He now saw his own anxious sensitivity and asthma as evidence of a 'harmful fateful shaft' within his own being. In addition, Nash told Richard Seddon that he had ceased trying to control nature.[14]

In his last pictures – especially in the equinox and solstice ones – Nash, in his acceptance of the beauty of that portion of existence governed by the moon, certainly allowed himself to be reunited with his lost mother. Hidden presences vanish from his work because he has located, at long last, the figure from whom he was separated and for whom he was searching. As a child, Nash had obviously suffered from the loss of his mother, and he remained, to a degree, distrustful of women. However, the touching, still beauty of the last canvases abounds with love and forgiveness. Much of Nash's life had been an attempt to understand the early deprivation he had endured, but in the mid-1940s he realized that this sense of loss had given him the impetus to create art. In his final paintings, he accepted that early loss, saw it as part of himself and his creativity. Indeed, what for many men would have been merely a source of neurotic anxiety, he had transformed into art.

Paul and Margaret were forced together in the last years of the artist's life. Previously, they had feared day-to-day intimacy. Theirs had not been an easy marriage. Despite the resulting bickering when they were confined to close quarters, Margaret remained steadfastly dedicated to her husband and his art, and he, in turn, responded warmly to his wife's gentle nurturing. Towards the end of his life, he was to write:

... sudden tears gushed into my beautiful eyes & trickled down my pathological nose. It was a small burst of anguish at parting, my

dove, to whom I seem more and more attached.

Just like the ivy, I cling to you as the old song goes. I'm a perfectly dreadful piece of old ivy by now, the sort with knobs & hairs on its chest. And my poor little sturdy oak must groan inside festooned with this monster parasite. You are a wonderful darling, the way you have flourished in spite of the trials & agonies of these last months. I know I have seemed very selfish & merciless....[15]

There is a smattering of self-mockery in 'beautiful eyes' and 'pathological nose', but the image of Margaret as 'the sturdy oak' is deeply felt. In March 1946, as he told Bottomley, he was 'by all accounts ... near being dead', but Margaret fought back:

[she] insisted I couldn't die when the specialist said I must. You don't know him, says she. He's a creative artist and he still has some work to do – just like that! And the doctor seemed impressed. But, think of it, they all went home that night and left me quite alone to face the crisis. I was lightheaded and spent the hours in and out of some other world. Margaret was marvellously calm.[16]

To a large extent, Nash now allowed Margaret to mother him and, as a result, his fear of women was dissipated. At last, his wife was able to provide him with the surety he had lost as a child. Perhaps because he had at last 'found' his mother, the final canvases are exuberant.

Once before, in his work, Nash had shown great fear at the notion of a slain king, whose impulse towards annihilation is lodged within himself. This is the real subject matter of *The Archer* pictures, the full implications of which the artist could not fathom when he created them. In those pictures, the conflict between the cast-shadow and the counter-menacing shadow led to the archer's destruction. Balder is thus a renewal of Nash's interest in such a shadow figure. In his last pictures, however, Nash solved the equation: it was not necessary to be frightened of the shadow or dark portion of one's self and that being so, a counter-menacing shadow could do little harm. Indeed, the counter-menacing figure has become benign. Death leads into a new existence beyond human mortality, as the sunflower pictures, especially, proclaim.

In one of his earliest surviving watercolours, *Angel and Devil* (page 221), Nash had depicted the bird-devil as a menacing figure who

would destroy the man-angel. As he approached the kingdom of death, which is under the control of that creature, he saw that he had nothing to fear. Nash had been working in such a direction in a hesitant manner for much of his career as an artist; after all, death is the strongest inspirational force in his entire work. But from 1942 to 1946, he realized fully that death threatened him no harm. On the contrary, he could look forward to it.

Nash's interest in Balder and in the convergence of seeming opposites in an aerial setting is anticipated in the allegorical *Battle of Britain* (plate 37) from 1941. Nash himself interpreted this picture as a conflict not only between Germany and England but also between the elemental forces of good and evil:

> The painting is an attempt to give the sense of an aerial battle in operation over a wide area, and thus summarise England's great aerial victory over Germany. The scene includes certain elements constant during the Battle of Britain – the river winding from the town areas across parched country, down to the sea; beyond, the shores of the continent; above, the mounting cumulus concentrating at sunset after a hot brilliant day; across the spaces of sky, trails of airplanes, smoke tracks of dead or damaged machines falling, floating clouds, parachutes, balloons. Against the approaching twilight new formations of the Luftwaffe, threatening.

> To judge the picture by reference to facts alone will be unjust to the experiment. Facts, here, both of science and nature are used 'imaginatively' and respected only in so far as they suggest symbols for the picture plan which itself is viewed as from the air. The movement of battle represents the impact of the opposing forces, the squadrons of the RAF sweeping along the coast and breaking up a formation of the Luftwaffe while it is still over the sea.[17]

As Nash's description indicates, this is a very different kind of war art in comparison to *Totes Meer* or *Dead March, Dymchurch*. His earlier war pictures had been mainly of the cadavers of aeroplanes; the later paintings are full of swirling action. Indeed, his *Battle of Germany* (1944), which was done the year before the sunflower and solstice pictures, was for him even more symbolical than *Battle of Britain*:

The moment of the picture is when the city lying under the uncertain light of the moon awaits the blow at her heart. In the background, a gigantic column of smoke arises.... These two objects, pillar and moon, seem to threaten the spent city no less than the army of bombers which are about to strike out of the red sky. The moon's illumination not only reveals the form of the city but, with the pillar's increasing width and height, throws its largening [sic] shadow nearer and nearer. In contrast to the waiting city and the quiet though baleful moon, the other half of the picture shows the opening of the attack. The entire area of sky and background and part of the middle distance are violently animated. Here forms are used arbitrarily and colour with a kind of chromatic percussion to suggest explosion and detonation. In the central foreground the group of descending discs may be a flight of paratroops or the crews of aircraft forced to bale out.[18]

Nash's reference here seems to point back to *Pillar and Moon*, which was begun in 1932 but not finished before 1940. There, Nash had suggested the interconnections between the natural and the man-made in a suggestive, undefined way: the columns of trees lead the viewer's eye to the pillar; the left-hand portion of the picture area is under the dominance of man, and the trees there appear leafless, whereas the trees under the dominion of the moon seem to have much more foliage; the moon has its counterpart in the circular orb at the top of the column. The world of the moon is, significantly, benign in the picture, and in the work of the 1940s a strong insistence on the inter-dependencies between the worlds of the sun and moon comes to the surface.

This is particularly true of *November Moon* (plate 38) from 1942. This painting recalls *Swan Song* from 1929, which had simply been about decay. This new painting has two demarcated sides: one for the moon and one for the sun. The right-hand portion of the picture, governed by the moon and fungus, is colder in coloration than the right-hand portion under the control of the convolvulus and sun. The convolvulus, as evident in Nash's work from the late twenties and early thirties, is the flower which symbolizes the possibility of eternal life after death: its position next to the fungus hints at a direct correlation between the world of death and the world of eternity.

The strongest, most vibrant outpourings of Nash's last years are

found in the equinox, solstice and sunflower pictures. These are intense, majestic paintings in which the artist directly explored the interpenetration of sun and moon, sun and sunflower. The *Sunflower and Sun* (plate 39) canvases of 1942 certainly demonstrate that the power of the heavenly sun resides in the mundane sunflower and that there is a direct connection between the supernatural and man's finite existence. Nash himself was plainly puzzled by this picture:

> I cannot explain this picture. It means only what it says. Its design was evolved from the actual landscape under much the same atmospheric conditions. There was such a sunflower and some such effect of sunlight. All the elements of this picture were present in more or less degree. But the drama of the event, which implies the mystical association of the sun and the sunflower is heightened by the two opposing ellipses and by the other echoing forms of the sky which retaliate with the same apparent movement of outspread wings made by the leaves of the flower.[19]

The 'mystical association of the sun and the sunflower' was also the subject of one of Blake's *Songs of Experience* – a poem which was to fascinate Nash in the last years of his life:

> Ah, Sun-flower! weary of time,
> Who countest the steps of the Sun,
> Seeking after that sweet golden clime
> Where the traveller's journey is done:
>
> Where the Youth pined away with desire,
> And the pale Virgin shrouded in snow
> Arise from their graves, and aspire
> Where my Sun-flower wishes to go.[20]

Nash continued to take a great interest in his garden, as he told Ruth Clark in July 1944: it 'has been my chief happiness. It has been and is at this moment lovely. You will come for a day or two won't you? I want you to see the little flowers I got with your present – nearly all have turned out quite large affairs. Not at all rock garden midgets such as you hate but quite robust "colourful" chaps with hairs on their chests.'[21] However, when it was desolate in the winter of February 1945, Nash saw this as a reflection of his

own despondency: 'My garden has reached a succession of peaks in degrees of beauty. But now is when I approach the doldrums. Roses are blown, jasmine is falling, soft fruits are all picked, and the pyrotechnics of the rock garden almost spent. Ours is ... a *brashy* soil which sounds wet like a hash but is really dry like a breakfast food.'[22] Nevertheless, he could be diverted when his tortoiseshell cat came on heat: 'the garden is riddled with toms uttering their satanic cries, shivvering their rigid tails and polluting the ground and the air. Rugg Tugg, a horrid brute with the face of a Boche thug, had the nerve to penetrate *into* the studio in pursuit of our creature, who *is* a pretty piece of goods I must say.'[23]

Despite his failing health, Nash could still display an astringent humour. He described his complaining letters as 'so much squeaking'.[24] He did grumble, but in the process often wandered into light comic moments, as when he reflected on the 'brother artists' who went to his Private Views: 'there is the same little wizened old face at the other end of the room, peering and scowling a little, at me. And, alongside this funny old frigate with the beetling figurehead, is rather a frisky sort of a craft, vaguely friggled and steel specsy, who now and then looses off a gummy smile.... On my side I retaliate a bit with a smirk or two, but it gets me nowhere.'[25]

Three of Nash's major oils of 1943-4 (*Landscape of the Vernal Equinox* (plate 40), *Landscape of the Summer Solstice*, *Landscape of the Moon's Last Phase*), like the earlier *Sunflower and Sun* pictures, employ the Wittenham Clumps as their setting, and Nash's comment on *Landscape of the Vernal Equinox* emphatically insists on the converging of opposites as its essential meaning:

> The phenomenon of the Spring Equinox, for example, presents the *fact* of equal day and night; which contains the idea of simultaneous sun and moon – a red disc and a white. Again, the thought of division into light and darkness in equal parts suggests a divided space wherein a landscape, on one side, is lit by the setting sun, while the other lies under the influence of a rising moon.[26]

In *Flight of the Magnolia* from 1944, the huge flower has become aerial and has entered into a domain from which it is thought to be excluded. As well, this impressive surrealistic flower shows that the finite can be conjoined to the infinite.

The last, magnificent sunflower pictures from 1945–6 (*Eclipse of the Sunflower* (*1945*), *Eclipse of the Sunflower* (*1946*), *Solstice of the Sunflower* (plate 41), and *The Sunflower Rises*) are even more directly related to the sunflowers Nash was growing in his garden in Oxford, to Frazer, and to Blake. As he himself recognized, these paintings were his most successful joining of *seeming* contraries:

> Four pictures in which the image of the Sunflower is exalted to take the part of the Sun. In three of the pictures the flower stands in the sky in place of the Sun. But in the 'Solstice' the spent sun shines from its zenith encouraging the sunflower in the dual role of sun and firewheel to perform its mythological purpose. The sun appears to be whipping the sunflower like a top. The Sunflower Wheel tears over the hill cutting a path through the standing corn and bounding into the air as it gathers momentum. This is the blessing of the Midsummer Fire.[27]

In Nash's case, the sunflower canvases were his way of ridding himself of the fear of death. In *Eclipse of the Sunflower*, the flower dies but its power has gone back to the sun, the source of all life. In September 1945 he asked a friend to bring him a sunflower 'that I may transplant it in my plot of land, parched with the salt, and show all day to the blue eyes of sky the anxiety of its yellow face'. In the same letter, he claimed that dark things tend towards brightness and 'bodies are consumed in a flow of colours'. He wistfully ended: 'Vanishing is … the adventure of all adventures.'[28]

Almost thirty-five years before in 1912, Nash, then still very much under the influence of Rossetti, had found an ideal landscape at Wittenham to mirror the conflicts within himself; when, a dying man, he returned there, he was no longer a disciple. Indeed, although he reminisced in the 1940s about his early attachment to the great Pre-Raphaelite Brotherhood exponent of the 'dual expression', he had by then abandoned Rossetti's insistence on the eternal warfare between men and women. Nash's first Wittenham pictures hint at enmity; the last paintings are serene. As well, the early Wittenham drawings suggest hidden presences; the final Wittenham canvases are gloriously free and open – the mystery stands at long last revealed: the worlds of life (sun) and death (moon) are one. These final paintings are radically different from all the artist's previous work because the fear of annihilation has gone.

At the time of his death, Nash was planning more Balder and sunflower compositions, but he also wanted to explore subject matter which was the next logical step in his pilgrimage: ghosts. This project was under consideration as early as September 1944, when he told Clare Neilson: 'Now I am beginning on my ghosts, souls and general behaviour after death.'[29] His concern with such subject matter (seen in *Urne Buriall*) parallels an obsession he experienced as a child, described at the beginning of *Outline*: 'The villa on the heath, which was the usual ugly modern building with no frightening features, was a quite different affair. It was *peopled* with ghosts. I cannot describe them now. They seemed unsubstantial presences, featureless bodies infesting the steep stairway.'[30]

Nash did not live to paint the landscape of the ghosts, but the full, autumnal coloration of his final canvases indicates his willing entrance into their terrain. These last pictures show the artist's reconciliation with death, the moon, and the feminine side of his nature. Where there had been discord and dissension, gentle serenity emerged. As well, the equinox, solstice and sunflower paintings, in their alliance of English source material (Blake and Frazer) with a rich, intuitive use of colour planes, amply show that Nash had been able to merge his early commitment to the 'dual expression' with international modernism.

The last two years of Nash's life were spent at home in Oxford, with periodic stays at the Acland Nursing Home, and short extended holidays at the Rising Sun, a hotel on Cleeve Hill outside Cheltenham. Although his art now displayed a tranquil clarity, he suffered, understandably, frequent depressions. To him, existence had become a 'fluid world where I seem to drown daily. . . . I feel exhausted and witless. And nothing apparently can be done about it.'[31] He saw himself variously as a 'mental mess', a 'battered creature', and 'an uneasy cat'.[32] More insistently than before suicide appealed to him as a way out, so horrible were his asthmatic attacks and the resulting weakness his body endured. He wrote a series of starkly revealing letters to Ruth Clark, in which he delved into the blackness which now invaded him. After his death, Ruth destroyed the letters because she felt the horrors her friend had faced were best hidden. Still, Nash could sometimes talk, as he did in December 1945, of his wretched health with a streak of self-depreciating humour: 'I am

about again but sworn to paint in any but a standing posture. All kinds of mobile, volatile behaviour has been suggested but in the end I expect to become slung from the ceiling like an aggressive sort of Christmas decoration stubbing with fistfuls of brushes at the bewildered canvas.'[33] Although he was worn out, his vision of Balder and the ghosts drove him on.

His step-mother, Audrey Nash, died in the autumn of 1945, and this 'meant that the family furniture had to be taken out of her little house and portioned out'. A quarrel with Jack, with whom he had not been on good terms for a long time, ensued. As well, as he told Bottomley, he had to endure the humiliation and misery of having become a professional patient:

> Well, I had no operation but I did have pneumonia with variations such as speechless flu, oedema & a small packet of dry pleurisy to top up with. It all began with the stalwart reliable guaranteed heart beginning to show signs of strain. Really, I'm a war victim, Gordon! I painted so many outsize pictures for the M of I that the strain crocked up my heart which of course I suppose had been already coughed into slight decline by my bogus asthma. Margaret suspected some of this but I was then under a fool of a (temporary) doctor who took no notice of my swollen ankles & funny feet. So Margaret took me to Horder (who turns out to be a fan of mine and was charming) & *he* said – this chap's trouble isn't asthma so much as strained heart. So I was put into the Acland & forced to rest for five months.... I am gradually recovering enough to work but I am very much hipped in some ways, not allowed to stand, must sit to paint evermore ... can't walk much & so on. *And* the cost. The oxygen tubes, the night nurses (5 changes), the body washers, the pills, the draughts....[34]

In June 1946, in search of a congenial place to rest, Margaret and Paul went to stay at the Florida Hotel at Boscombe, Hants. This trip was also the artist's last chance to see the ocean, and this thought was uppermost in his mind at the outset of the journey. Just as Nash had become reconciled to the world of autumn and the moon, he wanted to visit the sea, which was no longer for him a symbol of annihilation and destruction.

Just before leaving for Boscombe, Paul wrote to Jack about the share-out of Audrey's estate: 'I mend rather slowly – somewhat up & down and not much headway with work as yet. But just lately I

Angel and Devil, 1910

began to feel very unhappy & down hill so I threw all my pills out of window and proceeded under my own steam as it were, which made me feel very much better.' Later in the letter, Nash referred to Jack's complaint that he had not been fairly dealt with by himself

221

and Barbara, saying that Jack had 'picked very shrewdly'. Jack reacted angrily to this, and Paul wrote him his last extant letter, on 10 July 1946, in which he attempted to mollify Jack's hurt feelings and told him not to attach any '*Sinister* implications' to the word, 'shrewd'. He then went on to talk of the hotel's situation: 'This is an unbelievable place, inaccessible for us save by taxi! But the sea view stretches from a glimpse of the Isle of Wight and the S.W. and those frightening Old Harry Rocks. And the whole wall is windows with a balcony (modern arch). Just beyond is a derelict Pier.... All very queer & *surr*ealist as young people say.'[35]

After writing this letter, Nash went to bed and never awoke, dying, apparently, of a heart attack. Margaret provided this account: 'The doctor who was brought in at half past eight in the morning, turned to me after he had examined him and said, "Please don't distress yourself, this is how good men die; and I would say that your husband was a very good man, for he has fallen asleep like a child, and he must have had the heart of a child." '[36]

The doctor's words were curiously apt. Throughout his life Nash had retained a childlike sense of wonder, both at the world and whatever lay beyond it. The art he left behind is that of 'a tremendous love', and he survives, perhaps most, in the glorious images which remind us of the possibility of the 'things behind' – the other reality which he had often glimpsed and tried so hard to understand.

Epilogue

As NASH approached the end of his life, he collected photographs of his work. He showed these to Conrad Aiken, who was, as we have seen, moved by the range of his friend's work and by his passionate commitment to it. As well, Nash 'reviewed' his life in writing *Outline*. In a similar way, in Notebook 3, now in the Tate Archives, he made (*c.* 1945) this fragmentary sketch of his career:

(1) Landscape Interpretive
(2) Seascape Interpretive
(3) Still life and Windows Interpretive experimental, 1928–38
 1 Architectonic equation
 2 Paralogist equation
 3 Object equation
(4) Object personage equation experimental. Aerial ghost personages. New Landscapes.

These notes, obviously intended only for his own eyes, are difficult to explicate fully, but it is clear that Nash was attempting to place yet another 'outline' on his life's work, which had been, to a large extent, he realized, 'experimental'.

'Landscape Interpretive' refers to Nash's work up to 1920, and 'Seascape Interpretive' are the Dymchurch pictures. Nash divided '(3) Still life and Windows' into three periods: 'Architectonic equation' refers to his work from 1928 to 1929, when, as Bertram claimed, his work took on a classical, architectural ambient; 'Paralogist equation' is his work from 1929 to 1932, particularly that inspired by de Chirico and Sir Thomas Browne; 'Object equation'

refers to the Avebury pictures which occupied the artist from 1933 to 1938. The final, fourth stage was devoted to monsters, the mistletoe, and ghosts. In the above summation, Nash saw his career moving from 'interpretive' to 'equation' to 'personage'. Put another way, this suggests that the artist first attempted to understand and render nature in a deeply personal manner; dissatisfied with that subjective approach, he moved, under the influence of surrealism, to equations or 'equivalents' – paintings in which the conflicts between objects is the focus. In those years the 'laws of nature did not hold against the needs of art', which 'should control'. Finally, he came to monsters, Balder, and the ghosts, work which displays a more overtly anthropological and mythological use of symbols than at any other point in his career. At this time, he had ceased trying to 'control' nature.

In the same notebook, Nash showed a further interest in para- logism, which he defined as 'illogical reasoning of which reasoner is unconscious', and he went on to break the word down to its two constituent parts: 'para' meaning 'contrary' and 'logos' meaning 'reason'. This was a further bid on Nash's part to understand the forces behind his creativity, and I feel his interest in paralogism demonstrates his awareness that his art had been, despite his inten- tions, dictated by forces beyond his control, the obvious meaning of a work of art (its reasoned constituent parts) being governed by forces of which the artist might at times be 'unconscious'.

I also think that Nash's interest in paralogism helps to explain in part why he was able to integrate the Romantic vision of his early work with a strikingly contemporary style, particularly in the last seventeen years of his career. Nash's conscious ambition was to become a modern artist, while his unconscious pulled him back towards death and the unseen presences which governed his earliest artistic activity. In this regard, one of the most fascinating aspects of his career is that he, almost alone among the major English artists of the first half of this century, managed both to retain English subject matter and to employ contemporary expression.

Nash's friend Ben Nicholson, in avoiding representational art, also repudiated much of the English tradition in painting. On the other hand, Stanley Spencer was essentially an 'English' artist, outside the continental tradition. Paul Nash joined the two strands together. Indeed, Nash's slowly emerging understanding of a

governing spiritual force may have ironically aided this integration: since he was not precisely sure of what he sought, he experimented with stylistic means to entrap it. Thus, his uncertainty of what he would find at the end of the journey made him an innovator. As well, the pursuit of modernism, particularly in literature, has often entailed a search for clarity and purity of expression. This is certainly the direction in which Nash's art moved, particularly after 1929.

Towards the end of his life, Nash became more and more aware of the essential unity of his career. Having reconciled so many opposites, he was able to look forward to his own death without fear. The wheel had turned full circle, and he had come, like T. S. Eliot,[1] to a realization that

> *We shall not cease from exploration*
> *And the end of all our exploring*
> *Will be to arrive where we started*
> *And know the place for the first time.*

Notes

SHORT TITLES AND ABBREVIATIONS

Bertram Anthony Bertram, *Paul Nash, The Portrait of an Artist* (London: Faber and Faber, 1955).

BT Transcriptions of Nash letters made by Anthony Bertram, now on deposit at the Victoria and Albert Museum Library.

Causey Andrew Causey, *Paul Nash* (Oxford: The Clarendon Press, 1980).

The Golden Bough Sir James George Frazer, *The Illustrated Golden Bough* ed. Mary Douglas (London: Macmillan, 1978).

JNT John Nash Trustees: papers on deposit at the Tate Archives.

Lorelei II Clarissa M. Lorentz, *Lorelei Two, My Life with Conrad Aiken* (Athens: University of Georgia Press, 1983).

'Memoir' Margaret Nash's typescript, now on deposit at the Victoria and Albert Museum Library.

MN Margaret Nash.

Outline Paul Nash, *Outline, An Autobiography and Other Writings* (London: Faber and Faber, 1949).

'Picture History' Notes on his work, prepared by P N between 1933 and 1945, for Arthur Tooth & Sons.

PN Paul Nash.

PNT Paul Nash Trustees: papers on deposit at the Tate Gallery Archive.

Poet and Painter *Poet & Painter, Being the Correspondence between Gordon Bottomley and Paul Nash, 1910–1946*, ed. C. C. Abbott and Anthony Bertram (London: Oxford University Press, 1955).

TA The Tate Gallery Archive.
Urne Buriall Thomas Browne, *Urne Buriall* and *The Garden of Cyrus*
 (London: Cassell, 1932).
V & A The Victoria and Albert Museum Library.

CHAPTER ONE

Isolation and the Joy of Places 1889–98

1 *Outline*, p. 25.
2 PN to Martin Armstrong, 20
 August 1926, BT.
3 *Outline*, p. 123
4 Ibid., p. 47
5 Ibid., p. 48.
6 Ibid., p. 112.
7 Ibid., p. 50.
8 Ibid., p. 32.
9 Ibid., p. 57.
10 Ibid., p. 75.
11 MS of *Outline*, TA. Nash
 scribbled over this passage,
 but it can be read, except for
 the small illegible portion I
 have placed in brackets.
12 To Anthony Bertram, 14
 April 1934. BT. Nash's acute
 sense of the loss of his mother
 is remarkably similar to the
 adolescent experience of
 Virginia Woolf, who was
 thirteen when her mother
 died in 1895. In each life, the
 death of the mother was the
 most significant psychic
 event; this deprivation is also
 explored at great length in the
 art of each; also, for both Nash

and Woolf creativity was an
act of restoration which led
them back to the lost maternal
figure.
13 Ruth Clark in conversation
 with James King on 1 June
 1981.
14 *Outline*, p. 117.
15 PN to his parents, undated but
 c. 1896.
16 *Outline*, p. 30.
17 Ibid.
18 Ibid., p. 31.
19 Ibid., p. 38.
20 Ibid., p. 51.
21 Ibid., p. 49.
22 Ibid., p. 52.
23 Ibid., pp. 52–3.
24 Ibid., p. 35.
25 Ibid., p. 25.
26 Ibid., p. 43.
27 Ibid., p. 44.
28 Ibid., p. 26.
29 Ibid.
30 Ibid., pp. 26–7.
31 Ibid., p. 27.
32 Ibid.
33 Ibid., p. 36.
34 Ibid., p. 37.

CHAPTER TWO

Further Isolation and Dedication to Art 1898–1906

1 *Outline*, p. 45.
2 Ibid.
3 Ibid., pp. 59–60.
4 Ibid., p. 39.
5 Ibid.
6 Ibid., p. 54.
7 Ibid., p. 55.
8 Ibid., p. 60.
9 Ibid., p. 61.
10 Ibid., p. 62.
11 Ibid.
12 Ibid., p. 56.
13 Ibid., p. 57.
14 Ibid., p. 30.
15 Ibid., p. 41.
16 Ibid.
17 Ibid., p. 42.
18 Ibid., pp. 57, 56.
19 Ibid., p. 56.
20 Ibid., p. 63.
21 Ibid., p. 60.
22 Ibid., p. 58.
23 Ibid.
24 PNT.
25 *Outline*, p. 63.
26 Ibid., p. 64.
27 Ibid.
28 Ibid., p. 65.
29 Ibid., p. 66.
30 Ibid.
31 PNT.
32 *Outline*, p. 69.
33 Ibid.
34 Ibid.
35 Archives, St Paul's school.
36 *Outline*, p. 70.
37 Ibid., p. 71.

CHAPTER THREE

Rossetti, the Moon and the Woman in the Sky 1906–10

1 *Outline*, p. 72.
2 Ibid., pp. 72–3.
3 Ibid., p. 75.
4 Ibid.
5 Ibid., p. 86.
6 Ibid., p. 74.
7 Ibid., p. 75.
8 PN to Mercia Oakley, 5 March 1912. TA.
9 Ibid., p. 87. Nash's increasing mastery in this form is precisely delineated by Clare Colvin in 'The Early Bookplates of Paul Nash,' *The Bookplate Journal*, Vol. 2, No. 1 (March 1984), pp. 3–15.
10 *Outline*, p. 82.
11 Ibid., p. 76
12 Ibid., p. 75.
13 Dedicated to Mercia Oakley. Undated but probably 1911. TA.
14 See Causey, p. 13.
15 *Outline*, p. 78.

16 Ibid., p. 100.

17 PN to Nell Bethell, 17
September 1910. PNT.

CHAPTER FOUR

Sybil Fountain and Gordon Bottomley 1910–12

1 PN to Nell Bethell, 21 January 1909. TA.
2 PN to Nell Bethell, undated. TA.
3 PN to Nell Bethell, 21 January 1909. TA.
4 Ibid.
5 Ibid.
6 PN to Nell Bethell, 31 January 1909. TA.
7 PN to Mercia Oakley, undated but probably 1912. TA.
8 Bertram, p. 46.
9 PN to Mercia Oakley, c. 1912. TA.
10 Bertram, p. 51.
11 Ibid., p. 53.
12 *Outline*, p. 99.
13 Ibid., p. 100.
14 Ibid.
15 Ibid.
16 PN to Mercia Oakley, c. 15 May 1912. TA.
17 PN to Mercia Oakley, undated but 1912. TA.

18 PN to Mercia Oakley, before May 1912. TA.
19 PN to Mercia Oakley, undated but 1912. TA.
20 PN to Mercia Oakley, undated but 1912. TA.
21 PN to Mercia Oakley, undated but 1912. TA.
22 *Outline*, p. 83.
23 Ibid., p. 84.
24 As quoted in *Poet and Painter*, p. xiii.
25 *The Crier by Night* in *King Lear's Wife and Other Plays* (Boston: Small, Maynard and Company, n.d.), p. 53.
26 Ibid., p. 66.
27 Ibid.
28 *Poet and Painter*, p. 2.
29 Ibid.
30 Ibid., p. 30.
31 Ibid., p. 41.

CHAPTER FIVE

The Slade and Wittenham Clumps 1910–12

1 Michael Holroyd, *Augustus John, The Years of Innocence* (London: Heinemann, 1974), p. 38.
2 Joseph Hone, *The Life of Henry*

Tonks (London: Heinemann, 1939), p. 102.
3 *Outline*, p. 89.
4 John Woodeson, *Mark Gertler, Biography of a Painter, 1891–*

1939 (London: Sidgwick and Jackson, 1972), p. 110.
5 C. R. W. Nevinson, *Paint and Prejudice* (London: Methuen, 1937), p. 53.
6 *Poet and Painter*, p. 15.
7 Ibid., p. 21.
8 Ibid., pp. 22–3.
9 *Outline*, p. 93.
10 Ibid., p. 90.
11 *Paint and Prejudice*, p. 27.
12 *Outline*, p. 90.
13 *Paint and Prejudice*, p. 24.
14 PN to Dora Carrington, *c.* 1914. JNT.
15 Carrington to John Nash, *c.* 1914; PN to Dora Carrington, *c.* 1913. JNT.
16 PN to Carrington, *c.* 1913–14. JNT.
17 *Outline*, p. 91.
18 Ibid.
19 PN to MN, 21 March 1917. PNT.
20 *Poet and Painter*, p. 52.
21 *Outline*, p. 110.

22 *Poet and Painter*, pp. 25–6.
23 *Outline*, p. 134.
24 Ibid., p. 112.
25 Ibid., p. 111.
26 Ibid., pp. 106–7.
27 *Poet and Painter*, p. 45.
28 Ibid., p. 42.
29 Ibid., p. 43.
30 Ibid., p. 42.
31 Ibid., p. 46.
32 Lines 656–65.
33 PN to Mercia Oakley, 23 September 1911. TA.
34 *Outline*, p. 122.
35 Ibid., p. 63.
36 *Poet and Painter*, p. 32.
37 *Outline*, p. 63.
38 Woodeson, *Mark Gertler*, p. 87.
39 *Poet and Painter*, p. 39.
40 PN to Nell Bethell, *c.* May 1912. PNT.
41 BT.
42 *Poet and Painter*, p. 42.
43 *Outline*, p. 125.
44 Ibid., p. 126.

CHAPTER SIX

Margaret 1913

1 *Outline*, p. 124.
2 Ibid., p. 102.
3 Ibid., p. 103.
4 Ibid.
5 Ibid.
6 Ibid., p. 135.
7 Ibid., p. 140.
8 Ibid.
9 Ibid.
10 Ibid., p. 141.

11 Ibid., pp. 130–1.
12 Ibid., p. 145.
13 Eates, p. 56.
14 Lance Sieveking, *The Eye of the Beholder* (London: Hulton Press, 1957), pp. 54–5.
15 Ibid., p. 53.
16 Ibid., p. 54.
17 *Outline*, p. 147.
18 Ibid., p. 145.

19 *Poet and Painter*, p. 54.
20 Ibid.
21 *Outline*, p. 147.

22 Ibid., p. 148.
23 Ibid., p. 142.
24 Ibid., p. 144.

CHAPTER SEVEN

New Beginnings 1913–14

1 PN to MN, 8 May 1913. PNT.
2 PN to MN, undated but 1913–14. PNT.
3 PN to MN, 9 May 1913. PNT.
4 PN to MN, 28 March 1913. PNT.
5 *Outline*, p. 152.
6 Ibid.
7 *c.* 1912. TA.
8 PN to MN, 18 June 1913. PNT.
9 PN to MN, 25 May 1914. PNT.
10 PN to MN, 25 June 1913. PNT.
11 PN to MN, 15 October 1913. PNT.
12 PN to MN, 19 June 1914. PNT.
13 PN to MN, undated but *c.* 1913. PNT.
14 PN to MN, 17 October 1916. PNT.
15 *Outline*, p. 150.
16 PN to MN, 10 December 1914. PNT.
17 V & A. Deleted from the letter as printed on p. 73 of *Poet and Painter*.
18 See PN to MN, postmark 22 September 1913. PNT.
19 *Outline*, p. 161.
20 Ibid.

21 Ibid.
22 Virginia Woolf to Molly MacCarthy, 22 September 1919. *The Letters of Virginia Woolf: Volume IV, 1929–1931*, ed. N. Nicolson and Joanne Trautmann (London: Hogarth Press, 1978), p. 91.
23 *Outline*, p. 163.
24 Ibid.
25 PN to Rothenstein, undated but April 1913. BT.
26 *Outline*, p. 88.
27 Ibid.
28 Ibid., p. 121.
29 Ibid., p. 123.
30 *Poet and Painter*, p. 37.
31 Ibid., p. 61.
32 PN to JN, 9 December 1922. JNT.
33 Ibid.
34 Information on John Nash from Ronald Blythe.
35 *Poet and Painter*, p. 97.
36 Ibid.
37 Christopher Hassall, *Edward Marsh, Patron of the Arts* (London: Longmans, 1959), p. 258.
38 John Woodeson, *Mark Gertler*, p. 110.
39 *Outline*, p. 162.
40 *Poet and Painter*, p. 60.

41 Denys Sutton, ed., *The Letters of Roger Fry* (London: Chatto and Windus, 1972), pp. 47–8.

42 *Poet and Painter*, p. 68.

43 PN to Carrington, undated but early 1914. JNT.

44 John Lewis, *John Nash, The Painter as Illustrator* (Godalming: The Pendomer Press, 1978), p. 35.

45 PN to MN, postmark 10 March 1914. PNT.

46 Fry to PN, 3 September 1917. PNT.

47 Notebook 3, 19 r-v. TA.

48 'Memoir', p. 24. Frances Spalding in *Roger Fry, Art and Life* (London: Paul Elek, 1980) does not document such an antagonism, and I suspect that Nash's hostility to Fry might have been largely based on what he *assumed* Fry did to destroy his career. Richard Seddon was given further, unreliable information on this subject, which he cited in 'A Walk in the Park', *Manchester Guardian*, 28 April 1962.

49 See Causey, p. 83 and Spalding, p. 252.

50 *Paint and Prejudice*, p. 92.

51 *Outline*, p. 218.

52 Ibid., p. 139.

53 PN to Rothenstein, 11 October 1913. BT.

54 TA.

55 William C. Wees, *Vorticism and the English Avant-Garde* (Toronto: University of Toronto Press, 1972), p. 191. Richard Cork's *Vorticism and Abstract Art in the First Machine Age* (2 vols, London: Gordon Fraser, 1976) is the most comprehensive treatment of this movement.

56 Ibid, p. 50. The finest account of this establishment can be found in Richard Cork, *Art Beyond the Gallery* (New Haven and London: Yale University Press, 1985), pp. 61–115.

57 Ibid.

58 *Poet and Painter*, p. 59.

59 V & A. Bertram's transcription of PN's letter of *c.* 21 July 1913. This portion of the letter was omitted from *Poet and Painter*.

60 *Outline*, p. 167.

61 Ibid. Cf. Causey, p. 123.

62 *Outline*, p. 173.

CHAPTER EIGHT

The Great War 1914–18

1 *Poet and Painter*, p. 73.

2 PN to Eddie Marsh, August 1914. BT.

3 *Poet and Painter*, p. 76.

4 Ibid.

5 Bertram, p. 86.

6 'Memoir', p. 8.
7 *Poet and Painter*, p. 72.
8 'Memoir', p. 8.
9 *Poet and Painter*, p. 72.
10 Bertram, p. 86.
11 'Memoir', p. 9.
12 *The Eye of the Beholder*, p. 55.
13 Ibid., p. 56.
14 PN to MN, 28 December 1914. BT.
15 PN to Eddie Marsh, 1 January 1915. BT.
16 PN to MN, 26 October 1916. PNT.
17 PN to MN, dated '1916?' by MN. PNT.
18 Ibid.
19 Ibid.
20 PN to MN, 16 June 1916. PNT.
21 PN to MN, 27 October 1916. PNT.
22 Ibid.
23 PN to MN, 6 June 1916. PNT.
24 PN to MN, *c.* January 1917. PNT.
25 The destruction of the chivalric ideal is described by Mark Girouard in the final chapter ('Playing the Game') of *The Return to Camelot* (New Haven and London: Yale University Press, 1981), pp. 276–93. Many of the attitudes of mind described by Girouard in his fascinating book can be found in Paul Nash's pre-First World War sensibility.
26 *The Eye of the Beholder*, p. 57.
27 'Memoir', p. 10.
28 Ibid.
29 R. George Thomas (ed.), *Letters from Edward Thomas to Gordon Bottomley* (London: Oxford University Press, 1968), p. 269.
30 'Memoir', p. 11.
31 Ibid., p. 12.
32 PN to MN. 6 June 1916. PNT.
33 *Outline*, p. 203.
34 Ibid., p. 198.
35 Ibid., p. 189.
36 Ibid., p. 195.
37 Ibid., p. 192.
38 Ibid.
39 PN to MN, 21 March 1917. PNT.
40 PN to MN, 22 February 1917. PNT.
41 PN to MN, 26 April 1917. PNT.
42 PN to MN, 7 March 1917. PNT.
43 'Memoir', p. 13.
44 *Poet and Painter*, p. 86.
45 Ibid.
46 Bertram, pp. 94–5.
47 *Poet and Painter*, p. 94.
48 'Memoir', p. 11.
49 *Outline*, p. 211.
50 Ibid., p. 216.
51 Bertram, p. 95.
52 Ibid.
53 'Memoir', p. 22.
54 *Outline*, p. 217.
55 Information on the spirit voice and Nash's involvement with the lady at Chalfont St Peter: MS in MN's hand owned by PNT and information from Ruth Clark to James King in a letter of 11 July 1981.
56 *Outline*, p. 218.

CHAPTER NINE

Another Life, Another World 1919–21

1 *Poet and Painter*, p. 264.
2 PN to Anthony Bertram, *c.* 1935. BT.
3 Information supplied to Anthony Bertram.
4 See Noel Stock, *The Life of Ezra Pound* (Harmondsworth: Penguin Books, 1974), p. 267.
5 *New Witness*, 22 August 1919.
6 Ibid., 1 August 1919.
7 Ibid., 11 July 1919.
8 Ibid.
9 Ibid., 23 May 1919.
10 Ibid., 19 September 1919.
11 Autumn 1919.
12 *Arts Gazette*.
13 'Memoir', p. 26.
14 *Poet and Painter*, p. 123.
15 Ibid.
16 BT.
17 *Poet and Painter*, p. 113.
18 Ibid.
19 Ibid., p. 115.
20 Ibid., p. 116.
21 John Pearson, *The Sitwells* (New York: Harcourt Brace Jovanovich, 1978), p. 155.
22 PN to MN, undated but *c.* 1917. PNT.
23 *Poet and Painter*, p. 114.
24 Bertram, p. 124.
25 Ibid.
26 PN to Alice Daglish. BT.
27 *Outline*, p. 219.
28 'Memoir', p. 28.
29 Haldane Macfall, *The Book of Lovat* (London: J. M. Dent & Sons, 1923), p. 55.
30 Gordon Craig in *Catalogue of the Memorial Exhibition of ... Claud Lovat Fraser* (London: Leicester Galleries, 1921), p. 14.
31 'Memoir', p. 29.
32 Ibid.
33 Ibid.
34 *Outline*, p. 219.
35 Ibid.
36 'Memoir', pp. 29–30.
37 Ibid.
38 All citations in this paragraph and the summation of Holmes's prognosis and treatment: Gordon Holmes, Case Book 1921. Queen Square.
39 *Places* (London: Heinemann, 1923).
40 Ibid.

CHAPTER TEN

Searching 1922–9

1 *Outline*, p. 219.
2 Bertram, p. 125.
3 *Poet and Painter*, p. 151.
4 Ibid., pp. 154, 158.

5 Ibid., p. 161.
6 Ibid., p. 152.
7 Ibid., p. 144.
8 T. E. Lawrence to PN, 10 June 1921. BT.
9 T. E. Lawrence to PN, 16 June 1921. BT.
10 T. E. Lawrence to PN, August 1921. BT.
11 *Poet and Painter*, p. 156.
12 'Memoir', p. 31.
13 PN to Percy Withers, 15 May 1923. BT.
14 'Memoir', p. 33.
15 *Poet and Painter*, p. 156.
16 BT and *Poet and Painter*, p. 173.
17 PN to Gordon Bottomley, 11 January 1930. V&A.
18 PN to Percy Withers, 15 May 1923. BT.
19 PN to Percy Withers, 25 July 1923. BT.
20 See Causey, p. 128, note j.
21 *Paul Nash* (London: The Fleuron Ltd., 1927), p. 2. R. H. Wilenski in *The Modern Movement in Art* (London: Faber and Faber, 1927) claimed that 'the idea behind the modern movement in the arts is a return to the architectural or classical ideal' (p. ix) and on these grounds he gave his approbation to Nash: 'Paul Nash has resumed his study of architectural form, and is now, in my view, the leading, because the most subtle, artist of the modern movement in this country' (p. 146).

22 'The Artist and the Community', *Listener*, 20 January 1932. Nash designed the cover for *Shell Mex House* in 1933.
23 Shaw to PN, 14 October 1924. BT.
24 PN to Shaw, October 1924. BT.
25 Ibid.
26 Shaw to PN, 20 October 1924. BT.
27 Ibid.
28 PN to Shaw, November 1924. BT.
29 Ibid.
30 Ibid.
31 Shaw to PN, 10 November 1924. BT.
32 PN to Shaw, November 1924. BT.
33 *Lorelei II*, pp. 132–3.
34 PN to MN, undated but 1928. PNT.
35 Edward Bawden to James King, 4 September 1981.
36 Ibid.
37 Ibid.
38 PN to Audrey Withers, undated but autumn 1924.
39 PN to Audrey Withers, undated but 1922 or 1923. BT.
40 Information about Nash at Souldern Court: Audrey Withers Kennett in conversation with James King, July 1981.
41 'Memoir', p. 35.
42 Ibid., p. 36.
43 Ibid., p. 37.
44 PN to Anthony Bertram, 2 March 1925. BT.

45 Bertram, p. 114.
46 PN to Audrey Withers, undated. BT.
47 PN to MN, 31 November 1925. PNT.
48 Ibid.
49 PN to MN, undated but May 1926. PNT.
50 PN to Percy Withers, October 1927. BT.
51 PN to MN, undated but 1927. PNT.
52 PN to MN, undated but 1927. PNT.
53 PN to MN, undated but probably January 1926. PNT.
54 Ibid.
55 PN to MN, postmark 9 April 1928. PNT.
56 Ibid.
57 Ibid.
58 Ibid.
59 *Poet and Painter*, p. 190.
60 Ibid., pp. 191–2.
61 PN to MN, postmark 14 August 1928. PNT.
62 PN and MN, undated but 1928. PNT.
63 Ibid.
64 William Harry Nash to PN, 18 November 1928. PNT.
65 Bertram, p. 145.
66 PN to Hilda Felce, undated but 1929. BT.
67 *Poet and Painter*, p. 194.
68 Charles Harrison, *English Art and Modernism, 1900–1939* (London and Bloomington: Allen Lane and Indiana University Press, 1981), p. 200. See also p. 298.
69 PN to Richard de la Mare, *c.* end of May 1929. As cited by Pat Gilmour, *Artists at Curwen* (London: Tate Gallery, 1977), p. 48.
70 Lines 51–4.
71 Some (*Blue House on the Shore, Tower, Souvenir of Florence*) of Nash's paintings from 1928–9 seem to have been also inspired by the male–female duality found in alchemical literature. See Causey, p. 154.

CHAPTER ELEVEN

The Jugler 1930–2

1 'Memoir', p. 42.
2 *Lorelei II*, p. 113.
3 Edward Burra, *Well, Dearie!: The Letters of Edward Burra* (London: Gordon Fraser, 1985), pp. 28, 35.
4 Ibid., pp. 62, 64.
5 'Memoir', p. 42.
6 Edward Burra to William Chappell, undated but spring 1930. See Causey, p. 188.
7 'Memoir', p. 43.
8 Ibid.
9 See Quentin Bell, *Virginia*

Woolf, A Biography, Vol. I (London: The Hogarth Press, 1972), pp. 157–60.

10 'Memoir', p. 43.

11 Ibid., p. 44.

12 Eates, p. 45.

13 'Memoir', p. 47.

14 *Lorelei II*, p. 85.

15 'Memoir', p. 48.

16 Conrad Aiken, *Ushant* (London: W. H. Allen, 1963), p. 257.

17 *Lorelei II*, p. 89.

18 Ibid., pp. 105–6.

19 Ibid., p. 120.

20 Ibid., p. 123.

21 Barbara Bertram in conversation with James King, August 1981.

22 Bertram, p. 41.

23 *Week-end Review*, 16 July 1932.

24 Ibid., 27 June 1931.

25 *Listener*, 17 August 1932.

26 Ibid., 17 February 1932.

27 Ibid.

28 *Week-end Review*, 30 April 1932.

29 Ibid., 5 December 1931.

30 *Listener*, 3 October 1932.

31 Ibid.

32 Ibid., 29 April 1931.

33 *Room and Book*, pp. 37–8.

34 Ibid., p. 54.

35 Ibid., p. 24.

36 See Pat Gilmour, *Artists at Curwen* (London: Tate Gallery, 1977), p. 52.

37 *Week-end Review*, 5 December 1931.

38 *Urne Buriall*, p. 122.

39 Ibid., p. 112.

40 Ibid., p. 50.

41 Ibid., p. 67.

42 As cited by Causey, p. 233, note f.

43 PN to Audrey Withers, 1924? BT.

44 PN to MN, December 1929. PNT.

45 See Causey, p. 415.

CHAPTER TWELVE

America, Unit One and Avebury 1931–3

1 PN to Palmer, 11 December 1929. BT.

2 PN to Palmer, 6 February 1931. BT.

3 PN to MN, no date but postmarked Rye. PNT.

4 PN to Homer St Gaudens, 24 July 1931. BT.

5 'Memoir', p. 51.

6 Ibid., p. 52.

7 Ibid., p. 53.

8 Ibid., p. 54.

9 19 September 1931.

10 8 August 1931.

11 Ibid.

12 Ibid.

13 Ibid.

14 Ibid.

15 Burton Bernstein, *Thurber* (New York: Dodd, Mead & Company, 1975), pp. 194–5.

16 'Memoir', pp. 58, 60.

17 4 November 1931.

18 Rules of the competition as quoted by Susan Lambert in *Paul Nash as Designer* (London: Victoria and Albert Museum, 1975), p. 9.

19 Ibid.

20 Edward James, *Swans Reflecting Elephants* (London: Weidenfeld and Nicolson, 1982), p. 74.

21 PN to MN, postmark 23 March 1932. PNT.

22 PN to MN, postmark 25 May 1932. PNT.

23 Bertram, p. 174.

24 Ibid.

25 *Lorelei II*, p. 129.

26 'Memoir', p. 64.

27 Ibid., p. 65.

28 Ibid.

29 18 April 1931.

30 25 April 1931.

31 9 May 1931.

32 18 April 1931.

33 25 April 1931.

34 9 May 1931.

35 PN to Henry Moore, 12 June 1931. PNT.

36 *Listener*, 16 March 1932.

37 24 September 1932.

38 PNT.

39 Ibid.

40 Ibid. Nash had, however, written appreciatively of Hepworth's carvings in the 19 November 1932 issue of the *Week-end Review* (613).

41 12 June 1933.

42 Ibid.

43 5 July 1933.

44 'Memoir', p. 67.

45 Ibid.

46 Eates, p. 55.

47 Bertram, p. 217.

CHAPTER THIRTEEN

Ancient Forces 1933–4

1 Henry Moore to PN, 3 September 1933. PNT.

2 *Unit One*, Herbert Read (ed.) (London: Cassell, 1934), p. 81.

3 *Urne Buriall*, p. 102.

4 *Avebury. A Temple of the British Druids* (London, 1743).

5 Causey, p. 212.

6 Barbara Hepworth to PN, undated but c. 1935. PNT.

7 As quoted by Charles Harrison, *English Art and Modernism, 1900–1939* (London and Bloomington: Allen Lane and Indiana University Press, 1981), p. 261.

8 See Causey, p. 261.

9 *Listener*, 5 July 1933.

10 Ibid.

11 As quoted by Harrison, p.

260. In the October 1935 *Architectural Review*, Nash wrote a cautionary review of Nicholson's switch to abstraction.

12 See Causey, pp. 262–3.

13 Ibid., p. 263.

14 'Surrealism and the Romantic Principle,' in *The Philosophy of Art* (London: Faber and Faber, 1964), p. 105.

15 Frances Spalding, *Vanessa Bell*, (London: Weidenfeld and Nicolson, 1983), p. 285.

16 *Unit One*, Read, p. 109.

17 Ibid., pp. 109–10.

18 Ibid., p. 141.

19 *Week-end Review*, 7 February 1931.

20 Ibid.

21 *Sermons by Artists* (London: Golden Cockerel Press, 1934), pp. 7–9.

22 Ibid., pp. 8–9.

23 Ibid., p. 10.

24 Ibid.

25 'Memoir', p. 68.

26 PN to MN, postmark 7 August 1933. PNT.

27 Ibid.

28 'Memoir', p. 70.

29 PN to Ruth Clark, undated but December 1933 or January 1934. BT.

30 Ibid.

31 PN to Ruth Clark, undated but December 1933 or January 1934. BT.

32 'Memoir', p. 71.

33 To Edward Burra, March 1934. BT.

34 Ibid.

35 'Memoir', p. 34.

36 Ibid., p. 73.

37 PN to Ruth Clark, 26 January 1934. BT.

38 Ibid.

39 Ibid.

40 PN to Anthony Bertram, 14 April 1934. BT.

41 'Memoir', pp. 74–5.

42 Ibid., p. 75.

43 Ibid., p. 76.

44 Ibid., p. 79.

45 PN to Edward Burra, 7 November 1933. BT.

46 PN to Edward Burra, 9 February 1934. BT.

47 Edward Burra to PN, March 1934. BT.

48 *Unit One*, p. 81.

49 As cited by Charles Harrison, p. 251. There have been exhibitions re-creating the Unit One show at the Portsmouth Museum and Art Gallery in 1978, and at the Mayor in 1984.

50 PN to Conrad Aiken, January 1935. BT.

51 PN to MN, undated but *c.* 1927. PNT. In Notebook 2 at TA, Nash recorded the following figures, which are probably net of commission: 1929–30, £1,191; 1930–1: £887; 1931–2: £563; 1932–3: £508; 1933–4: £439; 1934–5: £141; 1935–6: £600; 1936–7: £700.

52 PN to MN, undated but *c.* 1927. PNT.

53 PN to MN, 12 March 1927. PNT.

54 PN to MN, undated but *c.*
1929. PNT.
55 PN to MN, 12 March 1927.

PNT.
56 PN to MN, undated but *c.*
1927. PNT.

CHAPTER FOURTEEN

Landscape from a Dream 1934–6

1 'Memoir', p. 81.
2 Ibid.
3 PN to Clare Neilson, 6 August 1934. BT.; Introduction to his Redfern Exhibition catalogue, 1937.
4 PN to MN, undated but 1934. PNT.
5 Ibid.
6 Ibid.
7 PN to Ruth Clark, undated but probably September 1934. BT.
8 PN to MN, undated but *c.* 1934. PNT.
9 PN to Ruth Clark, undated but probably September 1934. BT.
10 Ibid.
11 To Conrad Aiken, 5 January 1935. BT.
12 *Shell Guide to Dorset* (London: Architectural Press, 1936), p. 7.
13 Ibid., pp. 31–2.
14 Ibid., p. 9.
15 PN to Ruth Clark, undated but 1935. BT.
16 PN to MN, 8 August 1935. PNT.
17 Cited from *Outline*, p. 232.
18 Ibid., p. 234.
19 Ibid.
20 Ibid., pp. 235, 237.
21 When PN signed a contract for an autobiography with Cobden Sanderson in 1938, the working title was *Genius Loci.*

CHAPTER FIFTEEN

Monsters 1936–9

1 Dennis Farr, *English Art, 1870–1940* (Oxford: Clarendon Press, 1978), p. 277.
2 PN to Archie Russell, 1 September 1936. BT.
3 'Memoir', p. 86.
4 PN to Archie Russell, 1 September 1936. BT.
5 Edward Bawden to James King, 4 September 1981.
6 'Memoir', p. 90.
7 PN to MN, 31 August 1937. PNT.

8 Bertram, p. 269.
9 *Poet and Painter*, p. 212.
10 PN to MN, postmark 21 June 1938. PNT.
11 PN to Ruth Clark, 11 September 1937. BT.

12 PN to MN, 26 June 1938. PNT.
13 'The Monster Field', as printed in *Outline*, p. 244.
14 Ibid., p. 246.
15 Ibid., p. 245.

CHAPTER SIXTEEN

Machines of Death 1939–44

1 PN to Clare Neilson, 2 September 1939. BT.
2 PN to Archie Russell, undated but 1939. BT.
3 PN to Clare Neilson, 8 July 1940. BT.
4 PN to Clare Neilson, 27 December 1940. BT.
5 PN to Clare Neilson, 8 July 1940. BT.
6 Ibid.
7 Ibid.
8 Arts Bureau Prospectus.
9 BT.
10 PN to Lance Sieveking, 22 November 1939. BT.
11 PN to Kenneth Clark, 8 November 1940. BT.
12 PN to Ruth Clark, *c.* November 1940. BT.
13 PN to MN, undated but *c.* 1940. PNT.
14 PN to Kenneth Clark, 8 November 1940. BT.
15 Ibid.
16 PN to Dudley Tooth, 10 August 1944. BT.
17 'Memoir', p. 95.
18 PN to Kenneth Clark, 8 November 1940. BT.
19 'The Personality of Planes' in

Outline, p. 248.
20 Ibid., p. 250.
21 'Bombers' Lair' in *Outline*, pp. 255–6.
22 'Aerial Flowers' in *Outline*, pp. 260–5.
23 PN to Lance Sieveking, 11 February 1941. BT.
24 PN to Ruth Clark, 20 May 1941. BT.
25 PN to John Nash, ? November 1941. BT.
26 As cited by Pat Gilmour, *Artists at Curwen* (London: Tate Gallery, 1977), p. 53.
27 PN to Clare Neilson, 8 June 1942. BT.
28 PN to Clare Neilson, 29 June 1942. BT.
29 PN to MN, 31 August 1937.
30 Bertram, p. 235.
31 PN to Margot Eates, *c.* April 1946. BT.
32 Richard Seddon in conversation with James King, July 1981.
33 *The Eye of the Beholder*, p. 81.
34 Bertram, p. 306.
35 *Poet and Painter*, pp. 232–3, 237.

CHAPTER SEVENTEEN
The Slain God 1944–6

1 PN to Percy Withers, 9 May 1944. BT.
2 Ibid.
3 Barbara Bertram in conversation with James King; Margaret Nash denied the rumour after PN's death.
4 PN to MN, undated but *c.* 1940.
5 Ibid.
6 Ibid.
7 Joseph Killorin (ed.), *Selected Letters of Conrad Aiken* (New Haven and London: Yale University Press, 1978), p. 276.
8 PN to Clare Neilson, 8 July 1943. BT.
9 PN to Clare Neilson, March 1944. BT.
10 *The Golden Bough*, pp. 211–13.
11 Ibid., pp. 244–5.
12 *Outline*, p. 265.
13 TA.
14 PN to Richard Seddon, 26 December 1942. TA.
15 PN to MN, undated but 1945, PNT.
16 *Poet and Painter*, p. 266.
17 'Picture History'.
18 Ibid.
19 Ibid.
20 Geoffrey Keynes (ed.), *Poetry and Prose of William Blake* (London: The Nonesuch Library, 1967), p. 73.
21 PN to Ruth Clark, July 1944. BT.
22 PN to John Nash, 26 August 1945. BT.
23 Ibid.
24 PN to Ruth Clark, July 1944.
25 PN to John Nash, 26 August 1945. BT.
26 'Picture History'.
27 Ibid.
28 PNT.
29 PN to Clare Neilson, 5 September 1944. BT.
30 *Outline*, p. 45.
31 PN to Dudley Tooth, 10 August 1944. BT.
32 Three letters from 1945 to Ruth Clark. BT.
33 PN to Archie Russell, 18 December 1945. BT.
34 *Poet and Painter*, p. 266.
35 PN to John Nash, undated but late June or early July 1946. JNT.
36 'Memoir', p. 104.

EPILOGUE

1 T.S. Eliot, 'Little Gidding', *Four Quartets*, (London: Faber & Faber, 1st edn 1944).

Select Bibliography

Abbott, C. C. and Anthony Bertram (eds), *Poet and Painter, Being the Correspondence between Gordon Bottomley and Paul Nash, 1910–1946* (London: Oxford University Press, 1955)

Aiken, Conrad, *Ushant, An Essay* (New York: 1952; London: W. H. Allen, 1963)

— *Letters*, edited by Joseph Killorin (New Haven and London: Yale University Press, 1978)

Aldington, Richard, *Images of War* (London: Beaumont Press, 1919)

Anscombe, Isabelle, *Omega and After* (London: Thames and Hudson, 1981)

Armstrong, John, 'Tooth's "Recent Developments in British Painting"', *Week-end Review*, 17 October 1931

— 'The Present Tendency of Paul Nash', *Apollo*, November 1932

— 'Watercolours by Paul Nash at the Leicester Galleries', *Week-end Review*, November 1932

Bell, Clive, *Art* (London: Chatto and Windus, 1914)

— *Old Friends. Personal Recollections*, (London: Chatto and Windus, 1956)

Bell, Quentin, *Virginia Woolf, A Biography*, Vol. 1 (London: The Hogarth Press, 1972)

Blake, William, *Poetry and Prose*, edited by Sir Geoffrey Keynes (London: The Nonesuch Library, 1967), p. 73.

Bernstein, Burton, *Thurber* (New York: Dodd, Mead & Company, 1975)

Bertram, Anthony, *Paul Nash* (London: Benn, 1923)

— *Paul Nash* (London: The Fleuron, 1927)

— 'Paul Nash', *Architectural Review*, October 1932

— 'The Art of Paul Nash', *Listener*, 9 November 1932

— *Paul Nash, The Portrait of an Artist* (London: Faber and Faber, 1955)

Bottomley, Gordon, *The Crier by Night* in *King Lear's Wife and Other Plays* (Boston: Small, Maynard and Company, n.d.)

Brockbank, Philip, 'Browne and Paul Nash: The Genesis of Form' in

Approaches to Sir Thomas Browne: The Ann Arbor Tercentary Lectures and Essays, edited by C. A. Patrides (Columbia and London: University of Missouri Press, 1982), pp. 115–31

Browne, Thomas, *Urne Buriall and The Garden of Cyrus*, with thirty Drawings by Paul Nash, edited by John Carter (London: Cassell, 1932)

Burra, Edward, *Well, Dearie!: Letters*, edited by William Chappell (London: Gordon Fraser, 1985)

Causey, Andrew, *Paul Nash's Photographs, Document and Image*, introduction to Tate Gallery exhibition catalogue (London: 1975)

— 'The Art of Paul Nash', introduction to Tate Gallery exhibition catalogue (London: 1975)

— *Paul Nash* (Oxford: The Clarendon Press, 1980)

— *Edward Burra: a Complete Catalogue* (Oxford: Phaidon, 1985)

Chappell, William (ed.), *Edward Burra, A Painter Remembered by His Friends* (London: André Deutsch, 1982)

Colvin, Clare, *Paul Nash, Book Designs* (Colchester: The Minories, 1982)

— 'The Early Bookplates of Paul Nash', *The Bookplate Journal*, March 1984

Cork, Richard, *Vorticism and Abstract Art in the First Machine Age, Volume One: Origins and Development. Volume Two: Synthesis and Decline* (London: Gordon Fraser, 1975–6)

— *Art Beyond the Gallery* (New Haven and London: Yale University Press, 1985)

Craig, Gordon, Remarks in catalogue to Claud Lovat Fraser Memorial Exhibition (London: Leicester Galleries, 1921)

— 'Theatre Craft: The Exhibition at Amsterdam', *The Times*, 30 January 1922

Cross, Tom, *Painting the Warmth of The Sun. St Ives Artists 1939–1975* (Newmill and Guildford: Alison Hodge and Lutterworth Press, 1984)

Digby, George Wingfield, *Meaning and Symbol in Three Modern Artists* (London: Faber and Faber, 1955)

Eates, Margot, (ed.) *Paul Nash, Paintings, Drawings and Illustrations* (London: Lund Humphries, 1948)

— *Paul Nash, Master of the Image* (London: John Murray, 1973)

Epstein, Jacob, *Let There Be Sculpture: An Autobiography* (London: Readers Union, 1942)

Farr, Dennis, *English Art 1870–1940* (Oxford: The Clarendon Press, 1978)

Frazer, Sir James George, *The Illustrated Golden Bough*, edited by Mary Douglas (London: Macmillan, 1978)

Freeman, Julian, 'Professor Tonks: war artist', *Burlington Magazine*, May 1985

Fry, Roger, introduction to 'The Second Post-Impressionist Exhibition' catalogue (London: Grafton Galleries, 1912)

— *Vision and Design* (London: Chatto and Windus, 1920)

— *Transformations* (London: Chatto and Windus, 1926)

— *Letters*, edited by Denys Sutton (London: Chatto and Windus, 1972)

Gilmour, Pat, *Artists at Curwen* (London: The Tate Gallery, 1977)

Girouard, Mark, *The Return to Camelot* (New Haven and London: Yale University Press, 1981)

Gordon, Rosemary, *Dying and Creating: A Search for Meaning* (London: The Society of Analytical Psychology, 1978)

Hampstead in the Thirties (London: Camden Arts Centre, 1974)

Harrison, Charles, *English Art and Modernism, 1900–1939* (London and Bloomington: Allen Lane and Indiana University Press, 1981)

Hassall, Christopher, *Edward Marsh, Patron of the Arts* (London: Longmans, 1959)

Holroyd, Michael, *Lytton Strachey: The Unknown Years 1880–1910* (London: Heinemann, 1967)

— *Lytton Strachey: The Years of Achievement 1910–1932* (London: Heinemann, 1968)

— *Augustus John: The Years of Innocence* (London: Heinemann, 1974)

— *Augustus John: The Years of Experience* (London: Heinemann, 1975)

Hone, Joseph, *The Life of Henry Tonks* (London: Heinemann, 1939)

James, Edward, *Swans Reflecting Elephants* (London: Weidenfeld & Nicolson, 1982)

Lago, Mary (ed.), *William Rothenstein: Men and Memories* (London: Chatto and Windus, 1978)

Lambert, Susan, *Paul Nash as a Designer* (London: Victoria and Albert Museum: 1975)

Lewis, John, *John Nash: The Painter as Illustrator* (Godalming: The Pendomer Press, 1978)

Lewis, Wyndham, *Letters*, edited by W. K. Rose (Norfolk, Connecticut: New Directions, 1963)

Lewison, Jeremy, *Ben Nicholson: The Years of Experiment 1919–39* (Cambridge: Kettle's Yard Gallery, 1983)

Lorentz, Clarissa M., *Lorelei Two, My Life with Conrad Aiken* (Athens: University of Georgia Press, 1983)

Macfall, Haldane, *The Book of Lovat* (London: J. M. Dent & Sons, 1923)

Meyers, Jeffrey, *The Enemy: A Biography of Wyndham Lewis* (London: Routledge & Kegan Paul, 1980)

Morris, Lynda, *Henry Tonks and the 'Art of Drawing'* (Norwich: Norwich School of Art Gallery, 1985)

Nash, Margaret (ed.), *Fertile Image* (London: Faber and Faber, 1951)

Nash, Paul, as Robert Derriman (pseudonym), 'The Artist and the Public', part 2, *New Witness*, 9 May 1919

— 'An English Ballet', *New Witness*, 11 July 1919.
— 'The French Exhibition at the Mansard Gallery', *New Witness*, 22 August 1919
The Sun Calendar for 1920, autumn 1919
— Letter of apology regarding the Derriman incident, *Arts Gazette*, 17 January 1920
— *Places, Seven Prints Reproduced from Woodblocks Designed and Engraved by Paul Nash with Illustrations 'in Prose'* (London: Heinemann, 1923)
— 'Back to the Sources', *Week-end Review*, 7 February 1931
— ' "Going Modern" and "Being British" ', *Week-end Review*, 12 March 1931
— 'The Artist as Sportsman', *Week-end Review*, 18 April and 9 May 1931
— Letter answering Jacob Epstein, *Week-end Review*, 25 April 1931
— 'Giorgio di Chirico', *Listener*, 29 April 1931
— 'André Bauchant', *Listener*, 3 June 1931
— 'Advertising and Contemporary Art', *Week-end Review*, 11 June 1931
— 'Savage Messiah', *Week-end Review*, 20 June 1931
— 'Picasso and Painting', *Week-end Review*, 27 June 1931
— 'The Artist and Industry', *Week-end Review*, 24 September 1931
— 'Modern American Painting', *Listener*, 4 November 1931
— 'Peter Arno', *Week-end Review*, 14 November 1931
— 'Art and Photography', *Listener*, 18 November 1931
— 'A Painter and a Sculptor', *Week-end Review*, 19 November 1931
— *Room and Book* (London: Soncino Press, 1932)
— 'The Pictorial Subject', *Listener*, 17 February 1932
— 'Kit Wood. 1901–1930', *Week-end Review*, 30 April 1932
— 'The Meaning of "Modern" ', *Week-end Review*, 16 July 1932
— 'Photography and Modern Art', *Listener*, 27 July 1932
— 'Abstract Art', *Listener*, 17 August 1932
— 'Finding a Living in Art Today', *Journal of Careers*, May 1933
— 'Unit One. A New Group of Artists', *The Times*, 12 June 1933
— 'Art and the English Press', *Week-end Review*, 17 June 1933
— 'Unit One', *Listener*, 5 July 1933
— *Sermons by Artists*, contributor (London: Golden Cockerel Press, 1934)
— 'Unit One', letters to the *Observer*, 22 and 29 April 1934
— 'The Laocoon of El Greco', *Listener*, 3 October 1934
— 'For, But Not With', *Axis*, January 1935
— 'Ben Nicholson's Carved Reliefs', *Architectural Review*, October 1935
— *Dorset Shell Guide* (London: Architectural Press, 1936)
— 'Swanage or Seaside Surrealism', *Architectural Review*, April 1936
— 'Surrealism in Interior Decoration', *Decoration*, June 1936
— 'The Object', *Architectural Review*, November 1936

— 'Signs', *Listener*, 11 November 1936
— 'The Nest of Wild Stories' in *The Painter's Object*, edited by Myfanwy Piper (1937)
— 'Surrealism and the Illustrated Book', *Signature*, March 1937
— 'The Life of the Inanimate Object', *Country Life*, 1 May 1937
— 'Unseen Landscapes', *Country Life*, 21 May 1938
— 'The Giant's Stride', *Architectural Review*, September 1939
— 'The Personality of Planes', *Vogue*, March 1942
— 'Notes on the Picture called *Farewell*', *Transformation*, no. 3, 1945
— *Monster Field* (Oxford: Counterpoint Publications, 1946)
— *Aerial Flowers* (Oxford: Counterpoint Publications, 1947)
— *Outline, an Autobiography and Other Writings* (London: Faber and Faber, 1949)
Nevinson, C. R. W., *Paint and Prejudice* (London: Methuen, 1937)
Pearson, John, *The Sitwells* (New York, Harcourt Brace Jovanovich, 1978)
Perriam, D. R. *Gordon Bottomley, Poet and Collector* (Carlisle: Carlisle Art Gallery, 1970)
Piper, John, *British Romantic Artists* (London: Collins, 1942)
Potsan, Alexander, *The Complete Graphic Work of Paul Nash* (London: Secker and Warburg, 1973)
Ramsden, E. Hartley, 'Paul Nash. Surrealism in Landscape', *Country Life*, 2 January 1942
— 'In Memoriam. Paul Nash', *World Review*, September 1946
Ray, Paul, *The Surrealist Movement in England* (Ithaca and London: Cornell University Press, 1981)
Read, Herbert, *Reason and Romanticism* (London: Faber and Faber, 1926)
— (ed.), *Unit One* (London: Cassell, 1934)
— *Paul Nash* (London: Soho Gallery, 1937)
— *Paul Nash* (London: Penguin, 1944)
— 'Paul Nash, a Modern Romantic' *Picture Post*, 10 April 1948
— *The Philosophy of Modern Art* (London: Faber and Faber, 1952)
Rosenblum, Robert, *Modern Painting and the Northern Romantic Tradition* (New York: Harper & Row, 1975)
Rothenstein, John, *Modern English Painters. Volume Two: Nash to Bawden* (London: Macdonald, 1984)
Rutter, Frank, Letter exposing Robert Derriman, *Arts Gazette*, 27 December 1919
— *Some Contemporary Artists* (London: Harrap, 1922)
Seddon, Richard, 'A Walk in the Park', *Manchester Guardian*, 28 April 1962
— *A Hand Uplifted* (London: Muller, 1963)

Shone, Richard, *A Century of Change: British Painting since 1900* (Oxford: Phaidon, 1977)

Sieveking, Lancelot de G., *The Eye of the Beholder* (London: Hulton, 1957)

Spalding, Frances, *Roger Fry* (London: Paul Elek, 1980)

— *Vanessa Bell* (London: Weidenfeld and Nicolson, 1983)

— *British Art Since 1900* (London: Thames & Hudson, 1986)

Stock, Noel, *The Life of Ezra Pound* (Harmondsworth: Penguin, 1974)

Stukeley, William, *Avebury. A Temple of the British Druids* (London, 1743)

Sutton, Denys, *Walter Sickert* (London: Michael Joseph, 1976)

The Thirties: British Art and Design before the War, exhibition catalogue (London: Arts Council of Great Britain, 1979)

Thomas, Edward, *Letters from Edward Thomas to Gordon Bottomley*, edited by R. George Thomas (London: Oxford University Press, 1968)

Vaizey, Marina, *The Artist as Photographer* (London: Sidgwick & Jackson, 1982)

Watney, Simon, *English Post-Impressionism* (London: Studio Vista, 1980)

Wees, William C., *Vorticism and the English Avant-Garde* (Toronto: University of Toronto Press, 1972)

Wilenski, R. H., *The Modern Movement in Art* (London: Faber and Faber, 1927)

Woodeson, John, *Mark Gertler* (London: Sidgwick and Jackson, 1972)

Woolf, Virginia, *The Letters of Virginia Woolf: Volume IV, 1929–1931* edited by N. Nicolson and Joanne Trautmann (London: Hogarth Press, 1978)

— *Mr Bennett and Mrs Brown* (London: Hogarth Press, 1924)

Index